MUSÉE DES BEAUX-ARTS DU CANADA
**SERVICES ÉDUCATIFS**

Pudlo: Thirty Years of Drawing

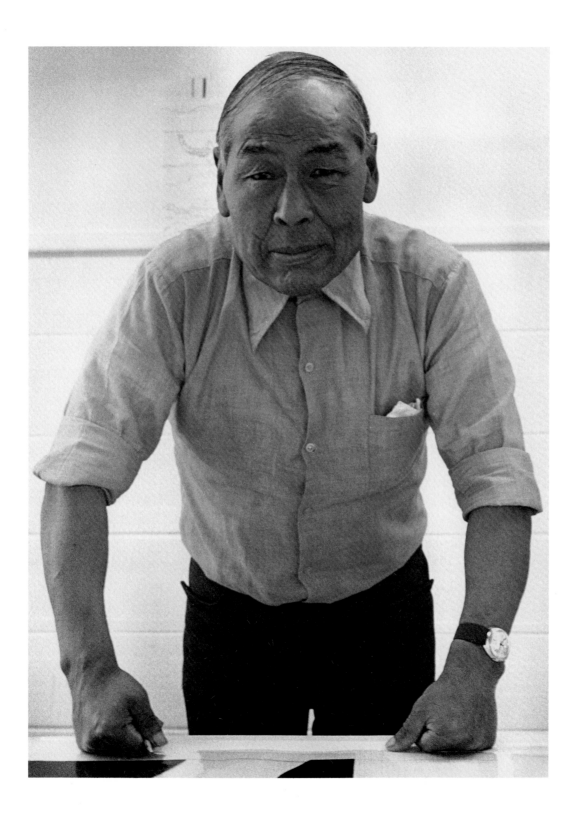

# Pudlo: Thirty Years of Drawing

Marie Routledge

with Marion E. Jackson

National Gallery of Canada
Ottawa, 1990

Published in conjunction with the exhibition *Pudlo: Thirty Years of Drawing*, organized by the National Gallery of Canada. Itinerary: 6 July–3 September 1990, Ottawa, National Gallery of Canada / 2 December 1990–27 January 1991, Winnipeg, Winnipeg Art Gallery / 22 March–19 May 1991, Ann Arbor, Michigan, University of Michigan Museum of Art.

Design: Eiko Emori
Typesetting: Zibra
Printing: Tri-Graphic

Available from your local bookseller or from The Bookstore, National Gallery of Canada, 380 Sussex Drive, Box 427, Station A, Ottawa K1N 9N4

An Inuktitut version of this book has also been issued by the National Gallery of Canada, under the title *Putlu: 30-nik arraagunik titiqtugaqattarlirninga*.

PRINTED IN CANADA

**Canadian Cataloguing in Publication Data**

Routledge, Marie.
Pudlo, thirty years of drawing.

Issued also in French under title: Pudlo, trente années de dessin.

ISBN 0-88884-603-7

1. Pudlo, 1916–    –Exhibitions. 2. Artists, Inuit–Canada–Exhibitions.
I. Jackson, Marion E. (Marion Elizabeth). II. National Gallery of Canada. III. Title.

NC143 P8 N3 1990          709'.2          CIP 90-099159-3

Cover: *Musk-ox, Frontal View* (cat. no. 26)

Frontispiece: Pudlo at Sheridan College, Hamilton, Ontario, November 1978

Back Cover: Pudlo, Cape Dorset, 1974

# Contents

Foreword       7
*Dr. Shirley L. Thomson*

Acknowledgments       9

Note to the Reader       11

Introduction       13

Thinking on Paper:       15
The Drawings of Pudlo Pudlat
*Marie Routledge*

Chronology       41

Family Tree       53

Map of Principal Locations       54

Pudlo Pudlat: Looking Back       57
*Marion E. Jackson*

Plates       85

Catalogue       101

Prints/Drawings Checklist       155

Exhibitions       177

Collections       183

Bibliography       185

Index of Titles       189

# Foreword

One of the noteworthy developments at the National Gallery over the past decade has been the growth of our collection of contemporary Inuit art. About seven years ago, we embarked upon a course that now reflects a strong commitment to the acquisition, study, and exhibition of this important part of Canadian visual and cultural history. In part through purchases, but also through the generosity of donors and through the transfer of an important body of works from the Department of Indian Affairs and Northern Development, the collection has grown to include over a thousand prints, drawings, sculptures, and wall hangings. These additions have greatly enhanced our representation of major artists and of the cultural, historical, and stylistic contexts out of which they emerged.

With the opening of our new building in May 1988 we inaugurated our first permanent galleries devoted to Inuit art. Not long afterwards, in January 1989, we were pleased to host our first special exhibition of Inuit art in the new building, *Contemporary Inuit Drawings*, organized by the Macdonald Stewart Art Centre. *Pudlo: Thirty Years of Drawing* is a further extension of our commitment to the art of the North. For the first time, we are using our own resources to organize a major exhibition that, we hope, will contribute significantly to the understanding of a most accomplished and fascinating artist.

The exhibition and this accompanying catalogue were conceived and organized by Marie Routledge, Assistant Curator, Canadian Art (Inuit). The catalogue in particular has been greatly enhanced by the contribution of Dr. Marion E. Jackson, Associate Dean of the University of Michigan School of Art, whose illuminating biographical essay grew out of her extensive interviews with Pudlo Pudlat.

The West Baffin Eskimo Co-operative deserves special mention for the generous access it has provided to its archives of Pudlo drawings. The majority of the works in this exhibition have been drawn from these rich holdings, and for their loan we are extremely grateful. As well, our thanks are due to the Macdonald Stewart Art Centre, the Montreal Museum of Fine Arts, and K.M. Graham for kindly agreeing to lend important drawings to the exhibition.

I would like as well to express our appreciation to Pudlo Pudlat himself for the effort he has put into this project, which made considerable demands on both his time and his energy. His participation has been indispensable.

In publishing this catalogue in English, French, and Inuktitut versions, the National Gallery hopes to make Pudlo's drawings accessible to as wide an audience as possible. The study of contemporary Inuit art is still in its infancy. Each exhibition, each new publication, becomes part of a larger and growing picture, one that will undoubtedly continue to fascinate us for many years to come.

*Dr. Shirley L. Thomson*
Director, National Gallery of Canada

# Acknowledgments

On behalf of Marion Jackson and myself, I would like first to extend our thanks to Pudlo Pudlat for his co-operation and for his unfailing patience during the many interviews with him that have given substance and shape to this exhibition and catalogue. Working as we did in two languages and sometimes across great distances posed enormous challenges. We hope we have done justice to the generous trust he has placed in us.

Our interviews with Pudlo were facilitated by three very able interpreters, Letia Parr, Mukshowya Niviaqsi, and Maata Pudlat, each of whom frequently went beyond the requirements of mere translation and sought to convey the actual spirit in which words were spoken. Additional translation assistance in the early stages of research was also provided by Josephee Pootoogook and Annie Manning.

To Marion Jackson herself (or Mame, as she is known to almost everyone), I owe a personal word of thanks, not only for her constantly helpful advice and encouragement, but above all for sharing with me the fruits of her research conducted over the past decade. Her extensive recorded interviews with Pudlo stand as a major document on this artist.

Most of Pudlo's drawings are held in the archives of the West Baffin Eskimo Co-operative in Cape Dorset, and of course access to this material was essential for our project. The support of the Co-op and the unstinting help of its staff have been indispensable. Over many years, Terry Ryan, the Co-op's manager, has answered innumerable questions, offered insights into Pudlo's work, and smoothed the way for our visits to Cape Dorset. In addition, he took the time to read our work in progress and came to Ottawa to review the initial selection for the exhibition. Jimmy Manning, the assistant manager of the Co-op, has also been most patient in the face of a barrage of questions and requests. Throughout, he has acted as a vital link in long-distance communication with Pudlo. Others at the Co-op who assisted us at various stages included Leslie Boyd, Margaret Gillis, Susan Breton, and Christina Alariaq.

My thanks to Peter Hogan, a teacher at the Peter Pitseolak School in Cape Dorset, for the use of his slide projector, which saved my 1989 research trip from disaster. Marion Jackson also extends her thanks to Annie Manning, who has been a friend and source of information and advice since 1978 and who, with her husband Pierre Lampron, kindly provided accommodation to her in July 1989. During the course of her 1989 research trip Marion Jackson was also assisted by Michael Ladoucent, the charge nurse at the Cape Dorset nursing station, who (with Pudlo's consent) helped verify information concerning Pudlo's medical history. Timmun Alariaq, the Northwest Territories government liaison officer, checked records in the Cape Dorset hamlet archives, specifically some of the birth and death dates used to establish the chronology of events in Pudlo's life. Reverend Michael Gardener and Margaret Gardener, now living in Iqaluit, also provided information and insights based on their experience with the Anglican church in Cape Dorset.

Wallace Brannen, Patricia Ryan, K.M. Graham, Sandra Barz, Dorothy Eber, Alma Houston, and James Houston shared with us their intimate knowledge of Cape Dorset and its art. In particular I would like to thank Wallace Brannen for talking with me in November 1988 and for offering his ideas on Pudlo's work. To Sandra Barz I owe much of my information on Pudlo's uncatalogued or "Dorset Series" prints, as well as the identification of a misattributed engraving and some technical information on the 1975 lithographs. I would also like to

acknowledge the work of Patricia Ryan, the primary cataloguer of the drawings in the Cape Dorset archives. More than once while using the Pudlo records, I was grateful for her precision and thoroughness and was awed by the magnitude of what she had accomplished.

The Department of Indian Affairs and Northern Development has given considerable support to this project. I am indebted to Maria Muehlen and Ingo Hessel of the Inuit Art Section for their advice and assistance throughout. Catherine Priest helped immensely with the locating and ordering of slides and photographs. Mary Halliwell-Cyr and other researchers in the section also searched files and checked documentation for us. David Webster of the Culture and Linguistics Section kindly made it possible for the translator Deborah Evaluarjuk to create the Inuktitut version of this book. Her contribution reflects her keen enthusiasm for the project and her exacting standards. I would also like to acknowledge the financial support of the Department's former Inuit Arts and Crafts Project Liaison Committee, which provided a generous grant to the West Baffin Eskimo Co-operative to enable us to conduct and document interviews in 1989.

Many other individuals also provided assistance to us during the research stages of our work. These included Odette Leroux at the Canadian Museum of Civilization; Judith Nasby, Ingrid Jenkner, and Monique Hempel at the Macdonald Stewart Art Centre; Micheline Moisan and Danièle Archambault at the Montreal Museum of Fine Arts; Norman Zepp, Cynthia Cook, and Sandy McKessock at the Art Gallery of Ontario; Razie Brownstone and John Bell at the Innuit Gallery of Eskimo Art in Toronto; as well as Patricia Feheley, Harry and Marsha Klamer, and staff from numerous galleries across Canada who kindly provided information on their collections and exhibitions. For their assistance in our photo research, I would also like to thank Debra Moore and other staff of the Hudson's Bay Company Archives, Stanley Triggs and Nora Hague at the McCord Museum, Dorothy Kealey of the Archives of the Anglican Synod, and Ed Tompkins and Sharon Uno of the National Archives of Canada.

At the National Gallery of Canada there are many people who have participated in this project. I would like especially to thank Julie Hodgson, Curatorial Assistant, who has worked with me since August 1989. Her attention to detail and her ability to keep our work organized have been of great benefit to this exhibition and catalogue. As well, I would like to thank Rosemarie Tovell, Associate Curator, Canadian Prints and Drawings, for her support and her helpful criticism based on her combined knowledge of prints and drawings and Inuit art. Michael Gribbon, Collections Co-ordinator for Prints, Drawings, and Photographs, and Lucille Banville, Secretary, have looked after countless details with customary efficiency and consideration.

Preparation of the exhibition has involved many other colleagues at the Gallery, including Anne Maheux, Conservator of Graphic Arts, Sat Palta, Framer, Rob Fillion, Acting Chief Photographer, Alan Todd, Senior Designer, Aline Séguin, Junior Graphic Designer, and Suzanne Lacasse, Education Officer. The staff of the Exhibitions Department, Catherine Jensen, Jacques Naud, Alison Cherniuk, and Naomi Panchyson, have also helped to bring this project to fruition.

Turning words on a page into a finished catalogue is the task of the Publications Department, which includes Serge Thériault, Head, Irene Lillico, Editorial Co-ordinator, Colleen Evans, Picture Editor, Jean-Guy Bergeron, Production Officer, and Micheline Ouellette, Word-Processing Operator. Usher Caplan and Hélène Papineau deserve special mention for their contribution as the English and French editors of this publication. Eiko Emori has complemented their efforts with her fine design work. It has been a pleasure to work with such a professional team.

Last, but far from least, I would like to thank my husband, Jeff Blackstock, for his helpfulness over the past three years, including his taking up many family responsibilities at various stages of my research and writing. His steadfast support and encouragement have been a much-valued source of strength.

*M.R.*

# Note to the Reader

### Titles of works

Strictly speaking, none of Pudlo's drawings is titled. To facilitate identification, descriptive titles have been assigned by the author for the works in the exhibition. Wherever possible, Pudlo's own comments and explanations have been used in establishing these titles. In cases where a related print exists, its title has been used for the drawing, unless information from the artist indicates that the print title is incorrect.

### Dating of works

Beginning in 1976 the West Baffin Eskimo Co-operative initiated a project to catalogue its archival collection of drawings. Since then drawings have been catalogued annually and, in the process, dated according to the fiscal year in which they were purchased by the Co-op from the artist. For example, a drawing purchased by the Co-op between July 1976 and June 1977 is dated 1976/77 — a form that has been followed here unless other information is available to specify a more precise date for the making of the drawing.

In assigning dates to its earlier works, the Co-op has demarcated two broad periods of production, 1959/65 and 1966/76; in this system, drawings can be dated mainly on the basis of the different media used in those periods. For this exhibition, an effort has been made to date the early drawings more precisely, using such evidence as inscriptions, the dates of related prints, and more detailed information on media and paper. For example, according to Patricia Ryan, who examined suppliers' invoices while cataloguing the drawings, the Co-op ordered its first Pentel-brand coloured pencils in November 1965 and its first Pentel-brand felt pens in December 1966. There are also indications from Patricia Ryan's research that wax crayons may have been used by the Co-op's artists before 1965.

Papers and their watermarks can also provide clues. Most of Pudlo's earliest drawings are on paper torn out of a coil-bound sketchpad. This paper was commonly used by Cape Dorset artists around 1960 to 1962. Other early papers included sheets from a gum-bound sketchpad and thin white bond paper. In 1969 the Co-op began ordering Rives rag paper (see Blodgett 1981, p. 50). Most of Pudlo's drawings after that point are on Rives paper, and later on Rives BFK paper.

In this catalogue, an exact date ("August 1961" or "1976") is given only when the drawing is inscribed as such by the West Baffin Eskimo Co-operative. An approximate date ("c. 1961") indicates that a related print or other dated work has been used as evidence for the dating of the drawing. A date followed by a question mark ("1961?") is a date proposed by the author on the basis of less definite evidence. A solidus between two dates ("1979/80") is used to indicate a span of time during which the drawing appears to have been made.

### Dimensions

Dimensions are given for the paper size, in centimetres, height preceding width. Measurements have been taken along the left side and bottom of the sheet.

### Cape Dorset catalogue numbers

Cape Dorset catalogue numbers, inscribed on virtually all drawings produced by the artists of the Co-op, have been used here as a primary means of identifying individual works. These numbers are made up of several descriptive components. The number *CD.024-56a-59/65(P)* may be taken as an example. *CD* stands for Cape Dorset. *024* is the number assigned to

works by Pudlo. *56* is the unique number given to this particular drawing within the Pudlo series. The letter *a* gives a description of the medium, in this case graphite (other designations are *b* for coloured pencil, *c* for wax crayon, *d* for felt pen and marker, or *f* for acrylic paint). *59/65* indicates the date assigned in cataloguing, in this case the period 1959 to 1965. The *(P)* at the end indicates that a print has been made after this drawing. Occasionally there is also a coded reference to the subject matter of the drawing and a recording of the dimensions (see cat. no. 105).

For purposes of identifying a particular drawing, an abbreviated form of the Cape Dorset catalogue number (for example, *CD.024-56*) is often used.

### Illustrations
Except where otherwise noted, all prints, drawings, and sculptures illustrated in this catalogue are by Pudlo.

### Commentaries in the catalogue entries
Except where otherwise noted, quotations in the commentaries and any statements in them attributed to Pudlo are taken from interviews with him conducted by the author in February 1989.

### Personal names
Traditionally, most Inuit were known by one name. About twenty years ago surnames were adopted. Some Inuit kept their traditional name as a first name, while others used it as a surname. In either case, the original, traditional name tends to be the name by which most individuals continue to be known.

Correct spelling of names is a perennial problem, in part because the system of Roman orthography for the Inuktitut language has undergone a series of changes over the past fifteen years. An effort has been made to follow current usage, but in order to avoid confusion commonly used spellings have been adopted for most artists' names.

### Place-names
Where they exist, official Canadian designations of place-names have been adopted for use in the text. Corresponding Inuktitut names are included on the map on pages 54–55.

### Inuktitut terms

| | |
|---|---|
| amautiq (pl., amautiit) | woman's parka with carrying pouch |
| Inuk (pl., Inuit) | literally, a person (the people). The term *Inuit* is commonly used to describe the indigenous people of Arctic Canada. |
| inukshuk (pl., inukshuit) | stone cairn, often in the rough outline of a human figure, usually erected as a landmark |
| kamik (pl., kamiit) | skin boot |
| komatik | sled of traditional Inuit construction (current orthography: *qamutik*) |
| qadlunaaq (pl., qadlunaat) | Caucasian |
| ulu | knife with a semi-circular blade, used by women |

# Introduction

In 1976 the annual Cape Dorset graphics collection included a print by Pudlo Pudlat titled *Aeroplane* that became the focus of considerable attention and a certain amount of controversy.[1] Here, practically for the first time, was an Inuit artist looking closely at modern technology, as experienced in the Arctic today, and making it an important subject in his work.[2] To some observers, this was a disquieting sign that the integrity of Inuit art, as a window on the traditions and spirit of a unique culture, was being eroded. To others, however, it confirmed the fact that Inuit art was a living and evolving form of creative expression.

Not surprisingly, *Aeroplane* and the discussions it generated have contributed to making Pudlo's name synonymous with modernity in Inuit art. Such a characterization of the artist was reinforced by subsequent drawings that incorporated the new vocabulary of airplanes, power lines, and wooden houses in the new medium of acrylic paint and which were featured in several solo exhibitions.[3]

At the same time, *Aeroplane* was part of an outpouring of Pudlo images that began appearing around 1975. Although his prints had been included in the graphics collections almost every year from 1961 onwards, it is mainly since the mid-1970s that Pudlo has become a major contributor to the work of the Cape Dorset print studio. For him, the period of the last fifteen years represents a coming of age, in terms of the development of his art and the recognition accorded to it.

The emergence of this mature body of work has led a number of writers and researchers to begin to explore its significance. The documentation collected for the 1977 exhibition *The Inuit Print*, the interviews conducted with the artist by Marion Jackson in 1978 and 1979, and the 1981 exhibition of Pudlo's prints prepared by Maria Muehlen for the Department of Indian Affairs and Northern Development have indicated that the kinds of thematic and formal concerns expressed in Pudlo's better-known work of the late 1970s and 1980s are not without precedents. It was becoming evident that many of the more recent images had their roots and prototypes in the earlier material and that all of Pudlo's work in fact reflected a remarkably coherent logic.

The present exhibition confirms this view. As well, it aims to demonstrate that Pudlo's talent goes beyond the obvious novelty of images such as *Aeroplane*. Pudlo's oeuvre now consists of close to 4,500 drawings (most of which are in the archives of the West Baffin Eskimo Co-operative in Cape Dorset), some 190 prints, and a small undetermined number of sculptures. Through a creative and provocative mingling of the old and the new, the real and the imaginary, Pudlo has fashioned a unique visual language in which to express the character of his times. Today he is undeniably an elder statesman within the Cape Dorset artistic community, a position that seems delightfully at odds with his innovative spirit and youthfully inquisitive turn of mind.

Pudlo's prints have been exhibited widely over the years and are well represented in numerous public collections. By focusing on his drawings,[4] the present exhibition brings into view a less well known but equally significant part of his creative endeavour. Unlike the prints, which involve the skill and collaboration of a printer who also makes a contribution to the realization of the work,[5] the drawings bring us closest to the hand and the eye of the artist.[6] Indeed, in the course of preparing this exhibition, many surprising drawings were discovered which, perhaps because of their complexity, were never used for print publication. To encounter these

little-known facets of Pudlo's work has been one of the highlights of this project. The 105 images that have been selected are a distillation of the best of his art, forming a survey of thirty years of growth and maturation.

All of this having been said, it is important to add that by and large Pudlo's prints do in fact reflect the strength and character of his drawings. Furthermore, from the researcher's point of view, documentation on the prints often provides essential information about the drawings — which is one reason why a checklist correlating Pudlo's prints to the drawings on which they are based has been appended to this catalogue.

In the course of his seventy-four years, Pudlo Pudlat has exchanged rifle and dog-team for pencil and paper: his sensitive eye and inquiring mind have served him equally well as hunter and as artist. To establish a dialogue between these realms of experience, two essays have been included here, one providing an interpretive approach to the drawings and the other offering a kind of memoir, generated by Pudlo's own desire to document some of the events and illustrate some of the values that have shaped his life. Not all of the biographical material presented is directly related to Pudlo's work as an artist, and yet without those contextual underpinnings his art cannot be fully understood.

The study of contemporary Inuit art requires that the bounds of traditional art history be expanded and reworked to respond to the character of the art itself. It is to be hoped that this exhibition and catalogue will accordingly enrich our knowledge, point the way to new interpretations, and result in a greater appreciation of Pudlo's remarkable achievement.

## Notes

1. For a reflection of this discussion see Sheppard 1976, Mekler 1977, and Dault 1978.
2. Strictly speaking, Pudlo was not the first Inuit artist to depict objects and activities of modern technology. In the early 1900s, for example, an artist from the Belcher Islands identified as Wetalltok drew scenes of motion-picture filming, Christmas festivities, and a New Year's day baseball game on the ice for the filmmaker Robert Flaherty (see Vancouver 1979, nos. 116–18). In the early 1960s the Cape Dorset artist Kiakshuk produced a series of drawings relating to the off-loading of the community's annual oil shipment in preparation for a possible print commission by Imperial Oil (archives, West Baffin Eskimo Co-operative, Cape Dorset). What distinguishes Pudlo's work from these and other similar examples is the way in which the subjects become not just a passing curiosity but an essential and integrated part of his concerns.
3. See "Exhibitions" below, p. 182, for a complete listing.
4. One exception to the selection of drawings is the inclusion of three lithographs and one drawing that incorporates lithography with coloured pencil. Created directly on the printing stone or plate, these images reveal important aspects of the artist's technical experience. In addition, they may be seen as central to Pudlo's development of images related to dwellings and other architectural constructions.
5. See Ottawa, National Museum of Man 1977, for a description of the printmaking process.
6. In contemporary Inuit art, drawings have until recently been of secondary interest in comparison to prints. This exhibition and catalogue are in some ways part of a broader effort among curators and scholars to foster a greater appreciation of Inuit drawings in general. See, for example, Blodgett 1981, 1984, and 1986; Christopher 1987; Jackson 1985; and Jackson and Nasby 1987.

# Thinking on Paper:

# The Drawings of

# Pudlo Pudlat

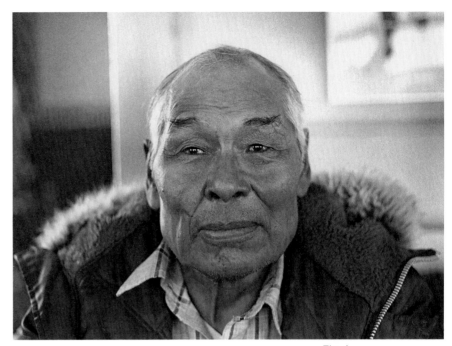

Fig. 1
Pudlo, Cape Dorset, 1985

*Marie Routledge*

If an artist draws a subject over and over again in different ways, then he will learn something. The same with someone who looks at drawings – if that person keeps looking at many drawings, then he will learn something from them too.[1]

Artists draw what they think… That's how they are. They draw what they think – and what they have seen also. But sometimes they draw something from their imagination, something that doesn't exist anywhere in the world.[2]

In the course of his career as an artist, Pudlo Pudlat has embarked upon an intriguing investigation of ideas and forms. Seen in retrospect, his work has been a continual process of growth, amalgamating personal experience and perception with a measure of artistic licence. To appreciate Pudlo's imagery one must understand the spirit of inquiry that fuels it, for it is through drawing that Pudlo has been able to reflect upon and synthesize his own encounters with the world.

Pudlo's life and art fall within a remarkable period of transition in the history of the people of the North. Born in 1916, Pudlo lived as a hunter and made his home in small camps along the southwest coast of Baffin Island until the mid-1960s. Today he resides in Cape Dorset, a modern community of about eleven hundred people that has gained an international reputation for its sculpture and graphics. For all Inuit, the twentieth century has been a time of swift and dramatic change – social, economic, technological, political, and cultural. For Inuit artists, who at various moments since the late 1940s began to carve, draw, make prints, or sew and weave wall hangings, change has provided the catalyst for their individual creative endeavours and for a collective artistic renaissance.[3]

Most Inuit artists have found in their art a timely way to record the past, to "grasp tight the old ways"[4] – the traditions, the legends, and the design sensibilities rooted in Inuit culture itself. Pudlo has been different. The strength of his vision goes beyond his abilities as an illustrator or designer; it lies rather in his indefatigable curiosity and rich imagination. Whether his focus is on an everyday object, or on one of nature's wonders, or on some technological marvel, or on the liberties and contradictions springing from the process of drawing itself, what always shines through is his talent to observe, to compare, and to extrapolate. It is this openness to experience, this eagerness to know, to understand, to assimilate the unfamiliar into the familiar, that is in a large sense the key to Pudlo's art.

## Beginning a New Career

Contemporary Inuit art may be seen as having been launched at an exhibition and sale of carvings held at the Canadian Handicrafts Guild in Montreal in November 1949. The excitement generated by those carvings, brought south from Inukjuak and Povungnituk, Quebec, by a young artist named James Houston, is now legendary. The event provided the impetus for organizations such as the Guild (now the Canadian Guild of Crafts Quebec) and the federal Department of Indian Affairs and Northern Development to take a role not just in bringing Inuit sculpture to southern audiences but also in actively encouraging its production. Through travels to camps and settlements across the North, individuals such as Houston played a pivotal role in nurturing artistic talent. The consequences of this cross-cultural interaction have been far-reaching: in artistic terms, it has meant the flourishing of new forms of expression and the emergence of gifted artists; in economic terms, it has provided many Inuit with an income, first as an enhancement to hunting and trapping in difficult times, and ultimately as a full-blown career.[5]

For the people of the southwest coast of Baffin Island, the beginning of contemporary art is linked with Houston's first visit to Cape Dorset in 1951. That spring, he and his wife, Alma, arrived by dog-team from Iqaluit, their mission being to continue the work he had begun several years earlier in collaboration with the Canadian Handicrafts Guild. Both of them have written about the rigours and delights of that journey.[6] Each was captivated by the spirit of the people they met and what they saw of their creative potential. Their interest in Cape Dorset brought them back again in the winter of 1952–53 when they spent several months there and at neighbouring camps. In 1955 they returned for an extended stay, with James taking up the post of area administrator for the federal government.

During the following seven years, until his departure in 1962, Houston's role as a catalyst for the arts took a new direction. Under his enthusiastic guidance, the first Inuit printmaking project was established.[7] The experimentation that began in the winter of 1957 resulted in some thirteen trial prints, which were sold through the Hudson's Bay Company in Winnipeg in December 1958 and exhibited at the Stratford Shakespearian Festival in the summer of 1959. The first official collection of prints, dated 1959, was presented at the Montreal Museum of Fine Arts in the spring of 1960. The success of the project at Cape Dorset soon made it a model for printmaking programs in other communities, such as Povungnituk, Holman, Baker Lake, and Pangnirtung.

In 1957 Pudlo was far from Cape Dorset and the burgeoning arts activities going on there. It was a hunting accident that spring that precipitated his eventual move to the settlement from his camp near Amadjuak. As a result of the mishap both Pudlo and his wife, Innukjuakju (who was ill at the same time), were flown to Cape Dorset for medical treatment. Pudlo spent much of the following year in hospitals and sanatoriums in Ontario and Manitoba. An initial trip for surgery on his arm was followed closely by a period of extended hospitalization for treatment of tuberculosis.[8]

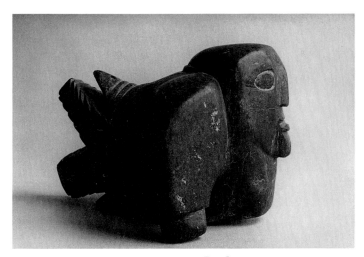

Fig. 2
*Spirit*, 1962, green stone, 22.9 cm long. Private collection

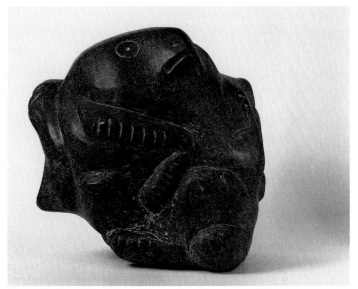

Fig. 3
*Owl*, 1968, grey-green stone, 30.2 × 31.2 × 25.4 cm. Collection: Vancouver Art Gallery (69.13)

During Pudlo's absence Innukjuakju stayed mainly at Kiaktuuq, a camp just a few kilometres northeast of Cape Dorset. Eventually she was joined by their five children, who had been looked after by others while both their parents were away. On Pudlo's return the family decided to stay at Kiaktuuq, where Pudlo's brothers Oshutsiak, Samuillie, and Joe Jaw were living. Here Peter Pitseolak was leader. A strong and influential figure, Peter Pitseolak would also come to be recognized as an important photographer, historian, and artist in his own right.[9] Here too lived Kenojuak, soon to become one of the most celebrated figures of contemporary Inuit art.[10] For Pudlo, Kiaktuuq had long been a good camp for hunting and fishing as well as a place with strong family ties. Now it was to become the place where a new direction in his life would begin.[11]

Pudlo remembers that when he moved to Kiaktuuq several men living in the camp were carving as a result of Houston's encouragement. These included his brothers Samuillie and Joe Jaw, Kopapik, and Peter Pitseolak.[12] What remains unclear is when Pudlo himself began to carve. While the likelihood is that he started only in 1958, upon his return from the South, he may in fact have carved occasionally while still at Amadjuak. There are in public collections several pre-1957 pieces attributed to him.[13] However, when he was recently shown photographs and slides of some fifteen sculptures attributed to him and dated variously from 1953 to 1980, he was unable to confirm his authorship for most of them.[14] One that he did identify as his own is a 1962 part-human part-fish figure titled *Spirit* (fig. 2). Two other sculptures from about 1968 had been identified by Pudlo in 1970 during the research conducted for the exhibition *Sculpture/Inuit*.[15]

Pudlo's sculptures can generally be described as being rather square, blockish, and often awkward. His subjects include birds, walruses, and sea spirits. Pudlo seems to have carved only sporadically, and he has said that he found sculpture boring.[16] In fact, he has also suggested that one possible reason he was encouraged to draw was that his carving was not very good. Sometime between the late 1960s and 1974 he stopped carving altogether.

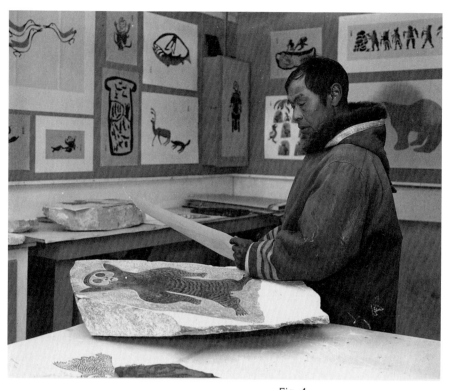

Fig. 4
Pudlo with the stoneblock for
*Avingaluk (The Big Lemming)*,
at the West Baffin Eskimo Co-
operative, Cape Dorset, August
1961 (see cat. no. 2). On the wall
behind are three other Pudlo
prints: *Man in Fish Weir* (Cape
Dorset 1961, no. 19), *Fish and
Spear* (Cape Dorset 1961, no.
20), and *Caribou Chased by Wolf*
(Cape Dorset 1961, no. 18)

Pudlo evidently began to draw around 1959 or 1960, while living at Kiaktuuq.[17] Because many Inuit men were unsure whether drawing was really an appropriate activity for a hunter, it was often the women who were more willing to make a first attempt at it.[18] Innukjuakju, for example, may have started drawing a little before Pudlo; five of her works were included in the 1960 Cape Dorset graphics collection. Both Pudlo and Terry Ryan (who arrived to work as an arts advisor in 1960) recall drawings done by Pudlo on small writing-pad sheets of the type given out by the Co-op around 1959–60. None of those drawings are included among the catalogued Pudlo works in the West Baffin Eskimo Co-operative archives. Among the many yet undocumented drawings in the archives, there are some on the 1959–60 writing-pad sheets that may be by Pudlo. Unfortunately, when Pudlo and Ryan reviewed some of these in the summer of 1989, none were recognized with any degree of certainty.

The earliest dated Pudlo drawings in the catalogued archives of the Co-op are marked June 1961, and were drawn mostly on sheets of coil-bound sketchpad paper.[19] It is clear that by mid-1961 at the latest Pudlo had taken up drawing in a consistent and committed way. Pudlo also recalls that James Houston seemed to like his drawings from the very beginning and that he encouraged him to continue.[20] The fact that ten prints of his work were included in the 1961 graphics collection supports this perception.

While drawing as an end in itself was certainly encouraged by Houston and Ryan, it was primarily through the print-making program that Inuit draftsmen were to achieve recognition. It might be said that Pudlo's career as an artist has had two sides: a public one, known through the published prints, and a more private one, embodied in the almost 4,500 drawings that he has produced over the last thirty years. The sheer volume attests to the constancy of his involvement with his art, and while parts of the work simply confirm the impression already gained through the prints, much of it also reveals a rich and varied engagement with drawing that merits close attention on its own.

## Working with Form and Line

During the first half of the 1960s Pudlo worked almost exclusively in graphite. From the 365 pencil drawings by him recorded in the Co-op's archives as belonging to the period 1960–65, it can be estimated that he was producing an average of one or two drawings a week.

These early drawings are already remarkably accomplished. Typically, the images consist of one or two silhouetted figures drawn in the centre of the sheet: forms are first outlined and then neatly filled in. Only occasionally are there signs of re-working or adjusting to get the shape or proportions right. In *Dogs Watching a Flying Creature* (cat. no. 4) lines of harnesses on the backs of the dogs are just slightly visible through the solid pencil-colouring; Pudlo evidently tried to minimize or eliminate them in favour of the overall shape. In *Man in Fish Weir* (cat. no. 9) the hunter with upraised arms has been enlarged twice in order to render him in a scale appropriate to the composition.

Often, as in *Woman with Bird Image* (cat. no. 1) and *Avingaluk (The Big Lemming)* (cat. no. 2), interior spaces are left white, providing greater definition and contrast. An interest in positive and negative spaces informs many early Inuit drawings – in part, perhaps, a reflection of the artists' previous notions of image-making, either as incised pictures on ivory or as cut-out pieces applied to garments or other sewn articles.[21] In Pudlo's case, even though he later gives equal consideration to detailing and to the linear aspects of an image, his early sensitivity to the overall form, the outer shape, is never lost.

Another constant in Pudlo's aesthetic is his sense of scale. Most of the very early images are large, taking up the full sheet of paper. Simple and bold, the drawings of about 1961 show a sureness of conception that is combined with a desire to focus on a few specific images. This selectivity is also a defining feature of much of Pudlo's work. As he himself commented once when asked about his choice of images:

> I'm not going to think about a *lot* of old things. If I do, I'm not going to be able to draw them all. When I try to draw things from the old days, I try just to think of a *few* things – just a little bit.[22]

Although the subjects of Pudlo's drawings are invariably drawn from Inuit life, they are seldom conceived in an overtly narrative mode. Conventional scenes of hunting or camp life are rare in his work; it would be difficult to use Pudlo's drawings to describe traditional Inuit culture. What Pudlo does, from the very beginning, is focus on a succession of subjects that come to have special meaning for him – his personal iconography, as it were. One such cluster of images relates to large animal and bird forms, examples being *Woman with Bird Image* (cat. no. 1), *Avingaluk (The Big Lemming)* (cat. no. 2), and *Birds* (cat. no. 3). Other groups relate to female figures, such as *Woman with Utensils* (cat. no. 8); fishing and landscape, exemplified by *Man in Fish Weir* (cat. no. 9); and dogs, as in *Chased by Dogs* (cat. no. 10). More subtly related to each other are the images of carrying and of various modes of trans-portation in general. Early drawings of this type, such as *Transported by a Bird* (cat. no. 6) and *Man Carrying Water* (cat. no. 7), complement some well-known prints – *Eagle Carrying Man* (Cape Dorset 1963, no. 34), *Man Carrying Reluctant Wife* (fig. 5), and *Man Carrying Bear* (Cape Dorset 1961, no. 17). In many of these works, we also see developing Pudlo's sense of the moment, expressed in perceptive and often humorous vignettes of daily life: dogs sitting transfixed by a buzzing insect, a man trudging once again to get water, hungry dogs nipping at their master's heels.

In shaping his observations, Pudlo often introduces seemingly unrelated objects into the composition, perhaps because he finds in them a better way to articulate the idea he is trying to visualize. In *Transported by a Bird* (cat. no. 6) the bird carrying the man wears a cap reminiscent not only of an airplane pilot's headgear but also of the kind of cap worn by seamen in the North, including some Inuit on their own boats.[23] Another example of the borrowing of details from another domain occurs in *Man Carrying Water* (cat. no. 7), where forms resembling Inuktitut syllabic characters become the shapes used to denote the fasteners on the man's coat.[24] In *Woman with Utensils* (cat. no. 8) a shape similar to that of a keyhole is

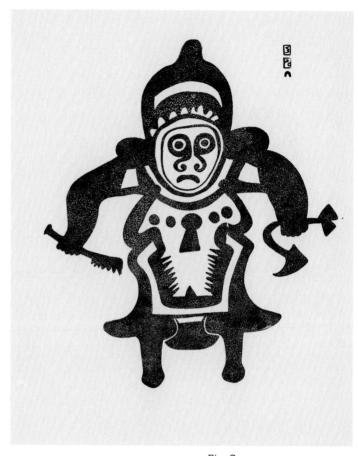

Fig. 6
*Spirit with Symbols*, stonecut,
Cape Dorset 1961, no. 49

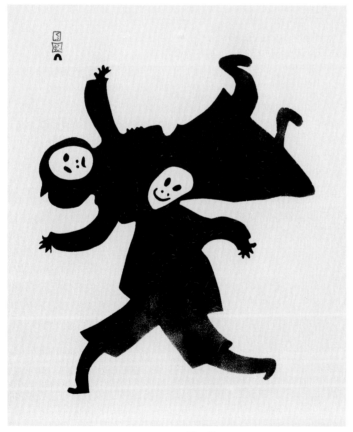

Fig. 5
*Man Carrying Reluctant Wife*,
stencil, Cape Dorset 1961, no. 16

used to describe the beading on a woman's parka; as if in an extension of the analogy, the shapes of a key and a door handle seem to have inspired the forms of the domestic utensils in her hands.[25]

Pudlo's often unexpected cross-referencing of imagery can sometimes result in incorrect shamanistic interpretations of his drawings and prints. A case in point is the print known as *Spirit with Symbols* (fig. 6), which is derived from the drawing *Woman with Utensils* (cat. no. 8).[26] From discussions with Pudlo it is clear that this supposed mythical creature is simply meant to be a representation of a woman in a decorated parka.[27] When told that shamanistic references have been observed in

his art, Pudlo has on occasion rejected the notion and expressed amusement over it.[28] The fact that he has lived all his life in the Anglican faith does not in itself preclude the possibility of such references being in his work, but on balance it seems that shamanism and spiritualism are really not as relevant to his imagery as some of the titles of his prints might indicate.

By 1962 significant changes begin to appear in Pudlo's drawings. In two works of that year, *Decorated Bird* (cat. no. 11) and *Decorated Seal* (cat. no. 12), the detailing becomes more intricate: a variety of geometric shapes embellish the large, flat forms in these compositions. Other drawings datable to about 1963/65 also show a steady development in the artist's drawing skills, with the images becoming more intricate and the articulation more linear. *Bird Boat* (cat. no. 13) shows Pudlo carrying his imaginative visual appropriations to a more complex level.[29] The various bird figures not only serve as passengers; they also become sail decorations (along with the fish) and form part of the prow of the vessel itself. A small silhouetted man stands on the mast, presumably where the

crow's nest would normally be. This image of a solitary figure looking off into the distance, watching the horizon, will recur frequently in later drawings.

In *Fish Line* (cat. no. 17), a drawing datable to 1965 or slightly earlier,[30] Pudlo concentrates more on linearity as the principal means of articulating a subject, although shading and silhouette, as seen in the drying fish and the women's hair, are not completely eliminated. Here too the ongoing interest in combining forms and images is sustained. Fish are hung to dry on a line across a frame made to store the kayak off the ground. But reality and imagination go their separate ways as the boat itself becomes a two-headed fish and the costumes of the women standing behind it take on the same striping as the fish on the boat.

In order to involve the artists more directly in the printmaking process, Houston and Ryan introduced copperplate engraving into the Cape Dorset print shop in the winter of 1961. Works in this medium dominated the 1962 and 1963 graphics collections and have continued to appear regularly. Some artists, such as Pitseolak Ashoona, Kenojuak, and Kiakshuk, seemed to take to the medium readily, while others found it too difficult to master. Although it is not generally known, Pudlo too was among the participants in these experiments. A 1963 engraving titled *Man Chasing Strange Beasts* (fig. 7), incorrectly attributed to Pitseolak Ashoona, is in fact the only published example of Pudlo's work in this medium.[31] The new linearity in Pudlo's drawings at this time may have been, in part, a result of his own efforts at engraving and his observation of the images that others around him were producing in this medium.

Fig. 7
*Man Chasing Strange Beasts*, engraving, Cape Dorset 1963, no. 17

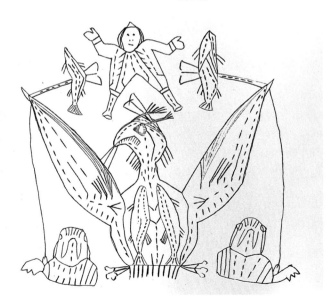

Fig. 8
Pitseolak Ashoona, *Boy Chasing Large Goose*, 1962, graphite on laid paper, 20.4 × 25.2 cm. Collection: Macdonald Stewart Art Centre, Guelph, Ont., purchased with funds donated by Omark Canada Ltd., a Blount, Inc., Company, 1982 (MS982.016)

It is interesting that the confusion of authorship of *Man Chasing Strange Beasts* should be between Pudlo and Pitseolak, for the parallels between their work can be quite striking. Another Pudlo drawing from the same period, *Bird and Woman* (cat. no. 15), is similar in spirit and style to Pitseolak's *Boy Chasing Large Goose* (fig. 8). Resemblances between Pudlo's work and that of his wife, Innukjuakju, have also been noted.[32] Indeed, as suggested by her drawing of one bird figure chasing another (fig. 9), there may in fact be links connecting the work of all three artists.[33]

It appears that Pudlo's first coloured works were done in wax crayon.[34] According to Patricia Ryan (who researched the sources of the various drawing materials as part of her cataloguing of the entire Cape Dorset drawing collection) wax crayons were being used by some of the artists as early as 1963 and were certainly in common use by about 1965. She has suggested that they may have been obtained through the newly upgraded public school. Since Pudlo helped in the construction of the school in 1963, and moved into the settlement permanently in 1964, it is possible that he too obtained wax crayons around that time. However, stylistic comparison with his graphite drawings seems to indicate that Pudlo's wax crayon works were done closer to 1966 or 1967 than to 1963. Several of his drawings using wax crayon are dated 1966 and there is at least one that is datable to 1967.[35]

Pudlo's first use of the wax crayons seems rather tentative. In *He Finally Caught a Fish* (cat. no. 18) the red and the orange serve only to accent the main design, which is in graphite. Eventually he adopts the approach of doing an outline drawing in graphite and then colouring it in completely with crayon. For the most part, colour choices appear to be unrelated to the subjects depicted, although in some works an attempt at realistic colour is evident.

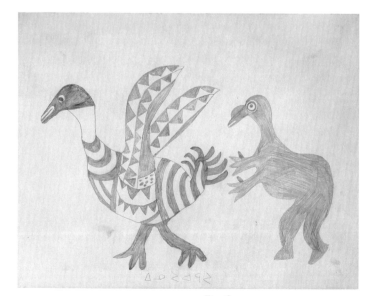

Fig. 9
Innukjuakju Pudlat, untitled drawing, August 1962, graphite on wove paper, 60.6 × 47.9 cm. Collection: West Baffin Eskimo Co-operative, Cape Dorset (CD.039-149)

Card games are a favourite pastime for many Inuit, including Pudlo, and so it is not surprising that card motifs should find their way into the visual repertory.[36] In *Bird with Playing-Card Designs* (cat. no. 19) the reference is apparent: a bird with outspread wings sports a spade and a heart on its breast. One is reminded too of the traditional methods of design and colouring found on playing cards, as this is primarily a line drawing with areas coloured in for accent.

In other works of the mid-1960s, such as *Landscape with Rainbow and Sun* (cat. no. 20) and *Bird and Landscape* (cat. no. 21), Pudlo turns to yet another theme that will receive considerable attention in subsequent work. In these drawings he makes some effort to represent sun, sky, and water in natural colours, thus going beyond the earlier, more schematic *Man in Fish Weir* (cat. no. 9) to articulate an actual landscape. Each of these images presents a window-view of the outside world. Like many of Pudlo's compositions, they are conceived as closed units centred on the sheet. The notion that a picture could extend to the edges of the paper is something that will come later, and will not make itself felt in the landscape drawings until about 1976, when Pudlo begins to use acrylic paint.

*Bird and Landscape* (cat. no. 21) suggests that Pudlo may also have been aware of Kenojuak's work. The U-shaped lines used to denote the bird's feathers are reminiscent of Kenojuak's decorative style — they appear as early as 1960 in the drawing for her most famous print, *The Enchanted Owl*, and are certainly evident in her engravings of the mid-1960s. Pudlo has also spoken of how he once tried using cut-out patterns to draw with, in the fashion of Kenojuak.[37] For him the procedure proved to be unsatisfactory and he quickly abandoned it.

The Co-op's records indicate that a first shipment of Pentel brand felt pens was received in Cape Dorset around May 1967.[38] With the four drawings *Caribou* (cat. no. 22), *Winter Angel* (cat. no. 23), *Fantasy Creature* (cat. no. 24), and *Fish Composition* (fig. 10), which can be dated roughly to between

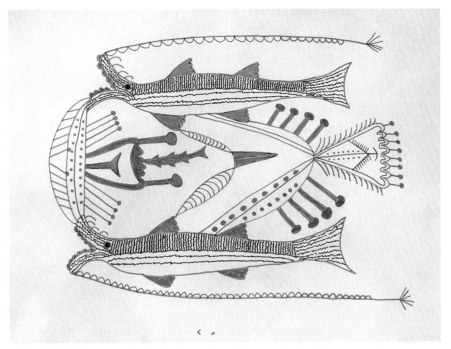

Fig. 10
*Fish Composition*, c. 1969, felt pen on wove paper, 45.7 × 61.2 cm. Collection: West Baffin Eskimo Co-operative, Cape Dorset (CD.024-570)

1967 and 1969, we again see Pudlo starting out with a new medium by approaching its colour possibilities in only the most tentative way. The earliest works seem to use no more than two or three colours at a time, often with just a single colour dominating. As in the wax crayon drawings, colour decisions seem to be unrelated to subject matter. What is striking in these works is how the smooth, flowing quality of the felt pen leads back to a focus on the decorative possibilities of line and to an elemental pleasure in the act of drawing itself.

In the works of the late 1960s one can trace the emergence of a pattern of selectivity and concentration, in both style and subject matter. Around 1968 or 1969 Pudlo's images of women become focused in a group of drawings that combine female and angel imagery with playing-card motifs. The best-known example is the 1969 stonecut *Ecclesiast* (fig. 11). The woman in

*Ecclesiast*, garbed in a long, robe-like dress and wearing what appears to be a tight-fitting headdress that frames her face in a triangular opening, is reminiscent of a playing-card Queen. Decorative interests that appeared in some of the earlier drawings now take over completely in the felt pen works: *Ecclesiast* is filled with scallops, circles, and patterns of parallel lines.

In *Winter Angel* (cat. no. 23) a winged female figure is decorated with a similar web of zig-zagging and scalloped lines. The conical projections on the headdress in *Ecclesiast* are here reduced to two striped cornute shapes. And the parachute-like objects in the upraised arms in *Winter Angel* seem to derive from similar ball-like forms that are also a part of the headdress in *Ecclesiast*.

This decorative inclination leads to even more fanciful compositions. In *Fantasy Creature* (cat. no. 24) the scallop, dot, and line motifs are worked into an image that blends the angel/woman form with a fish. In *Fish Composition* (fig. 10) the female figure is not incorporated into the image, but the same dot, scallop, and tassel motifs are used to link the fishes in a decorative pattern.

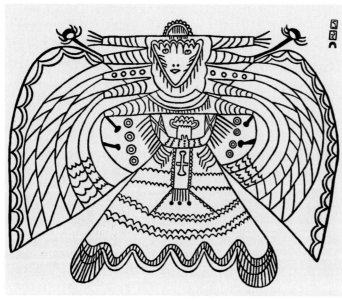

Fig. 11
*Ecclesiast*, stonecut, Cape Dorset 1969, no. 52

## Thoughts Take Shape

In the spring of 1969 Pudlo had a recurrence of tuberculosis. From May to September he underwent treatment at the Toronto Hospital in Weston, Ontario. On his return home he joined a group of Cape Dorset men who were hired to help with the sealift in Resolute. The group travelled by plane, and on the return flight a herd of musk-oxen was sighted in the Bathurst Inlet area. The pilot, as Pudlo recalls, swooped down over the herd so that his passengers could have a closer look; since these animals do not inhabit Baffin Island, they were a decided novelty.

Pudlo had also seen musk-oxen in northern Quebec in 1957 while travelling back to Cape Dorset on the *C.D. Howe* after his stay in Hamilton. The ship had engine trouble and stopped near Kuujjuaq. The passengers were able to go ashore, and they saw some musk-oxen being brought to the area as part of a wildlife project. It was probably on the basis of that sight that Pudlo drew the musk-ox featured in his 1963 print *Musk Ox Trappers* (fig. 21). The later encounter, however, made a much greater impression on him and became the catalyst for a large part of his subsequent imagery. In interviews in 1978 and 1979 he said of the musk-ox:

> I have seen two kinds of musk-oxen — one near Resolute and one down in northern Quebec. I like the ones near Resolute better. Those musk-oxen were bigger and had softer fur.
>
> I have done quite a few musk-oxen. That could be the only thing I have drawn over and over again. It could be that I am amazed by that kind of animal.[39]

*Umayuluk* (cat. no. 25), *Musk-ox, Frontal View* (cat. no. 26), and *Umingmuk* (cat. no. 27) are probably among the first drawings done after the Resolute trip. The anatomical details are not quite accurate. In *Umayuluk* the horns resemble caribou antlers and the tail is also more like that of the caribou. In *Musk-ox, Frontal View* and *Umingmuk*, the horns are the right shape but point up instead of down. It is clear that Pudlo is mainly interested in the texture of the animal's fur and its massive body — all three drawings seek to evoke the impressive bulk of the dense, shaggy hair.

Still other works continue this investigation of the "amazing" animal, though realism increasingly gives way to imagination. The creature in *Head of a Musk-ox* (cat. no. 28)

looks more like a caribou or steer. *Musk-ox with Double Horns* (cat. no. 29) studies how the animal might move and turn, but an invented element is added: double, star-tipped horns. The musk-ox leads Pudlo in two different directions: his desire to understand and portray the actual animal goes hand in hand with the consideration of it as a motif that lends itself to creative reworking, unfettered by the constraints of realism. It is an example of how Pudlo uses his own experience as a point of departure for creative inspiration; from here the process includes as well artistic licence and accident. In Pudlo's words: "My brain and the pencil seem to go together when I start to draw something that I have in my head."[40]

While images of the musk-ox form one of the strongest elements of Pudlo's work in the early 1970s, they are not his only interest. Other large-scale animal studies also appear, such as *Spider* (cat. no. 30), *Gigantic Bird on a Leash* (cat. no. 31), *Dogs Tied to a Tree* (cat. no. 32), and *Seals Meet a Bear* (cat. no. 33). In *Spider* and *Seals Meet a Bear* Pudlo explores the idea of a subject that extends beyond the edge of the paper. *Spider* gives the impression of the insect having just walked onto the sheet. By showing only the gaping mouth of the bear in *Seals Meet a Bear*, Pudlo makes the predator seem even larger and more imposing than if it were fully drawn. A feature of all these works is the artist's return to a linear and occasionally decorative style.

The female figure also continues to fascinate Pudlo at this time. Here too his successive inventorying of the multiple facets of a subject is evident, from straightforward images of feminine beauty, as in *Woman Holding a Bird* (cat. no. 36), to traditional and familiar figures from Inuit mythology and Christianity, as in *Sedna* (cat. no. 34) and *Esigajuak* (cat. no. 35). Although the exhuberant stripes, scallops, and dots of the early felt pen drawings are now left behind, there is a continued exploration of costume and its decorative possibilities.

An interest in transportation informs yet another group of images from this period. Pudlo has described his own fascination with modern technology, and the airplane in particular, as stemming from an appreciation of its usefulness to the North. But as his art clearly shows, it is a fascination that also goes much deeper. For Pudlo the airplane is, in a way, like the musk-ox: an exotic, amazing creation that he feels compelled to explore through drawing.

Pudlo had already seen airplanes by the 1940s[41] and flew on them periodically beginning in the 1950s. His 1961 *Transported by a Bird* (cat. no. 6) may perhaps be seen as an early effort to grapple with the notion of human flight. In the early 1970s he turned his attention to airplanes themselves. A trip to Ottawa in 1972 may have left its mark. Several years later, during the upgrading of the airstrip at Cape Dorset in 1976 and 1977, Pudlo took particular interest in watching a Hercules plane drop construction vehicles at the work site. As Wallace Brannen recounted at the time:

> The Hercules did its first drops by flying very low over the strip for several hundred yards — maybe eight to ten feet off the ground, maybe even lower than that — and letting a chute out the back door … and this huge chute or group of chutes would suck out a truck or some piece of heavy equipment… [Pudlo] generally looks at those things from the hill behind the shop, which is also where the towers are. Only once has he asked us to take him to the strip. He was particularly interested that day — I think it was just a Twin Otter — but he drove up with Terry and me, got out, looked the plane over, and took absolutely no interest in anything or anybody that was coming off, and got back in the truck, and we drove him into the settlement.[42]

As if in an effort to visualize and understand how an airplane flies, Pudlo begins his explorations by suggesting analogies to the shape and movement of birds and fish. Through drawings such as *Airplane* (cat. no. 38) and *Fish-Airplane* (cat. no. 39) he gradually makes the transition from nature to machine. It is important to remember that for the Inuit, the modern airplane arrived ready-made, without any long history of technological development. Leonardo da Vinci's drawings, Wilbur and Orville Wright's experiments, Charles Lindbergh's trip across the Atlantic Ocean — none of these landmarks in flight could have entered into Pudlo's awareness of where the airplane came from.

*Bird with Cap and Symbols* (cat. no. 37) seems at first to belong to no particular subject group, but on closer consideration it appears that it may be related to Pudlo's airplane drawings. The cap, the epaulettes, the star, even the suggestion of a rope and ladder, are conceivably part of the paraphernalia of the pilot and his plane. The composition is aimed primarily at experimenting with shapes, but at the same time the drawing underscores Pudlo's fascination with emblems and his openness to all sources of imagery. *Bird with Cap and Symbols* also seems to be part of a series of drawings that show various types of costumes and uniforms — perhaps even inspired by images seen on television, which came to Cape Dorset in the mid-1970s. Other subjects in the series include a figure in Mexican garb (CD.024-1002) and a dog dressed like a bellhop (CD.024-1030).

Other drawings, such as *Tent and Fish* (cat. no. 40), *Tent with Caribou Head* (cat. no. 41), *Double Tent* (cat. no. 42), and *Tupiit* (cat. no. 43), all completed around 1973, show Pudlo embarking on yet another series of images, this time relating to dwellings. From these beginnings, an interest in architecture will evolve over a number of years. The initial focus is on traditional dwellings, which may again suggest a link with Pitseolak Ashoona's work. *Tupiit*, in particular, echoes her characteristic inclusion of details such as the whimsical seal-like creature displayed in the foreground and the mass of coiled ropes that loop over the ends of the upright sleds.

The primary interest in the tent drawings is in the patterns created by the pieced-together skins and the stitching that joins them. Commenting on these drawings in a recent interview, Pudlo noted that it seemed as if he was trying so hard to make the tent-skins look perfect that they became unreal. The artist's method of presenting the tents parallels his approach to the presentation of the musk-ox: a view from the left (*Tent and Fish*), a view from the right (*Tent with Caribou Head*), and frontal views (*Double Tent* and *Tupiit*) are all presented in turn.

In *Tent and Fish* a line is strung across the roof and a fish is hung to dry on it. This may seem at first to be no more than a realistic touch, but a comparison with *Tent with Caribou Head* and *Double Tent* points to other considerations as well. Each of these dwellings is crowned with a different sort of animal emblem: fish flag, caribou head, and musk-ox horns. Some years later Pudlo spoke about how impressed he was by statues he had seen on churches in the South. It is generally thought that his idea of placing Inuit statues on his buildings begins only around 1975, with the publication of *Shaman's Dwelling* (fig. 24), a print showing an igloo flanked by two large birds and said by Pudlo to represent a church.[43] The tent series suggests that this motif actually begins to appear a few years earlier.

That the land itself could be an important subject for drawing is suggested by works of the 1960s such as *Man in Fish Weir* (cat. no. 9), *Landscape with Rainbow and Sun* (cat. no. 20), and *Bird and Landscape* (cat. no. 21). In 1974 Pudlo returned to some of the ideas in those earlier drawings and created an extraordinarily lyrical series of images. The new landscapes seem to have been inspired in part by his 1972 flight to Ottawa, and the dramatic vistas implied in some of these drawings were probably first experienced as views from an airplane window. At the same time, there appears to be another link here between Pudlo's images and those of Pitseolak Ashoona. Even a cursory examination of her published drawings and prints (such as *Summer Journey*, *Crossing the Straits*, and *Netsilik River*) confirms that by the early 1970s Pitseolak was beginning to situate her joyful narrative accounts of traditional life within an articulated landscape framework.[44] Although her landscape drawings are probably the best known, they actually appear to be part of a broader interest in the genre within the Cape Dorset community. Etidlooie, for example, was also doing landscapes from the latter half of the 1960s onward.[45] According to Terry Ryan, both Kananginak and Kingmeata were also experimenting with landscapes around 1969–70 when he gave them oil paints and watercolours respectively.[46]

Some of Pudlo's landscapes seem to arise out of his interest in habitations. In *Winter Camp Scene* (cat. no. 44) he uses fragments of landscape in combination with a camp scene featuring a large double igloo. The idea of distance and space is suggested by the layering of compositional elements, in this instance moving out from bottom to top. In the foreground we are shown a sled, in the middle ground a snowhouse, some hills, and a bear, and in the background snow and possibly open water. *Long Journey* (cat. no. 47) adds a zig-zagging line and *inukshuit* to suggest the path followed by the silhouetted figures proceeding up and into the distance. Across the top of the sheet a fragment showing a building serviced with electricity indicates the final destination.

*Long Journey* shows Pudlo beginning to work on a vaster scale than in *Winter Camp Scene*; the tiny figures are more important as markers in space than as actual subjects. In the late 1970s he commented:

> Now in my drawings I draw land, because everybody in this world sees land every time they get up... I really love making landscapes — the sky and everything. I like it when it's in a drawing. I even like it when someone takes a photograph outside, with no people. I like the scenery and I really love to draw it.[47]

Ten more landscapes, all probably done in 1974, are included in the present exhibition to indicate the richness of this series and the intensity of Pudlo's involvement in it. It is difficult to establish the actual chronology of these images and thereby reconstruct their evolution. Nevertheless one can see from the drawings how Pudlo arrives at a number of distinctive forms to interpret his thoughts about landscape. Except in *Arctic Waterfall* (cat. no. 48), he seems to move away from the layering structure that first allowed him to define an implied sense of expanse. Instead, these landscapes, like most of his previous drawings, become contained, definable objects in the centre of the sheet.

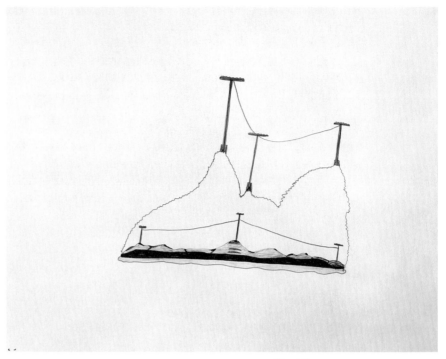

Fig. 12
*Landscape with Utility Poles*,
c. 1974, felt pen on wove paper,
51.2 × 66.2 cm. Collection: West
Baffin Eskimo Co-operative,
Cape Dorset (CD.024-1355)

The 1974 landscape drawings seem to fall into four distinct types. The simplest, such as *Landscape with Ice Floes* (cat. no. 49), *Landscape with Antenna* (cat. no. 50), and *Landscape with Utility Poles* (fig. 12), might be called landscape fragments. These pieces of landscape are isolated from their surrounding context; they are like views through a telescope. Others such as *Camp Scene with Igloos and Drying Racks* (cat. no. 51) and *Spring Landscape* (cat. no. 54) are best understood as encapsulated landscapes, made up of one view circumscribed by another. Here the sense of physical distance is implied not by separating the different parts of a scene, but by placing one inside the other. A third group, exemplified by works such as *Spring Landscape (Dirty Snow)* (cat. no. 53) and *Igloos in a*

*Landscape* (fig. 13), might be called landscape maps. These are aerial views, and as Pudlo has described them, such images are meant to be seen as curved, like the surface of the earth.[48] Here in particular it is easy to imagine that Pudlo's travels to the South and his interest in flight have surely had an impact.

The fourth and last group might be described as time/space landscapes. These are the most complex of Pudlo's landscapes, in which he is clearly trying to expand beyond physical reality to bring an added philosophical dimension to the image. *North and South* (cat. no. 52), a remarkable and crucial drawing, shows on one side a land of blue lakes and lush, green forests and on the other side a white Arctic camp scene. Dated April 1974, the drawing seems to be a kind of summation of the artist's interests in the land, transportation, and communication.

I tried to portray the Inuit land – the North – and the white man's land – the South… When you go out by plane from North to down South, you can hardly see any more snow as you go down, and you can see a lot of ponds and lakes, and it is so beautiful. And so that's how I tried to make it down South and Inuit land … Canada. In the old days it seemed as if the North of Canada – the Inuit land – was split off, before telephones or radio. We were separated, even though we were part of one piece, Canada. But now we are touching each other – through CBC radio and telephones. So that's why I made this [arc connecting the two pieces of landscape], because we are starting to understand each other. So this line that you see here means that we're co-operating more.[49]

For Pudlo, then, landscape drawing is more than just the exploration of a geographical reality. Behind it lies a quest for understanding the greater implications of space within a social context. Landscape and travel, time and space, are facets of the same thought: how do we understand distances and geographic expanses, and how do we communicate across those distances?

## A Modern Vision

Between the 1950s and the 1970s Cape Dorset was transformed from a trading post to a government administrative centre and then to a modern Northern community. In 1951 only three families were actually living at the site; primarily it was a base for the Hudson's Bay Company post, a Roman Catholic mission, and a newly arrived teacher. By the time Pudlo settled there permanently in 1964, Cape Dorset's population had grown to almost four hundred. "Match-box" houses (as the first wooden buildings were called) dotted the landscape, and an in-settlement telephone system linked some twenty-eight subscribers.[50] Skidoos were quickly becoming a part of everyday life. By the mid-1970s, Cape Dorset was very much in touch with the rest of the world – it had electricity, long-distance telephone communication, television, and regular scheduled flights in and out of its airport.

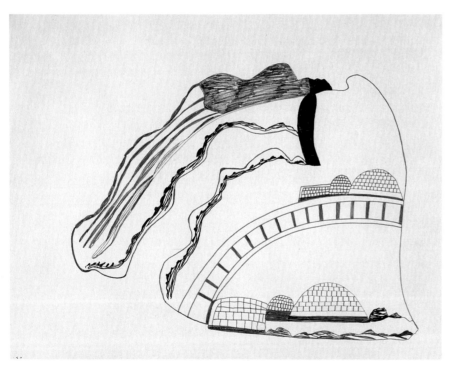

Fig. 13
*Igloos in a Landscape*, c. 1974, felt pen on wove paper, 50.8 × 66 cm. Collection: West Baffin Eskimo Co-operative, Cape Dorset (CD.024-1348)

During this period of change and growth Cape Dorset also established itself as a major centre of contemporary Inuit art. For some of its artists, the early 1970s brought more individualized recognition. Kenojuak, for example, was commissioned (along with her husband, Johnniebo) to design and execute a large plaster mural for the Canadian Pavilion at Expo '70 in Osaka, Japan. In 1970 her print *The Enchanted Owl* (Cape Dorset 1960, no. 24) became a famous household image when it was reproduced on a postage stamp commemorating the centennial of the Northwest Territories' entry into Confederation. The 1971 publication of the abundantly illustrated autobiography *Pitseolak: Pictures Out of My Life* was an acknowledgment of Pitseolak Ashoona's artistic genius. Exhibitions such as *Sculpture/Inuit*, which opened in 1971, brought international acclaim to sculptors across the North, underscoring in particular the great contribution of the Cape Dorset artists.

For the graphic artists in Cape Dorset, an important factor in the maturity and consistency of their work was the support offered by both James Houston and Terry Ryan. Houston's initial involvement, in the creation of the printmaking studio and the encouragement of drawing, helped establish a working environment that allowed for personal expression as well as technical excellence. Ryan became the manager of the West Baffin Eskimo Co-operative in 1961, a position he holds to this day. It is Ryan, more than anyone else, who has provided the vital elements of continuity and openness to experimentation. The Co-op's decisions to purchase better-quality drawing paper, coloured pencils, and felt pens in the mid-1960s can be credited largely to his efforts at expanding the range of experiences available to the Cape Dorset artists.

In the 1970s further additions were made to the types of materials and media that could be used, including the change to coloured pencils instead of felt pens and the introduction of lithography, watercolours, and acrylics. The 1970s also brought increased contact with southern printmakers and artists. Joyce Wieland, Toni Onley, Les Levine, K.M. Graham, Michael Snow, and Wallace Brannen, were among the principal visitors to Cape Dorset in the 1970s. Some came strictly to do their own work, others to conduct workshops or stay for an extended period. Their presence contributed in various ways to the development of new interests and a broadening of artistic awareness.

As with the introduction of copperplate engraving in the early 1960s, the addition of a lithography studio was aimed at providing the artists with another vehicle for greater participation in the printmaking process. A lithography press purchased by Ryan from the Toronto artist Charles Pachter arrived at the Co-op in 1972. Workshops were held in 1972 and 1973 with the assistance of two printmakers, Lowell Jones and Robert Patterson. But it was not until Wallace Brannen's tenure, beginning in the summer of 1974, that lithography became an integral part of the graphics program.

The arrival of Brannen, a master lithographer from the Nova Scotia College of Art and Design, signalled the beginning of an important new phase in Pudlo's work. Brannen invited a number of artists to experiment with drawing directly on the lithography stones and metal plates. His initial efforts were concentrated in particular on Pudlo and Kananginak. In 1975 and 1976 both men spent considerable time working in the new medium, and the annual collections for those years include a number of lithographs by each of them (see figs. 14, 22, 23).

The 1975 lithographs show Pudlo's continuing interest in habitations. In *Hunter's Igloo* (cat. no. 58) and *My Home* (cat. no. 59) he focuses primarily on the igloo form and on its possibilities for imaginative reconstruction. The aerial view used in *Hunter's Igloo* emphasizes the web-like structure of the snow blocks. *My Home*, on the other hand, uses the basic igloo as a

springboard for working out a fanciful rendition of a multi-part and multi-level architectural fantasy. Pudlo has spoken of how people sometimes used to make a double igloo – two snow houses joined by a single porch.[51] In this print, though, he seems also to be alluding to modern high-rise buildings; the resulting image becomes an expanded version of a traditional shelter, complete with ladders joining the various sections.

One of Pudlo's most ambitious lithographs, *The Seasons* (cat. no. 60), was produced in 1976. Here architectural interests are integrated into a kind of world view reminiscent of the 1974 landscapes. The image presents a mosaic of familiar Pudlo motifs. At the right, hunters travel on foot in a hilly spring landscape, presumably on their way to the duck lake enclosed by the rocky black form. Near the lower left corner, a frustrated hunter waves his whip at a disobedient team of dogs that have their lead ropes thoroughly tangled. Above them sits a curious building, igloo-like, yet decorated with crosses and two pedestalled birds. The architecture of St. Jude's Anglican Church in Iqaluit has not escaped the artist's attention. Here the church, noted for its distinctive geodesic dome, is reinterpreted with sculptural embellishments, a decorative feature of southern buildings and places of worship that evidently impressed Pudlo.

Working in lithography introduced Pudlo to a new drawing tool, the lithography crayon – a special thick wax crayon that moves easily across a surface and creates a rich, textured line. *Composition with Komatik and Figures* (cat. no. 57), one of Pudlo's few drawings using the lithography crayon on paper, reveals his obvious delight in the kind of image he could create with it; the looping ropes appear to be added more for the beauty of their flowing blackness than for functionality. We see here the same sense of liberation that Pudlo experienced when he began using coloured felt pens in the late 1960s.

Despite the success of the lithographs of 1975 and 1976, Pudlo did not continue to work directly on the stone, apart from the occasional experiment. He found it difficult to keep the plates clean while drawing on them, and he was never comfortable in the shop setting. Yet the experience was not without its effect on his art. Lithography made him more conscious of the need to deal with the entire working surface and led him to "open up" his drawings. Isolated single images and enclosed forms occur less frequently in his subsequent work.

Fig. 14
Pudlo drawing on a lithography plate at the West Baffin Eskimo Co-operative, Cape Dorset, 1975

In many respects, Pudlo's drawings of the last fifteen years are not unlike his earlier works. Certainly there is a strong thematic continuity. Yet something about his approach to his work alters in the mid-1970s. Pudlo's passionate statement (quoted earlier) about his 1974 drawing *North and South* provides a key to this change. His thoughts are now no longer bound by the past; the conviction that he is communicating with a receptive audience beyond his own community has the effect of firmly planting his art in the present. For Pudlo the modern reality of the North becomes as valid a subject as traditional camp life.

It is this interest in showing what the North is really like that would appear to underlie drawings of the mid-1970s such as *Aeroplane* (cat. no. 63), *Qulaguli* (cat. no. 64), and *Island Landscape* (cat. no. 65). *Aeroplane*, in particular, deserves special mention. In print form, this image has played a crucial role in bringing Pudlo's art to prominence. Unlike the airplane studies of just a few years earlier, which still consider the machine as an exotic apparition, this drawing presents modern technology as a plain fact of everyday life. It is as much a part of the Arctic reality as the men and women in their parkas and *amautiit* watching on the hills, or the seals basking on the spring ice floes. Some commentators have puzzled over the ambiguous blue forms that enable two of the small figures to get close to the airplane. Pudlo himself has been unclear about these, although he once indicated that they were icebergs. Whatever the original referent may be, they become an important visual link between the ground and the air, symbols perhaps of the dynamic curiosity of the artist, who would himself like to get closer and have a better look.

In 1975 the Co-op encouraged its artists to abandon the use of felt pens, when it was discovered that they produced unstable and impermanent colours. Subsequently, coloured pencil became the primary medium, enabling Pudlo to work in softer tones. The change also resulted in a subtler quality of shading and linear definition.

A new phase of Pudlo's work begins in 1976 with the introduction of acrylics into his drawings. As with lithography, the introduction of this new medium to a number of Cape Dorset artists was part of an ongoing effort to expand the range of their artistic experience. Terry Ryan has recounted how he gave Kingmeata some watercolours to experiment with around 1969 or 1970. In 1973 several artists, including Pitseolak Ashoona and Lucy, observed K.M. Graham doing her own watercolours and acrylic paintings on paper. During her 1974 visit Graham worked on an edition of prints with Wallace Brannen in the newly created lithography studio. In 1975 she was invited back to work in a painting studio set up in a small building next to the Co-op complex. Here Graham painted with her Bocour acrylics, continuing her abstracted landscapes inspired by the hills and vibrant spring colours of the Arctic. Her studio door was always open, and so she "taught" mainly by just going about her work. Following traditional Inuit custom, those artists who were interested would learn through observation rather than through formal instruction. At the end of the summer, Graham left behind her materials for others to use.

In the spring of 1976 the small painting studio that had been created for Graham was reopened for use by the Cape Dorset artists themselves. Along with Pudlo, the principal participants in this experiment included, at various times, Etidlooie, Eliyakota, Kingmeata, Lucy, Napatchie, Sorosiluto, and Egevadluq Ragee. Of them all, it was Pudlo who became most involved, not only with acrylics, but also with the use of the studio as a new place to work on his drawings. Up to this point he had always worked at home, either at the kitchen table by the window or at another table in his bedroom. The comings and goings of grandchildren and other family members imposed limits on the time and space that could be devoted to art. For Pudlo the studio provided a welcome retreat. Initially it was shared by several artists. Before long, however, it was found that Pudlo needed more solitude, and a second studio was opened for the other artists. For a period of several years in the late 1970s Pudlo thus had his own exclusive studio space. As Brannen recalled, Pudlo would spend entire days working alone.

He would sit in that little building next door ... there would be utter, total silence in the place... You'd walk in and he'd be humming some Anglican tune and it would [take] a little adjusting time before he'd bother to stop humming and look at you. He was quite intense with his work ... more than anybody I saw up there. After his first experience with the studio, I don't think his "at home" works were as good for a long time. He really loved not staying at home ... he has a strong personal relationship as an artist to where his studio is based.[52]

The private studio remained available to Pudlo until the winter of 1979–80, at which time it was closed because of economic constraints. The years that he spent working in that studio were among the most productive in his life. In 1981 a second effort was made to open a common studio for drawing and painting, in a building that had previously housed a jewellery-making project. Pudlo used this space for a time, but most of his work has since been done at home.

Pudlo's use of acrylics had a striking effect on his drawings. The acrylic wash clearly brought the entire paper surface into the composition. It also provided a new way of articulating foreground and background, land and sky, through bands of saturated colour. Where two bands met, a horizon was suggested, and from that line Pudlo would often compose his image. Given the fluidity of the paint, accident now took on an important role in the process of composition; more than once an unintentional drip on the paper was to become a point of departure for part of the image. Brannen noted:

Pudlo, of all the people who painted in acrylic, incorporated the phenomenology of the paint more than anyone else... I remember the first day he used an accident. He dropped a big blob of dark colour on a drawing sheet and he drew a little gun and leaned it up against the blob. What a revelation that was.

Brannen has also suggested that Pudlo's knowledge of lithography entered into his work with the acrylic paint:

There are quite a few lithos that use the split fountain roll – you know, the two colours rolling off in a rainbow against one another. Pudlo does some interesting paintings like that. He began to divide his painted fields, still using them as backdrops, but also making something bigger... [His work] flops back and forth [between painting and lithography]. It makes you take notice and ... you begin to realize if nothing else the great change that took place in those days when he was experimenting with the acrylics and working in the lithography studio.

Throughout the acrylic drawings, the fascination with flight prevails. In works such as *Aeroplane* (cat. no. 63), done just before acrylics were introduced, the study of the machine itself, as a stationary, inanimate object, seems basically completed. In the acrylic drawings Pudlo focuses on getting the airplane off the ground and moving. In *Airplanes in the Settlement* (cat. no. 67), for example, while the large fish/airplane in the foreground restates the analogy between flight in air and suspension in water, the airplane in the background lifts its nose and begins its ascent. Other works, such as *Airplane between Two Places* (cat. no. 70), show the airplane in the air, but with wings upraised as if flapping like a bird's. Here Pudlo again tries to devise a visual analogy for space and time. The journey is implied not only by the central destination-landscape (encapsulated in a brilliant red cloud), but also by the red splotches joined by a line attached to the back of the airplane – perhaps intended to represent its flashing lights, or points on an airline routing map. Finally, in drawings such as *Jets, Boats, and Birds in Formation* (cat. no. 71), the airplane becomes a simple, small black silhouette, soaring high, with jet trails streaming behind. Motion has been achieved.

If an airplane can look like a fish, then a fish can also look like an airplane. In *Sea Creatures* (cat. no. 68) Sednas and other creatures familiar from Pudlo's earlier works reappear. The sea goddess rides on the back of a fish while an airplane flies overhead. All three shapes are decorated along their sides with small black dots that suggest a line of windows. On the horizon, as whales dive, other remarkable half-human beings emerge. Off to the side, a man in a small boat pulls his dog along in the

water and watches the unfolding of this marvellous vision in which the airplane seems to become a new creature of Inuit mythology.

In *Sea Goddess* (cat. no. 69) Pudlo's skill at comparing and assimilating objects and ideas is again at work. The woman who lives under the ocean is portrayed wearing a miner's helmet, complete with lamp. In the dark depths, she now benefits from the same electrical illumination that is carried by the power lines to the house on shore. Like the airplane, electricity is for Pudlo a fact of modern life, and part of his intention is to emphasize its usefulness. On the other hand, the magic of this unseen yet tangible energy clearly elicits an imaginative response.

The suggestion of something known yet unseen is an important feature of many of the acrylic drawings. In *Jets, Boats, and Birds in Formation* (cat. no. 71) such a suggestion is made through the depiction of boats half-hidden behind icebergs or land formations. In other drawings, the motif of the unseen or partially seen subject takes a decidedly surreal turn, where oversize images of birds or walruses suddenly emerge out of a distant landscape (see cat. nos. 71 and 72). The incongruity of these figures within a landscape composition gives these drawings an unsettling air of mystery.

After the closure of his private painting studio, Pudlo returned primarily to coloured pencil. However, the compositional and perceptual lessons acquired from painting and lithography were to leave their imprint on his later work. In drawings such as *Modern Life and the Old Way* (cat. no. 74) and *Umimmak Kalunaniituk* (cat. no. 75) the overlap between North and South, and between tradition and modernity, continues to be explored through the same kind of landscape format developed in the acrylic drawings. In *Modern Life and the Old Way* a mysterious face emerges in the distant cityscape, almost hidden in the maze of buildings, trees, and buses. By contrast, the Inuit hunter in the lower portion of the drawing stands out large and clear in his uncluttered space. Pudlo's thoughts here about the South appear to coincide with a trip to Toronto and Montreal in 1978. The building in *Umimmak Kalunaniituk* ("Musk-ox in the City") seems to owe its unusual arched windows to the Château Champlain hotel in Montreal; the musk-ox, as Pudlo has explained, is meant to be read as a piece of sculpture, or a large sign, or a picture on a billboard.

As Pudlo becomes more conscious of the colour, texture, and shape of the paper, the sheet itself becomes a more important feature in his drawings. *Blue Musk-ox* (cat. no. 76) and *A Good Catch* (cat. no. 77) both present figures going to or coming from some unspecified place off the sheet. After 1977 Pudlo's compositions become much flatter and more two-dimensional. Images such as *Airplane with Antlers* (cat. no. 79), *Transported* (cat. no. 80), and *Skins and Blankets Hanging to Dry* (cat. no. 81) reveal a rather sophisticated understanding of the inherent possibilities and limitations of the two-dimensional paper as a means of capturing reality.

Between 1975 and 1981 the annual Cape Dorset graphics collections included almost sixty prints by Pudlo. His growing stature as one of the leading Cape Dorset graphic artists was bringing him numerous honours, including a commission in 1978 to design banners for the lobby of the Department of Indian Affairs and Northern Development in Hull, Quebec (see fig. 38), the reproduction of his 1976 print *Aeroplane* on a Canadian postage stamp, and the commission of his print *Shores of the Settlement* for presentation at a ceremony honouring "Twenty Great Montrealers." In 1981 the Department of Indian Affairs and Northern Development organized the first in-depth retrospective of his work.

In February 1981 Pudlo celebrated his sixty-fifth birthday while he was at a hospital in Montreal having a pacemaker implanted to regulate a heart condition. On his return to Cape Dorset he continued drawing and helping to look after a growing family of grandchildren. The operation must have amazed the artist as a feat of modern technology. One drawing suggests that he responded to it with his characteristic logic and wit. In *New Parts for an Inuk* (cat. no. 83) the figure not only sports a wristwatch but also has a clock ticking away over his heart. In the spirit of exploration and visual punning, Pudlo appears to have taken his conception of mechanical implantation and the addition of foreign parts to the human body one step further: in place of hands the man has hoofs, his head is graced with both caribou antlers and musk-ox horns, and the cap on his head, complete with light bulb, suggests he may even be wired for electricity. Once again, understanding and imagination are linked through drawing.

## Concentration and Diversity

Memory and present-day experience, new materials and techniques, a sensitivity to the formal and symbolic possibilities of objects, an eye for other artists' work, a measure of humour: for Pudlo these are the elements that are brought to the testing ground of each new drawing. Through the years, a pattern of phases of creativity becomes evident. At times, diversity and searching seem to be the dominant motivating forces, as Pudlo experiments simultaneously with a variety of different subjects, styles, or compositional structures. Yet, within this ongoing exploration, there have also been moments of concentration in which a single component of the mix crystallizes. These points of focus have often resulted in a series of exceptional drawings.

One such phase emerges in the early 1980s, particularly between 1982 and 1984. Familiar motifs such as the musk-ox, the loon, the walrus, the caribou, and the bird/fish/airplane become the springboard for an outpouring of works in which Pudlo seems to enlarge and flatten out his subjects, as if to examine them more closely as abstracted two-dimensional forms.

In a number of these drawings Pudlo experiments with unusual ways to situate the image on the sheet. In *Caribou-Creature Seen from Above* (cat. no. 84), *Composition with Caribou-Creature and Loon* (cat. no. 91), and *Caribou* (cat. no. 92) an aerial perspective is introduced to reinterpret these favoured animal forms as if their hides had been flattened on the ground. Splayed, skinny legs and branching antlers provide a delicate counterpoint to body mass; typically, the animals are cropped to further heighten the scale. As with the earlier *Pungnialuk* (fig. 15), these are not real animals but images that the artist has chosen to arrange within the context of the paper surface.

Pudlo's interest here in different compositional possibilities seems to be related to his work with Wallace Brannen. Although Pudlo had probably not drawn on a printing stone since the 1975–76 efforts, Brannen on at least one occasion persuaded him to again work in the lithography studio. The experimental lithograph/drawing *Composition with Caribou-Creature and Loon* (cat. no. 91) is actually one of several versions of an idea for a composition that centres on the flattened animal form (see figs. 16 and 17).[53] As Brannen has explained, the intent was to encourage Pudlo "to take something halfway through, stop, rework it, and start again." In this exercise with proofs of the caribou/musk-ox shape, Pudlo uses the opportunity to further explore the creative options suggested by one of his flat-figure compositions.

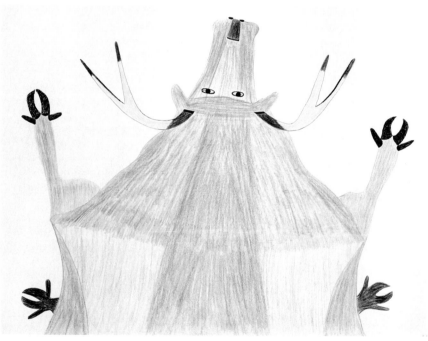

Fig. 15
*Pungnialuk*, 1976/78?, coloured pencil and black felt pen on wove paper, 56.3 × 76.3 cm. Collection: Macdonald Stewart Art Centre, Guelph, Ont., purchased with funds donated by Omark Canada Ltd., a Blount, Inc., Company, with assistance from the Canada Council, 1982 (MS982.092)

Enlargement and cropping are used to dramatic effect in *Walrus Close Up* (cat. no. 87), where Pudlo focuses on the muzzle, neck, and tusks of the huge mammal as if it were rising out of the water just inches in front of the viewer. This looming figure has its antecedents in a number of earlier drawings, such as *Walrus on the Horizon* (cat. no. 72) and a large-scale work produced in 1978/79.[54] But in *Walrus Close Up* reality has been reworked and a visual pun added as Pudlo overlays a small human figure on the walrus, using the animal's nose for the face and the shadows of the muzzle and tusks for the body.

Like many Cape Dorset artists, Pudlo has often made pattern and decoration a central component of his bird compositions. Drawings such as *Ship of Loons* (cat. no. 88), *Snow Swan of Parketuk* (cat. no. 89), and *Loon in Open Water* (cat. no. 90) also show him working with the problem of how to suggest motion. In *Ship of Loons* the composition is animated by a simple shift in the placement of the subject. The tilting of the canoe not only conveys the impression that it is riding up the

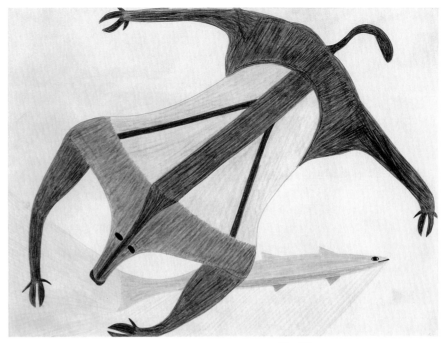

Fig. 17
*Composition with Caribou-Creature and Fish*, 1983/84, coloured pencil and black felt pen on wove paper, 56.5 × 76.6 cm. Collection: West Baffin Eskimo Co-operative, Cape Dorset (CD.024-3593)

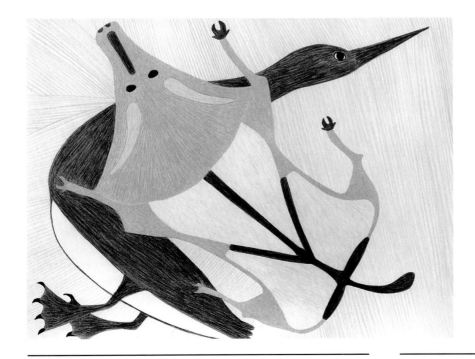

Fig. 16
*Composition with Caribou-Creature and Bird*, 1983/84, lithograph, coloured pencil, and black felt pen on wove paper, 56.7 × 76.7 cm. Collection: National Gallery of Canada, Ottawa, gift of Dorothy M. Stillwell, M.D., 1987 (29919)

side of a wave but also gives an energetic diagonal thrust to the drawing. *Snow Swan of Parketuk* and *Loon in Open Water* show Pudlo representing motion in another way – behind each bird a spray of lines denotes rushing water.

In *Flying Figure* (cat. no. 94) Pudlo reworks his motif of the bird/fish/airplane using the possibilities of both placement and line to full advantage. The figure soars diagonally across the sheet, while streams of lines jetting from behind and off the tips of the wings reinforce the suggestion of speed. In this work, which sums up many of the earlier images of flight, the idea of motion virtually becomes the subject itself.

In his drawings of 1982 to 1984 Pudlo also continues his eclectic, often witty, juxtapositions of the familiar and the exotic. The musk-ox drawings, such as *Tale of a Huge Musk-ox* (cat. no. 85) and *Winds of Change* (cat. no. 95), carry on the study of these creatures that have so amazed him. Starting in the late 1970s, Pudlo's musk-oxen begin to be decorated, saddled, and mounted (see fig. 25). Of the genesis of these new versions, he has explained:

> I have seen people riding on animals – usually on TV. I have seen horses with saddles being ridden, and also cows and camels and elephants. But I have never seen anybody ride a musk-ox! That's why I drew this… This was just my imagination.[55]

That television should provide the artist with a source of ideas is not surprising. And given Pudlo's interest in transportation, his turning a musk-ox into a riding animal almost seems inevitable. One must remember, too, that from Pudlo's vantage point a riding horse or bucking bronco is just as novel as a dog-team might be for someone living in the South. In *Winds of Change* Pudlo is at his imaginative best: hunters and a dog are seated on the undulating, humpy back of a musk-ox, and an airplane is tied to its horns, as if about to be slung into flight.

In other works Pudlo takes a more abstracting approach to his images. A kind of visual shorthand emerges, in which one aspect of an object represents the whole, or one form serves two functions. In *Sail in the Settlement* (cat. no. 96) the fragment of landscape at the lower left denotes the shore at the same time that it stands in for the hull of the sailing ship behind it. As well, the lines of the sails are linked to the power lines of the settlement at the right. Thus boat, land, and settlement are all fused into a single form.

Reduction and abstraction are carried still further in *Composition with Arms and Bird* (cat. no. 97) and *Composition with Arm, Braids, and Fish* (cat. no. 98), where references to actual figures are pared to a minimum. The fragments used in the former work – arms in a parka, the head of a loon, a hand, a suggestion of hills and water, stripes reminiscent of designs on a parka – conspire to create an air of mystery, almost suggesting the presence of a vaguely defined male figure. Elements in the latter work – fish, braids, an arm and shoulder, and a hand holding something – suggest that the starting point for this image was probably a female form.

The exploration of the large-scale, two-dimensional figure has led Pudlo through a kind of compositional analysis to abstraction. However, the concentration on this kind of image ends, for the most part, around 1984. The abstractions of 1983–84 represent the furthest Pudlo has gone in a broad exploration of the principles of drawing, moving out in many ways from the standard practices and approaches used by most Inuit artists. Perhaps as a reaction, or perhaps as a necessary part of further growth, Pudlo's most recent drawings signal what could best be described as a return to diversity and experimentation.

In the drawings of the past five years, one of the most notable developments has been a considerable reduction in the use of colour. Even in the early 1980s, in images such as *Caribou-Creature Seen from Above* (cat. no. 84) and *Snow Swan of Parketuk* (cat. no. 89), Pudlo begins to show an interest in working only with a black coloured pencil. Here the choice is most effective, as the artist sets out to emphasize the linear qualities of the forms and their relationship to the whiteness of the paper surface. In later drawings, such as

*Alerted Loons* (cat. no. 99), *Shielded Caribou* (cat. no. 100), and *Proud Hunter* (cat. no. 101), the use of graphite or black felt pen as the dominant medium allows Pudlo to concentrate the mass of the figures. The monochromatic shading becomes the focus of attention. In the graphite works, most particularly *Shielded Caribou*, the effect is delicate and subtle. With the fine-tipped felt pen used in *Proud Hunter* the artist achieves a rich, luminous range of blacks.

In 1979, while commenting on his use of colour, Pudlo emphasized his preference for those that made his drawings clear and bright.[56] More recently he has modified that view and is now considering a more limited palette. While Pudlo continues to use bright colours, his choices have become more selective. The presence of black felt pen and crayon in much of the recent work suggests a new kind of exploration, with black often defining an image and colour becoming its counterpoint within the composition.

Moving away from the large, flattened, and abstracted drawings of the early 1980s, Pudlo has also introduced a stronger narrative element into his recent work. Whaling themes, as in *Whale Hunter's Boat* (cat. no. 102), have provided a new perspective on the ideas of transportation and carrying.[57] Even here he personalizes the drawing by adding two huge, gaily striped flags flying from the mast. The man in the crow's nest looking through the telescope is, according to Pudlo, "watching the plane instead of watching out for the whales' waves." In *Pulling In a Walrus* (cat. no. 103) the rigging used by whalers to haul the whale on board has been adapted by Pudlo to one of his familiar icons, a walrus looming out of the water. The rigging itself is mostly imaginary; an interest in the *avatuq*, the sealskin float used by Inuit hunters, has prompted the artist to add them to the boat, as if as counterweights. The jaunty figure on the bow, sporting sunglasses and an upturned hat, his arm raised to signal the success of the catch, might be seen as a self-portrait.

Other thoughts on transportation and carrying have been directed to a series of drawings that show helicopters lifting bears, fish, or anything imaginable. In one of the first of these, *Aerial Portage* (fig. 18), a large, double-bladed, military-type helicopter is seen lifting a sled that supports a canoe and four dogs. Pudlo has remarked that one of the things he appreciates most about helicopters and airplanes is their usefulness in the North, especially in helping stranded individuals (as happened with him in 1957). However, as the series grows to encompass a variety of transformations, the descriptive interest is once

Fig. 18
*Aerial Portage*, lithograph, Cape Dorset 1986, no. 28

again supplanted by the imaginative.[58] An eerie and visually powerful counterpoint to this series emerges in *Helicopters and Woman* (cat. no. 104). If helicopters can carry things, they can also drop things. Seen from above, with her arms, legs, and *amautiq* spread out, the woman spins through the air with the same force that moves the helicopter blades. Previous experiments with aerial perspective have not been totally abandoned, and, as the graphite underdrawing in this work suggests, Pudlo has quite carefully and deliberately worked out the three forms and their relationship in the composition.

In *Carried by a Kite* (cat. no. 105) the iconography of flight and transportation takes a lighter, almost romantic turn. Here a man and woman in traditional garb ride in the air, suspended by a colourful stylized kite-form and framed by a blue-green wedge of colour suggesting the gust of air that carries them skyward.[59]

From the 1961 *Transported by a Bird* (cat. no. 6) to the very recent *Carried by a Kite*, the experience of living and drawing in the changing North has taken Pudlo on a full and rewarding journey. As with the innumerable images related to carrying, flight, and transportation in general, a thread of continuity binds much of Pudlo's work. Musk-oxen and other large animals, an array of appropriated signs and symbols, habitations, female figures: these icons have been constant companions through the years. And yet, at each stage, with each new series or burst of activity, the process is enriched. During interviews about his drawings, Pudlo would often digress to consider how he might rework and improve them now. Although Pudlo's drawings may be enjoyed as finished works, they also function for him as preparatory sketches: one engenders the next, and they become part of his own experience.

From the 1960s to the present, Pudlo has continued to follow his own dictum, to "draw a subject over and over again in different ways." At age seventy-four, his commitment to his art and to the spirit of exploration and learning remains unwavering.

## Notes

1. Jackson 1979, p. 113. In the interest of clarity, some quotations from Pudlo have been edited slightly by the present author. Tapes and transcripts of all interviews with Pudlo cited in this essay are now in the Documentation Centre, Inuit Art Section, Department of Indian Affairs and Northern Development, Hull, Quebec.

2. Jackson 1979, p. 91.

3. While it is generally agreed that there is little overt resemblance between the art of the contemporary Inuit and that of their ancestors, the peoples of the Thule and Dorset cultures, Dr. Robert McGhee has offered an insight into how these different periods of artistic production might be seen in relation to one another. He suggests that we consider contemporary Inuit art to be yet another periodic explosion of artistic production linked to significant cultural change and, as such, "an integral part of the long and diverse artistic heritage of the peoples of Arctic Canada" (McGhee 1987, p. 14). It is in the spirit of this interpretation that the notion of "renaissance" is here applied to contemporary Inuit art.

4. The phrase "grasp tight the old ways" was found inscribed on a sculpture by Mariano Aupilarjuk and was made famous through its use as an exhibition title. See Blodgett 1983, pp. 12, 228 (Aupilarjuk, no. 150).

5. On the history of contemporary Inuit art, see Martijn 1964; Swinton 1972; Ottawa, National Museum of Man 1977; and Hoffmann 1988.

6. See their respective accounts, James Houston, "Cape Dorset 1951," and Alma Houston, "Cape Dorset," in Winnipeg 1979, pp. 9–11, 13–18.

7. See Houston 1967 and Ottawa, National Museum of Man 1977.

8. For a more detailed account of Pudlo's injury, Houston's role in his rescue, and the subsequent trips to southern Canada, see Marion Jackson's essay below, pp. 70–71.

9. See Pitseolak and Eber 1975 and Bellman 1980.

10. See "The Autobiography of Kenojuak," as told to Patricia Ryan, in Blodgett 1981, p. 20.

11. See Marion Jackson's essay below, pp. 72–73 . In interviews with the author in February 1989 Pudlo emphasized that between the hunting and the presence of his family, especially when his mother was still alive and living with his brothers, Kiaktuuq had been a particularly good place for him.

12. Jackson 1979, pp. 81–82. Pudlo's recollections tie in with other accounts. Kopapik's wife, Mary Qayuaryuk, has talked about her husband's first carving, done after the Houstons' stopover at Kiaktuuq on the 1951 dog-team trip. See Dorothy Eber, "Glimpses of Seekooseelak History," in Winnipeg 1979, p. 24.

13. For example, *Sleeping Duck*, 1953 (Winnipeg Art Gallery, G-60-107), and *Loon*, c. 1956 (fig. 20), which were attributed to Pudlo by George Swinton. They were dated according to when they were purchased in the South.

14. The slides and photographs were shown to him by Marion Jackson on behalf of the author in August 1989.

15. *Owl Alighting* (1968, Canadian Museum of Civilization, IV-C-4050) and *Owl* (fig. 3).

16. Pudlo Pudlat, interview with Marion Jackson, August 1989, with Letia Parr as interpreter.

17. See Marion Jackson's essay below, p. 72.

18. Personal communication with Terry Ryan, June 1989. See also Ryan's essay in Blodgett 1986. It is interesting to note that Kenojuak, probably the first Inuit woman to draw, had a different view – she saw drawing as a man's activity (Blodgett 1981, p. 32).

19. These include the drawings numbered CD.024-28, 41, and 44 to 47. Numbers 44 and 45 are not on the same paper.

20. Jackson 1979, p. 82. Although the project never came to fruition, Pudlo also recalled Houston inviting him to try drawing on walrus skin. Perhaps this was related to initial efforts with stencil print-making that involved experimenting with sealskin as a medium; the skins proved impractical and were abandoned for heavy waxed paper.

21. See Vastokas 1971–72, Jackson 1985, Labarge 1986, Christopher 1987, and Jackson and Nasby 1987.

22. Jackson 1978, p. 29.

23. Peter Pitseolak's photographs provide examples of some likely sources, including (in addition to those mentioned here) the hat worn by RCMP officers. See Bellman 1980, p. 46 (15b), and Pitseolak and Eber 1975, p. 40. Jimmy Manning, the assistant manager of the West Baffin Eskimo Co-operative, recalls seeing Pudlo himself wearing such a cap.

24. It is perhaps useful to recall that as a child Pudlo, like other Inuit, taught himself to read by poring over an Inuktitut Bible (see Marion Jackson's essay below, p. 61). The syllabary has therefore long been part of his visual repertory. Kenojuak and Peter Pitseolak also talk of similar experiences. See Blodgett 1981, p. 11, and Pitseolak and Eber 1975, p. 40.

25. See Ottawa, National Museum of Man 1977, no. 22.

26. Titling of the prints, especially in the first years, was often done without the involvement of the artists. Most of them were still living at camps, and it would have been difficult to contact each of them about their individual works.

27. Where no source is cited, statements in this essay attributed to Pudlo are taken from interviews with him conducted by the author at Cape Dorset in February 1989, with Letia Parr as interpreter.

28. Jackson 1978, pp. 50–51, 73–74. See commentary to cat. no. 8.

29. A similar print, *Animal Boat* (1963? unreleased) is illustrated in Houston 1967, p. 73. The dating is based on Terry Ryan's comment (personal communication, July 1989) that he recalls this print having been completed before his departure for his North Baffin trip in January 1964. Comparison with the drawing for *Animal Boat* (CD.024-2817) suggests that the more complex *Bird Boat* may have been done somewhat later.

30. The related print, *Fish Line* (Cape Dorset 1966, no. 38), is dated 1965.

31. I am indebted to Sandra Barz for pointing out this misattribution. She noted Pudlo's signature on a copy of this print in the Toronto Dominion Bank Collection, and in June 1989 Pudlo confirmed for her that the work is by him. A proof copy of the print in the collection of the Canadian Museum of Civilization is also inscribed "Pudlo" (in syllabics) on the recto, although "Pitseolak" is written in English on the verso. According to Terry Ryan other engravings by Pudlo are included in the unreleased editions in the Co-op's archives (personal communication, September 1989).

32. Jackson and Nasby 1987, no. 24.

33. Pitseolak once remarked that she had seen something of Pudlo's that she liked (Eber 1971, n.p.).

34. In November 1965 the West Baffin Eskimo Co-operative began ordering coloured pencils for its artists (see Blodgett 1981, p. 50). Judging from the catalogued works in the Co-op's archives, it appears that Pudlo himself did not use coloured pencils until the following decade.

35. Five drawings, numbered CD.024-603 to CD.024-607, are each inscribed on the verso "Pudlo 1966." The drawing numbered CD.024-873 combines wax crayon and felt pen; felt pens were not available before 1967.

36. At Kiaktuuq, Peter Pitseolak photographed a man named Seuteapik wearing *kamiit* with inlaid playing-card motifs (see Bellman 1980, p. 42, no. 92).

37. Jackson 1978, p. 52. Two drawings in the collection of the Macdonald Stewart Art Centre, *Bird Fantasy* (MS982.97) and *Five Owls* (MS982.98), may have been drawn using such patterns.

38. Letter to the author from Patricia Ryan, July 1989.

39. Jackson 1979, p. 91; Jackson 1978, p. 24.

40. Jackson 1978, p. 2.

41. Pudlo once recounted that the first airplane he observed from close up was one that came when the M.V. *Nascopie* sank in 1947 (Ottawa, Canadian Eskimo Arts Council 1971). In his 1989 conversations with Marion Jackson, he added that airplanes have been a common sight in the North since the Second World War.

42. [Robertson] c. 1977, pp. 4–5.

43. Jackson 1978, p. 53; Jackson 1979, pp. 96, 98.

44. See Cape Dorset 1970, nos. 6, 8; Cape Dorset 1973, no. 26; Eber 1971.

45. See Blodgett 1984.

46. Personal communication, September 1989.

47. Jackson 1978, p. 81; Jackson 1979, p. 92.

48. Jackson 1978, p. 89.

49. Jackson 1978, pp. 84–85.

50. Higgins 1968, p. 39.

51. Jackson 1979, p. 94.

52. Quotations in this essay attributed to Wallace Brannen are from interviews with him conducted by the author in November 1988.

53. It is likely that the drawing numbered CD.024-3593 (fig. 17) is the initial image. From here, it appears that Pudlo redrew the caribou-like form on the lithography stone and reworked it. The inclusion of horns and a mane of hair on the head suggests that Pudlo began to see the animal partly as a musk-ox. In printing, the form was reversed, as shown in the subsequent versions. In the National Gallery drawing (fig. 16) the caribou-creature has been turned to face upwards and the detailing on its body has been refined. Here the fish, which remained in at least one other version (CD.024-3597, not illustrated), has been replaced by the loon. *Composition with Caribou-Creature and Loon* (cat. no. 91) might be the latest of the variants – the bird form is simplified and made more graphic, and the inking has been changed from grey to black.

54. CD.024-2564b, an untitled work, in acrylic paint, coloured pencil, and felt pen on wove paper, 77.5 × 107 cm, present location unknown. See New York 1980, no. 2.

55. Jackson 1979, p. 103.

56. Jackson 1979, p. 114.

57. It seems that this interest in whaling may have been inspired by the work of his brother Oshutsiak, who began drawing in 1980. See Toronto 1985. Oshutsiak's drawings and reminiscences about whaling are also featured in Eber 1989, pp. 150–54.

58. See, for example, the lithographs *Imposed Migration* (Cape Dorset 1986, no. 32) and *Flight to the Sea* (Cape Dorset 1986, Other Releases). The related drawings are listed in the Prints/Drawings Checklist below, pp. 173–74.

59. Pudlo actually began to explore kite imagery in his drawings more than ten years ago (see, for example, CD.024-1048), apparently at a time when kite flying had become very popular in Cape Dorset (see Jackson 1978, pp. 75–76).

# Chronology

| | |
|---|---|
| 1860–1910 | American whalers are active in Hudson Bay and Hudson Strait. Inuit from the Lake Harbour area are recruited as crew. |
| 1900 | Robert Kinnes and Sons, of Dundee, Scotland, owners of the whaling ship *Active*, open a trade depot and a mica and graphite mine near Lake Harbour and employ Inuit miners. |
| c. 1904/05 | Inuit begin moving into the vicinity of Lake Harbour in order to be close to the trade depot. |
| 1906? | Pudlo's father and mother, Pudlat and Quppa, marry. |
| 1907? | Pudlo's brother Kellipellik Pudlat is born. |

Fig. 19
Pudlo, Cape Dorset, 1969

| 1908? | Pudlo's brother Simeonie Quppapik is born. Simeonie is adopted by Tumira Maik and Tulik Quvianaktuq. (Although Simeonie's date of birth is usually given as 2 December 1909, he and his brother Oshutsiak agree that he is the older of the two.) |
|---|---|
| 1909? | Pudlo's brother Oshutsiak Pudlat is born near Amadjuak. (His date of birth is usually given as 2 or 3 September 1908). |
| 1909 | An Anglican mission is established at Lake Harbour. |
| 1911 | The first Hudson's Bay Company post on Baffin Island is established at Lake Harbour. |
| 1913 | A Hudson's Bay Company post is established at Cape Dorset. |
| 1913–14 | The Third Mackenzie Expedition winters at Amadjuak. Included in its party is the photographer and filmmaker Robert Flaherty. |
| 1916 | 4 February: Pudlo is born at Ilupirulik, near Amadjuak. |
| 1919 | August/September: A number of Inuit families, including Pudlo's, are transported from Lake Harbour to Coats Island on the Hudson's Bay ship M.V. *Nannuk*. The *Nannuk* also picks up Inuit at Cape Wolstenholme on the northwest coast of Quebec. |
| | Winter: Pudlo's father, Pudlat, dies while on a trip by dog-sled. |
| 1920 | 1 January: Pudlo's brother Samuillie Pudlat is born at Coats Island. |
| 1921 | The Hudson's Bay Company opens a trading post at Amadjuak; with the assistance of herders from Lapland, it starts an experimental project to raise domestic reindeer (the project is discontinued in 1924). |

| 1923/24? | Pudlo's mother, Quppa, marries Paungi, from Arctic Quebec. |
|---|---|
| 1924 | Summer: The post at Coats Island is abandoned by the Hudson's Bay Company. Its Inuit population, including Pudlo's family, is transported on the S.S. *Bayeskimo* to Southampton Island, where the settlement of Coral Harbour is established. |
| | Autumn: Pudlo's half-sister Katalik (known today as Françoise Oklaga) is born at Coral Harbour. She is adopted by Nahadluq and Tautu. |
| | Quppa and Paungi separate, and Paungi returns to Arctic Quebec. |
| c. 1925/26 | Quppa marries Mialia at Coral Harbour. |
| 1926/27? | Pudlo's half-brother Joe Jaw is born at Coral Harbour (according to the recollections of Pudlo and his brother Simeonie; Joe Jaw's date of birth is usually given as 4 July 1930). |
| 1927 or 1928 | Summer/Fall: Pudlo's family (except for Kellipellik) moves from Coral Harbour to Lake Harbour aboard the M.V. *Nascopie*. They spend the winter at Ukiaklivilluut, the camp of Mialia's uncle Nuvualia. |
| 1928 or 1929 | July: Pudlo's family travels from Lake Harbour to Cape Dorset aboard the M.V. *Nascopie*, and then moves to Ikirasak, where Pudlo's cousin Pootoogook is camp leader. |
| 1930s–1940s | Pudlo lives on the land as a hunter, moving among various camps along the southwest coast of Baffin Island, principally Kiaktuuq, Ikirasak, and Qarmaarjuk (Amadjuak). He takes Meetik as his first wife and together they have four children (none of whom survives past childhood). He also takes Meetik's sister Ouivirok as a wife during the same period. |

| 1938 | A Roman Catholic mission is established at Cape Dorset. |
| 1939 | The Baffin Trading Company establishes a post at Cape Dorset. |
| c. 1944 | Pudlo's wife Meetik dies (at Amadjuak?). Pudlo remains with his other wife, Ouivirok. |
| 1946 | 15 February: A son, Kellipellik, is born to Pudlo and Ouivirok. |
| 1947 | 21 July: The Hudson's Bay Company ship M.V. *Nascopie* sinks off Cape Dorset. |
| c. 1948 | Ouivirok dies (at Amadjuak?). |

Fig. 20
Attributed to Pudlo, *Loon*,
c. 1956, green-black stone,
15 × 10.5 × 19.9 cm.
Collection: Canadian Museum of
Civilization, Hull, Que., gift of
the Department of Indian Affairs
and Northern Development,
1989 (NA270)

| 1948 | James Houston, a young Canadian artist, goes on a painting trip to Arctic Quebec and brings back carvings from Inukjuak. He shows the works to members of the Canadian Handicrafts Guild in Montreal. The Guild subsequently sponsors additional trips by Houston, and collects and exhibits the works he brings back. |
| 1949 | Pudlo visits his cousin Peter Pitseolak's camp at Kiaktuuq and from there travels to Ikirasak to take the widowed Innukjuakju as his wife. He returns to Amadjuak with Innukjuakju and her children, Elija Qatsiya and Qabaroak Qatsiya. |
| | The Baffin Trading Company closes its post at Cape Dorset. |
| | 21 November: The first exhibition and sale of Inuit carvings opens at the Canadian Handicrafts Guild in Montreal (known since 1971 as the Canadian Guild of Crafts Quebec). |
| 1950 | A one-room school is established at Cape Dorset. |
| | 6 April: Pudlo and Innukjuakju are formally wed by an itinerant Anglican missionary. |
| | Late summer: A daughter, Quppa, is born to Pudlo and Innukjuakju at Cape Dorset. |
| 1951 | Spring: James Houston and his wife Alma travel from Iqaluit to Lake Harbour and Cape Dorset by dog-team to assess the carving and handicrafts activity in the area. They leave on the medical ship *C.D. Howe* later that summer to visit other communities and then return south. |
| | An Anglican church is built in Cape Dorset. The project is organized by the camp leader and lay catechist, Pootoogook. |

| 1952 | The Houstons return to Cape Dorset and also spend several months at Ikirasak and neighbouring camps. |
|------|---|
| 1953 | Spring: The Houstons return south. James is employed by the federal Department of Indian Affairs and Northern Development and is charged with the development of arts and crafts programs in the North. |
| 1954 | 9 August: A son, Alariaq, is born to Pudlo and Innukjuakju (at Amadjuak?). |
| 1955 | James Houston becomes the area administrator for southwest Baffin Island. He and Alma settle in Cape Dorset and concentrate on encouraging carving and handicrafts in the area. |
| 1957 | Winter/Spring: The first printmaking experiments at Cape Dorset (including stencil and stonecut) are initiated by James Houston. |
|      | Spring: Pudlo injures his arm at Kiaktuuq, a camp near Amadjuak. He is brought to Cape Dorset for medical attention and sent south for surgery at Mountain Sanatorium in Hamilton, Ontario, 22 May–26 June. He returns to Cape Dorset on the *C.D. Howe*, but a few days later he is diagnosed as having tuberculosis and leaves Cape Dorset on the *C.D. Howe* to be hospitalized at Clearwater Lake Sanatorium in The Pas, Manitoba, 29 July 1957–14 January 1958. |

| 1958 | 14 January: Pudlo is transferred to the Brandon Sanatorium in Brandon, Manitoba. |
|------|---|
|      | 12 May: Pudlo is discharged from the Brandon Sanatorium. He returns to Cape Dorset via Churchill, Manitoba, and rejoins his family at Kiaktuuq. |
|      | December: The first Cape Dorset prints are sold through the Hudson's Bay Company in Winnipeg. |
|      | Winter: James Houston goes to Japan to study printmaking. |
| 1958? | Pudlo begins to carve. |
| 1959 | The West Baffin Sports and Fishing Co-operative (forerunner of the West Baffin Eskimo Co-operative) is incorporated. |
|      | Summer: Cape Dorset prints from 1957 and 1958 are shown at the Stratford Shakespearean Festival in Stratford, Ontario. |
| 1959/60 | Encouraged by James Houston, Pudlo and Innukjuakju begin to draw while living at Kiaktuuq. (Although no dated works of this period have been located, Pudlo recalls using graphite pencil and small writing-pad sheets of the type given out by the Co-op around 1959–60.) |
| 1960 | The Roman Catholic mission in Cape Dorset closes. |
|      | Spring: The 1959 Cape Dorset graphics collection is exhibited at the Montreal Museum of Fine Arts and is subsequently distributed to dealers for release. |
|      | Summer: Terry Ryan arrives in Cape Dorset to work as an arts advisor. |

| | |
|---|---|
| 1961 | An Anglican rectory is established in Cape Dorset, with Reverend Michael Gardener as its first resident minister. |

Fig. 21
*Musk Ox Trappers*,
stonecut, Cape Dorset
1963, no. 36

**1961** An Anglican rectory is established in Cape Dorset, with Reverend Michael Gardener as its first resident minister.

13 February: A daughter, Kanayuk, is born to Aggeak Petaulassie and Sheowak. Sheowak dies shortly after the birth and Kanayuk is adopted by Pudlo and Innuk-juakju.

March: The West Baffin Eskimo Co-operative is incorporated. Terry Ryan becomes the manager.

Summer: The Co-op purchases drawings from Pudlo (in graphite, on sheets from a coil-bound sketchpad). These include the first of his drawings to be dated (June 1961).

Autumn: The 1960 Cape Dorset graphics collection is released. Five prints by Innukjuakju are included.

**1962** James Houston leaves Cape Dorset.

Alex Wyse, an English artist, comes to Cape Dorset to teach engraving.

Autumn: The 1961 Cape Dorset graphics collection is released. Ten prints by Pudlo are included.

**1963** Pudlo helps in the construction of a new three-room school in Cape Dorset and stays on to winter over in the settlement.

Autumn: The 1962 Cape Dorset graphics collection is released. No prints by Pudlo are included.

**1964** The first "matchbox" houses are brought to Cape Dorset. Pudlo gets one for his family and settles permanently in Cape Dorset.

The first in-settlement telephone system is set up. Outside communication is still via radio.

Autumn: The 1963 Cape Dorset graphics collection is released. Four prints by Pudlo are included.

**1965** An RCMP detachment is posted at Cape Dorset.

Autumn: The 1964/65 Cape Dorset graphics collection is released. One print by Pudlo is included.

Fig. 22
Toni Onley (centre) and Wallace Brannen (right) in the lithography studio of the West Baffin Eskimo Co-operative, Cape Dorset, July 1975, with Pudlo in the background at his drawing table

1966     January: Coloured pencils ordered by the West Baffin Eskimo Co-operative in November 1965 begin to be used for drawing.

Summer/Autumn(?): The first three-bedroom housing units are built in Cape Dorset; Pudlo and his family move into one of the new houses.

Autumn: The 1966 Cape Dorset graphics collection is released. Three prints by Pudlo are included.

24 November: A daughter, Pitseotuk, is born to Kiawak Ashoona and Sorosiluto. She is adopted at birth by Pudlo and Innukjuakju.

1967     May(?): Pentel brand felt pens ordered by the West Baffin Eskimo Co-operative in December 1966 begin to be used for drawing.

Autumn: The 1967 Cape Dorset graphics collection is released. Two prints by Pudlo are included.

1968     11 June: Pudlo's son Kellipellik dies.

Summer(?): An airstrip is built at Cape Dorset (up to now landings are on water or ice).

Autumn: The 1968 Cape Dorset graphics collection is released. No prints by Pudlo are included.

1969     16 May – 22 September: Pudlo is hospitalized for tuberculosis at the Toronto Hospital in Weston (Toronto), Ontario.

Autumn: Pudlo and others from Cape Dorset travel to Resolute by airplane to help unload materials for a mineral-prospecting team.

Autumn: The 1969 Cape Dorset graphics collection is released. Three prints by Pudlo are included.

1969/70     Terry Ryan gives Kingmeata Etidlooie some watercolours to experiment with. He also gives Pauta Saila and Kananginak Pootoogook some oil paints.

1970     October: The 1970 Cape Dorset graphics collection is released. Two prints by Pudlo are included.

| 1971 | The artist K.M. Graham makes her first trip to Cape Dorset to paint the Arctic landscape. |
|---|---|

1971    The artist K.M. Graham makes her first trip to Cape Dorset to paint the Arctic landscape.

October: The 1971 Cape Dorset graphics collection is released. No prints by Pudlo are included.

1972    30 March: Pudlo's wife, Innukjuakju, dies.

Summer: The West Baffin Eskimo Co-operative receives a lithography press purchased from the Toronto artist Charles Pachter.

30 October: The 1972 Cape Dorset graphics collection is released. Three prints by Pudlo are included.

November: Pudlo travels to Ottawa for the opening of an exhibition honouring nine Canadian artists selected to have their works reproduced on UNICEF greeting cards. Pudlo is represented by his 1970 print *Umingmuk*.

1972–73    The printmakers Lowell Jones and Robert Patterson spend time in Cape Dorset assisting with experiments in lithography.

1973    Summer: K.M. Graham makes a second visit to Cape Dorset. She leaves her water-colours with Lucy Qinnuayuak and her acrylic paints with Pitaloosie Saila.

26 October: The 1973 Cape Dorset graphics collection is released. Four prints by Pudlo are included.

Fig. 23
Pudlo drawing on a printing plate in the lithography studio of the West Baffin Eskimo Co-operative, Cape Dorset, July 1975

1974    Summer: Wallace Brannen, a master printer from the Nova Scotia College of Art and Design, arrives in Cape Dorset to start up a lithography program. K.M. Graham makes a third trip to Cape Dorset and does some printing in the lithography studio with Brannen.

Summer: The artist Les Levine visits Cape Dorset. His video and photography project entitled *We Are Still Alive* is based on the visit (shown at Galerie Gilles Gheerbrant, Montreal, 6–31 January 1976).

2 November: The 1974 Cape Dorset graphics collection is released. Three prints by Pudlo are included.

| 1975 | CBC television begins broadcasting to Cape Dorset. |
|---|---|

CBC television begins broadcasting to Cape Dorset.

The West Baffin Eskimo Co-operative orders coloured pencils to replace the felt pens that the artists have been using. Pudlo begins to draw with coloured pencils.

Pudlo and Kananginak Pootoogook work with Wallace Brannen in the lithography studio and experiment with creating images directly on the printing stone.

Summer: The West Baffin Eskimo Co-operative invites K.M. Graham as artist-in-residence, and she produces a series of lithographs. Cape Dorset artists visit her studio; she introduces Kingmeata to the use of acrylic paints.

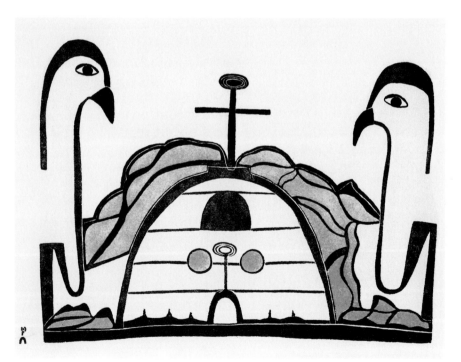

Fig. 24
*Shaman's Dwelling*, stonecut and stencil, Cape Dorset 1975, no. 32

July: The artist Toni Onley visits Cape Dorset and works in the lithography studio.

10 October: The 1975 Cape Dorset graphics collection is released. Lithographs are published as part of the collection for the first time. Thirteen prints by Pudlo are included.

1976    The West Baffin Eskimo Co-operative opens two small studios for drawing. Besides Pudlo, the participants include Kingmeata, Lucy, Etidlooie Etidlooie, Eliyakota Samualie, Napatchie Pootoogook, Sorosiluto Ashoona, and Egevadluq Ragee.

Pudlo begins to use acrylic paint in his drawings.

Spring: The 1976 Cape Dorset lithographs collection is released. Four prints by Pudlo are included.

May: Pudlo's print *Timiat Nunamiut* is released as a special commission for "Habitat: The United Nations Conference on Human Settlements" in Vancouver.

31 May–11 June: An exhibition of eight 1975 prints by Pudlo on the theme of dwellings is shown at the Surrey Centennial Arts Centre, Surrey, B.C, in conjunction with "Habitat: The United Nations Conference on Human Settlements."

Summer: K.M. Graham conducts a painting workshop at Cape Dorset.

29 October: The 1976 Cape Dorset graphics collection is released. Thirteen prints by Pudlo are included. Pudlo travels to Toronto to attend the official opening of the collection at the Innuit Gallery of Eskimo Art. He stops in Ottawa en route and visits the National Gallery of Canada.

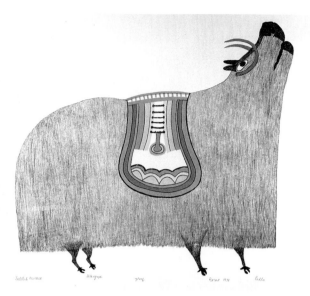

Fig. 25
*Saddled Muskox*, litho-
graph, Cape Dorset
1979, no. L24

1976–77    The Cape Dorset airport is relocated and
           upgraded. Heavy construction equipment is
           airlifted by army helicopter.

1977       Spring: The 1977 Cape Dorset lithographs
           collection is released. Four prints by Pudlo
           are included.

           21 October: The 1977 Cape Dorset graphics
           collection is released. One print by Pudlo is
           included.

           21 October: Pudlo's son Alariaq dies.

1978       11–25 February: The exhibition *Acrylic
           Paintings on Paper by Pudlo of Cape Dorset*
           is held at the Innuit Gallery of Eskimo Art,
           Toronto.

           Spring: The 1978 Cape Dorset lithographs
           collection is released. Four prints by Pudlo
           are included.

           21 September: A series of four Canadian
           postage stamps featuring Inuit images of
           travel is issued. Pudlo's 1976 print
           *Aeroplane* is included.

           28 October: The 1978 Cape Dorset graphics
           collection is released. Two prints by Pudlo
           are included. Pudlo travels to Edmonton to
           attend the official opening of the collection
           at the Canadiana Galleries.

           October–November: Pudlo has been
           commissioned by the Department of Indian
           Affairs and Northern Development to
           design banners for the lobby of its new
           building in Hull, Quebec. The banners are
           produced at Sheridan College, Mississauga,
           Ontario. Pudlo travels to Sheridan College
           to finalize the design and to work with
           Doug Mantegna, who oversees the silk-
           screening. He also visits Niagara Falls.

           November: The artist Joyce Wieland visits
           Cape Dorset and works in the lithography
           studio.

           November: Pudlo's print *Shores of the
           Settlement* has been commissioned by the
           Queen Elizabeth Hotel, Montreal, as a gift
           to honour "Twenty Great Montrealers."
           Pudlo attends the presentation dinner.

           1–31 December: The exhibition *Pudlo:
           Acrylic Paintings* is held at the Canadian
           Guild of Crafts Quebec, Montreal.

Fig. 26
Cape Dorset, 1989

1979

Spring: The 1979 Cape Dorset lithographs collection is released. Three prints by Pudlo are included.

May—31 July: The exhibition *Pudlo Acrylics* is held at the Fleet Galleries, Winnipeg.

20 October: The 1979 Cape Dorset graphics collection is released. Five prints by Pudlo are included.

November: Pudlo's print *In Celebration* is released, commissioned by the Canadian Guild of Crafts Quebec, Montreal, to celebrate the thirtieth anniversary of the first exhibition of contemporary Inuit art held at the Guild.

1980

Pudlo's print *Muskox and Airplane* is included in the Cape Dorset Etchings Portfolio I (released separately from the annual collection).

Spring: The 1980 Cape Dorset lithographs collection is released. Four prints by Pudlo are included.

Spring(?): The artist Michael Snow visits Cape Dorset and works on his film *Presents*.

10 May—5 June: The exhibition *Pudlo Pudlat: Ten Oversize Works on Paper* is held at Theo Waddington Gallery, New York.

17 October: The 1980 Cape Dorset graphics collection is released. Four prints by Pudlo are included.

1981 The exhibition *Pudlo* is organized by the Department of Indian Affairs and Northern Development, to be circulated starting in 1982.

4–11 February: Pudlo goes to Montreal to have a heart pacemaker implanted.

Spring: The 1981 Cape Dorset lithographs collection is released. Four prints by Pudlo are included.

19 April–8 May: The exhibition *Pudlo Pudlat: Arctic Landscapes* is held at Theo Waddington Gallery, New York.

24 October: The 1981 Cape Dorset graphics collection is released. Six prints by Pudlo are included.

1982 29 January–26 February: The exhibition *Pudlo Pudlat: A Retrospective Show* is held at the Raven Gallery, Minneapolis, Minnesota.

Spring: The 1982 Cape Dorset lithographs collection is released. One print by Pudlo is included.

3 October: The 1982 Cape Dorset graphics collection is released. No prints by Pudlo are included.

1983 Spring: The 1983 Cape Dorset lithographs collection is released. Five prints by Pudlo are included.

1 November: Pudlo attends the opening of the exhibition *Contemporary Indian and Inuit Art of Canada* at the United Nations, New York.

4 November: The 1983 Cape Dorset graphics collection is released. Ten prints by Pudlo are included, and he is presented as the featured artist for the year.

1984 Wallace Brannen leaves Cape Dorset.

The 1984 Cape Dorset calendar features prints by Pudlo.

27 October: The 1984 Cape Dorset graphics collection is released. Eleven prints by Pudlo are included.

22 November–31 December: The exhibition *Pudlo Pudlat Drawings: A Retrospective* is held at the Canadian Guild of Crafts Quebec, Montreal.

1985 26 October: The 1985 Cape Dorset Graphics collection is released. Thirteen prints by Pudlo are included.

1986 Pudlo's 1984 print *Muskox and Loon* is released through Norgraphics Limited, Toronto.

Pudlo's 1985/86 print *Flight to the Sea* is released through the Marion Scott Gallery, Vancouver, to commemorate Expo '86.

24 October: The 1986 Cape Dorset graphics collection is released. Twelve prints by Pudlo are included.

1987 12 September–2 October: The exhibition *Drawings by Pudlo of Cape Dorset* is held at the Innuit Gallery of Eskimo Art, Toronto.

23 October: The 1987 Cape Dorset graphics collection is released. Eleven prints by Pudlo are included.

| 1988 | The artist and printmaker William Ritchie arrives in Cape Dorset to work with the lithography program. |
|------|--------|
|      | 20 May: As one of the Canadian artists whose works are included in its inaugural exhibition, Pudlo attends the opening of the new National Gallery of Canada in Ottawa. |
|      | 21 October: The 1988 Cape Dorset graphics collection is released. No prints by Pudlo are included. |
| 1989 | 29 January–4 March: The exhibition *Graphik und Zeichnung von Pudlo Pudlat* is held at the Inuit Galerie, Mannheim, West Germany. Pudlo travels to Mannheim to attend the opening. |
|      | 27 October: The 1989 Cape Dorset graphics collection is released. Six prints by Pudlo are included. |
| 1990 | 23 June–4 August: The exhibition *Pudlo Pudlat: A Retrospective* is held at the Canadian Guild of Crafts Quebec, Montreal. |
|      | 5 July–11 August: The exhibition *Pudlo Pudlat: Drawings* is held at the Ufundi Gallery, Ottawa. |
|      | 7–28 July: The exhibition *Pudlo Pudlat: Recent Drawings* is held at the Innuit Gallery of Eskimo Art, Toronto. |

# Family Tree

male

female

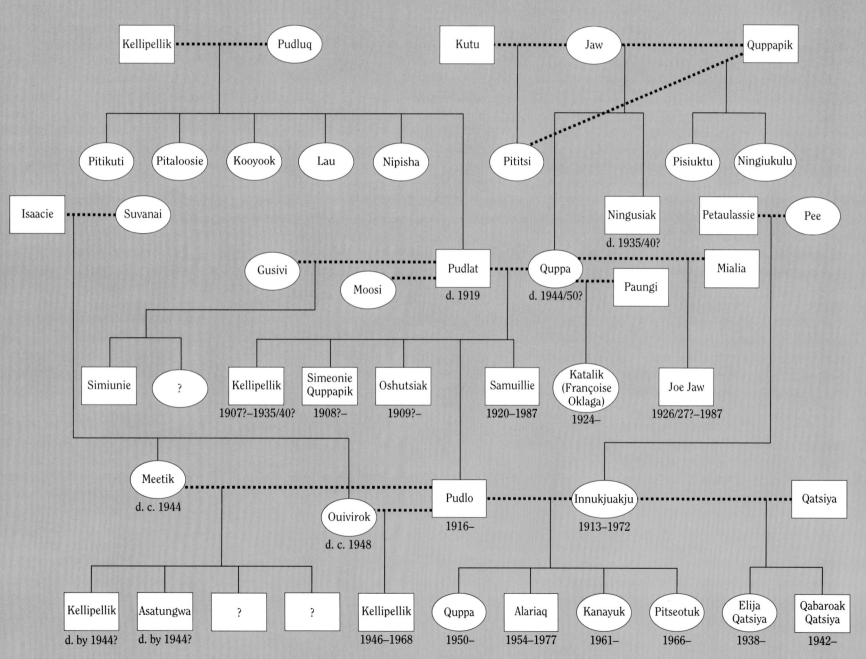

Kellipellik ···· Pudluq

Kutu ···· Jaw ···· Quppapik

Pitikuti · Pitaloosie · Kooyook · Lau · Nipisha

Pititsi

Pisiuktu · Ningiukulu

Isaacie ···· Suvanai

Ningusiak
d. 1935/40?

Petaulassie ···· Pee

Gusivi ···· Pudlat ···· Quppa ···· Mialia
Moosi           d. 1919    d. 1944/50?    Paungi

Simiunie · ? · Kellipellik · Simeonie Quppapik · Oshutsiak · Samuillie · Katalik (Françoise Oklaga) · Joe Jaw
                1907?–1935/40?   1908?–            1909?–        1920–1987      1924–                  1926/27?–1987

Meetik ···· Pudlo ···· Innukjuakju ···· Qatsiya
d. c. 1944        1916–      1913–1972

Ouivirok
d. c. 1948

Kellipellik · Asatungwa · ? · ? · Kellipellik · Quppa · Alariaq · Kanayuk · Pitseotuk · Elija Qatsiya · Qabaroak Qatsiya
d. by 1944?   d. by 1944?       1946–1968    1950–   1954–1977   1961–      1966–        1938–            1942–

Baker Lake
(Qamanittuaq)

District of Keewatin
(Kivalliq)

Southampton
Island

Coral Harbour
(Salliit)

Chesterfield Inlet
(Igluligaarjuk)

Rankin Inlet
(Kangiqhiniq)

Coats Island
(Appatuurjuaq)

Arviat

HUDSON BAY

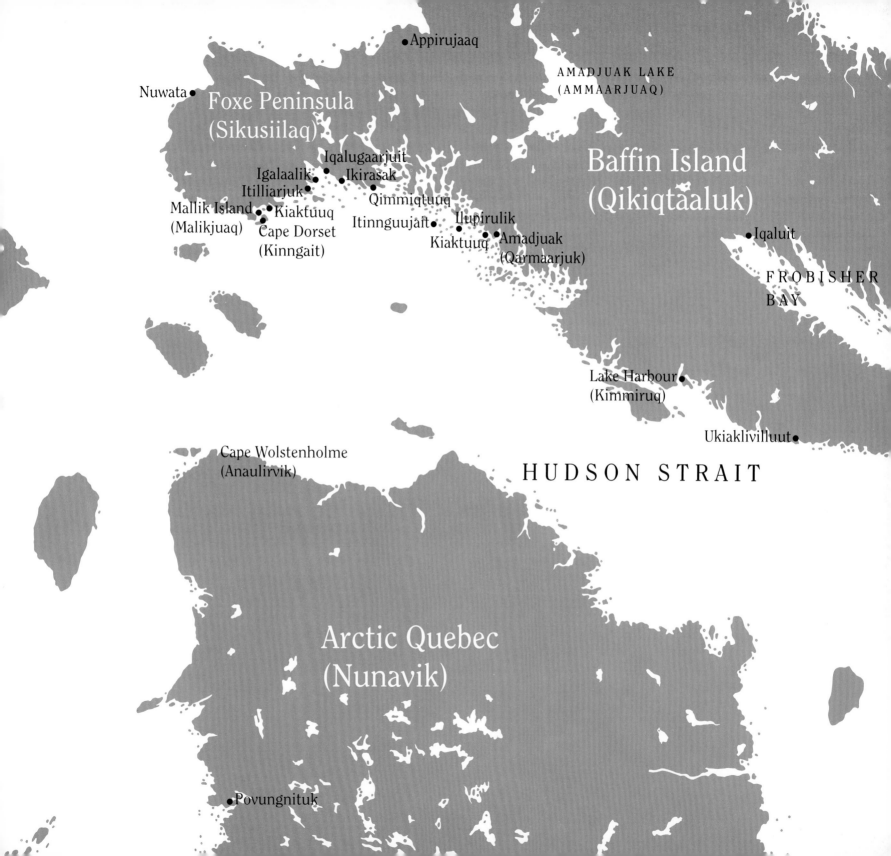

●Appirujaaq

AMADJUAK LAKE
(AMMAARJUAQ)

Nuwata●

Foxe Peninsula
(Sikusiilaq)

Baffin Island
(Qikiqtaaluk)

Iqalugaarjuit
Igalaalik● ● ●Ikirasak
Itilliarjuk●

Qimmiqtuuq

Iqaluit●

Mallik Island      ●Kiaktuuq
(Malikjuaq)●            Itinnguujait●   ●Ilupirulik
Cape Dorset                  ●Kiaktuuq
(Kinngait)                        ●Amadjuak
(Qarmaarjuk)

FROBISHER
BAY

Lake Harbour●
(Kimmiruq)

Ukiaklivilluut●

Cape Wolstenholme
(Anaulirvik)

HUDSON STRAIT

Arctic Quebec
(Nunavik)

●Povungnituk

Fig. 27
Pudlo at home, Cape Dorset,
1974

# Pudlo Pudlat:

# Looking Back

*Marion E. Jackson*

There is much to learn from the old Inuit ways. Inuit struggled through a great deal, and so they had to have understanding and patience. You will find that there is still a lot of that in the Inuit. But nowadays young people are not like the older people used to be. Maybe young people still have some of those feelings of understanding and sympathy, but not quite in the same way. So this story from my experience should help, help to make people more aware. This is a way to tell people more about feeling ... and understanding ... and patience.[1]

The history of art is filled with accounts of artists whose early interest in drawing was discouraged by parents who, seeing little value in such endeavours, guided their children toward "more practical" pursuits. Rarely, however, has the gulf between the parents' expectations and the child's ultimate emergence as an artist been so great as in the case of Pudlo Pudlat. Born in an igloo on Baffin Island over seventy years ago, Pudlo remembers being reprimanded for drawing on the walls of his family's snow house.

We used to like to make pictures by etching on the wall of our igloo. I especially liked the ice window, but then it was hard to reach! Mothers didn't like it when the kids gouged the wall. We were only trying to draw things we had seen. For example, if I saw a harpoon, I would want to draw a harpoon. But then my mother would get in the way, saying "Don't carve up the wall."

Today, Pudlo is an artist of international renown, whose bold, often humorous, and occasionally enigmatic drawings and prints are widely admired.

In a series of interviews conducted in preparation for the National Gallery of Canada's retrospective exhibition, Pudlo turned his thoughts back to the early drawings he had made as a child on the ice windows and to the events and ideas that shaped his life in the ensuing decades. While his experiences may seem at first to be no different from those of his brothers or other Inuit elders, his interpretations of these experiences are distinctively his own. At this stage in his life, Pudlo is eager to share his story with his community and with people around the world. To know what Pudlo has lived through is to gain an insight not only into the Inuit experience during this century, but also into the thinking of one of Canada's most inventive contemporary artists.

### The Growing Years: 1916–1929

Born in early February 1916 at Ilupirulik, a small camp near Amadjuak approximately 350 kilometres east of Cape Dorset, Pudlo was the fourth son in a family of strong, healthy boys. His father, Pudlat, died when Pudlo was very young. Pudlo's knowledge of his earliest years is based on information given to him by his mother, Quppa, and by his older brothers — Kellipellik, Simeonie, and Oshutsiak.[2]

Fig. 28
Lake Harbour, 1918–19,
showing the Hudson's Bay
Company post, with skins airing
on lines, and the M.V. *Nannuk* in
its winter quarters on the beach

From Pudlo's earliest years, his family had regular contact with *qadlunaat* – missionaries, traders, and government personnel – whose increasing presence in the Arctic has had a significant impact on the Inuit way of life. In 1919 the M.V. *Nannuk*, a small Hudson's Bay Company supply ship, transported several Amadjuak families, including Pudlo's, from Lake Harbour to Coats Island (see figs. 28–30) as part of an effort to establish a new Hudson's Bay post there.[4] Pudlo's brother Simeonie, who had been adopted into another family before Pudlo was born, remained behind at Amadjuak.[5]

Though the journey itself was known to him only through his mother's recounting, Pudlo could never forget his first few months at Coats Island, when he was still only three years old.

My earliest memory is of sorrow. My earliest memory is of the time of my father's death. I remember wanting my father, and his not being there for me. We waited for him to come home. Spring came, and we were still waiting for him to come home. It was terribly hard on my mother, to see how heartbroken I was – we would go out for a walk, and I would cry. It was a sad time for us.

Pudlo knows some of the details of his father's death from information that his mother later gave him.

Winter was approaching, and it was a good time to go out hunting by dog-team – that's when my father died. He was travelling with a white person [a trader] and an interpreter. The three of them started from our camp, though I'm not sure where they were going. There were white people in the North at that time, even before airplanes arrived. In the winter, people travelled by dog-team. The white people too had to go by dog-team. A white man would ask an Inuk to act as guide when he wanted to go somewhere. My father was serving as a guide for that trader. The three of them

I was born very close to Amadjuak. That was before the traders. There were some photographers there as well, but I don't remember them myself, I just heard about them.[3]

In the Inuit way, if people say they were born at Cape Dorset, it could be they were born anywhere along the coast near Cape Dorset. So I say I was born at Amadjuak, but actually I was born in an igloo at Ilupirulik. The interesting thing about it is why it was called Ilupirulik. It is because a certain family – a distant relative of mine – went to another camp and left their igloo with a tent inside. People would call it *ilupiru* if there was a tent on the inside and an igloo on the outside – to make the igloo warmer we would put in a tent as insulation. This particular family left that camp without taking their tent from inside the igloo, and they never came back for it. So that's why it's called Ilupirulik.

Fig. 29
On board the M.V. *Nannuk* en route to Coats island, 1919

were heading along their way by dog-team, when my father told the interpreter that he wanted to stop for a smoke. Saying that, he brought the dogs to a stop. There are certain sounds you make if you want the dogs to go, or to stop. My father was using those sounds to direct the dogs. As soon as he had halted the dogs, he just managed to say, "I'm dying," and then he collapsed and died. My mother never said that he had any health problems, but perhaps he did.[6]

Pregnant at the time of her husband's death, Quppa gave birth to Pudlo's brother Samuillie at Coats Island on New Year's Day 1920. Quppa's brother, Ningusiak, looked after his widowed sister and her young family in the months and years that followed. Pudlo recalls that his older brothers Kellipellik and Oshutsiak, who were in their teens at the time, were able to help with hunting and trapping. "I don't remember being hungry at the time," Pudlo has said of those early childhood years, though he does recall a particularly frightening experience he had when barely more than a toddler.

> I saw a polar bear coming into our igloo. It was terrifying, even though the bear didn't actually enter our snow house — he was in the entranceway and we could hear his sounds. We were all very frightened — me, my brother, and my mother. That was when Samuillie was still very little, still breast-fed. And it was very frightening — knowing the polar bear was there. Somebody outside eventually scared the bear away. I stayed under a blanket the whole time. I wanted to remain there, but I kept having to come up for air. My mother was in a state of panic. Every now and then she would grab hold of an old axe, to be ready to strike at the bear if it should approach. That was unforgettable, the time the polar bear came into our house.[7]

From about the same period Pudlo also remembers another incident in which his mother accidentally cut his face with her crescent-bladed *ulu* while turning quickly in their small snow house. The scar is still noticeable on his right cheek.

In time, Quppa married Paungi, a man from Arctic Quebec. Though this marriage ended in separation, Quppa was again pregnant in the summer of 1924 when the Hudson's Bay Company abandoned the Coats Island post and transported the people living there to Southampton Island, where the settlement of Coral Harbour was established. Pudlo was eight years old at the time and he still remembers the move.

We left Coats Island on a big ship. This was a real ship, the first one of its kind that I ever saw. The ship stopped by Coats Island and picked up the Hudson's Bay staff house, the manager, and the rest of the population, and took us over to Coral Harbour. It was a Hudson's Bay ship — we Inuit called it the *Inuk* [the S.S. *Bayeskimo*; see fig. 31].

When we moved to Coral Harbour there was not a single wooden building there. In fact the local population was very, very small, so we brought over everything — the people and everything. When we got to Coral Harbour, we started building. We built the Hudson's Bay manager's house, the store, and the outbuilding to store food for the dogs.[8]

Fig. 30
The beacon erected on Coats Island as a landmark for the M.V. *Nannuk*, 1919

Thus Pudlo and his brothers and his pregnant mother settled at Coral Harbour in the summer of 1924. Pudlo remembers that his half-sister, Katalik, was born there that autumn; she was adopted shortly after by a family that later moved to Chesterfield Inlet.[9]

Nahadluq was her [adoptive] father and Tautu was her [adoptive] mother. When they adopted her, I remember crying — and my brothers too, because she was the only sister we ever had, and she was being adopted. We took it very hard. She was just a newborn baby when she was adopted.

Shortly after Katalik's adoption, Pudlo's mother married her third husband, Mialia, a Baffin Islander who, like Pudlo's family, had been taken from Lake Harbour to Coats Island in 1919. Pudlo was now old enough to learn about hunting and trapping, and he found in his new stepfather a good model.

The way I learned about being a hunter was by going along with the men for the day. No one said to me, "This is the way you do this and this is the way you do that." In those days, we just learned by example, by watching and trying. For us, when we were learning about life, about life skills, it was from experience, from watching and by example. The teacher was there, but he was not there to tell us, "Hey, that's a mistake."

If something was difficult for a kid out on the land with a hunter, the hunter would explain it to him. Otherwise, everything else was silent. We weren't told. We just learned from experience. I don't recall any hardships while we were at Coral Harbour, although in those days the possibility of hunger was always just around the corner. I only remember the new things I was learning, and that was exciting for me. I learned all my hunting from the man my mother was living with, Mialia.

Even as a boy, Pudlo displayed a strong, independent will and a hunter's ability to endure discomfort with stoicism and even humour.

My mother was a sickly person. When we lived at Coral Harbour, my brothers Kellipellik and Oshutsiak and a fellow named Akalayu were going on the floe edge hunting. It was a nice day.

I was just a little boy then, but I wanted to go with them – I was usually allowed to go in good weather. At the time my mother wasn't feeling well. I asked her if she would let me go, and she said I was not to go with them because she was ill. My mother didn't have a daughter, so I would be the one to do certain things for her, such as getting oil for the lamp, and she didn't want me to go.

Nevertheless I stayed away from home and secretly got ready to go hunting. I waited for the dog-team to go out so that I could just follow without saying a word to anybody. I even got my warm mitts. We used to have caribou fur parkas, and I had that on too. I avoided going home while the hunters were getting ready because I knew my mother would stop me.

There was an accident on that hunting trip. When you are on the floe edge, sometimes the ice breaks off behind you, way up by the shore. That happened to us when we were out on the ice. I was just a young boy then. We stayed out in the open for three days and two nights. We stayed out, sleeping on the open ice, snowless ice too. I suffered from thirst and cold. And that was the punishment I got for deceiving my mother.

I drank some salt water – sea water – twice. We had a Coleman stove with us at the time, but there was no fresh-water ice to melt. Everything was salt, even the ice. With a harpoon, we would make a little hole and then we started drinking. With the first few sips, you don't feel it. But after you've been drinking, you stop and you get that awful taste, and it's so salty. It's awful, and it makes you even thirstier. We weren't hungry for food because Akalayu killed a square-flipper seal, but the problem was thirst. That's how it was with me at that time. I brought on my own punishment!

Finally, by listening to the sounds of the ice, we were able to get back to shore. You can hear the ice when it is breaking and colliding. That only happens toward the land. So we listened for the noise of the ice breaking, and we headed that way in the dark. And it was right in the direction of our camp.

From a very early age Pudlo had an intense interest in seeing and learning new things and was always determined to gain as much knowledge as possible from every opportunity.

I have always known how to read and write syllabics, right from childhood. I learned syllabics from the Bible. I would sit with a friend, and we would read from the beginning. We didn't try to read "ai – ii – u – ah" and that. We would open the Bible and start from the beginning and figure out what this character was and what that character was, or we would take turns reading and telling each other what we knew. That is how I learned. I don't remember any particular person I was reading with. It used to be any kid who was willing. It would be after nightfall. We weren't allowed to be out in the dark, so we stayed in the hut or the tent and started reading out of the Bible. It was something to do.

Fig. 31
On board the S.S. *Bayeskimo* en route to Southampton Island, 1924

In 1927 or 1928 Pudlo and his family, with the exception of his brother Kellipellik, moved again, this time returning to Lake Harbour aboard the Hudson's Bay supply ship M.V. *Nascopie*. Kellipellik remained at Coral Harbour to help his uncle, Ningusiak.[10] The family moving back to Lake Harbour now included Pudlo's mother and stepfather and four children — Oshutsiak, Pudlo, Samuillie, and a baby, Joe Jaw, who was born to Quppa and Mialia during their time at Coral Harbour.[11]

> I don't remember exactly the year that we moved to Lake Harbour because we weren't keeping track. The only thing I kept track of was my age. I must have been in my early teens or close to it by then, because I was already able to go out on rougher hunting trips. My stepfather, Mialia, had two brothers at Lake Harbour and my mother had relatives at Cape Dorset, so we moved back. The *Nascopie* brought us from Coral Harbour to Lake Harbour. We spent a year near Lake Harbour. It was the oldest trading post [on Baffin Island]. People from Sikusiilaq used to go there for trading.[12]

Pudlo recalls that year as a time of hardship and hunger for many people, though his own family was relatively fortunate because of abundant walrus hunting at Ukiaklivilluut — the camp of Mialia's uncle, Nuvualia — which was located approximately two days by dog-team travel east of Lake Harbour.

Pudlo's recollections of the hunger around Lake Harbour fit with the reports of Ernie Lyall, a Hudson's Bay clerk who was posted at Lake Harbour from the summer of 1928 to the summer of 1929.[13] A perceptive teenager, Pudlo remembers Lyall helping his family move to Cape Dorset.

> Ernie Lyall interpreted for my stepfather when my stepfather wanted to go from Lake Harbour to Cape Dorset. He picked us up in a small boat and took us over to the bigger boat. The *Nascopie* took us from Lake Harbour to Cape Dorset. We came to Cape Dorset around the end of July. Then we moved to Pootoogook's camp at Ikirasak.

Pudlo's memory of Lyall establishes 1927–28 or 1928–29 as the period that Pudlo's family wintered near Lake Harbour. The move to Ikirasak the following summer marked a new phase in Pudlo's life.

At Ikirasak Pudlo encountered many relatives with whom he was to have continuing alliances over the next several decades. Living as a young hunter, he grew increasingly comfortable with his kinfolk and with the land.

> Many people were at Pootoogook's camp at Ikirasak: Peter Pitseolak,[14] Ningusuituk, Osuajuk, Inuujaq, Tapaungai, Ashoona, Itulu, my stepfather Mialia, Alariaq and his sons, and all the children and the wives.
>
> And there were a lot of people in other camps too, from Nuwata all the way along the coast past Lake Harbour and up around Amadjuak Lake — people who now all reside in Cape Dorset. I have been all through there, from Nuwata all the way to Lake Harbour and further down. My footprints are everywhere. I've been all the way up to Amadjuak Lake; I spent a winter there. So all around here, my footprints are everywhere.
>
> Ikirasak, Cape Dorset, Amadjuak — those were the biggest camps, the main places where people would meet in those days. Pootoogook and Peter Pitseolak, and those other families — we are all related. Everybody moved back and forth. We are all relatives, and we would stay over the winter with this relative or that one.

While enjoying his kinship ties with other families at Ikirasak and at numerous other camps, Pudlo derived special status from his immediate family. In South Baffin's hierarchical camp structure, with its powerful camp bosses, Pudlo grew to adulthood favoured by his stepfather's recognized success as a hunter and by the independence that his family consequently enjoyed.

Pudlo gradually became more independent as a hunter and assumed the traditional male responsibilities. The spring after his family moved to Ikirasak, he killed his first seal.

> When you're growing up as a boy, you're after birds and small game like that. But later, as you get bigger, you go after bigger things, like a seal. In your teens, perhaps, you might catch a seal. And after that, bigger animals are hunted. I remember when I caught a seal myself. Iqalugajuit — just north of Ikirasak — that's where I caught my first seal.

Manumee and I were teenagers then. In the spring, when the little shelters where the seal pups winter were melting off, I was out hunting with Manumee. I was at one seal hole, and a seal appeared. I felt nervous and kind of shaky. I had learned a lot from my stepfather, Mialia. From that day, from the time that I caught my first seal, I gradually went on to catch other game as well.

## Hunter on the Land: 1930–1960

Within a few years after the move to Ikirasak, Pudlo's older brother Oshutsiak gave Pudlo his first four sled dogs. This enabled Pudlo to go out hunting on his own. While still young, he left his mother and took his first wife, Meetik, at a camp called Qimmiqtuuq. Not long after the marriage, Meetik's family moved to Lake Harbour. Pudlo still remembers the tension he felt in the period that followed.

Meetik's mother moved back to Lake Harbour, but Meetik and I were living together already. We couldn't go with her because the Hudson's Bay manager — his name was Aupuqtu ["Red"] — wanted me to stay in the Cape Dorset area, so I had no choice.[15]

All the time I was worrying about my wife's parents, thinking that they wanted their daughter with them. Eventually we moved to Lake Harbour so that my wife could be near her parents. But things didn't go well. I was homesick. I was concerned that we were going to be short of food that year. I missed my family. And I was bored. I was also unhappy with how my father-in-law was treating me. So I waited for one of my relatives to show up, and then I returned with him [to Cape Dorset]. I left my first wife — although we had a child already. I left her with her parents.

Fig. 32
The Hudson's Bay Company post
at Amadjuak, c. 1932

On the way, as I was travelling with my relative back to Cape Dorset, I had a chance to talk to my aunt Maata – she was a cousin of my mother's. When my aunt heard that I had been married to Meetik by a minister [an Anglican missionary], she advised me to stay married with Meetik and to keep her and support her. So I went back for Meetik with another man's dog-team and brought her back to this area. At the same time I also started living with her younger sister, Ouivirok. We went to live just outside of Cape Dorset, at another camp – Igalaalik. That was Kiakshuk's and Ashoona's camp, but there were other people living there too.

During the late 1930s and into the 1940s, Pudlo lived with his two wives, the sisters Meetik and Ouivirok, at various camps between Cape Dorset and Lake Harbour. Much of this time was spent in the area of Amadjuak (see fig. 32), where Pudlo frequently camped with his brother Simeonie. The two brothers lived much as their parents had before them, hunting by kayak in the summer and by dog-team in the winter; their wives sewed fur garments, prepared the food, and raised the children. In the summer the families lived in skin tents, and in the winter either in igloos or in more substantial *gammait*, wood-frame structures that supported an "inside tent" and an "outside tent" with mosses stuffed in-between for insulation.

Pudlo's memories of that time convey not only his acute awareness of the harsh realities of Arctic living but also a reverence for life and a tenderness toward the younger people who were struggling to learn the ways of survival. He still has haunting recollections of an ill-fated trip he once made by sailboat with two teenage boys; one of them, Namunai, had been born to a sister of Pudlo's wives and was adopted by his grandparents Isaacie and Suvanai, Pudlo's father-in-law and mother-in-law.

> We used to travel back and forth from Amadjuak to Cape Dorset by sailboat before we got motors. One spring, we headed for Cape Dorset, thinking to get tobacco, tea, and biscuits. Those were the main things we would go for – and for ammunition, things like that. On the way, we camped for the night in the area near Itinnguujait. All the ice was gone, except in the inlets. After we had our tents up and our

supplies in place, we went out hunting – knowing that there would be some seals on what was left of the ice. I was with my brother Simeonie and his son Kapik, and also Johnniebo and Pitseolak from Iqaluit, and Namunai.

As we took off for hunting, the wind was blowing a bit. We were using our sails, and they work only when it is windy. It was springtime, duck-egg season, and the weather was nice. There was no problem at all as we started on our hunt.

Then the wind began to get a little stronger, and then suddenly it would die down again, very unpredictably. When wind is like that, it tends to blow at the sails of the boat and make the boat tip sideways. When you are out at sea in a boat, you can notice spots of water darker than the rest, from little gusts of wind here and there. A wind like that came up and tipped the boat over.

We would have been all right if a sail had not hit the water. It soaked up water, and slowly caused us to tip over again. There was no one else in sight [to help]. In those days there weren't as many hunters around as there are now.

Namunai and Kapik were still very young then – in their early teens or close to their teens. One of them was washed out of the boat and started sinking right away. I wasn't able to reach him, so I took a paddle, thinking that maybe if he at least felt the paddle against his body, he would grab it. I did that, and the boy grabbed it, and I pulled him back into the boat with us. I put the two boys in the front of the boat to keep them away from the water, but the water kept coming up and over them. We were all up to our knees in water the whole time we were in the boat.

We were in an area with lots of islands, but we were quite a distance away from any of them. Even though the boat was full of water, it did not sink completely, and we had one of

the sails up. We kept tipping over, but we just barely managed to make it to a piece of ice that was floating around. That's how we saved ourselves, by landing on a piece of ice.

But that boy, Namunai, died of exposure. He was already dead before we landed on the ice. Kapik was freezing, and he was slowly dying too. He practically wasn't breathing anymore. But his father and Pitseolak tried to keep him warm, while Johnniebo and I bailed water out of the boat — it was our only means of getting back to land. So while Simeonie and Pitseolak revived the one boy, Johnniebo and I bailed the water out of the boat. We had to divide the work between us — we had to try and save the boys, and to keep our boat from sinking. So we were able to save Kapik, but Namunai died.

And after that, the winds stopped gusting. It was as if nothing had happened, and we were on our way home smoothly. But our minds were heavy with sorrow because we lost a child.

Pudlo's concern was not just for Namunai himself but for the grief that the boy's death would bring to his parents and to others in the small camp.

We could have gone back home right away, but we decided to camp overnight because we didn't know how to break the news to the parents of the dead boy [i.e., Isaacie and Suvanai]. That couple loved their children so much. Simeonie and I were scared to go home. It was terrible. We didn't want to bring in the dead body while everybody was waiting for us to come home with food. So we waited until very early the next morning, in order to arrive when everybody was asleep. We used our sail to make a tent until we were able to go back.

Simeonie had somebody living with him, an older person, Guani. We went straight to her when we got in, so that she could wake the boy's parents and tell them about the death. It was my father-in-law and my mother-in-law that we had to face. We expected that they would be upset and unable to understand. But when we came back home, we saw that they understood. Instead of being upset, they seemed to welcome us more than usual.

It made me feel even closer to them and happier. I felt as if I myself had caused them to lose their child, but they understood it was an accident.

On another occasion when Pudlo was again hunting with Kapik, a similarly distressing mishap occurred, though this time with a happier conclusion.

One time I went out seal hunting by dog-team with Kapik, my brother Simeonie's son. We went down to the floe edge, hoping to catch some seals, but we didn't catch any. The days were getting longer then. It was early in the evening, and the weather was beautiful. We just left the dogs attached to the komatik. I built an igloo, but I didn't put any top on it because it was so nice out. We had our equipment with us — sleeping bags and things like that. I don't know if I made a point of checking the sky, but I was unaware of any indication of bad weather coming. After we had our tea, we went to bed. The open water was close by.

During the night it started snowing heavily. Because we were sleeping in a half-made igloo, I woke up, feeling the snow and the cold. The wind had picked up — it was coming from the direction of the land, and snow was drifting and blowing on me. I knew we were very close to the open water and that something could happen, but I was chilly so I didn't get up right away.

Shortly after, I heard the sound of a crack. In those days, when people were living in igloos, they would often hear cracking sounds — it would usually be the shore, the rough ice. But what I had heard sounded like it came from the ice that we were sleeping on, right by the igloo. After a while I got up. I was able to look out immediately because the igloo had no top. Since the wind was coming from the direction of the land, I looked toward the land — but what I saw was open water! So the sound of the crack *was* from the ice beneath us. It had broken, and we were drifting away from the main floe.

I roused the boy, and he got up right away. There was a large island close by, and we were able to move toward it. I went in front, jumping from one ice floe to another. Finally there was one floe between where we were and where the land was, and I was able to cross over it. But the boy behind me — he couldn't make it to the land. He was only able to get back to where the igloo was. There was no way for him to get to where I was, and there was no way for me to get to him. All I could do was stand there and watch, watch him drifting away.

I had my binoculars and my harpoon, and I think I had my whip — in those days they were the most essential things for a man to have. If I had had my kayak with me, I would have been able to get the boy. But we had gone out only with the komatik and the dog-team. I thought, because the days are getting longer, perhaps during the day the weather will settle down. So there I was on the island, helplessly watching him drift away.

When ice breaks away from the main floe, it usually drifts quite fast, and that's what was happening. Luckily I had my binoculars with me. Otherwise I would have had a difficult

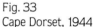

Fig. 33
Cape Dorset, 1944

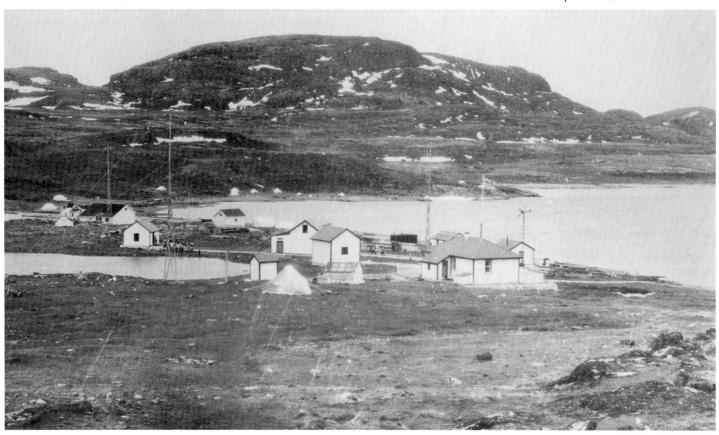

Pudlo: Thirty Years of Drawing

time keeping an eye on the boy, seeing where he was located. As the ice drifted away, it also began breaking apart. Anxious as I was, I just stayed on the spot and watched the boy, having no possible way to help him.

I don't remember exactly where our camp was located at that time – either Amadjuak or Kiaktuuq.[16] I couldn't go back there for help. It would have taken me a long time, and I would have lost sight of where the boy had drifted. So I decided to stay where I was and use my binoculars to watch him. At that time of year, the ice would usually drift out to the open sea at low tide, and would drift back in at high tide. That's what I assumed would happen.

All that day I kept a close watch on the boy through my binoculars, and there were times when it was quite difficult for me to see where he was. I did that for many hours until the tide started to rise again. There were so many things going through my mind. When the water started to rise, the boy appeared to look bigger, perhaps because he was drifting in again. I was hoping that he would end up on the island, but I could see that he would not come right back to where I was. So I started to run to where I thought he might come in.

When the ice that he was on was close enough for me to see without my binoculars, all I kept thinking was that he should jump from ice to ice to get to shore. But the boy had gotten everything together. He had the sleeping bags and all the things that we had on the komatiks, and he started approaching with the dog-team. He would be on a piece of ice, and another would get to where he was, and he would get to that one with the dog-team, and then on to the next. And I was thinking, if only he would leave the dog-team and just come, just save himself.

I had my rifle with me, but it didn't occur to me to shoot in the air. In those days, if someone caught an animal he would start shooting and the dogs would come. If I had done that, the dogs would have been more anxious to get to where I was, but I didn't think of it then. So when the boy started coming with the dog-team, I used my voice to get the dogs to come to me. Hunters used to use different sounds to make the dogs turn left or turn right or go faster. So I used my voice, guiding the dogs to come to me.

The dogs were brave, and smart too. When dogs are on thin ice they spread out, knowing that if they stick together they might drown! Finally they got onto a thick floe, and then they were safe at last. I was just beside myself with joy and relief. I was so happy because here was this boy who had drifted out, coming back safely. I was just overjoyed.

At that time, having come through that awful experience unharmed, it seemed as if we would live forever – of course that doesn't happen. But I was just overjoyed that I was able to be reunited with the boy. I didn't shed any tears – all I could think about was how joyful and thankful I was.

When we were together again there wasn't even a need to talk, because we felt all these emotions. I didn't even think to ask Kapik any questions about what he had been going through out on that open water. When the boy was out there on the ice, so many things went through my mind. One thing I was thinking was that the boy wasn't going to be thirsty because there was ice, and he had the Coleman stove and gas and would be able to have tea and bannock.

If I had lost the boy, I wouldn't have rushed back to the camp. I would have taken my time going back because it would have been really difficult for me to tell the other people that I had lost him. Of course, if they had sensed that we were gone too long, they would have come out to look for us and followed the dog tracks and perhaps met us.[17]

Throughout his prime years as a hunter, Pudlo was confidently independent and always resourceful in his ability to handle any situation that might arise. At the same time, he was conscious of the authority of the Inuit camp bosses and of the Hudson's Bay Company traders and recognized their influence on the life of the Inuit. These two power structures converged during the annual summer sealifts.

Pootoogook was the leader of the Sikusiilarmiut people, and at Lake Harbour Nuvualia [Pudlo's stepfather's uncle] was the leader. Before Nuvualia, they had Adamie. Adamie was the Inuk boss of the ship that took us to Coral Harbour. In the Sikusiilaq area, Saila was the leader before Pootoogook. When Pootoogook became the main leader, Ottochie and Saila were the assistant leaders.

When the supply ship would make its stop at Cape Dorset, the leaders would encourage people to help with the sealift. They would walk around to the tents to see who might be interested in helping. They didn't force anyone. They just went around and told people that anyone interested should go down and help. People responded right away.

When Saila was the leader, at sealift time he had a pot made out of a barrel, like a big drum. It was cut in half, and he would make tea in it. The tea was for everybody helping with the sealift. There would also be biscuits. He brewed the tea outdoors, and prepared a snack for everybody to have while taking a break. In the sealift in those days supplies used to come in small boxes. They would come in piece by piece, not like today when things come in big crates. That's why they would need so many people to help with the sealift. When Pootoogook became leader, people began to have their tea in their own homes, so Pootoogook didn't brew all the tea out there.

It was like a celebration each year. People played games outdoors — not just the children, but also the adults. We would play games if the weather wasn't good enough for hunting. While some would go out hunting, others would stay at Cape Dorset and play games. It was like a celebration, just like Christmas.

I used to join in some games too. My favourite was wrestling, wrestling with another man and trying to get him down on the ground. I liked that best because I didn't necessarily lose all the time. The other game I liked was football, a game almost like football but with Inuit rules. You kick the ball as hard as you can, and you run after it and try to keep it, or just grab it and run, while someone on the other team tries to get it away. Those old games have disappeared. I used to be interested in demonstrating them to younger people, but now that I am older I don't have the energy.

After the sealift, people went back to their camps. And they would take supplies with them, of course — tobacco, flour, tea, and so forth. The Hudson's Bay managers would keep track of how much we owed at the store, and in the winter we would gradually pay it back by bringing in furs.

The sealift in 1947 was a particularly memorable occasion and one that remains vivid in the memories of all who were there. That summer the Hudson's Bay Company supply ship M.V. *Nascopie* hit an uncharted reef and gradually took on water over a period of several days until it sank offshore at Cape Dorset on 21 July.

The *Nascopie* was the main boat that came up here, travelling around Baffin Island to bring food and supplies from the South. I am sure people were saddened by the shipwreck. But at the time — before it was completely sunk — we were able to get a lot of its cargo.

My brother Simeonie and I had a boat then, something like a Peterhead but smaller. We went to the site of the shipwreck, and brought a lot of other people with us to help. Everybody in that boat was helping. At the time, duffle and fabric things were being introduced. Before the shipwreck it

Fig. 34
Kiaktuuq, c. 1947, showing the wooden house Peter Pitseolak built partly with lumber salvaged from the M.V. *Nascopie*

was just tea, tobacco, biscuits, things like that — mainly food. But that time, there were duffle and fabric things among the supplies on board. We brought everything in, and people shared — no one person getting more than any other. There were also other boats from around here that were helping to get things from the shipwreck. And from what I saw, everybody shared.

The ship was lying on a slant. The tide would come up and the ship would fill with water. Then the tide would go down, and we would go onto the ship and take things out through the back, as the front was under water. It was there for several days, slowly sinking, and then it started to crack apart. The front went down first, and then the back. But it was there for several days, so there was time to take out a lot of the supplies.

Summer sealifts provided happy interludes in lives that were basically hard and fraught with danger. The prospect of suffering through hunger, accident, or illness was never far off for the people of South Baffin. With his first wife, Meetik, Pudlo had three sons and a daughter, none of whom survived past early childhood. Meetik herself died of illness as a very young woman, probably in her early twenties. Pudlo's second wife, Ouivirok, died in the late 1940s, not long after the birth of their only child, Kellipellik, in 1946. Isaacie and Suvanai, the parents of Pudlo's two deceased wives, looked after Kellipellik in infancy and took him with them to Iqaluit when they moved there in the late 1940s. Kellipellik remained with his grandparents until Pudlo remarried a few years later.

In 1949 Pudlo visited Peter Pitseolak's camp at Kiaktuuq (see fig. 34), and from there he travelled to Ikirasak to take the widowed Innukjuakju as his wife. He then returned with her to Amadjuak, where they lived together near his brother Simeonie. With them were Innukjuakju's two young children, Elija and Qabaroak, offspring of her previous marriage. A year later, in the spring of 1950, Pudlo and Innukjuakju were formally wed by an itinerant Anglican missionary.

That summer they took the two children to Cape Dorset for the sealift and annual celebration. The first child of their new marriage, Quppa, was born in a rather surprising circumstance at the end of the summer.

After the sealift we were getting ready to leave, when my wife said that she felt as if she was about to go into labour. She felt contractions. But we went ahead anyway, and just as we were leaving, she started going into labour. So we landed right across the bay at the edge of Mallik Island, and the baby was born right there — in the canoe! While we were leaving, it was still in the mother, but by the time we arrived at the island we had a baby!

With their three children, Pudlo and Innukjuakju returned to Amadjuak, where they were to live for the next seven years. During that time, they had another son, Alariaq. Pudlo also arranged for his son Kellipellik to join their growing family.

Ottochie and Tommy [Manning] often travelled back and forth from Lake Harbour to Cape Dorset, and to Iqaluit too, because of their work for the Hudson's Bay Company. One day I heard that they were going to Iqaluit, so I asked Tommy if he could bring Kellipellik. I had heard that Kellipellik was having a hard time. That was the time when people started drinking, and Kellipellik no longer felt welcome in his grandmother's house. When Tommy and Ottochie were on their way back and had Kellipellik with them, they happened to meet another man halfway who brought Kellipellik right to our camp.

Pudlo's deep feeling for children is evident in the memories he has of his stepson Qabaroak and his son Kellipellik helping him hunt — or trying to do so. His youngest son, Alariaq, was still an infant in his mother's *amautiq*.

Qabaroak was the more helpful because he was older. He would go out hunting with me and would tend to the dogs while I tried catching seal. By then Kellipellik was getting interested in hunting, but he was still young and I was concerned about him getting too cold. So when I had to go hunting I would try to sneak off while Kellipellik was out playing. Just as I'd be leaving in the canoe, Kellipellik might come home and realize that I had gone. Even the water wouldn't stop him from trying to follow me, so I had to be very careful to keep him from noticing.

It seems to me that it is much harder for kids to lose their mother than to lose their father, because a mother is the main source of security for the children. Since Kellipellik had only a stepmother, he was really struggling. And for me too, that was very painful to witness.

Even though he could count on the help of his growing sons, game was sometimes scarce and hunting difficult. In 1957 Pudlo was injured while hunting, and his family nearly starved.

I was living near Amadjuak at a place called Kiaktuuq (not the Kiaktuuq by Cape Dorset). It is on a very small island. It must have been in April. I was out walking and I came across a rabbit. I was chasing it when I slipped. I was holding my gun up to protect it from hitting the rock, and I fell on my elbow. It hurt for a while, but it got better. A month or so later, though, it got so bad that I couldn't do anything. I couldn't hunt and feed the family. My arm swelled up and got infected. That's when I lost everything. I even lost my dogs.

My wife was also in bad health at the time. So I would send Qabaroak to the Hudson's Bay store and tell him to bring back naphtha. He would get a little bit of naphtha for heating water and to heat our home.

One day I was able to lift my arm enough to carry a gun, so I went out looking for ptarmigan. Almost every morning, it seemed to me, a plane would come by. That morning I went out while the family was sleeping. I was waiting for the ptarmigan to appear when I saw an airplane. It looked as if it was going to land on the ice in front of my camp, and it did!

That was after James Houston had started living at Cape Dorset.[18] The men from the plane came to my camp for a while and found out that I was in bad health and that the family was hungry. They took word back, and James Houston had a plane come bring us food.

But that morning, before the plane came back, when I walked out of the hut, I killed the only dog I had left. And it was a young dog too. I killed that dog so my wife could cook it in the half-barrel stove. I didn't think about eating the dog myself, but I wanted my family to have something to eat in case I didn't get anything from hunting. That's when the plane came and brought food for us. That was very lucky; we would have eaten the dog.

When the plane came, they brought meat — seal meat, square-flipper seal meat, and also some *qadlunaaq* food. So all at once we had all that food, after all that hunger. If we had not been sick, we would have cheered. We were happy, but we were also weak and sick from hunger.

James Houston was in the plane too. He saw our house. When times are good, and you are in good health and can get around and go hunting, that's when a house looks comfortable, when people are able to look after it. When James Houston saw the dog I had killed that morning and the condition of our hut, he started wondering what to do with us. My brother Simeonie had come with him. The plane was very small and was able to hold only four passengers.

When James Houston saw that my wife was sick and that my arm was in bad shape, he left Simeonie at my camp with the rest of the family and took my wife and me back to Cape Dorset. There was a small nursing station at Cape Dorset then. So my wife and I came to Cape Dorset in the plane and left the rest of the family in the hut with Simeonie.

Pudlo and Innukjuakju received medical care at Cape Dorset, but Pudlo's arm injury required further treatment not available in the modest nursing station located there. In May 1957 Pudlo travelled to southern Canada for the first time.

The nurse at Cape Dorset looked after my arm and made sure that it would not go completely bad, that I wouldn't lose it. He had me do arm exercises. Eventually I had to be flown out. There was a white man we called Tiriganiak who had something to do with fox furs and other animal furs. He was being picked up by plane, and I went with him down to Hamilton [Ontario].

In typical fashion, Pudlo welcomed the entire experience with great interest. In spite of his pain and the worry that his arm might never again function properly, he viewed the trip south as an adventure.

I wasn't scared at all. I looked forward to seeing a different place — I was always full of curiosity then. We left Cape Dorset in one of those DC-3s, and we stayed overnight at Inukjuak. At that time, we used to hear that down south they had so many big buildings. When we got to Kuujjuarapik and I saw some buildings, I thought I was probably down south! They had an airstrip too, constructed of sand and gravel.[19]

After stopping at Kuujjuaq, Inukjuak, and Kuujjuarapik on the plane trip south, Pudlo also had his first train ride on his way to Hamilton.

> Tiriganiak did a good job of escorting me. We took a train along the way – I don't remember where – we took a passenger train, and it had bunk beds and all. Tiriganiak slept right across from me to make sure I was alright. On the way to the hospital – I think it was at a train station – Tiriganiak met his wife, and my next escort came to take me to the hospital.

Pudlo was hospitalized at Mountain Sanatorium in Hamilton from 22 May to 26 June 1957. There he underwent successful surgery and recovered in time to return to Cape Dorset on the *C.D. Howe* at the end of June. The trip back by ship was interrupted by a fortuitous delay at Kuujjuak, where Pudlo got his first view of musk-oxen – those extraordinary, dishevelled animals that were to figure so prominently in his art.

> The ship had some sort of engine problem. They were taking a while to fix it, and the captain wanted us to have something to do, so they put us in a car and took us out in the country to show us the animals. If we had stayed on the ship while they were fixing the engine, we would have gotten bored. The captain was nice enough to think about our entertainment.

Pudlo's reunion that summer with his wife in Cape Dorset was to be short-lived. During the annual health examinations conducted by the *C.D. Howe* medical team, he was diagnosed as having tuberculosis and was again taken south for further hospitalization when the *C.D. Howe* left Cape Dorset just a few days after it had arrived.

> When I came back, my wife was in a little hut that the male nurse had put her up in. While people were being X-rayed and having their physical checkups on the *C.D. Howe*, that's when I had some time with my wife. I spent only those few days with her because I had tuberculosis, and I had to go back south on the same ship that I had arrived on.

There were some other people from Cape Dorset who were going down too. Saggiak was one of them, and Etungat, and there were others too. We went through Churchill [Manitoba]. We stayed in a tent in Churchill because there was no boarding house. Then we took a train from Churchill to where we were going.

Pudlo was taken first to the Clearwater Lake Sanatorium in The Pas, Manitoba, and then transferred in January 1958 to the Brandon Sanatorium in Brandon, Manitoba. He remembers that year as one of loneliness, inactivity, and boredom.

> We all had to stay in our beds for so many months. The skin on my feet even got dry, because I was in bed for so long. We were not allowed to put our feet on the floor. Even while the nurse made the bed, we had to move from one side to the other.

Finally, with a clean bill of health, Pudlo was discharged from the Brandon Sanatorium on 12 May 1958 and sent by train to Churchill to await the *C.D. Howe* for his return to Cape Dorset.

> On the way home I met up with Tukikikulu, Paulassie Pootoogook's oldest son. We were heading home at the same time. We took a passenger train from Brandon to Winnipeg, and from Winnipeg we took a train to Churchill. At Churchill we were supposed to wait for the *C.D. Howe* to come by and pick us up, but there was this fellow Iritija, a white man, completely bald, who had a dog-team. He was flying to Cape Dorset, so he brought us with him in the plane. Thus our trip was cut short. We were supposed to wait until summer for the boat to come. I have often remembered that and appreciated it.

During Pudlo's hospitalization over the winter of 1957–58, Innukjuakju lived at Kiaktuuq, near Cape Dorset, with three of Pudlo's brothers — Oshutsiak, Samuillie, and Joe Jaw. On his return Pudlo rejoined his family at Kiaktuuq and remained there and at other nearby camps until he relocated permanently in Cape Dorset six years later. Though there was still movement among camps, Pudlo remembers that the people identified with Kiaktuuq at that time included Peter Pitseolak, the camp leader, whose family lived in a house built of wood from the ship-wrecked *Nascopie*; Pudlo himself and his wife; his brothers Oshutsiak, Samuillie, and Joe Jaw and their wives; Johnniebo and his wife, Kenojuak; Joanassie Igiu; Tauki; Kopapik and his wife, Mary Qayuaryuk; Kavavou, who later died in Iqaluit; Papiarak, from northern Quebec; and the families of these people.

Pudlo recalls that many of the men at Kiaktuuq — particularly Peter Pitseolak, Kopapik, and Pudlo's brothers Samuillie and Joe Jaw — began carving soapstone at the urging of James Houston. Pudlo himself did some carving at Kiaktuuq, but he never really enjoyed it and never considered himself a skilled carver. Houston was encouraging people to carve as a way to supplement their income.[20] Pudlo remembers that Houston invited some people to draw for this same reason and says that he was one of the people chosen by Houston for drawing. Both Pudlo and Innukjuakju began drawing around 1959 or 1960, when they were still living at Kiaktuuq.

At first it was very difficult for us to draw. We had just pencils and small pieces of paper to begin with. I got my supplies from James Houston. The paper was in a very small writing pad — just an ordinary writing pad. It was at Cape Dorset that James Houston gave me that paper. We had a choice, either to carve or to draw, and James Houston suggested that I draw. I took the paper back to Kiaktuuq and drew.

When I took the drawings back to James Houston, he would give me a piece of paper [a chit] with a "20" on it. And at that time things were cheap in the store, so I could get a lot of things with a "20."

Pudlo appreciated being able to exchange his drawings for trade items but he had no idea what would become of the drawings.[21]

I didn't think about what would happen with those drawings. I was doing it as if the drawings had no future. I was drawing for *that* moment. I never thought it would carry on to the future. I didn't know about the printmaking James Houston was trying to organize.

In the early 1960s Pudlo still thought of himself basically as a hunter and not an artist. By the same token he saw Houston primarily as a government official and was most impressed with what he perceived to be Houston's authority in areas more central to his life than the new arts projects. For example, Pudlo recalls thinking that Houston had the authority — as he also felt the Hudson's Bay managers had — to determine where Inuit should live. Pudlo himself relocated at one point, responding to what he regarded as a directive from Houston.

The year they built those first three government houses in Cape Dorset [1960] was when we stayed over the winter up at Appirujaaq — Etidlooie and Eckalook Nungusuituq and myself. James Houston was living in Cape Dorset at that time, and we already had started our drawings.

The reason we stayed [at Appirujaaq] was because there was fishing there. If we hadn't been lucky enough to catch fish we would have come back down to Cape Dorset, but there were plenty of fish so we stayed up there. After we settled in there, the men headed back [to their camps] for more supplies. We each went to different camps. My brothers lived at Kiaktuuq at the time, so I headed for Cape Dorset for tea, tobacco, and whatever else we needed. I had my two boys with me — Qabaroak and Kellipellik.

When we came for our supplies, James Houston (who represented the government) talked to us and told us not to camp up there any longer. He told us to come back down to Cape Dorset to hunt caribou. Shortly after Christmas, we came back. We were pretty well off up there and we didn't really want to come down, but we had to. We had no choice because it was a government order. That's the way it was at that time.

The spring of 1961 brought great hardship for the people around Cape Dorset. Influenza struck many camps; almost everyone was sick, and many people died. Pudlo's sense of responsibility and compassion is evident in his reactions to the difficult times that befell his people.

After we came back and went to Kiaktuuq, everybody got sick. It was around April. Everybody in my family got sick except me. I was the only one up and about in Kiaktuuq, so I was taking care of people who were sick. The weather was good most of the time, and I was thankful for that because I had to go from one place to another to see if everybody was all right. Nobody wanted to eat, so I wasn't concerned about going out hunting. I was more concerned about checking with each family to see how they were. It was a kind of sickness that really drains you. You have no energy, no strength. People didn't want to eat, and they would black out from headaches.

At that time everybody from Ikirasak was staying in Cape Dorset except for Paulassie Pootoogook and his wife. Etidlooie's wife, Kuklaujuk, died in Cape Dorset. She was a sister of Paulassie and Pudlat [Pootoogook]. Pudlat needed to inform his brother Paulassie that their sister had died, so he came out to Kiaktuuq and asked me to go with him to Ikirasak to talk to his brother. He sort of leaned on me. We depended on each other in those days — we sometimes still do.

On the way back from Ikirasak we went to Itilliarjuk. That was where Aoudla Pee was camping, and Aggeak Petaulassie. We came to Itilliarjuk just before they buried Aggeak's wife, Sheowak, shortly after she died. Nobody had done much about preparing the body for burial before we got there because everybody was sick there too. When Pudlat headed back to Cape Dorset, I stayed behind in that camp because that family had just lost their woman. I think it would have bothered me forever if I had gone off with Pudlat to Cape Dorset. I stayed behind and helped, and I feel good about that. I wanted to help, so I stayed behind.

Fig. 35
Artists of the West Baffin Eskimo Co-operative, Cape Dorset, August 1961. Left to right, in front, Egevadluq Ragee, Kenojuak, Lucy, Pitseolak Ashoona, Kiakshuk, Parr; in back, Napatchie, Pudlo

When his wife Sheowak died, Aggeak was left as the sole parent of their infant daughter, Kanayuk. Pudlo obtained Aggeak's permission to take the small baby, thus adopting Kanayuk into his family.

Kanayuk was only a few months old then. Aggeak's older daughter, Mayureak, was looking after Kanayuk because she was the only woman left when her mother died. I asked Aggeak if I could have the baby, and Aggeak didn't refuse, because Mayureak was too young to raise a child. And so I adopted Kanayuk.

I wanted to take Kanayuk back to Kiaktuuq right away, but I didn't have an *amautiq* in which to carry her. My wife wasn't strong enough yet to go back with me to get the baby, so I brought Kingmeata. This was before Kingmeata started living with Etidlooie. Kingmeata picked up the baby for me and my wife because my wife wasn't strong enough at the time.

All through the sickness, everybody had burdens. It was a rough time. That sickness killed a lot of people. Then, in the late spring, everybody gradually got better.

By the early 1960s many Inuit families began to settle permanently in Cape Dorset. For some families the motivation was to be near their young children who were attending the new government day school. The availability of health care and other services also provided an impetus for leaving the traditional camps. With Houston's guidance and government backing, local Inuit had formed the West Baffin Eskimo Co-operative in 1959 to nourish the local economy and encourage self-governance. By allowing for the collective purchase of consumer goods, the Co-op provided an alternative to the Hudson's Bay Company and, more important, established an organizational structure to support the community's fine arts projects. Through the Co-op, soapstone and ivory carvings were purchased and shipped south for sale, and drawings were bought for potential use in the new printmaking program. Pudlo and others turned with increasing seriousness and energy to drawing and carving, and artists began to play a respected new role in the small community.

## Evolution as an Artist: 1960 to the Present

Pudlo's sense of himself as an artist and his appreciation of the important role that art has played in his community has evolved gradually during the past three decades. Looking back, he attributes the success of Cape Dorset's arts projects as well as his own continuing involvement in these projects to the quiet but sustained leadership provided by Terry Ryan. Ryan, who arrived in Cape Dorset on the *C.D. Howe* in 1960, had been trained as an artist and had been serving as a weatherman in Clyde River, further north on Baffin Island. During his visit to Cape Dorset, Ryan eagerly accepted Houston's invitation to stay on as his assistant to help with the Co-op's new arts projects. Ryan quickly involved himself with the Co-op and with the Inuit artists. By the time Houston left Cape Dorset in 1962, Ryan had become the manager of the Co-op and the main advisor to its fine arts projects, a position he continues to hold to this day.

When many people were starting to leave their camps and move to Cape Dorset, that's when Terry arrived. James Houston might have been the one who started up the drawing, but Terry is the one who made sure it would continue. Terry is the one who really knows about drawing. Besides, James Houston was working for the government, while Terry began working for the Co-op. Terry, along with Iyola Kingwatsiak, Kananginak Pootoogook, and Lukta Qiatsuk — those are the guys who really encouraged people at the beginning. They were the staff there. When Terry took over, that's when I began to know about printmaking.

People at Kiaktuuq and other nearby camps responded readily to increasing overtures from staff at the new Co-operative who asked them to produce drawings for the new print shop. With Ryan's encouragement, Pudlo continued to draw. He enjoyed using the larger and better-quality paper and pencils that Ryan provided, and he even tried his hand at engraving a few images on copper plates.[22]

Gradually Pudlo began to spend more and more time in the settlement. After he finished a short-term construction job working on the new school during the summer and fall of 1963, he and his family remained in the settlement through the winter. He continued to go hunting, and remembers that he shot two polar bears that winter. He traded one of the skins to Peter Pitseolak for a long komatik and the other to Lucas-siekudluq[23] for a "100" note with which he purchased supplies for camping. In the spring of 1964 Pudlo and his family camped along the Foxe Peninsula with Etungat. Later that summer they returned to settle permanently in Cape Dorset.

That summer when we came back, I built a hut down in front of the new Anglican staff house, near the water. Even before the hut was finished a high tide came in and washed across the floor, almost up to the bed! That was when they were building those "matchbox" houses. When they first started building those "matchboxes," I went up to the social worker who was here at the time, Bill Berry, to ask him if I could get a house. Bill Berry okayed it, and I moved into that house.

I don't remember exactly why we stayed in Cape Dorset, but it was about the time that all the children were starting to go to school. I'm sure school was one of the reasons. Qabaroak went to school, and Quppa. Alariaq grew up going to school. Elija was overage already. And Kanayuk was just a little child – my wife had her in her *amautiq* when we moved into Cape Dorset.

At first Pudlo's life in Cape Dorset was much like his life on the land. Even though he and his family lived in the prefabricated, one-room "matchbox" house, he and his brothers still maintained dog-teams and continued to rely on hunting and trapping for a major portion of their livelihood. The "matchbox" houses had no electricity or running water; Coleman lanterns provided light. Change accelerated, however, and Pudlo responded with eager curiosity to the new technology and new ideas. He was one of the first to buy a snowmobile from the Hudson's Bay Company in the mid-1960s.

When we lived in the "matchbox" I still had my dog-team. But I got a skidoo at the same time. I still had the whole team, but then I was one of the first to get a skidoo. I think there were only two at the time, and the Hudson's Bay was testing how fast they would sell. I hunted with it – caribou, seal, fox.

In 1966 Pudlo and his family became even more permanently settled in the community, moving to a bigger three-bedroom prefabricated house with heat and electricity. In November Pudlo and Innukjuakju adopted Pitseotuk from Kiawak and Sorosiluto.

It was about the time we adopted Pitseotuk that we moved into one of the houses that the *C.D. Howe* brought in, the three-bedroom house. My wife used to help women in labour. In those days women did not give birth at the nursing station. My wife was helping Sorosiluto, Kiawak's wife, when she was having a baby. At the time of the birth they realized that there were going to be twins, and my wife wanted to adopt one of them. I was at home. Innukjuakju was helping with the birth and couldn't leave, so she had someone come and ask me if we could have one of the babies, and I agreed. We adopted the one that came out first, and then the second baby was stillborn. So Kiawak and his wife ended up with no baby, while we had the firstborn. I guess it wasn't very comfortable for Kiawak and his wife to say "we want to keep that baby," because the firstborn was ours already. So that's how we adopted Pitseotuk.

Having a young family to feed and clothe, both Pudlo and Innukjuakju continued to produce drawings in order to supplement the income Pudlo earned by hunting and trapping. By the mid-1960s improved drawing materials including coloured crayons and, later, felt pens, were available through the Co-op. Pudlo was able to make good use of these new materials. The rapid development of Cape Dorset also proved stimulating – by the late-1960s, the settlement had telephones, an airstrip, and a growing number of prefabricated houses and buildings.

The sudden availability of new goods and services also had some unforeseen destructive effects, which Pudlo's family experienced in a particularly tragic way. In June 1968 Pudlo's eldest surviving son, Kellipellik, died accidentally from poison after drinking with two of his friends, Attachie and Pitseolak. The three young men, all in their twenties, had taken a container of duplicating fluid from the new Cape Dorset school, thinking that they could drink it like alcohol. Ignoring the poison warning on the container, they mixed the duplicating fluid with juice and drank it, and then quickly experienced severe burning in their stomachs. Pudlo remembers that Kellipellik returned home, leaving the partially-emptied container of duplicating fluid under the open steps of the house, where Pudlo was to discover it shortly afterwards.

The container still had fluid in it. Kellipellik put it under the steps as he was going into the house. When I came home I found the container right away. Kellipellik drank something that burned his stomach. It was burning and burning, and he was screaming and asking his mother to stand on his stomach.

Attachie was already dead. The other two – Kellipellik and Pitseolak – were taken to the nursing station. The nurses gave them some fluid to make them throw up. Pitseolak was still able to swallow, so he was able to throw up, but Kellipellik couldn't swallow any more. By the time we got him to the nursing station it was too late. They couldn't save him. Pitseolak survived that drinking thing, but later on he got shot while out hunting, and so he is now dead too.[24]

Pudlo grieved deeply for his son, whom he saw as a victim of the changing culture.

If he had been able to read the label, maybe he wouldn't have drunk it. My son was more a hunter than a student. He was never very interested in school, and so he couldn't read English. Maybe my son wouldn't have died if he had been able to read labels.

I should have showed the nurses the container right away because maybe they would have been able to save Kellipellik. But I was embarrassed. At that time, we were afraid to tell the white people what we knew. If I had shown the container right away, maybe they would have been able to do something. But I didn't. I hid it from them. I just didn't know what it was and I didn't know what to do with it. Eventually I showed it – after the two guys were dead. It was too late.

Pudlo's own health problems recurred in 1969, and he was again hospitalized for tuberculosis, this time from mid-May through mid-September at the Toronto Hospital in Weston, Ontario. Expecting the Toronto Hospital to be as restrictive as the sanatoriums he had been in a decade earlier in Manitoba, Pudlo was pleasantly surprised to discover that, apart from the requirement to nap each afternoon, he could walk freely in certain areas of the hospital. He recalls being intrigued by the apparent clairvoyance of the attending physician.

I was amazed at the Chinese doctor they had. He was a lung specialist. He had an interpreter, a missionary who had learned to speak Inuktitut in the Keewatin with Reverend Marsh [Donald Marsh, the Anglican bishop of the Arctic]. I don't remember how many months that Chinese doctor said it would be, but it was definitely fewer than five months. He told me that in that time my lungs would be healed and I would be going home. And I did! I was amazed at how accurate he was about my lungs.

Soon after his return home in September 1969, Pudlo joined a group of men from Cape Dorset who were responding to an attractive opportunity to travel to the settlement of Resolute in the High Arctic to work for a mineral-prospecting team.

I don't remember all the people who came from Cape Dorset, but there was me and Etulu Etidlui and Pauta, and some others too. We picked up some more people in Hall Beach and Igloolik. Our job was to help unload pipes and other things. For me it was a different experience, a very interesting experience.

When I was in Resolute, I was constantly sleepy, so I would just go somewhere where nobody would see me and doze off for a while. I was so tired that I would just go to sleep during working hours. They gave us plenty of food and we had lots of rest, and yet I used to be tired.

We stayed in tents, big heavy canvas tents. I was the only Inuk in my tent – the others were all *qadlunaat*. I was glad of that, because they didn't try to talk to me. They just left me alone, and that suited me fine. I would rather be left alone than have someone try to talk to me.

When the job in Resolute was finished we flew home. The pilot knew where there was a herd of musk-oxen along the way, and we went by and saw lots of them. The first time I had seen a musk-ox was when I was travelling down south [in 1957]. But this was the first northern musk-ox I ever saw, in Resolute. There's a difference between the southern musk-ox and the northern musk-ox, and my drawings are of the northern musk-ox.

By 1970, when Pudlo was in his mid-fifties, he and Innukjuakju had been drawing steadily for about ten years. It was then that Innukjuakju's health began to fail, and she gradually stopped drawing. Her long debilitating illness eventually ended in her death from throat cancer in March 1972. Again Pudlo suffered the grief of profound loss, a loss that still pains him today.

Even now, though it has been many years since my wife died, still it's that sad feeling. Several of my children have died – two of unnatural causes – and those were unhappy times for me. But even then, losing a wife doesn't compare – that's the saddest thing that I've known.[25]

Innukjuakju's death was difficult for the children too, particularly for the two adopted daughters, Kanayuk and Pitseotuk, who were eleven and five years old respectively at the time and still very dependent on their mother.

The same year that Innukjuakju died, Pudlo was invited to Ottawa, along with four other Cape Dorset artists, for what was to be the first of several art-related trips he would make. Pudlo made this 1972 trip to Ottawa under the aegis of UNICEF after one of his prints, *Umingmuk* (Cape Dorset 1970, no. 39), had been chosen for publication on a UNICEF greeting card. The sense of affirmation that he experienced during this and subsequent trips south had an energizing effect on Pudlo as he continued his adventurous explorations in the drawing medium.

The arrival in Cape Dorset in 1974 of Wallace Brannen, a master lithographer from the Nova Scotia College of Art and Design, provided yet another impetus for Pudlo's artistic experimentation. Fresh from one of the liveliest and most innovative art schools in North America, Brannen had been invited by Terry Ryan to initiate a lithography program for the West Baffin Eskimo Co-operative. Up to then Pudlo had shown little interest in stonecut or engraving, but he responded personally to Brannen and became intrigued by the lithographic process. With Brannen's encouragement, Pudlo spent a great deal of time in the lithography studio and did a number of drawings directly on the lithography stones.

It was also during the 1970s that the Co-op initiated an informal visiting artist program, occasionally inviting artists from southern Canada to Cape Dorset for short residencies. Among the artists responding enthusiastically to this opportunity was K.M. Graham, a Toronto painter who had visited Cape Dorset independently in 1971 and returned periodically at the invitation of Terry Ryan – each time sketching and painting and, from 1974 onward, working in the new lithography studio. Graham's presence and the discipline with which she pursued her work proved stimulating to many Cape Dorset artists. Some of her techniques and materials also had an influence. Pudlo and others were particularly interested in the water-soluble acrylic paints she used and in her method of laying dilute acrylic washes on watercolour paper to establish colour fields. Pudlo began using acrylic washes as a background for his coloured pencil drawings in 1976.

A further innovation undertaken during the 1970s was the creation of studio space in a small building owned by the Co-op (see fig. 36). Several artists were invited to share the studio, which was equipped with broad working tables and storage shelves for paints and other supplies. Pudlo appreciated having a working space away from home, where the commotion generated by his grandchildren and their friends often made it difficult for him to concentrate. He was even more grateful when a second studio was made available for the other artist's, leaving him on his own in the first one. For several years in the late 1970s Pudlo kept disciplined hours in his "private" studio, working on his drawings at his standing-height table with deliberation and concentration (see fig. 37). In an interview around that time, he reflected:

It is better when I work in my private studio because there is no noise. There used to be two other people working in the studio with me [Kingmeata and Elija], but they have gone, and it's quieter now and nothing can distract me. I don't even listen to the radio when I am working on my drawings. When I try to draw at home, it is always noisy. It's a lot better working here in the studio. At my house, whenever my grandchildren come to visit and I am drawing a picture, they make so much noise that it makes me forget what I was going to draw.[26]

During the 1970s Pudlo was becoming increasingly well-known for the prints based on his drawings. In the autumn of 1976 he travelled to Toronto for the opening of the annual Cape Dorset graphics collection. The imaginative content and style of his images attracted considerable attention. In particular, his stonecut and stencil print *Aeroplane* (Cape Dorset 1976, no. 13; see cat. no. 63) surprised dealers and collectors and established new expectations for Inuit art because it combined modern technology with traditional northern imagery. Again, as on his trip to Ottawa four years earlier, Pudlo was extremely pleased by the response to his art, and he returned to Cape Dorset keenly motivated for further work.

A year later, in the autumn of 1977, tragedy again entered Pudlo's life, this time nearly disabling him with anger and grief. His youngest and only surviving natural son, Alariaq, committed suicide at the age of twenty-three. Pudlo is still haunted by memories of that terrible day.

When Alariaq died, it was a white person who told me about the death. I took it very hard because white people are a lot more straightforward. They are more factual. They tell you straight, exactly what it is, without being sensitive to a person's feelings. I remember very clearly how Terry [Ryan] started breaking the news to me by asking where Alariaq was, even though he knew what had happened. I thought everything was okay. Terry had somebody with him, an RCMP officer. He asked me first where Alariaq was, and I told him, "Maybe he's home. I don't know. He's living with Tirak now." And Terry said, "No, he's dead. He killed himself with a gun." And that was it. And it hit me so hard.

Fig. 36
Pudlo, Kingmeata, and Etidlooie in front of the drawing studio of the West Baffin Eskimo Co-operative, Cape Dorset, 1976

I was so angry at how I was told. I didn't even feel like crying. I just felt so angry. They had to take me to the nursing station. I was really upset. I wanted to see Tirak. She had been married to Isaacie before she started living with Alariaq. Isaacie too had committed suicide. That all came to my mind. I was really angry.

When they took me to the nursing station, I asked to see Alariaq's body, but they wouldn't let me. It was in no condition to be seen by anyone, especially anyone close to him. Tirak was at the nursing station too, and of course she was also distressed and crying. I was very, very upset, and I wanted to talk to her and sit by her side. I guess the nurses called the police and said that I should be watched and I should not be allowed to go near Tirak because I was too upset at the time. So the nurses and the police were watching me, keeping me away from Tirak because I was a nervous wreck and all upset and couldn't control myself.

The policemen who were with me kept grabbing hold of me, every move I would make. Each time I made a move they would grab me, which only made me more upset and nervous. Then this woman — a nurse or somebody, I don't quite remember — put her arms around me and started talking to me. And that calmed me down. After that woman talked to me, my urge to see Alariaq's body sort of faded away.

I knew that there was a scheduled plane that day. So that same day I left Cape Dorset, because I wasn't going to be able to control myself if I stayed. I took off, because I knew that I was going to remain upset as long as I stayed in Cape Dorset. I went to Iqaluit that day.

Pudlo never fully recovered from the shock and the sense of despair arising from his son's death. The tragic loss drained his energy and diminished his will to carry on. Alariaq's violent suicide occurred just at the time when Pudlo might normally have expected to share with and gradually turn over to his son the proud responsibility of hunting and providing for the family. Such, however, was not to be the solace of Pudlo's old age.

Even in grief, however, he continued to draw, perhaps finding in his art a distraction from pain. His reputation as an innovative and unusually creative artist continued to grow. In the autumn of 1978 he was invited to Sheridan College in Mississauga, Ontario, to collaborate in the design of a series of large-scale banners commissioned by the Department of Indian Affairs and Northern Development for a new office building in Hull (see fig. 38). He visited Montreal and Edmonton on the same trip, and was stimulated by his travels. Back in Cape Dorset he continued to draw energetically and vigorously through the late 1970s and into the 1980s.

Fig. 37
Pudlo at work in the drawing studio of the West Baffin Eskimo Co-operative, Cape Dorset, 1976

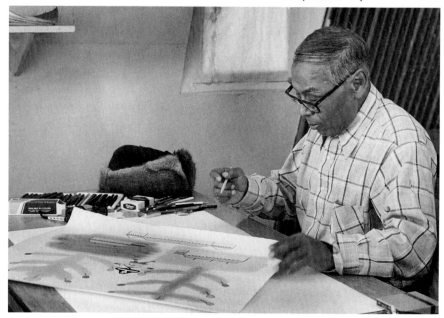

Fig. 38
One of the sets of silkscreen banners commissioned from Pudlo by the Department of Indian Affairs and Northern Development in 1978 for its headquarters in Hull, Que.

Despite his earlier bouts of tuberculosis, Pudlo has remained generally healthy and strong, though failing energy and an irregular pulse rate resulted in his being sent to Montreal for the implantation of a pacemaker in 1981. His doctors cautioned him then about his lifestyle. Pudlo consequently stopped smoking and drinking, and also gave up certain activities, such as gambling, which might tempt him to smoke.[27]

As a result of his increasing prominence as an artist, Pudlo made two international trips during the 1980s. In 1983 – along with the sculptor Judas Ullulaq from Gjoa Haven – Pudlo

attended the official opening of an exhibition of Canadian Indian and Inuit art at the United Nations in New York. In January 1989, accompanied by Jimmy Manning (the assistant manager of the West Baffin Eskimo Co-operative), Pudlo travelled to Mannheim, West Germany, for the opening of a successful solo exhibition of his prints and drawings at a prominent commercial gallery.

> I liked [the trip to Germany] very much. I was entertained the whole time, taken to see a lot of things, and visited by a lot of people. I had a good time there. When we got to the place in Germany where they were having the exhibition, I saw some of my drawings outside the building as posters for advertising. At that exhibition, quite a few of my drawings were bought, and that pleased me. I would have been uncomfortable if people had not liked my drawings.

Pudlo's trip to Germany provided him with many new and unusual experiences. His visit to a planetarium left a particularly striking impression.

> From a distance I saw an igloo-shaped building – like a dome. I didn't realize at first that we were actually heading there. When we entered that domed building, it seemed like a theatre or something. There were lots of people, me and Jimmy and lots of people.
>
> They told me we were going to a movie, so I was expecting a movie. As the lights went out, a lot of stars could be seen all about! I thought I was in space. I just stared in amazement! You could see the Big Dipper and other constellations. It was so real that I expected to get cold, and I waited for the wind to blow, though of course it didn't.

The public acclaim that Pudlo now enjoys has finally allayed the lack of confidence with which he originally started out.

> When we first began drawing, we used to think, "I wonder if [the Co-op staff] will buy this or not." Nowadays I feel more confident because I know for sure that the Co-op is going to buy my drawings. I don't have to worry about whether my drawings will be bought or not.
>
> If I am okay in 1990 – we never know what is going to happen in our lives – but if I am okay, I'm pretty sure I will have a good time in Ottawa, with no embarrassment about people not liking my drawings.

Fig. 39
In 1989 Pudlo was interviewed by Marion Jackson, with Letia Parr acting as interpreter. Here Pudlo and Letia pause to look at a globe during a discussion about Pudlo's travels, in particular his trip that year to Mannheim, West Germany.

People do indeed respond to Pudlo's drawings and seem to gain insight from his thinking. Now in his mid-seventies, Pudlo's reflections on his life and his culture are broadening into wider observations on the complex and changing world he has experienced. Looking back and remembering the loss of three wives and six of his eleven children, as well as misfortunes befalling others, he is extremely sensitive to the "heaviness" in the human condition. Yet he is not defeated – he retains an active interest in his art and in sharing his wisdom with those who will listen.

> So now, I'm up to being an old man. All those heavy things have gone by. Even when I turn to remembering, some thoughts come into my mind once in a while, but I don't feel those things any more. They are just memories now. It's not the heaviness for me now like it was in the past.

Fig. 40
Pudlo (left) with his brothers
Oshutsiak (centre) and Simeonie
(right), Cape Dorset, 1985

Even during the hardest and saddest of times, Pudlo has been driven by an insatiable curiosity and by a fierce will to live. He takes for granted the necessity of a strong spirit and knows no other attitude than that of unqualified openness to all eventualities. Pudlo is thus profoundly troubled when he encounters an inability or unwillingness in others, particularly young people, to face their own challenges with energy, imagination, and resolve.

> I have been through a lot. Today, when people are going though a hard time, they give up. They even commit suicide. Although I was often close to death, I always fought for life. I don't think it ever entered my mind that dying could be a way to make things better. I wanted to live, I didn't want to die. When I think about it, in the old days everybody struggled. Everybody fought hard for life.

Pudlo's philosophy reflects the thinking of the traditional Inuit culture, for which he now speaks as an elder, but his varied experience and his keen intellect have also given him the insight to see beyond the boundaries of his culture. Through his travels, through his lifelong effort to understand non-native people, and through his reflections on the new challenges facing younger Inuit, Pudlo has come to know a world beyond the limits of his own experience and can see the universal applicability of the life-affirming values he cherishes.

Emblematic of the value that Pudlo places on co-operation and on overcoming the barriers that separate people is his drawing entitled *North and South* (cat. no. 52). In it Pudlo presents the Inuit experience on the left side and the *qadlunaaq* experience on the right, connecting these disparate entities with a line establishing a new unity, both formally and metaphorically. Though Pudlo rarely comments on his drawings, he has made clear his intention in this drawing.

> I tried to portray the Inuit land – the North – and the white man's land – the South … In the old days, it seemed as if the North of Canada – the Inuit land – was split off, before telephones or radio. We were separated, even though we were part of one piece, Canada. But now we are bridging the gap – through CBC radio and telephones. So that's why I made this [arc connecting the two pieces of landscape], because we are starting to understand each other. So this line that you see here means that we're co-operating more.[28]

Today Pudlo looks even beyond the boundaries of Canada and shares his story with the wider world. He offers his remembrances and his art not just as a record of his own experience but as a "truth" generously added to the store of truths to which all humankind is heir.

## Notes

1. Except where otherwise indicated, quotations attributed to Pudlo are excerpted from interviews with him conducted by the author at Cape Dorset in August 1989, with Letia Parr as interpreter. In the interest of clarity some passages have been edited by the author, but care has been taken to preserve the spirit of Pudlo's own statements. Tapes and transcripts of all interviews with Pudlo cited in this essay are now in the Documentation Centre, Inuit Art Section, Department of Indian Affairs and Northern Development, Hull, Quebec.

2. Kellipellik, Simeonie, Oshutsiak, and Pudlo were all offspring of the marriage of Pudlat and Quppa. Pudlat had two prior marriages. With his first wife, Gusivi, he had fathered twins – a boy, Simiunie, and a girl abandoned as an infant in a snow house during a time of starvation. Pudlat's union with Gusivi dissolved when he took his second wife, Moosi, with whom he had no children. Pudlat later left Moosi to marry Quppa. Pudlo says he does not know "exactly how this worked out, these marriages from one lady to another."

3. The "photographers" to whom Pudlo refers were associated with the third of four Arctic expeditions commissioned by Sir William Mackenzie between 1910 and 1916. The Third Mackenzie Expedition, which wintered at Amadjuak in 1913–14, included in its party the photographer and filmmaker Robert Flaherty (see Vancouver 1979). The "traders" to whom Pudlo refers were the Hudson's Bay Company staff who maintained a post and experimental domestic reindeer project at Amadjuak from 1921 to 1924. Personnel from both the Mackenzie Expedition and the Hudson's Bay Company called the site Amadjuak, but the name by which the Inuit knew it was Qarmaarjuk. In a conversation with the author in 1979, Pudlo explained: "The original Amadjuak was the lake [to the north]. A *qammaq* is a hut that people use in the winter, a hut made out of wood and also moss and canvas. The Inuit called the place Qarmaarjuk because there were those huts there. The white people started calling it Amadjuak. That's how it got that name" (Jackson 1979, p. 84).

4. Pudlo's brother Oshutsiak spoke to Dorothy Eber about his memories of Coats Island. Oshutsiak referred to the island as Appatuurjuaq, meaning "the place of many *akpaks* [thick-billed murres]" (Eber 1989, pp. 150–51). Pudlo used the name Appatuurjuaq to refer to the specific site of the new Hudson's Bay Company post on Coats Island.

5. Simeonie was adopted by Tumira Maik and her husband Tulik Quvianaktuq. Simeonie's vivid memories of the Amadjuak area during the early decades of this century are recorded in a manuscript held by the West Baffin Eskimo Co-operative.

6. Pudlo Pudlat, interview with the author, at Cape Dorset, April 1979, with Mukshowya Niviaqsi as interpreter (Jackson 1979, p. 85).

7. Pudlo Pudlat, interview with the author, at Cape Dorset, July 1978, with Martha Pudlat as interperter (Jackson 1978, p. 79).

8. A corroborating account of the arrival of the Baffin Island Inuit at Coral Harbour and the establishment of the new Hudson's Bay Company trading post in the summer of 1924 is given by A. Dudley Copland (1985, pp. 34–47). Copland, then a young Hudson's Bay clerk, recalls the arrival of the company's supply ship S.S. *Bayeskimo* at Coral Harbour in the summer of 1924 before the Southampton Island post was established. Copland reports that the *Bayeskimo* carried District Manager Ralph Parsons, along with the new Coral Harbour Post Manager Sam Ford and his wife, twenty to twenty-five Inuit families from Coats Island who had originally come from Baffin Island, and also a prefabricated building. Copland remained in Coral Harbour as a clerk during 1924–25.

9. Katalik was later given the name Françoise. In 1975 she moved with her husband, Emile Oklaga, to Baker Lake, where – as Françoise Oklaga – she has recently become a graphic artist. Though Pudlo had lost contact with his half-sister following her adoption in 1924, he believed that she lived "in the Keewatin somewhere." Marie Routledge discovered the relationship between Pudlo and Oklaga while conducting research for this exhibition.

10. Pudlo later heard that Kellipellik and Ningusiak perished on drifting ice which had broken loose from a floe edge.

11. Though Joe Jaw's birth date is listed in Cape Dorset records as 4 July 1930, Pudlo's recollection is that Joe Jaw was born in Coral Harbour before his family returned to Lake Harbour. Pudlo's brother Simeonie, who had remained in Amadjuak, recalls that the family returned to Lake Harbour with Joe Jaw and that he had been born in Coral Harbour. If Joe Jaw was indeed born in Coral Harbour, and if (as this author surmises) the family did return to Baffin Island in 1927 or 1928, then Joe Jaw may actually have been born somewhat earlier than the records indicate, perhaps in 1926 or 1927.

12. Pudlo explained that in his mind Sikusiilaq (which means coastal area, "free of ice") refers to the Baffin coast west of Cape Dorset and east as far as Chorkbak Inlet. Pudlo uses the term Saqpaq ("moving water which does not freeze over") to distinguish the Baffin coast from Chorkbak Inlet east to Lake Harbour. Inuit from the entire southern Baffin coast travelled back and forth frequently, trading at both Hudson's Bay Company posts – the one at Lake Harbour (established in 1909) and the other at Cape Dorset (established in 1913).

13. In his autobiography, Lyall recalls interpreting, providing food, and arranging relocation for Inuit in the area of Lake Harbour during 1928–29: "My first trip to Baffin Island was in the summer of 1928 when I left Cape Smith to go to Lake Harbour... [The] year that I went in was a very poor year for hunting. There were a lot of people at the camps who were hungry, so one of my first jobs was to take the big motor boat and put as much grub in it as the boat could hold – and it was a lot. Then I went around to the people and gave them

ammunition and staple grub… And they said to me, 'Now ask the people where they'd like to go, where is better hunting ground, and then help them to move where they want to go.' … One reason I was sent to this post, I guess, was because of this situation where they needed someone to talk to the people and I was beginning to speak Eskimo pretty well" (Lyall 1979, pp. 62–63).

14. Pootoogook and Peter Pitseolak were first cousins to Pudlo. Their mother, Kooyook, was the sister of Pudlo's natural father, Pudlat.

15. Aupuqtu, the Hudson's Bay manager to whom Pudlo refers, was Chesley Russell, who managed the post at Cape Dorset at the time. Peter Pitseolak also mentions Chesley Russell in his autobiography and recalls that Russell was known to the Inuit as "Owpatuapik," the "red-faced one" (Pitseolak and Eber 1975, p. 125).

16. The Kiaktuuq to which Pudlo refers in this instance is a traditional camping spot near Amadjuak. Kiaktuuq ("warm spot, or heat wave, in the area where sunlight reflects off a rock-faced hill") was also the name given to the camp Peter Pitseolak established near Cape Dorset in 1946.

17. Pudlo Pudlat, interview with the author, at Cape Dorset, August 1989, with Mukshowya Niviaqsi as interpreter.

18. See Marie Routledge's essay above, p. 16.

19. Cape Dorset was not to have its first airstrip until eleven years later, in 1968.

20. While James Houston is recognized for his extraordinarily successful efforts during the 1940s and 1950s to encourage the Inuit to carve in indigenous stone, ivory, and antler as a way to increase their economic independence, many Inuit had prior experience with carving and often used their carvings as trade items. Pudlo remembers that he saw people carving even when he was a small boy: "I remember that I saw a person carving at Coats Island and also at Coral Harbour and at Lake Harbour too. They weren't doing much then, but Isaacie was one of the first persons I saw carving, out of whale tusk." Pudlo's recollection is that "if a man was carving, he could take his carving to the Hudson's Bay manager and trade it for something he needed." In a conversation with the author in August 1981, Eric Mitchell, a Hudson's Bay manager in the Keewatin during the 1950s, concurred with Pudlo's description, saying that it was common practice among the company's managers throughout the Arctic to accept small carvings in exchange for cigarettes, tea, or other trade items as a "customer courtesy" during times of poor hunting.

21. On Pudlo's earliest drawings, see Marie Routledge's essay above, pp. 18–19.

22. In 1961 the West Baffin Eskimo Co-operative received the gift of a small proofing press from the Canadian Banknote Company. In 1962 a young English artist, Alex Wyse, was hired to teach copperplate engraving to Inuit artists at Cape Dorset. Several Inuit artists — notably Kiakshuk, Pitseolak, Kenojuak, Johnniebo, and Pauta — took readily to working directly on the copper plates. The 1962 and 1963 graphics collections were predominantly engravings. While Pudlo made a few attempts at engraving, he did not persist with this technique as he found the graver difficult to control and the surface of the copper plates too fragile.

23. Terry Ryan has identified Lucassiekudluq as Roy Lukas, the business manager of the West Baffin Eskimo Co-operative in the early 1960s.

24. Pitseolak was Kellipellik's cousin and the son of Oshutsiak. For the story of Pitseolak's life and tragic death, see Raine 1980.

25. Pudlo Pudlat, interview with the author, at Cape Dorset, June 1979, with Mukshowya Niviaqsi as interpreter (Jackson 1979, p. 118).

26. Pudlo Pudlat, interview with the author, at Cape Dorset, May 1978, with Josephee Pootoogook as interpreter, further translation by Jeannie Manning (Jackson 1978, pp. 2–3).

27. Card games have been the most common form of gambling in Cape Dorset. Adults who like to gamble gather in the evening in a designated home to play patik, a game similar to gin rummy. The deal rotates, and the dealer of each hand determines the stakes, usually in the range of two to five dollars. Since the game is fast and each deal is over quickly, a lot of money can be won or lost. Often the stakes escalate during an evening, so that extremely large sums or even snowmobiles may change hands over games of patik.

28. Pudlo Pudlat, interview with the author, at Cape Dorset, July 1978, with Martha Pudlat as interpreter (Jackson 1978, pp. 84–85).

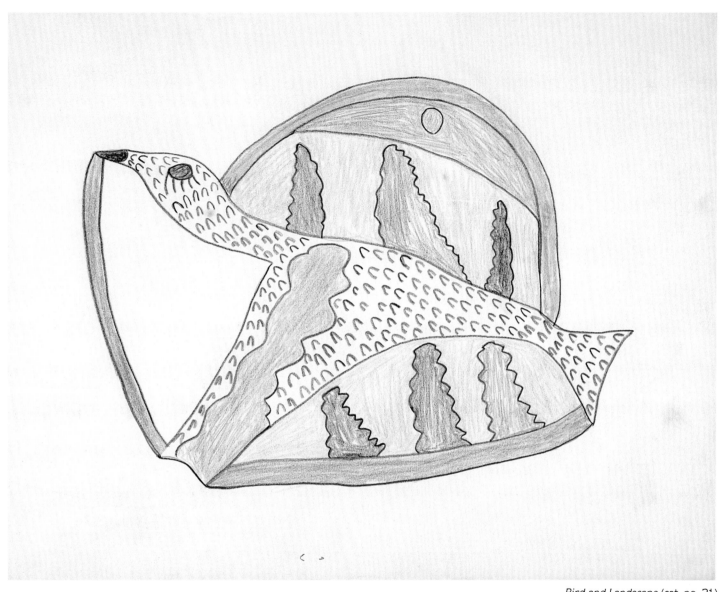

*Bird and Landscape* (cat. no. 21)

*Musk-ox, Frontal View* (cat. no. 26)

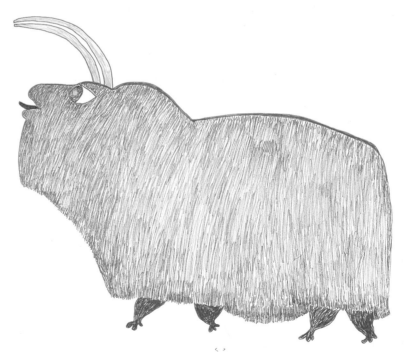

*Umingmuk* (cat. no. 27)

*Airplane* (cat. no. 38)

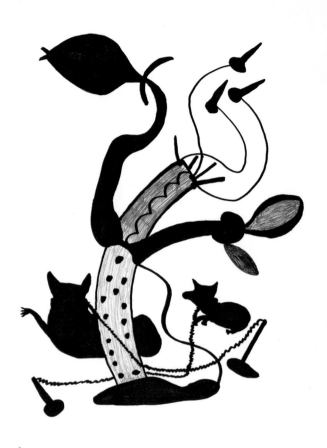

*Dogs Tied to a Tree* (cat. no. 32)

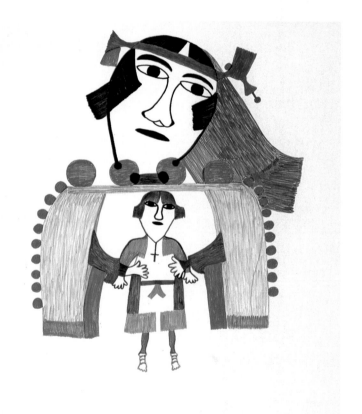

*Esigajuak* (cat. no. 35)

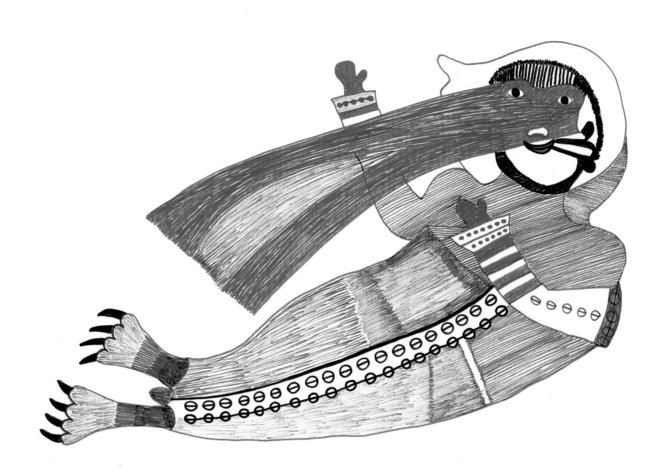

*Sedna* (cat. no. 34)

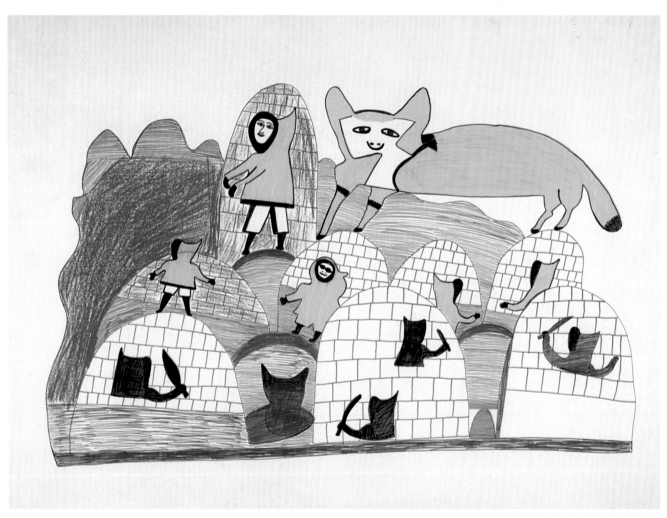

*Fox in Camp* (cat. no. 56)

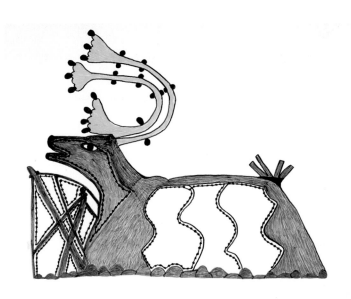

*Tent with Caribou Head* (cat. no. 41)

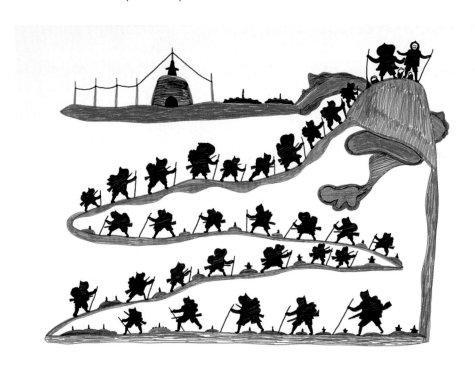

*Long Journey* (cat. no. 47)

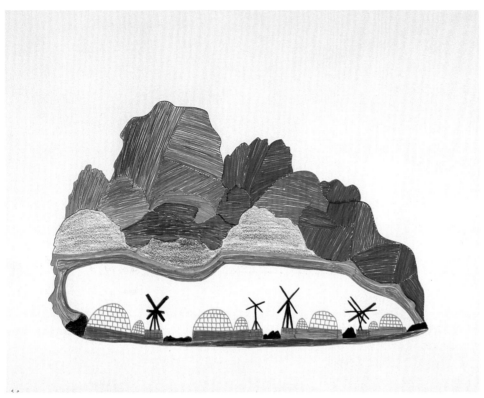

*Camp Scene with Igloos and Drying Racks* (cat. no. 51)

*Landscape with Ice Floes* (cat. no. 49)

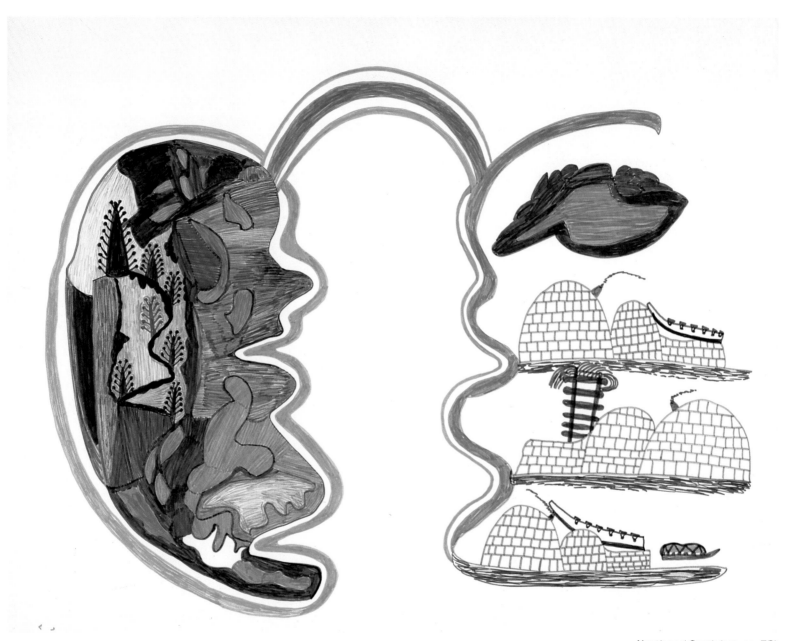

*North and South* (cat. no. 52)

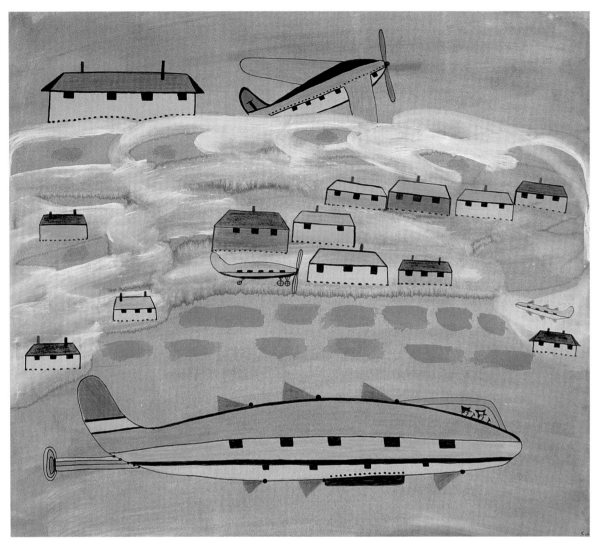

*Airplanes in the Settlement* (cat. no. 67)

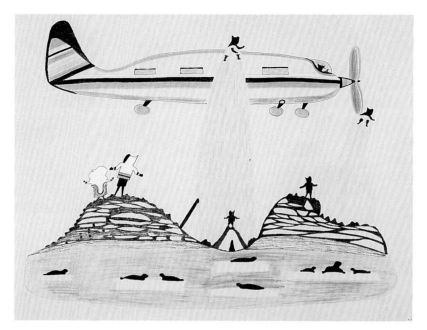

*Aeroplane* (cat. no. 63)

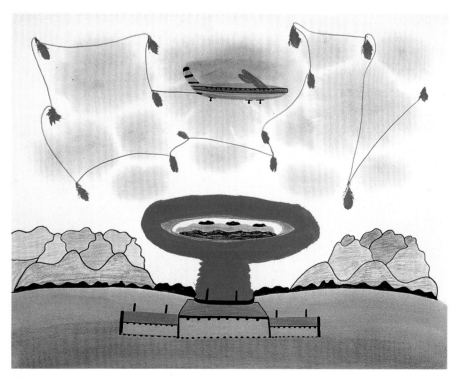

*Airplane between Two Places* (cat. no. 70)

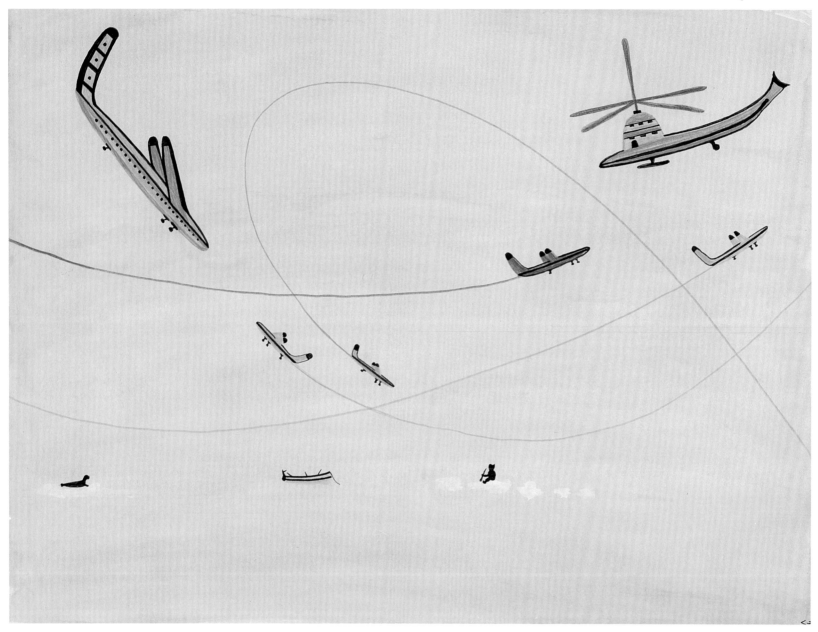

*View from the Ice* (cat. no. 73)

*New Parts for an Inuk* (cat. no. 83)

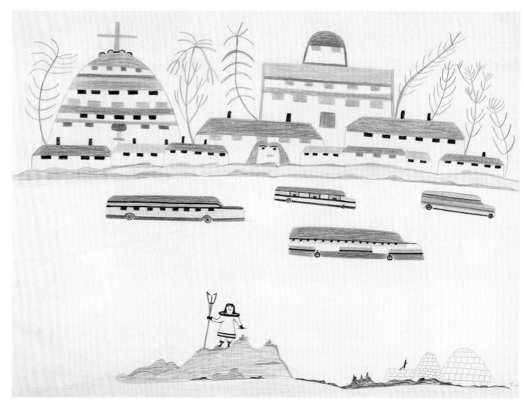

*Modern Life and the Old Way* (cat. no. 74)

*Skins and Blankets Hanging to Dry* (cat. no. 81)

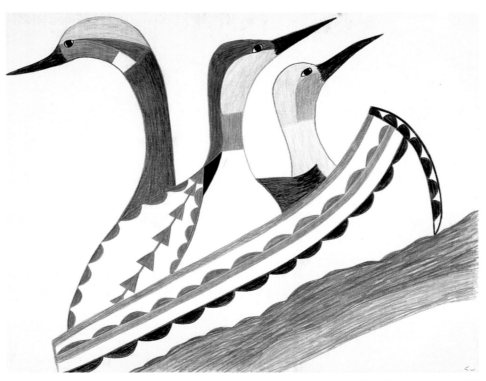

*Ship of Loons* (cat. no. 88)

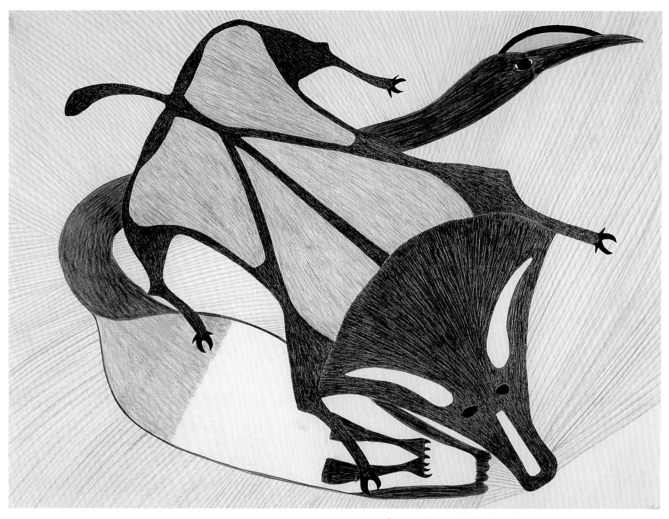

*Composition with Caribou-Creature and Loon* (cat. no. 91)

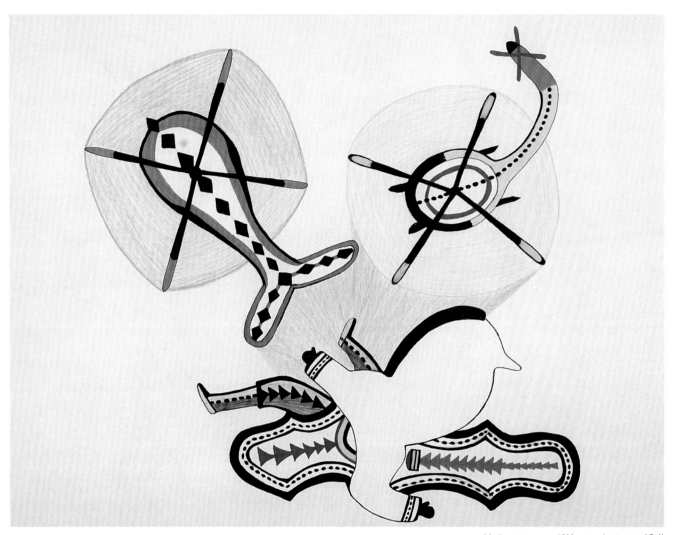

*Helicopters and Woman* (cat. no. 104)

# Catalogue

**1**

*Woman with Bird Image*
c. 1961
Graphite on wove paper (sheet from a coil-bound
sketchpad); watermark: *Howard Smith / Victory Bond /
Made in Canada*
60.9 × 45.8 cm
*Inscriptions*: Verso: l.l., *CD.024-56a-59/65(P)*; l.r., *1-6 /
250 / Pudlo / CD / F-21*
*Collection*: West Baffin Eskimo Co-operative, Cape Dorset
*Related print*: *Woman with Bird Image*, Cape Dorset 1961,
no. 14
*Literature*: Blodgett 1983, no. 94 (print); Labarge 1986,
no. 27 (print), no. 28 (drawing)

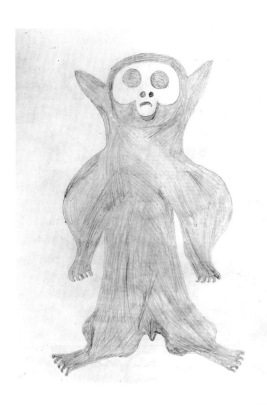

**2**

*Avingaluk (The Big Lemming)*
c. 1961
Graphite on wove paper (sheet from a coil-bound
sketchpad); watermark: *Howard Smith / Victory Bond /
Made in Canada*
60.8 × 45.7 cm
*Inscriptions*: by Terry Ryan l.l., *Pudlo*
*Collection*: Montreal Museum of Fine Arts, purchase 1963,
Harriett J. Macdonnell Bequest (Dr.1963.161)
*Related print*: *Avingaluk (The Big Lemming)*, Cape Dorset
1961, no. 22

*Avingaluk* means "big lemming."

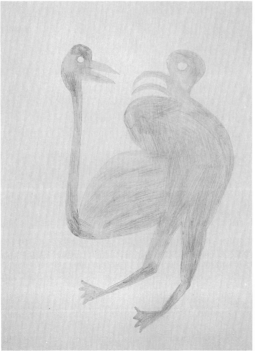

**3**

*Birds*
1961 / 62?
Graphite on cream-coloured wove paper
61.2 × 45.7 cm
*Inscriptions*: by Terry Ryan l.l., *Pudlo*; Verso: l.l.,
*CD.024-114a-59/65*
*Collection*: West Baffin Eskimo Co-operative, Cape Dorset

**4**

*Dogs Watching a Flying Creature*
c. 1961
Graphite on wove paper (sheet from a coil-bound sketchpad); watermark: *Howard Smith / Victory Bond / Made in Canada*
60.8 × 45.7 cm
*Inscriptions*: by Terry Ryan l.r., *Pudlo*; Verso: l.l., *CD.024-40a-59/65*
*Collection*: West Baffin Eskimo Co-operative, Cape Dorset

A similar creature is found in the print *Spirit Watching Games* (Cape Dorset 1965, no. 45). However, it is likely that in both instances the creature is not a spirit but some sort of flying insect or bird.

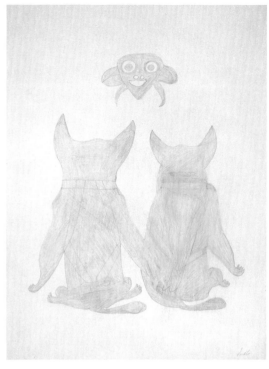

**5**

*Men Carrying a Caribou*
c. 1961
Graphite on wove paper (sheet from a coil-bound sketchpad); watermark: *Howard Smith / Victory Bond / Made in Canada*
60.9 × 45.8 cm
*Inscriptions*: Verso: l.l., *CD.024-68a-59/65*
*Collection*: West Baffin Eskimo Co-operative, Cape Dorset

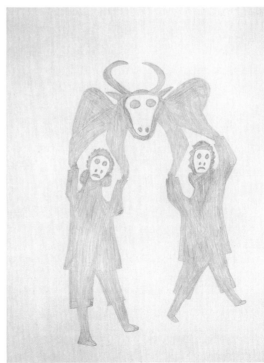

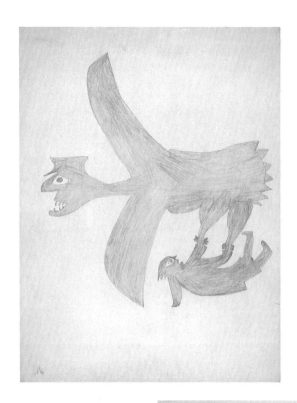

**6**

*Transported by a Bird*
August 1961
Graphite on wove paper (sheet from a coil-bound sketchpad); watermark: *Howard Smith / Victory Bond / Made in Canada*
60.8 × 45.7 cm
*Inscriptions*: by Terry Ryan l.l., *Pudlo / 8/61*; Verso: l.l., *CD.024-67a-59/65*
*Collection*: West Baffin Eskimo Co-operative, Cape Dorset

Images of carrying, and of transportation in general, recur often in Pudlo's work. This drawing introduces an element of fantasy, as the bird with its cap becomes both airplane and pilot for a rather startled-looking passenger.

**7**

*Man Carrying Water*
c. 1961
Graphite on wove paper (sheet from a coil-bound sketchpad); watermark: *Howard Smith / Victory Bond / Made in Canada*
60.5 × 45.8 cm
*Inscriptions*: Verso: l.l., *CD.024-327a-59/65*
*Collection*: West Baffin Eskimo Co-operative, Cape Dorset

"An old man getting some water ... On the front of his jacket, those are hooks to do it up."

**8**

*Woman with Utensils*
c. 1961
Graphite on wove paper (sheet from a coil-bound sketchpad); watermark: *Howard Smith / Victory Bond / Made in Canada*
60.5 × 45.8 cm
*Inscriptions*: by Terry Ryan u.r., *Pudlo*; Verso: l.l., *CD.024-11a-59/65(P)*
*Collection*: West Baffin Eskimo Co-operative, Cape Dorset
*Related print*: *Spirit with Symbols*, Cape Dorset 1961, no. 49
*Literature*: Ottawa, National Museum of Man 1977, no. 22 (print); Jackson 1978, pp. 50–51 (print); Blodgett 1983, no. 95 (print)

"Those are supposed to be beads [on the front of the woman's *amautiq*] … those are little brooms and a dustpan [in her hands]." Asked by Marion Jackson in 1978 whether this drawing was meant to represent a shaman, Pudlo replied: "No, I don't think of her as a shaman, maybe only you do" (Jackson 1978, p. 51). During the same conversation he described the objects in the woman's hands as seaweed and a backscratcher.

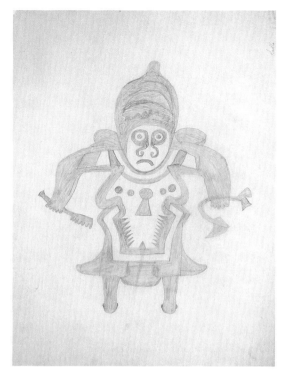

**9**

*Man in Fish Weir*
c. 1961
Graphite on wove paper (sheet from a coil-bound sketchpad); watermark: *Howard Smith / Victory Bond / Made in Canada*
60.8 × 45.8 cm
*Inscriptions*: by Terry Ryan l.r., *Pudlo*; Verso: l.l., *CD.024-55a-59/65(P)*; u.r., *CAP # / 3-305 / LR: MS / 250 / Pudlo / F-21 / CD*
*Collection*: West Baffin Eskimo Co-operative, Cape Dorset
*Related print*: *Man in Fish Weir*, Cape Dorset 1961, no. 19
*Literature*: Jackson 1983, pp. 24–25 (print); Labarge 1986, no. 33 (print), no. 34 (drawing)

"This is about how we used to go fishing… The trap would have a little doorway for the fish to go in and out. The person who got to the trap first would watch, and when there were a lot of fish in it, he would place a rock in the entrance. After that, he would put his hands up, he would make some kind of sign for everyone else to come, to show that the trap was ready."

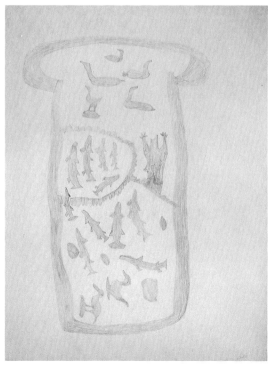

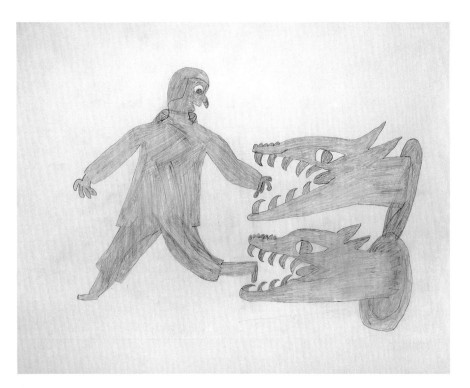

**10**

*Chased by Dogs*
1961/62?
Graphite on wove paper; watermark: *Bienfang / Ermine Bond*
47.7 × 60.7 cm
*Inscriptions*: Verso: l.l., *CD.024-157a-59/65*; u.r., *Pudlo*
*Collection*: West Baffin Eskimo Co-operative, Cape Dorset
*Literature*: Jackson 1978, p. 19

In Pudlo's view, the dog is clearly important to the hunter, though perhaps not always his best friend. Here two rather ferocious dogs seem close to biting their master's hands and heels. The rings around the animals' necks appear to be collars (Jackson 1978, p. 19).

**11**

*Decorated Bird*
May 1962
Graphite on wove paper; watermark: *Bienfang / Ermine Bond*
60.7 × 48 cm
*Inscriptions*: by Terry Ryan l.l., *Pudlo / 29/5/62*; Verso: l.l., *CD.024-151a-59/65*
*Collection*: West Baffin Eskimo Co-operative, Cape Dorset

**12**

*Decorated Seal*
c. 1962
Graphite on cream-coloured wove paper
61.2 × 45.8 cm
*Inscriptions*: Verso: l.l., *CD.024-133a-59/65*
*Collection*: West Baffin Eskimo Co-operative, Cape Dorset

**13**

*Bird Boat*
1963/65?
Graphite on wove paper (sheet from a sketchpad)
65.2 × 50.8 cm
*Inscriptions*: signed l.c., *Pudlo* (in syllabics); Verso: l.l.,
*CD.024-215a-59/65*
*Collection*: West Baffin Eskimo Co-operative, Cape Dorset

"We used to watch movies ... showing wooden boats, big
ships, the kind with a figurehead carved on the front.
Maybe I was thinking of those movies... The man on the top
of the sail must be very strong to stand there like that...
I forgot to put in the crow's nest."

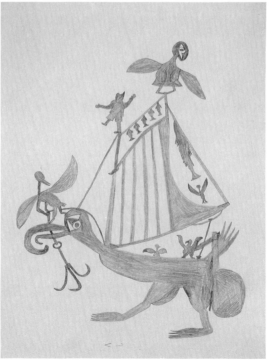

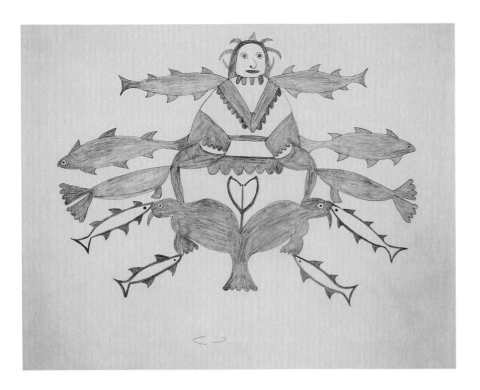

**14**

*Composition with Woman, Fish, and Seals*
1963/65?
Graphite on wove paper (sheet from a sketchpad)
50.7 × 65.4 cm
*Inscriptions*: signed l.c., *Pudlo* (in syllabics); Verso: l.l.,
*CD.024-308a-59/65*
*Collection*: West Baffin Eskimo Co-operative, Cape Dorset

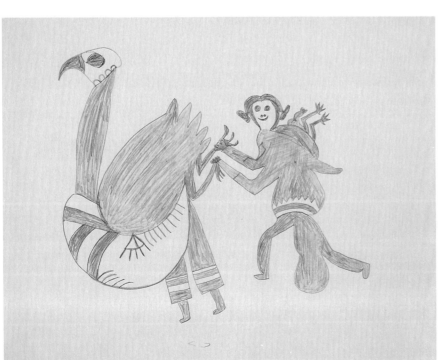

**15**

*Bird and Woman*
1963/65?
Graphite on wove paper (sheet from a sketchpad)
50.7 × 65.4 cm
*Inscriptions*: signed l.c., *Pudlo* (in syllabics); Verso: l.l.,
*CD.024-334a-59/65*
*Collection*: West Baffin Eskimo Co-operative, Cape Dorset

**16**

*Fish-Creatures Attack Kayak*
1963/65?
Graphite on wove paper (sheet from a sketchpad)
50.7 × 65.4 cm
*Inscriptions*: signed l.c., *Pudlo* (in syllabics); Verso: l.l.,
*CD.024-260a-59/65*
*Collection*: West Baffin Eskimo Co-operative, Cape Dorset

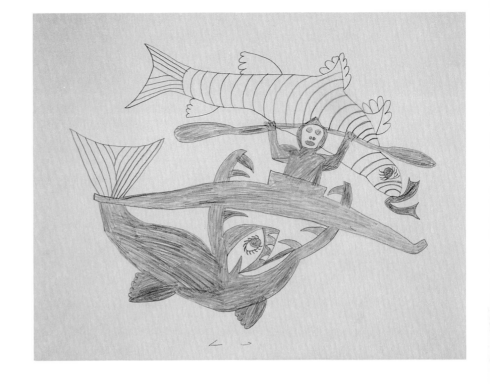

**17**

*Fish Line*
c. 1965
Graphite on wove paper (sheet from a sketchpad)
50.8 × 65.4 cm
*Inscriptions*: signed l.c., *Pudlo* (in syllabics); Verso: l.l.,
*CD.024-303a-59/65(P)*
*Collection*: West Baffin Eskimo Co-operative, Cape Dorset
*Related print*: *Fish Line*, Cape Dorset 1966, no. 38

"Fish hanging to dry … but they are hanging the wrong way
[the tails should be attached to the line]. The wind must be
blowing. Look at the fish and the hair of the women!"

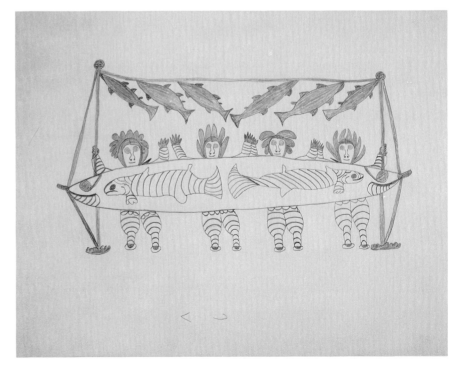

**18**

*He Finally Caught a Fish*
1963/66?
Graphite and wax crayon on wove paper (sheet from a sketchpad)
50.8 × 65.7 cm
*Inscriptions*: signed l.c., *Pudlo* (in syllabics); Verso: l.l., *CD.024-517ac-59/65*
*Collection*: West Baffin Eskimo Co-operative, Cape Dorset

The title of this drawing is a quotation from Pudlo's own description of the scene represented in it. He also noted that he "made the feet too small."

**19**

*Bird with Playing-Card Designs*
1963/66?
Graphite and wax crayon on wove paper (sheet from a sketchpad)
50.7 × 65.4 cm
*Inscriptions*: signed l.c., *Pudlo* (in syllabics); Verso: l.l., *CD.024-549ac-59/65*
*Collection*: West Baffin Eskimo Co-operative, Cape Dorset

Playing-card motifs have been used elsewhere in Inuit design and decoration. At Kiaktuuq, Peter Pitseolak photographed a man named Seuteapik wearing *kamiit* with inlaid playing-card motifs (see Bellman 1980, p. 42, no. 92).

**20**

*Landscape with Rainbow and Sun*
1963/66?
Graphite and wax crayon on wove paper (sheet from a sketchpad)
50.8 × 65.7 cm
*Inscriptions*: signed l.c., *Pudlo* (in syllabics); Verso: l.l., *CD.024-426ac-59/65*
*Collection*: West Baffin Eskimo Co-operative, Cape Dorset

The title is based on Pudlo's description of the drawing.

**21**

*Bird and Landscape*
1963/66?
Graphite and wax crayon on wove paper (sheet from a sketchpad)
50.7 × 65.7 cm
*Inscriptions*: signed l.c., *Pudlo* (in syllabics); Verso: l.l., *CD.024-344ac-59/65*
*Collection*: West Baffin Eskimo Co-operative, Cape Dorset
*Literature*: Jackson 1978, pp. 21, 80

"Do you see the bird here, the goose — and the moon and the blue sky?... I once saw some trees, but they were not real trees. I saw them not very far away, at a place called Inukjuak. They were not really trees, but they were like trees, the first I ever saw. Maybe that's why I tried to draw them here, though they didn't turn out that well" (Jackson 1978, p. 80). What Pudlo had seen was probably an indigenous shrub known as arctic willow.

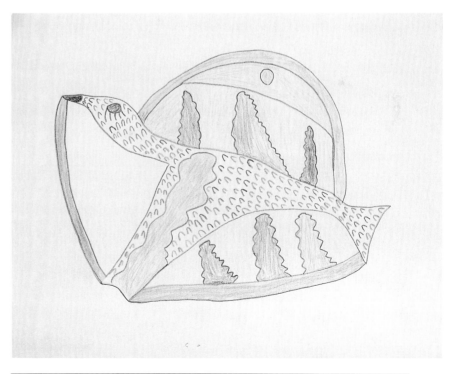

**22**
*Caribou*
1967?
Felt pen on textured wove paper; watermark: *Carousel*
45.7 × 61 cm
*Inscriptions*: signed l.c., *Pudlo* (in syllabics) Verso: l.l.,
*CD.024-577d-66/76*
*Collection*: West Baffin Eskimo Co-operative, Cape Dorset

**23**
*Winter Angel*
c. 1969
Felt pen on wove paper
45.7 × 61.2 cm
*Inscriptions*: signed l.c., *Pudlo* (in syllabics); Verso: l.l.,
*CD.024-752d-66/76(P)*
*Collection*: West Baffin Eskimo Co-operative, Cape Dorset
*Related print*: *Winter Angel*, Cape Dorset 1969, no. 54
*Literature*: Ottawa, National Museum of Man 1977, no. 51
(print)

**24**

*Fantasy Creature*
c. 1969
Felt pen on wove paper
61.2 × 45.7 cm
*Inscriptions*: signed l.c., *Pudlo* (in syllabics); Verso: l.l.,
*CD.024-745d-66/76*
*Collection*: National Gallery of Canada, Ottawa, purchase
1986 (29582)

**25**

*Umayuluk*
c. 1970
Felt pen on wove paper
45.7 × 61.2 cm
*Inscriptions*: signed l.c., *Pudlo* (in syllabics); Verso: l.l.,
*CD.024-748d-66/76*; l.l., *(P) Dorset Series*
*Collection*: West Baffin Eskimo Co-operative, Cape Dorset
*Related print*: *Umayuluk*, "Dorset Series," 1970

*Umayuluk* means "big living creature" or "big animal." Onto
the massive, shaggy body of a musk-ox, Pudlo has attached
the antlers and tail of a caribou.

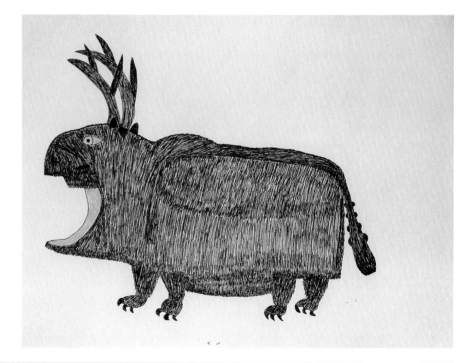

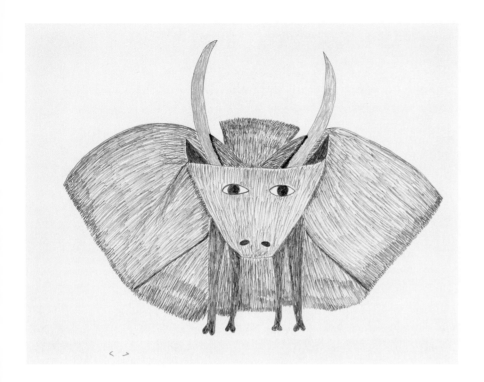

**26**

*Musk-ox, Frontal View*
c. 1970
Felt pen on wove paper; watermark: *Rives*
50.8 × 66.1 cm
*Inscriptions*: signed l.l., *Pudlo* (in syllabics); l.r., *W.B.E.C.
Limited / Cape Dorset N.W.T.* (blind stamp); Verso: l.l.,
*CD.024-1118d-66/76*; l.r., *7-1005 / F-21*
*Collection*: West Baffin Eskimo Co-operative, Cape Dorset

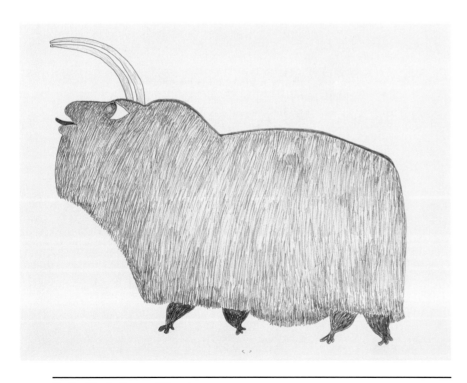

**27**

*Umingmuk*
c. 1970
Felt pen on wove paper; watermark: *Rives*
50.5 × 66.4 cm
*Inscriptions*: signed l.c., *Pudlo* (in syllabics); Verso: l.l.,
*CD.024-1018d-66/76(P)*
*Collection*: West Baffin Eskimo Co-operative, Cape Dorset
*Related print*: *Umingmuk*, Cape Dorset 1970, no. 39
*Literature*: Roch 1974, p. 116 (print); Jackson 1978, p. 55
(drawing), p. 63 (print); Jackson 1979, p. 93 (print)

*Umingmuk* means "musk-ox." In November 1972 Pudlo
travelled to Ottawa to attend the opening of an exhibition of
works reproduced on UNICEF greeting cards, including the
print of this drawing. He continues to remember it as the
first work for which he was invited south and accorded
public recognition (see Jackson 1979, p. 93).

**28**

*Head of a Musk-ox*
1970/73?
Felt pen on wove paper
48.5 × 61.2 cm
*Inscriptions*: signed l.l., *Pudlo* (in syllabics); Verso: l.l.,
*CD.024-1005d-66/76*
*Collection*: West Baffin Eskimo Co-operative, Cape Dorset

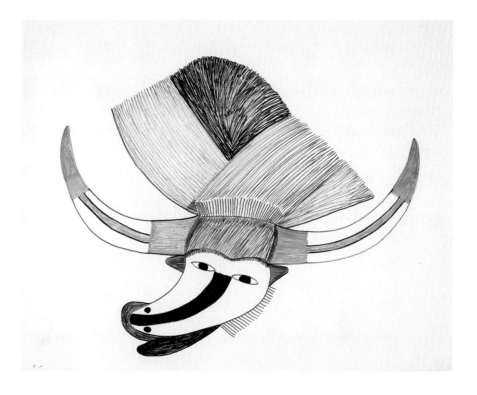

**29**

*Musk-ox with Double Horns*
1973?
Felt marker on wove paper; watermark: *Rives*
50.5 × 66.1 cm
*Inscriptions*: signed l.l., *Pudlo* (in syllabics); Verso: l.l.,
*CD.024-1004d-66/76*
*Collection*: West Baffin Eskimo Co-operative, Cape Dorset

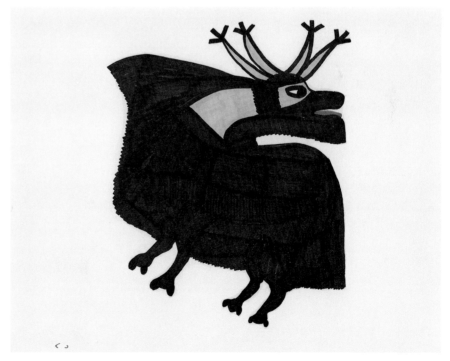

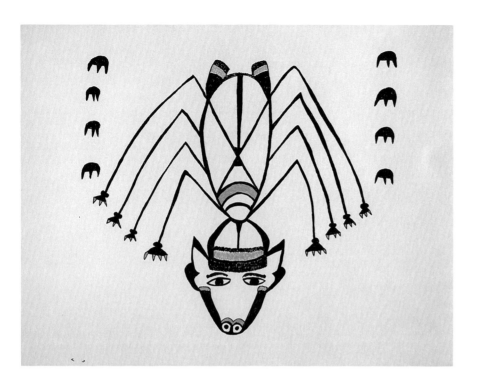

**30**

*Spider*
1970/73?
Felt pen on wove paper
50.8 × 66.3 cm
*Inscriptions*: signed l.l., *Pudlo* (in syllabics); Verso: l.l.,
*CD.024-1017d-66/76*
*Collection*: West Baffin Eskimo Co-operative, Cape Dorset
*Literature*: Jackson 1978, pp. 59–60

"I meant to make a spider, but as you see, I didn't do a
very good job of it... As I went along, the pencil itself
started making a dog's face, and that's how it turned
out" (Jackson 1978, p. 60).

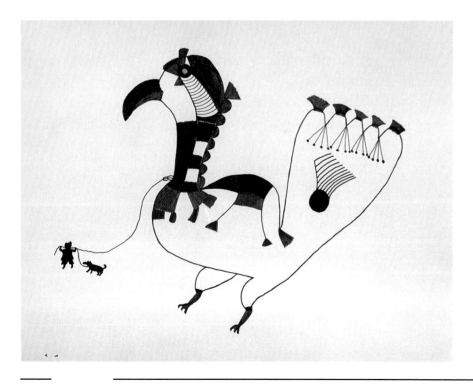

**31**

*Gigantic Bird on a Leash*
1970/73?
Felt pen on wove paper; watermark: *Rives*
50.6 × 66.4 cm
*Inscriptions*: signed l.l., *Pudlo* (in syllabics); Verso: l.l.,
*CD.024-841d-66/76*
*Collection*: West Baffin Eskimo Co-operative, Cape Dorset

**32**

*Dogs Tied to a Tree*
1973?
Felt marker on wove paper; watermark: *Rives*
66 × 51.7 cm
*Inscriptions*: signed l.l., *Pudlo* (in syllabics); Verso: l.l.,
*CD.024-899d-66/76*
*Collection*: West Baffin Eskimo Co-operative, Cape Dorset

In the mid-1960s Pudlo began drawing the trees he saw on
his various travels south (see also cat. no. 21). Here he puts
his rendition of this exotic form to practical use to tie up a
pair of dogs. Of the dogs Pudlo noted: "You can tell they are
tired."

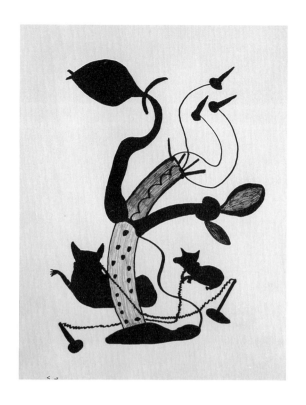

**33**

*Seals Meet a Bear*
1970/73?
Felt pen on wove paper; watermark: *Rives*
51 × 66.5 cm
*Inscriptions*: signed l.l., *Pudlo* (in syllabics); Verso: l.l.,
*CD.024-994d-66/76*
*Collection*: West Baffin Eskimo Co-operative, Cape Dorset

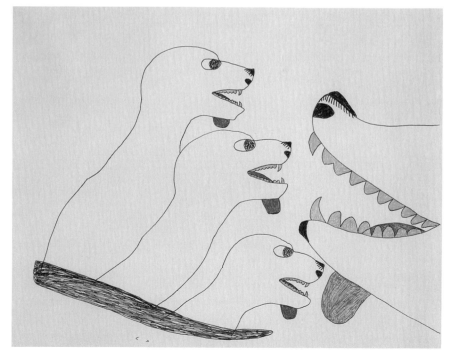

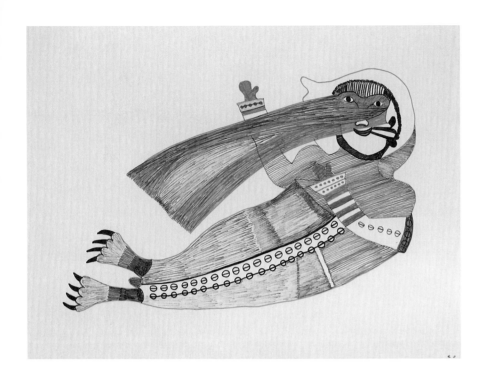

**34**

*Sedna*
1973?
Felt pen on heavy wove paper
45.8 × 61 cm
*Inscriptions*: signed l.r., *Pudlo* (in syllabics); Verso: l.l.,
*CD.024-702d-66/76(P)*
*Collection*: West Baffin Eskimo Co-operative, Cape Dorset
*Related print*: *Sedna*, Cape Dorset 1976, no. 24

In Inuit mythology, Sedna is one of the principal names
given to the woman who becomes the mother of the crea-
tures of the sea. Here she is depicted as part-female and
part-seal. She also wears a mask that curiously extends out
from her face as she swims along. In Pudlo's description:
"It is as if the mask was being stretched by the force of
the water."

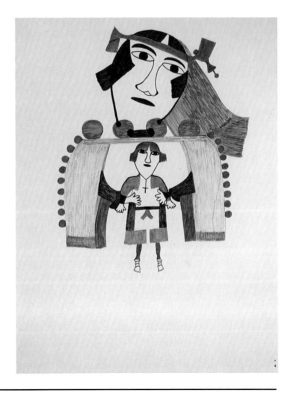

**35**

*Esigajuak*
c. 1973
Felt pen on wove paper; watermark: *Rives*
65.7 × 51.1 cm
*Inscriptions*: signed l.r., *Pudlo* (in syllabics); Verso: l.l.,
*CD.024-857d-66/76(P)*
*Collection*: West Baffin Eskimo Co-operative, Cape Dorset
*Related print*: *Esigajuak*, Cape Dorset 1973, no. 54
*Literature*: Blodgett 1984, "Christianity and Inuit Art,"
p. 20 (print)

*Esigajuak* (or *iksirajuaq*, as it might now be transliterated)
means "Catholic missionary" or "Catholic priest."
Presumably this title was given to the print because of the
small figure wearing a cross, robe, and sandals. Pudlo
himself has described the image as showing "a large female
figure holding a smaller person who does not know she is
there." Although he could not recall his exact intentions, it is
likely that the image represents a Christian subject, such as
a Madonna and Child, which he may have seen illustrated in
a Bible.

**36**

*Woman Holding a Bird*
1973?
Felt pen on wove paper
48.5 × 61.2 cm
*Inscriptions*: signed l.l., *Pudlo* (in syllabics); l.r., *W.B.E.C.*
*Limited / Cape Dorset N.W.T.* (blind stamp); Verso: l.l.,
*CD.024-785d-66/76*; l.r., *7-1001 / F-21*
*Collection*: West Baffin Eskimo Co-operative, Cape Dorset

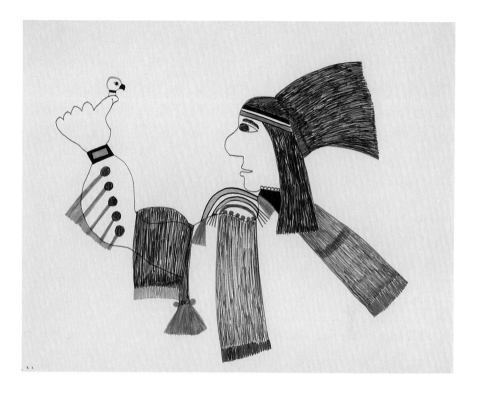

**37**

*Bird with Cap and Symbols*
1973?
Felt marker on wove paper; watermark: *Rives*
50.6 × 66.1 cm
*Inscriptions*: signed l.l., *Pudlo* (in syllabics); Verso: l.l.,
*CD.024-1001d-66/76*
*Collection*: West Baffin Eskimo Co-operative, Cape Dorset

This drawing seems to be part of a series on costumes,
uniforms, and related symbols produced sometime around
1973. Here the cap and uniform suggest that Pudlo may
have been thinking of an airplane pilot. The five-pointed star
also calls to mind the insignia used on the caps and parkas
of employees of the Baffin Trading Company (see Pitseolak
and Eber 1975, p. 139). Of note too are the rope and ladder
motifs, which re-appear in later works as more integrated
parts of the composition (see cat. nos. 43, 55, 57).

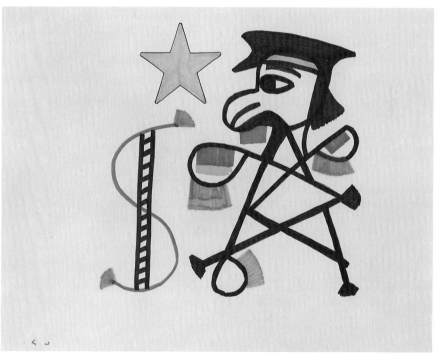

**38**
*Airplane*
1973?
Felt pen on wove paper; watermark: *Rives*
50.8 × 66 cm
*Inscriptions*: signed l.l., *Pudlo* (in syllabics); l.l., *West Baffin Eskimo Co-operative* symbol (blind stamp); Verso: l.l., *CD.024-1035d-66/76*; l.c., *P. Pudlat*; l.r., *MS82.37*
*Collection*: Macdonald Stewart Art Centre, Guelph, Ont., purchased with funds donated by Omark Canada Ltd., a Blount, Inc., Company, with assistance from the Canada Council, 1982 (MS982.037)
*Literature*: Christopher 1987, p. 6

**39**
*Fish-Airplane*
1973/74?
Felt pen on wove paper; watermark: *Rives*
51.4 × 66.4 cm
*Inscriptions*: signed l.r., *Pudlo* (in syllabics); Verso: l.l., *CD.024-1034d-66/76*
*Collection*: West Baffin Eskimo Co-operative, Cape Dorset

**40**

*Tent and Fish*
1973?
Felt marker on wove paper; watermark: *Rives*
50.5 × 65.7 cm
*Inscriptions*: signed l.l., *Pudlo* (in syllabics); Verso: l.l.,
*CD.024-896d-66/76*
*Collection*: West Baffin Eskimo Co-operative, Cape Dorset

**41**

*Tent with Caribou Head*
c. 1973
Felt pen on wove paper; watermark: *Rives*
51 × 65.6 cm
*Inscriptions*: signed l.l., *Pudlo* (in syllabics); Verso: l.l.,
*CD.024-1065d-66/76(P)*
*Collection*: West Baffin Eskimo Co-operative, Cape Dorset
*Related print*: *Shaman's Tent*, Cape Dorset 1973, no. 51;
see also *Caribou Tent*, Cape Dorset 1973, no. 53
*Literature*: Roch 1974, p. 124 (print, *Shaman's Tent*);
Ottawa, National Museum of Man 1977, no. 62 (print,
*Caribou Tent*); Ottawa, Department of Indian Affairs and
Northern Development 1981, no. 3 (print, *Caribou Tent*)

Since Pudlo does not speak of any shamanistic intention in
this image, the title of the related print, *Shaman's Tent*, has
not been used here for the drawing. The caribou head
serves as a visual embellishment, playing perhaps on the
fact that animal skins are used in making a tent.

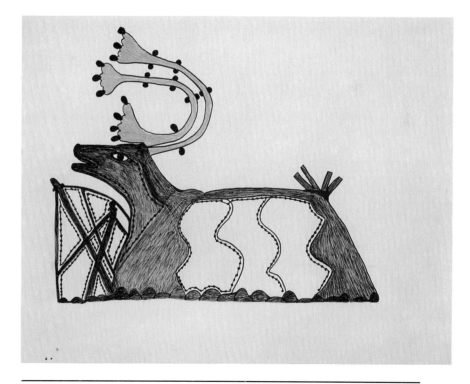

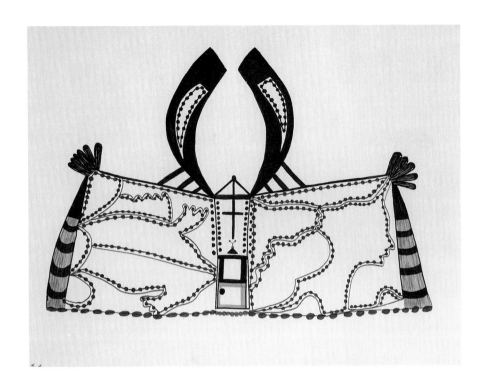

**42**
*Double Tent*
c. 1973
Felt pen on wove paper; watermark: *Rives*
50.2 × 65.9 cm
*Inscriptions*: signed l.l., *Pudlo* (in syllabics); Verso: l.l.,
*CD.024-998d-66/76*
*Collection*: West Baffin Eskimo Co-operative, Cape Dorset

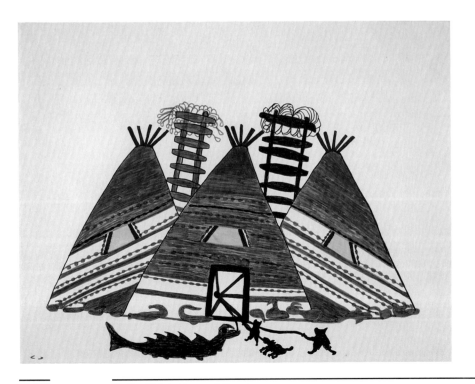

**43**
*Tupiit*
1973?
Felt pen on wove paper; watermark: *Rives*
50.2 × 65.8 cm
*Inscriptions*: signed l.l., *Pudlo* (in syllabics); Verso: l.l.,
*CD.024-890d-66/76(P)*
*Collection*: West Baffin Eskimo Co-operative, Cape Dorset
*Related print*: *Tupiit*, Cape Dorset 1976, no. 45

*Tupiit* means "tents."

**44**

*Winter Camp Scene*
c. 1974
Felt pen on wove paper; watermark: *Rives*
50.5 × 65.7 cm
*Inscriptions*: signed l.l., *Pudlo* (in syllabics); Verso: l.l.,
*CD.024-1459d-66/76(P)*
*Collection*: West Baffin Eskimo Co-operative, Cape Dorset
*Related print*: *Winter Camp Scene*, Cape Dorset 1974,
no. 37

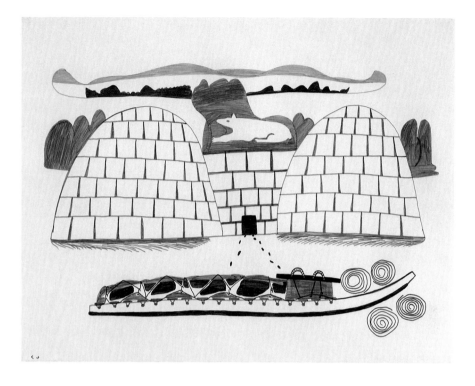

**45**

*Encounter with a Polar Bear*
1974?
Felt pen on wove paper; watermark: *Rives*
50.8 × 66 cm
*Inscriptions*: signed l.l., *Pudlo* (in syllabics); Verso: l.l.,
*CD.024-1056d-66/76*
*Collection*: West Baffin Eskimo Co-operative, Cape Dorset
*Literature*: Jackson 1978, p. 79

"It's a polar bear entering somebody's house – that
sometimes happened in the old days. I myself had such an
experience when I was still living with my mother. It was
very frightening" (Jackson 1978, p. 79). See Marion
Jackson's essay above, p. 59.

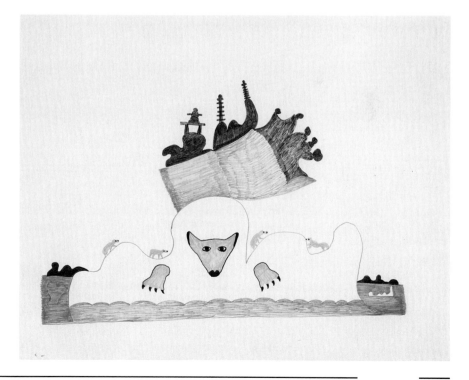

**46**

*Spring Travellers*
1974?
Felt pen on wove paper; watermark: *Rives*
50.5 × 65.7 cm
*Inscriptions*: signed l.l., *Pudlo* (in syllabics); Verso: l.l.,
*CD.024-1381d-66/76(P)*
*Collection*: West Baffin Eskimo Co-operative, Cape Dorset
*Related print*: *Spring Travellers*, Cape Dorset 1976, no. 16

"The komatik with the boat, and the little cabin — they are
real things. But the birds in the boat, I just added them to
the drawing."

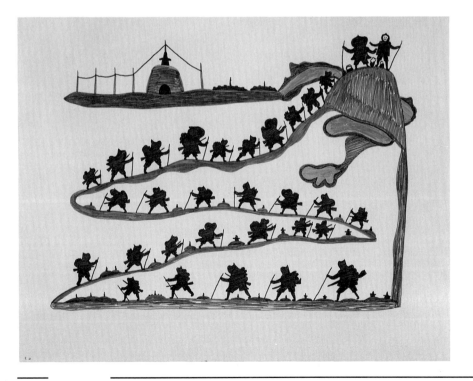

**47**

*Long Journey*
c. 1974
Felt pen on wove paper; watermark: *Rives*
50.7 × 65.5 cm
*Inscriptions*: signed l.l., *Pudlo* (in syllabics); Verso: l.l.,
*CD.024-1040d-66/76(P)*
*Collection*: West Baffin Eskimo Co-operative, Cape Dorset
*Related print*: *Long Journey*, Cape Dorset 1974, no. 36
*Literature*: Jackson 1983, pp. 23–25 (print); Blodgett
1983, no. 100 (print); Hoffmann 1988, no. 221 (print)

"This is a reminder of how people used to travel on foot. It's
summertime, and because they have come to a lake, they
have to go around, they can't go straight… The building up
on the left is what those people who've reached the top of
the mountain can see … that's where they are trying to go."

**48**

*Arctic Waterfall*
May 1974
Felt pen on wove paper; watermark: *Rives*
50.5 × 65.4 cm
*Inscriptions*: signed l.l., *Pudlo* (in syllabics); Verso: l.l.,
*CD.024-2442d-66/76(P)*; l.l., *1976 P*; l.l., *Padloo May/74*
*Collection*: West Baffin Eskimo Co-operative, Cape Dorset
*Related print*: *Arctic Waterfall*, Cape Dorset 1976, no. 15
*Literature*: Alma Houston, "Foreword," in Cape Dorset
1976, p. 6 (print); Ottawa, Department of Indian Affairs and
Northern Development 1981, no. 5 (print)

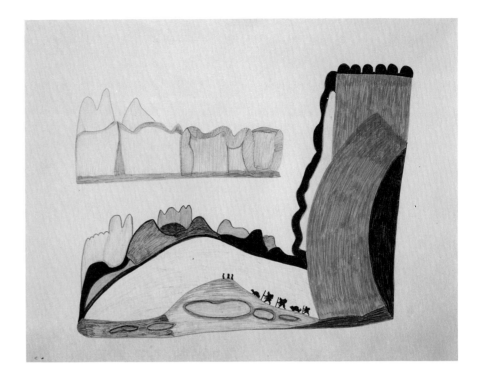

**49**

*Landscape with Ice Floes*
c. 1974
Felt pen on wove paper; watermark: *Rives*
51.5 × 66.5 cm
*Inscriptions*: signed l.l., *Pudlo* (in syllabics); Verso: l.l.,
*CD.024-1443d-66/76*
*Collection*: West Baffin Eskimo Co-operative, Cape Dorset

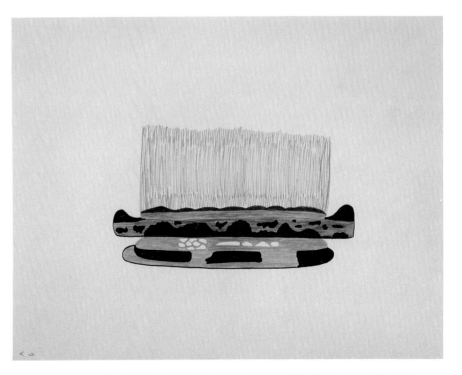

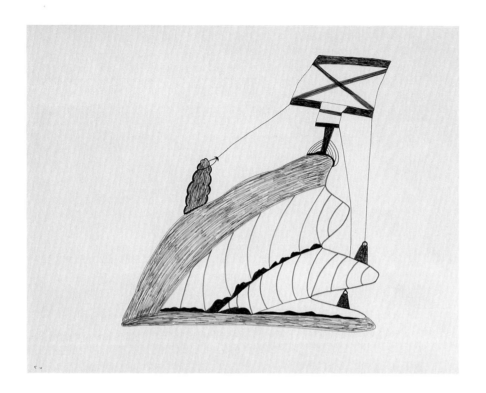

**50**

*Landscape with Antenna*
c. 1974
Felt pen on wove paper; watermark: *Rives*
51.5 × 66.5 cm
*Inscriptions*: signed l.l., *Pudlo* (in syllabics); Verso: l.l.,
*CD.024-1340d-66/76*
*Collection*: West Baffin Eskimo Co-operative, Cape Dorset

In this "landscape fragment," Pudlo focuses on some sort
of antenna or receiving dish perched on the crest of a hill.
Since the permafrost prevents any digging to secure such
structures, all supports are aboveground – hence the
system of guy-wires and weights shown in this image.

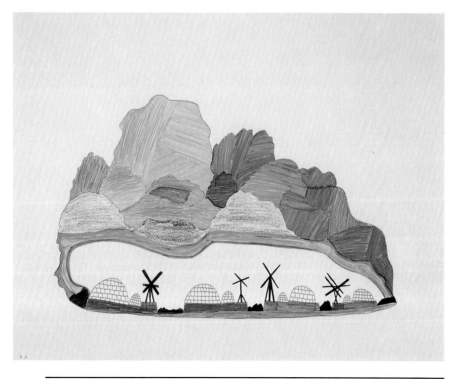

**51**

*Camp Scene with Igloos and Drying Racks*
c. 1974
Felt pen and coloured pencil on wove paper; watermark:
*Rives*
51.5 × 65.7 cm
*Inscriptions*: signed l.l., *Pudlo* (in syllabics); Verso: l.l.,
*CD.024-1046bd-66/76*
*Collection*: West Baffin Eskimo Co-operative, Cape Dorset
*Literature*: Jackson 1978, p. 77

Pudlo has explained that the peculiar structures beside each
igloo are simply pieces of wood stacked together to make a
sort of rack that could be used for drying meat (Jackson
1978, p. 77). Similar racks can been seen in the right
foreground of Figure 28.

**52**

*North and South*
April 1974
Felt pen on wove paper; watermark: *Rives*
51.1 × 65.4 cm
*Inscriptions*: signed l.l., *Pudlo* (in syllabics); Verso: l.l.,
*CD.024-1054d-66/76*; u.r., *Padloo April/74*
*Collection*: West Baffin Eskimo Co-operative, Cape Dorset
*Literature*: Jackson 1978, pp. 84–85

In this drawing Pudlo gives visual form to his sense of the
increasing links between the North and southern Canada.
See Marie Routledge's essay above, p. 28.

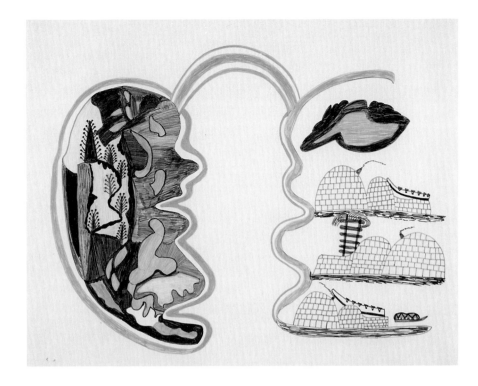

**53**

*Spring Landscape (Dirty Snow)*
April 1974
Felt pen on wove paper; watermark: *Rives*
50.5 × 65.8 cm
*Inscriptions*: signed l.l., *Pudlo* (in syllabics); Verso: l.l.,
*CD.024-1376d-66/76*; u.r., *Padloo April/74*
*Collection*: West Baffin Eskimo Co-operative, Cape Dorset
*Literature*: Jackson 1978, p. 89

Some of Pudlo's landscapes reflect an awareness of the
curvature of the earth, especially as depicted in modern
maps (see Jackson 1978, p. 89). In this drawing two
different camps of igloos appear to be joined by a sinuous
range of water, hills, and coastal islands. Pudlo has explained
that the spring season is suggested by the open water and
also by the dirty igloos, which have turned grey because of
soot from the chimneys.

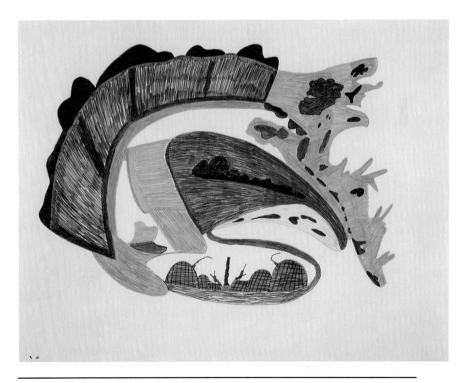

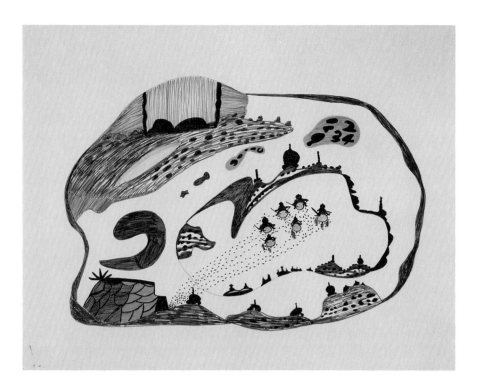

**54**

*Spring Landscape*
May 1974
Felt pen on wove paper; watermark: *Rives*
51.2 × 65.3 cm
*Inscriptions*: signed l.l., *Pudlo* (in syllabics); Verso: l.l.,
*CD.024-1325d-66/76(P)*; l.l., *Padloo May/74*
*Collection*: West Baffin Eskimo Co-operative, Cape Dorset
*Related print*: *Spring Landscape*, Cape Dorset 1977, no. 53
*Literature*: Jackson 1979, p. 97 (print); Ottawa, Department
of Indian Affairs and Northern Development 1981, no. 6
(print)

Here Pudlo shows two separate places simultaneously
by enclosing the ice-fishing scene in its own bubble. The
encircling landscape represents the camp from which the
fishing party set out. The open water and the skin tents tell
us this is a spring scene. Pudlo has also commented that the
very noticeable footprints left by the figures are meant to
suggest the soft, deep snow of spring.

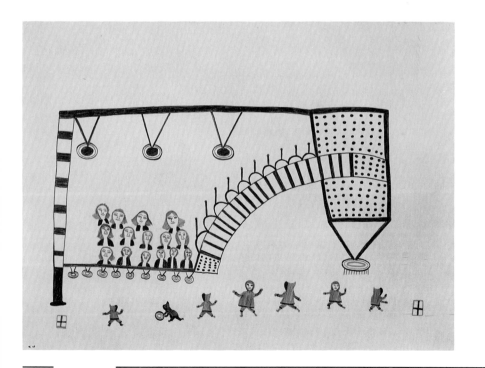

**55**

*Winter Games*
c. 1976
Felt pen on wove paper; watermark: *BFK Rives / France*
56.2 × 76.5 cm
*Inscriptions*: signed l.l., *Pudlo* (in syllabics); Verso: l.l.,
*CD.024-1565d-66/76(P)*
*Collection*: West Baffin Eskimo Co-operative, Cape Dorset
*Related print*: *Winter Games*, Cape Dorset 1976, no. 8

"I remember thinking of Christmas when I drew this…
There are children playing, there's the audience, and it's
decorated too." The scene is probably in the present-day
school gymnasium, where special events such as Christmas
gatherings are often held. The children are playing with a
ball, and the round form suspended just above them at the
right may be a basketball hoop.

## 56

*Fox in Camp*
c. 1975
Felt pen and wax crayon on wove paper; watermark:
*BFK Rives / France*
56.1 × 76.1 cm
*Inscriptions*: signed l.l., *Pudlo* (in syllabics); Verso: l.l.,
*CD.024-1564bd-66/76(P)*
*Collection*: West Baffin Eskimo Co-operative, Cape Dorset
*Related print*: *Fox in Camp*, Cape Dorset 1975, no. 44
*Literature*: Ottawa, National Museum of Man 1977, no. 68
(print); Jackson 1979, p. 96 (print); Ottawa, Department of
Indian Affairs and Northern Development 1981, no. 4
(print)

"Those are children in the igloos, playing with the snow
knives. It looks like they are making pictures."

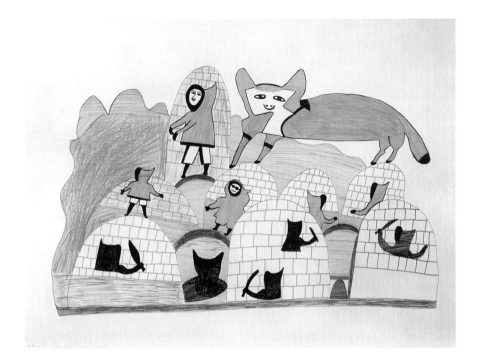

## 57

*Composition with Komatik and Figures*
1975
Black lithographic crayon, wax crayon, and black felt pen on
wove paper; watermark: *BFK Rives / France*
56.3 × 76.5 cm
*Inscriptions*: signed l.l. and l.r. *Pudlo* (in syllabics); Verso:
by Wallace Brannen l.l., *Pudlo Pudlat WBEC Fall 1975 (WB)
For Kay x Wallie*; l.l., *CD.024-2574bd-1975*
*Collection*: K.M. Graham, Toronto

In this sketch Pudlo uses ladder and rope designs to unify
the composition – a precursor to the more ordered
arrangement of igloo, hills, and ladders in *My Home*
(cat. no. 59).

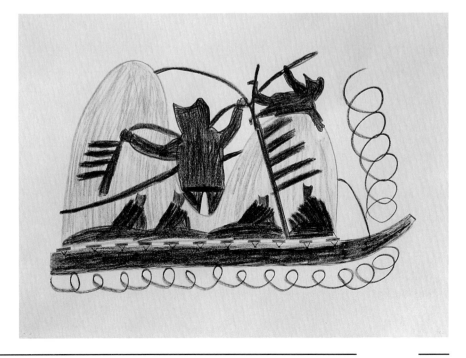

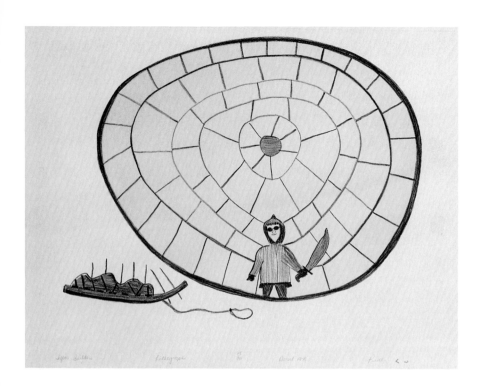

**58**

*Hunter's Igloo*
1975
Colour lithograph on wove paper; printed by Aoudla Pudlat
43.5 × 56.7 cm
*Inscriptions*: signed l.r., *Pudlo* (in syllabics); b., *Igloo Builders Lithograph 28/30 Dorset 1975 Pudlo*; l.r., West Baffin Eskimo Co-operative symbol (blind stamp); l.r., Canadian Eskimo Arts Council symbol (blind stamp); Verso: l.l., *48/5*; l.c., *Hunter's Igloo*; *3.75.43*; l.r., *75aCD75-48*
*Collection*: National Gallery of Canada, Ottawa, gift of the Department of Indian Affairs and Northern Development, 1989
*Print catalogue*: Cape Dorset 1975, no. 48

"A poor man with no dogs, after dragging his komatik, is making himself a big igloo."

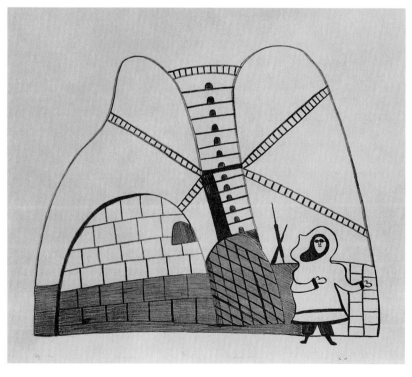

**59**

*My Home*
1975
Lithograph in black and brown on buff wove paper; printed by Pee Mikkiga
57 × 65.8 cm
*Inscriptions*: signed l.r., *Pudlo* (in syllabics); b., *My Home Lithograph 22/39 Dorset 1975 Pudlo*; l.r., West Baffin Eskimo Co-operative symbol (blind stamp); l.r., Canadian Eskimo Arts Council symbol (blind stamp); Verso: l.l., *50/5*
*Collection*: National Gallery of Canada, Ottawa, gift of Dorothy M. Stillwell, M.D., 1985 (29069)
*Print catalogue*: Cape Dorset 1975, no. 50 (listed as *Our Home*; image transposed with no. 49)

**60**

*The Seasons*
1976
Colour lithograph on wove paper; watermark: *Rives*;
printed by Pitseolak Niviaqsi
56.6 × 87 cm
*Inscriptions*: signed l.r., *Pudlo* (in syllabics); b., *The Seasons
Lithograph 33/50 Dorset 1976 Pudlo*; l.l., *Pitseolak*
(in syllabics, printer's stamp in grey ink); l.l., Cape Dorset
symbol (stamped in red ink); l.r., West Baffin Eskimo
Co-operative symbol (blind stamp); l.l., Canadian Eskimo
Arts Council symbol (blind stamp); Verso: l.l., *6176 /
CD1976-61*; l.l., *3.76.46*
*Collection*: National Gallery of Canada, Ottawa, gift of the
Department of Indian Affairs and Northern Development,
1989
*Print catalogue*: Cape Dorset 1976, no. 61
*Literature*: Patterson and Socha 1977, p. 48; Blodgett
1984, "Christianity and Inuit Art," p. 20

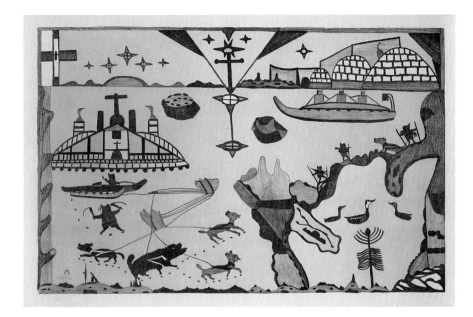

"That's me standing there with the two whips. I am angry
because my dogs won't listen to me. I have just tangled
them on the rock and I'm beating up my poor dogs... Dogs
make the man, because a hunter can't go anywhere without
them... Dogs are not like skidoos. With a snowmobile, you
can't tell if it's going toward a dangerous area or not. With
dogs, dogs can warn you... But hunters used to get angry
at their dogs too, because some days they just wouldn't
listen, they just wouldn't do as the hunter told them."

**61**

*Thoughts of My Childhood*
c. 1975
Coloured pencil and black felt pen on wove paper;
watermark: *BFK Rives / France*
56.5 × 76.2 cm
*Inscriptions*: signed l.l., *Pudlo* (in syllabics); Verso: l.l.,
*CD.024-1541bd-66/76(P)*
*Collection*: West Baffin Eskimo Co-operative, Cape Dorset
*Related print*: *Thoughts of My Childhood*, Cape Dorset
1976, no. 38

"On one side there is a tent, on the other an igloo, with a
cross in the middle."

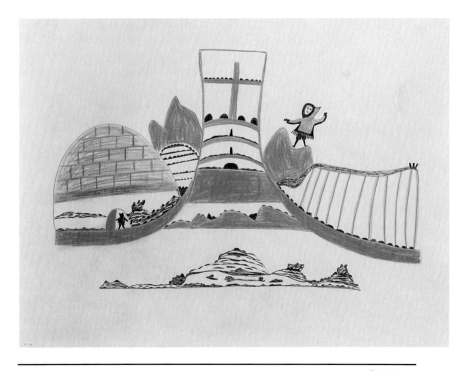

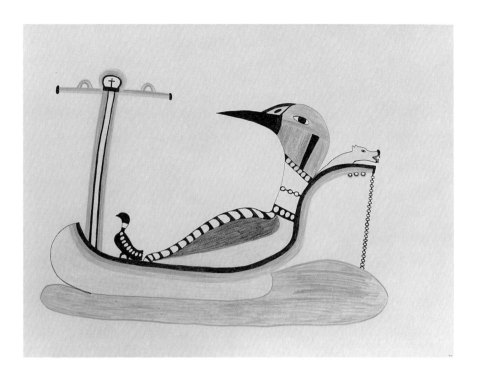

**62**

*Boat at Anchor*
1976?
Coloured pencil and black felt pen on wove paper;
watermark: *Arches / France*
56.8 × 76.7 cm
*Inscriptions*: signed l.r., *Pudlo* (in syllabics); Verso: l.l.,
*CD.024-1477bd-66/76*
*Collection*: West Baffin Eskimo Co-operative, Cape Dorset
*Literature*: Jackson 1978, p. 14

"That's the mast, not a cross. That's a light bulb [on top]…
That's the dog looking at the water. That's the chain of the
anchor… I almost like this drawing, because there's never
been a loon with colourful feathers" (Jackson 1978, p. 14).

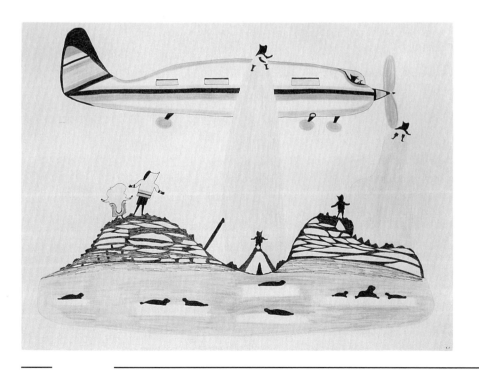

**63**

*Aeroplane*
c. 1976
Coloured pencil and black felt pen on wove paper;
watermark: *Arches / France*
56.8 × 76.3 cm
*Inscriptions*: signed l.r., *Pudlo* (in syllabics); Verso: l.l.,
*CD.024-1478bd-66/76(P)*
*Collection*: West Baffin Eskimo Co-operative, Cape Dorset
*Related print*: *Aeroplane*, Cape Dorset 1976, no. 13
*Literature*: Alma Houston, "Foreword," in Cape Dorset
1976, p. 6 (print); Sheppard 1976 (print); Mekler 1977
(print); Ottawa, National Museum of Man 1977, no. 70
(print); Jackson 1978, p. 10 (drawing); Jackson 1979, p. 97
(print); Surrey 1979 (print); Burnaby 1986, p. 27 (print)

"Whenever there is a plane, we go up to the hills to get a
better look at it" (Jackson 1978, p. 10). Of the pale blue
forms, Pudlo added: "This is like an iceberg or a big hill of
snow; that is what I was thinking when I was drawing"
(Jackson 1979, p. 97).

**64**

*Qulaguli*
1976?
Coloured pencil and black felt pen on wove paper;
watermark: *Arches / France*
56.5 × 76.3 cm
*Inscriptions*: signed l.r., *Pudlo* (in syllabics); Verso: l.l.,
*CD.024-1476bd-66/76(P)*
*Collection*: West Baffin Eskimo Co-operative, Cape Dorset
*Related print*: *Qulaguli*, also known as *Helicopter*, Cape
Dorset 1979, no. 53
*Literature*: Jackson 1978, p. 13 (drawing); Jackson 1979,
p. 99 (print); Cape Dorset 1979, p. 65 (print); Ottawa,
Department of Indian Affairs and Northern Development
1981, no. 9 (print)

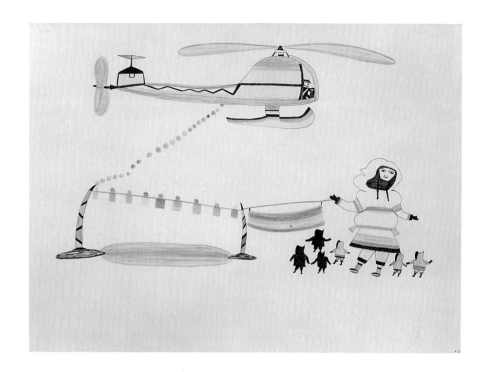

*Qulaguli* means "helicopter." "The mother is telling the
children to look at the colourful clothes on the line… The
helicopter is dripping some water when it lifts off" (Jackson
1978, p. 13). "I was thinking that perhaps this helicopter
was dropping something to these people. If I had drawn an
airplane instead of a helicopter, perhaps it would have
looked better" (Jackson 1979, p. 99; Cape Dorset 1979,
p. 65). "I like [helicopters and airplanes] because they are so
useful. If somebody needs to be rescued, they can go out
and rescue them. Or if people need help, they can deliver
other people to help them. They are so useful."

**65**

*Island Landscape*
1976?
Coloured pencil and black felt pen on wove paper;
watermark: *Curtis Rag*
51 × 66.2 cm
*Inscriptions*: signed l.l., *Pudlo* (in syllabics); Verso: l.l.,
*CD.024-1508bd-66/76*
*Collection*: West Baffin Eskimo Co-operative, Cape Dorset

"You can see the people there in the landscape, but one of
them is stuck between some rocks and some water."

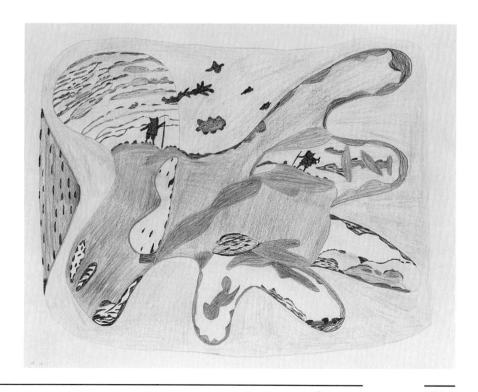

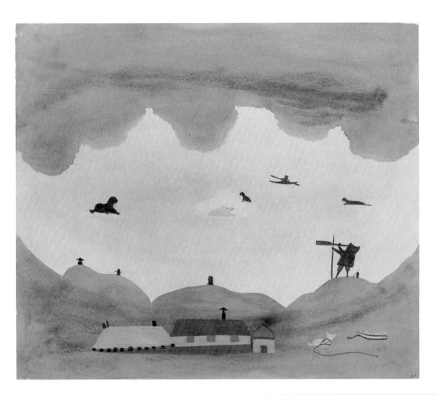

**66**

*Northern Landscape*
1976
Acrylic paint and coloured pencil on wove paper
56.8 × 66.3 cm
*Inscriptions*: signed l.r., *Pudlo* (in syllabics); Verso: l.l., *SCAP / WBECD 231 Pudlo 1976 OXXG*, l.r., *3.83.15*; l.r.: *$950.00*
*Collection*: National Gallery of Canada, Ottawa, gift of the Department of Indian Affairs and Northern Development, 1989

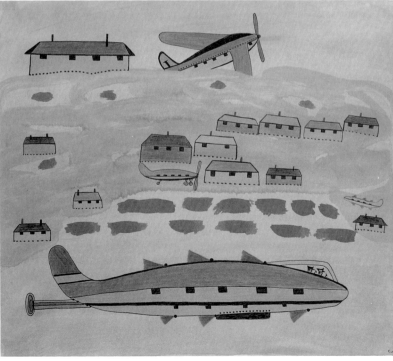

**67**

*Airplanes in the Settlement*
1976
Acrylic paint, coloured pencil, and black felt pen on wove paper
49.5 × 56.5 cm
*Inscriptions*: signed l.r., *Pudlo* (in syllabics); Verso: l.l., *CD.024-2439bdf-1976*; l.l., *SCAP / WBECD 493 Pudlo 1976 / GTKX*
*Collection*: West Baffin Eskimo Co-operative, Cape Dorset

**68**

*Sea Creatures*
1976
Acrylic paint, coloured pencil, and black felt pen on wove
paper; watermark: *BFK Rives / France*
49.2 × 56 cm
*Inscriptions*: signed l.r., *Pudlo* (in syllabics); Verso: l.l.,
*CD.024-50bdf-1976*; l.l., *WBECD 0197 PUDLO 1976*; l.r.,
*19 ¼ × 22 / 17*
*Collection*: National Gallery of Canada, Ottawa, gift of
Dorothy M. Stillwell, M.D., 1987 (29920)

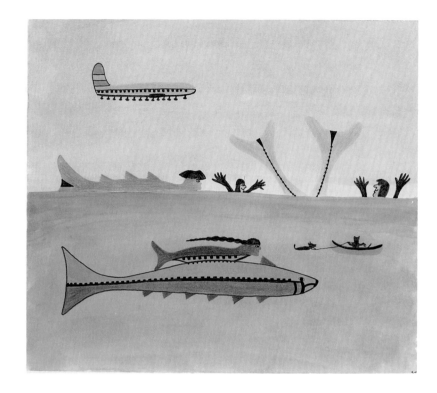

**69**

*Sea Goddess*
1976
Acrylic paint, coloured pencil, and black felt pen on wove
paper; watermark: *Arches / France*
56.3 × 76.3 cm
*Inscriptions*: signed l.r., *Pudlo* (in syllabics); Verso: l.l.,
*CD.024-2399bdf-1976*; l.l., *SCAP / WBECD 515 Pudlo 1976
/ GO x G / 200-*
*Collection*: National Gallery of Canada, Ottawa, gift of
Dorothy M. Stillwell, M.D., 1987 (29918)

The house along the shore is lit up by electricity from the
power lines, while the woman of the sea has been provided
by the artist with a miner's helmet, complete with lamp, to
brighten her underwater domain.

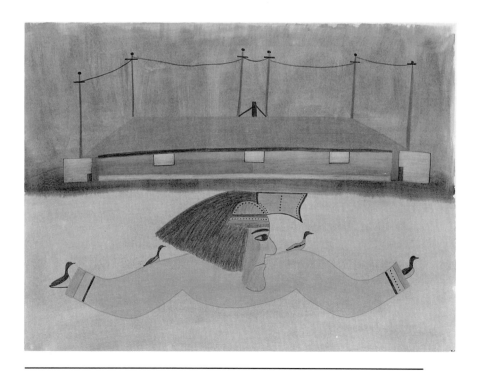

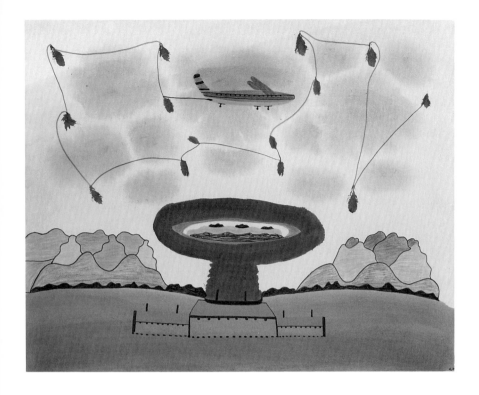

**70**

*Airplane between Two Places*
1976/77
Acrylic paint, coloured pencil, and black felt pen on wove paper
53 × 66.1 cm
*Inscriptions*: signed l.r., *Pudlo* (in syllabics); Verso: l.l., *CD.024-1599bdf-76/77*; l.l., *0690*
*Collection*: West Baffin Eskimo Co-operative, Cape Dorset

The zig-zag line of red splotches, which may be seen as the flashing lights of the plane or as points on an airline routing map, seems intended to suggest motion. The landscape encapsulated in the red cloud appears to represent the destination at the end of the journey.

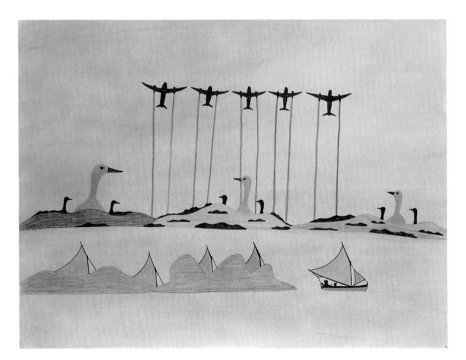

**71**

*Jets, Boats, and Birds in Formation*
1976/77
Acrylic paint, coloured pencil, and black felt pen on wove paper; watermark: *Arches / France*
56.7 × 76.3 cm
*Inscriptions*: signed l.r., *Pudlo* (in syllabics); Verso: l.l., *CD.024-1783bdf-76/77*; l.l., *3163*; l.r., *3.81.61*
*Collection*: National Gallery of Canada, Ottawa, gift of the Department of Indian Affairs and Northern Development, 1989
*Literature*: Ottawa, Department of Indian Affairs and Northern Development 1981, no. 12

**72**

*Walrus on the Horizon*
1977/78
Acrylic paint, coloured pencil, and black felt pen on wove
paper; watermark: *Arches / France*
56.8 × 76.5 cm
*Inscriptions*: Verso: l.l., *CD.024-2164bdf-77/78*; l.r., *77
78 332*
*Collection*: West Baffin Eskimo Co-operative, Cape Dorset

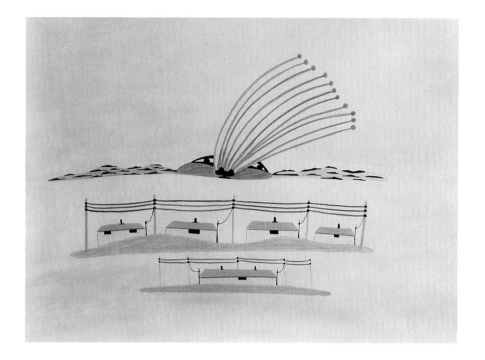

**73**

*View from the Ice*
1979/80
Acrylic paint, coloured pencil, and black felt pen on wove
paper; watermark: *BFK Rives / France*
56.7 × 76.1 cm
*Inscriptions*: signed l.r., *Pudlo* (in syllabics); Verso: l.l.,
*CD.024-2797bdf-79/80*
*Collection*: West Baffin Eskimo Co-operative, Cape Dorset

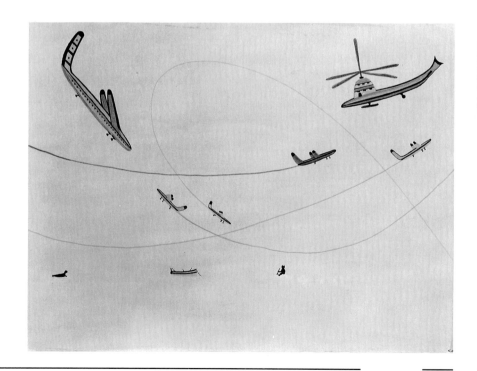

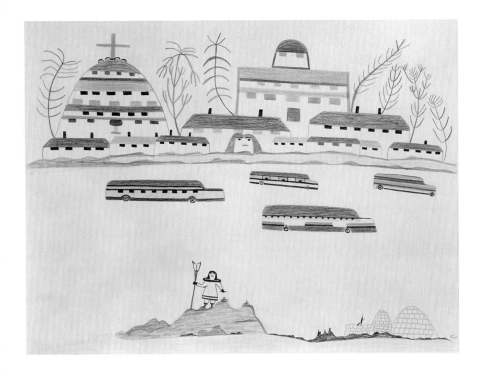

**74**

*Modern Life and the Old Way*
1978
Coloured pencil and black felt pen on wove paper;
watermark: *BFK Rives / France*
56.5 × 76.2 cm
*Inscriptions*: signed l.r., *Pudlo* (in syllabics); Verso: l.l.,
*CD.024-3549bd-78/79*; l.r., *78 79 170*
*Collection*: West Baffin Eskimo Co-operative, Cape Dorset

"You can see that on top it's modern life, and at the bottom
the old way." Asked about the woman's head in the
cityscape, Pudlo jokingly replied: "It's a ghost."

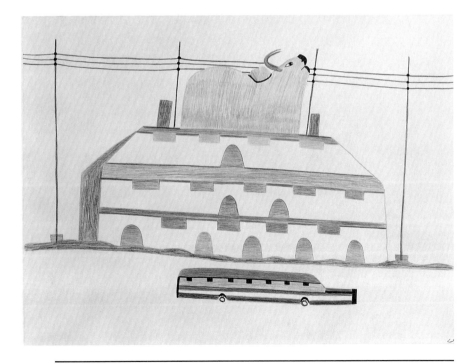

**75**

*Umimmak Kalunaniituk*
1978
Coloured pencil and black felt pen on wove paper;
watermark: *BFK Rives / France*
56.6 × 76.1 cm
*Inscriptions*: signed l.r., *Pudlo* (in syllabics); Verso: l.l.,
*CD.024-3557bd-78/79(P)*; l.r., *78 79 188*
*Collection*: West Baffin Eskimo Co-operative, Cape Dorset
*Related print*: *Umimmak Kalunaniituk*, also known as
*Muskox in the City*, Cape Dorset 1979, no. 56
*Literature*: Cape Dorset 1979, p. 65 (print); Jackson 1979,
p. 101 (print); Ottawa, Department of Indian Affairs and
Northern Development 1981, no. 8 (print); Jackson 1983,
pp. 24–25 (print)

"When I did this drawing I was thinking about a church with
a musk-ox on top. In the South I have seen churches with
statues, and I was thinking about them when I drew this,
but this is not meant to be a religious picture or anything
like that" (Jackson 1979, p. 101; Cape Dorset 1979, p. 65).
*Umimmak Kalunaniituk* can be translated as "musk-ox in the
city" or "musk-ox in the South." The drawing appears to
have been inspired by Pudlo's 1978 trip to Montreal, where
he saw not only the Notre Dame Basilica but the nearby
Château Champlain hotel with its distinctive arched
windows (Jackson 1983, p. 25; Ottawa, Department of
Indian Affairs and Northern Development 1981, no. 8).

**76**

*Blue Musk-ox*
1978/79
Coloured pencil and felt pen on wove paper; watermark:
*BFK Rives / France*
56.3 × 76.2 cm
*Inscriptions*: signed l.r., *Pudlo* (in syllabics); Verso: l.l.,
*CD.024-2800bd-78/79(L-79)*
*Collection*: West Baffin Eskimo Co-operative, Cape Dorset
*Related print*: *Blue Musk Ox*, Cape Dorset 1979, no. L26

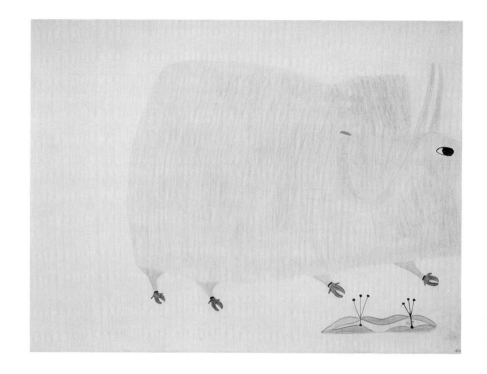

**77**

*A Good Catch*
1979/80
Coloured pencil and black felt pen on wove paper;
watermark: *BFK Rives / France*
56.3 × 76.2 cm
*Inscriptions*: signed l.r., *Pudlo* (in syllabics); Verso: l.l.,
*CD.024-3564bd-79/80(P)*
*Collection*: West Baffin Eskimo Co-operative, Cape Dorset
*Related print*: *A Good Catch*, Cape Dorset 1980, no. L25
*Literature*: Ottawa, Department of Indian Affairs and
Northern Development 1981, no. 10 (print)

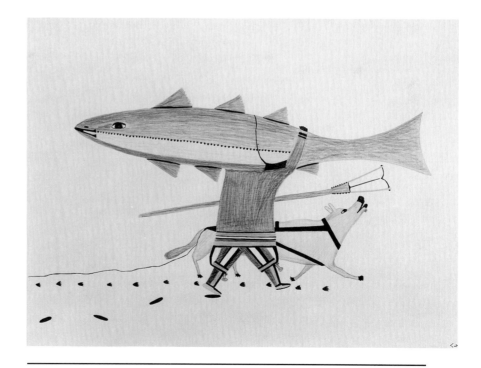

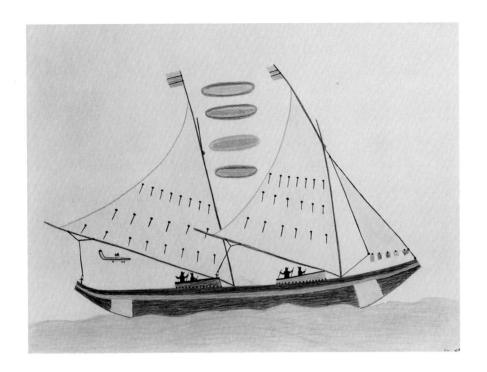

**78**

*Umiakjuak*
1979/80
Coloured pencil and black felt pen on wove paper;
watermark: *Arches / France*
56.5 × 76.3 cm
*Inscriptions*: signed l.r., *Pudlo* (in syllabics); Verso: l.l.,
*CD.024-3560bd-79/80(P)*
*Collection*: West Baffin Eskimo Co-operative, Cape Dorset
*Related print*: *Umiakjuak*, Cape Dorset 1980, no. 51

"A kayak with sails ... colourful clouds." *Umiakjuak* means
"ship" or "very large boat." Specifically, what Pudlo has
drawn is a very large kayak; normally meant for one or two
hunters, it has here become a sailing ship.

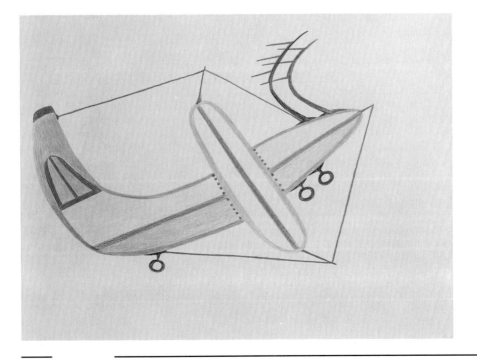

**79**

*Airplane with Antlers*
1979/80
Coloured pencil on wove paper; watermark: *BFK Rives /
France*
56.2 × 76.4 cm
*Inscriptions*: signed l.r., *Pudlo* (in syllabics); Verso: l.l.,
*CD.024-2664bd-79/80*
*Collection*: West Baffin Eskimo Co-operative, Cape Dorset

"It looks like an airplane but it also has antlers... It's like the
antennae for CB radios."

**80**

*Transported*
1979/80
Coloured pencil and black felt pen on wove paper;
watermark: *Arches / France*
56.5 × 76.4 cm
*Inscriptions*: signed l.r., *Pudlo* (in syllabics); Verso: l.l.,
*CD.024-2706bd-79/80(P)*
*Collection*: West Baffin Eskimo Co-operative, Cape Dorset
*Related print*: *Arrival of the Prophet*, Cape Dorset 1983,
no. L18
*Literature*: Blodgett 1984, "Christianity and Inuit Art," p. 20
(print); Hoffmann 1988, no. 223 (print)

"A white person told me that this reminds him of religion or
Christianity because it has the cross on top and the rainbow
colours leading upward... To me it's just a drawing without
a meaning." In fact, the image seems closely related to
Pudlo's preoccupation with the theme of transportation.

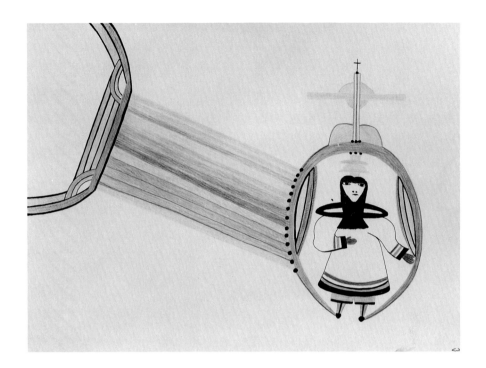

**81**

*Skins and Blankets Hanging to Dry*
1978
Coloured pencil and black felt pen on wove paper;
watermark: *BFK Rives / France*
56.5 × 76.2 cm
*Inscriptions*: l.r., *B*; Verso: l.l., *CD.024-2770bd-79/80*; l.r.,
*78 79 191*
*Collection*: West Baffin Eskimo Co-operative, Cape Dorset

"Sealskin, a red fox skin, and blankets ... but I don't
remember what that one in the centre is!"

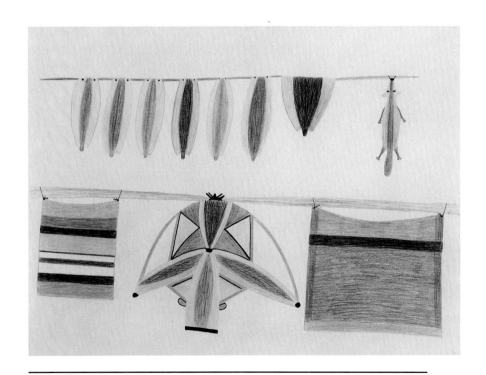

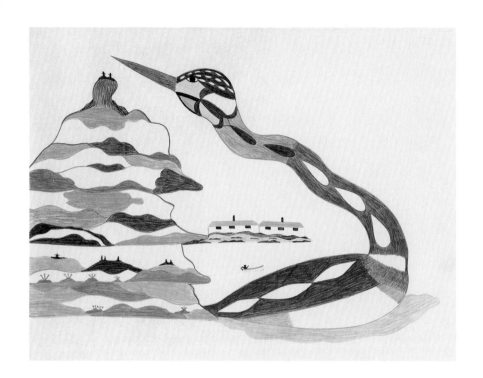

**82**

*Large Loon and Landscape*
1980/81
Coloured pencil and black felt pen on wove paper;
watermark: *BFK Rives / France*
56.5 × 76.1 cm
*Inscriptions*: Verso: l.l., *CD.024-3574bd-80/81 (P)*
*Collection*: West Baffin Eskimo Co-operative, Cape Dorset
*Related print*: *Large Loon and Landscape*, Cape Dorset 1981,
no. L27
*Literature*: Ottawa, Department of Indian Affairs and
Northern Development 1981, no. 11 (print)

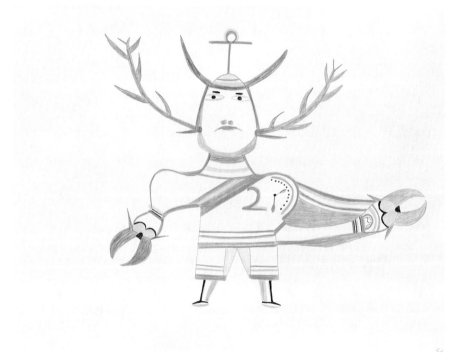

**83**

*New Parts for an Inuk*
1981
Coloured pencil and black felt pen on wove paper;
watermark: *Rives*
50.8 × 66 cm
*Inscriptions*: signed l.r., *Pudlo* (in syllabics); Verso: l.l.,
*CD.024-2825bd-1981*
*Collection*: West Baffin Eskimo Co-operative, Cape Dorset

**84**

*Caribou-Creature Seen from Above*
1982/83
Coloured pencil on wove paper; watermark: *Arches /*
*France*
76.5 × 56.5 cm
*Inscriptions*: Verso: l.l., *CD.024-3474bd-82/83*
*Collection*: West Baffin Eskimo Co-operative, Cape Dorset

"It looks like it has the hind of a caribou, and the body is
something like that of a caribou… Too bad I didn't add a
penis to it!".

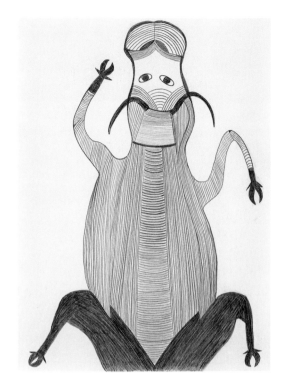

**85**

*Tale of a Huge Musk-ox*
1982/83
Coloured pencil and black felt pen on wove paper;
watermark: *Arches / France*
56.7 × 76.5 cm
*Inscriptions*: signed l.r., *Pudlo* (in syllabics); Verso: l.l.,
*CD.024-3586bd-82/83(P)*
*Collection*: West Baffin Eskimo Co-operative, Cape Dorset
*Related print*: *Tale of a Huge Muskox*, Cape Dorset 1983,
no. 43

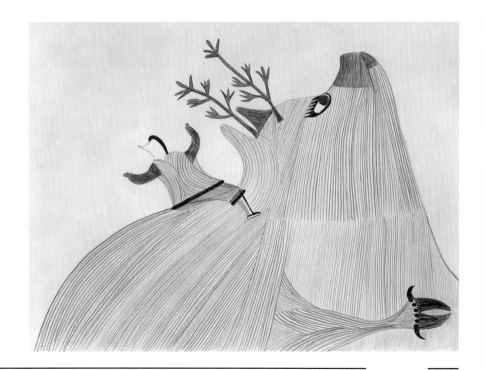

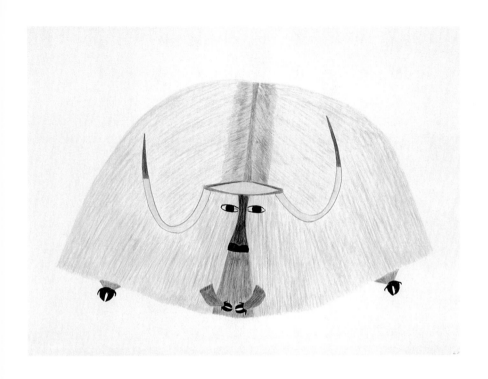

**86**

*Musk-ox*
1982/83
Coloured pencil and black felt pen on wove paper;
watermark: *Arches / France*
56.6 × 76.5 cm
*Inscriptions*: signed l.r., *Pudlo* (in syllabics); Verso: l.l.,
*CD.024-3499bd-82/83*
*Collection*: West Baffin Eskimo Co-operative, Cape Dorset

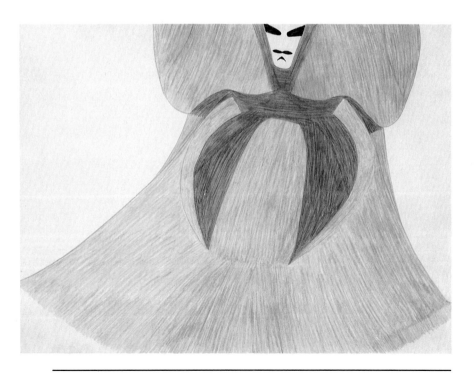

**87**

*Walrus Close Up*
1982/83
Coloured pencil and black felt pen on wove paper;
watermark: *Arches / France*
57 × 76.6 cm
*Inscriptions*: Verso: l.l., *CD.024-3529bd-82/83*
*Collection*: West Baffin Eskimo Co-operative, Cape Dorset

"There is no such thing as blue tusks... The face should be
taken out."

**88**

*Ship of Loons*
1982/83
Coloured pencil and black felt pen on wove paper;
watermark: *Arches / France*
56.6 × 76.6 cm
*Inscriptions*: signed l.r., *Pudlo* (in syllabics); Verso: l.l.,
*CD.024-3580bd-82/83(P)*
*Collection*: West Baffin Eskimo Co-operative, Cape Dorset
*Related print*: *Ship of Loons*, Cape Dorset 1983, no. 34

**89**

*Snow Swan of Parketuk*
1982/83
Coloured pencil on wove paper; watermark: *Arches / France*
56.5 × 76.5 cm
*Inscriptions*: signed l.r., *Pudlo* (in syllabics); Verso: l.l.,
*CD.024-3584b-82/83(P)*
*Collection*: West Baffin Eskimo Co-operative, Cape Dorset
*Related print*: *Snow Swan of Parketuk*, Cape Dorset 1983,
no. 41

**90**

*Loon in Open Water*
1983/84
Coloured pencil and black felt pen on wove paper;
watermark: *Arches / France*
56.6 × 76.5 cm
*Inscriptions*: signed l.r., *Pudlo* (in syllabics); Verso: l.l.,
*CD.024-3845bd-83/84(P)*
*Collection*: West Baffin Eskimo Co-operative, Cape Dorset
*Related print*: *Loon in Open Water*, Cape Dorset 1984, Pudlo
Pudlat Folio of Lithographs

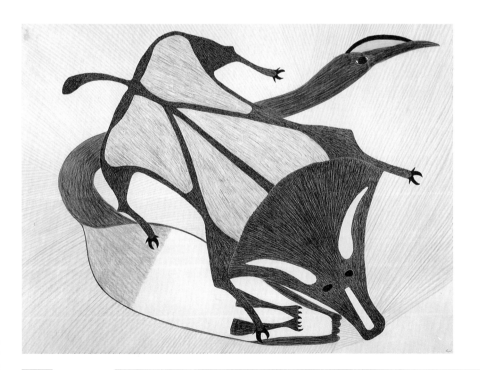

**91**

*Composition with Caribou-Creature and Loon*
1983/84
Lithograph with coloured pencil and black felt pen on wove
paper; watermark: *Arches / France*
56.5 × 76.5 cm
*Inscriptions*: signed l.r., *Pudlo* (in syllabics); Verso: l.l.,
*CD.024-3850 litho,bd.83/84*
*Collection*: West Baffin Eskimo Co-operative, Cape Dorset

See figs. 16 and 17 and related discussion, p. 34

**92**

*Caribou*
1983/84
Coloured pencil on wove paper; watermark: *Arches / France*
56.5 × 76.5 cm
*Inscriptions*: signed l.r., *Pudlo* (in syllabics); Verso: l.l.,
*CD.024-3691b-83/84*
*Collection*: West Baffin Eskimo Co-operative, Cape Dorset

"A caribou walking into the picture … It has very skinny legs."

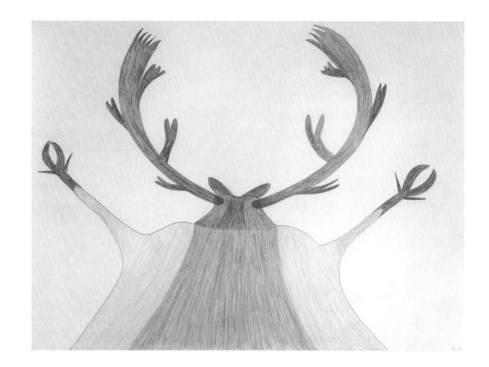

**93**

*Walrus and Young*
1983/84
Coloured pencil and black felt pen on wove paper;
watermark: *Arches / France*
56.7 × 76.5 cm
*Inscriptions*: signed l.r., *Pudlo* (in syllabics); Verso: l.l.,
*CD.024-3844bd-83/84(P)*
*Collection*: West Baffin Eskimo Co-operative, Cape Dorset
*Related print*: *Walrus and Young*, Cape Dorset 1984, Pudlo
Pudlat Folio of Lithographs

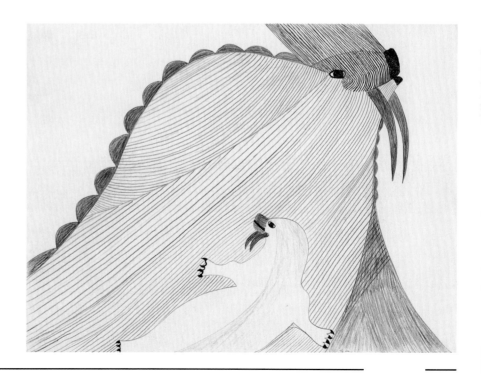

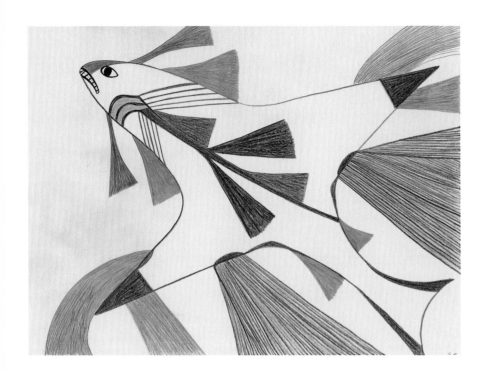

**94**

*Flying Figure*
1983/84
Coloured pencil, black felt pen, and graphite on wove paper;
watermark: *Arches / France*
56.5 × 76.5 cm
*Inscriptions*: signed l.r., *Pudlo* (in syllabics); Verso: l.l.,
*CD.024-3672bd-83/84*
*Collection*: Macdonald Stewart Art Centre, Guelph, Ont.,
purchased with funds donated by Omark Canada Ltd., a
Blount, Inc., Company, 1988 (MS988.018)
*Literature*: Jackson and Nasby 1987, no. 58

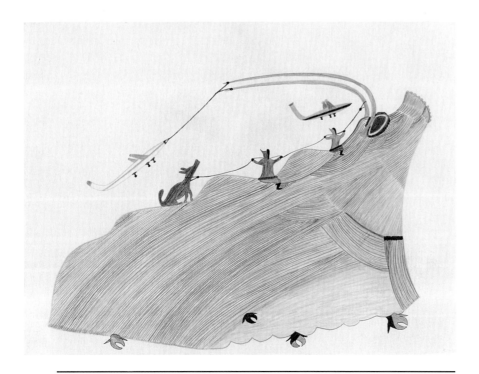

**95**

*Winds of Change*
1983/84
Coloured pencil and black felt pen on wove paper;
watermark: *BFK Rives / France*
57 × 76.5 cm
*Inscriptions*: signed l.r., *Pudlo* (in syllabics); Verso: l.l.,
*CD.024-3847bd-83/84(ed.P)*
*Collection*: West Baffin Eskimo Co-operative, Cape Dorset
*Related print*: *Winds of Change*, Cape Dorset 1985, no. 40
*Literature*: Burnaby 1986, p. 2 (print)

**96**

*Sail in the Settlement*
1983/84
Coloured pencil and black felt pen on wove paper;
watermark: *Arches / France*
56.5 × 76.4 cm
*Inscriptions*: signed l.r., *Pudlo* (in syllabics); Verso: l.l.,
*CD.024-3741bd-83/84*
*Collection*: Private collection, Ottawa

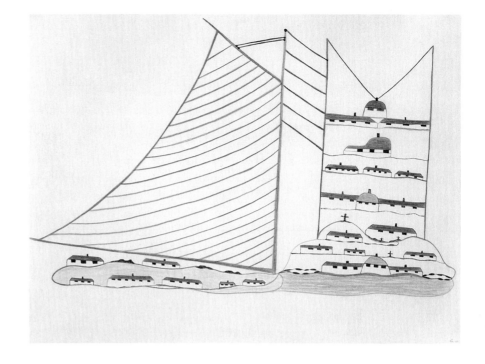

**97**

*Composition with Arms and Bird*
1983/84
Coloured pencil and black felt pen on wove paper;
watermark: *Arches / France*
56.7 × 76.5 cm
*Inscriptions*: signed l.r., *Pudlo* (in syllabics); Verso: l.l.,
*CD.024-3715bd-83/84*
*Collection*: West Baffin Eskimo Co-operative, Cape Dorset

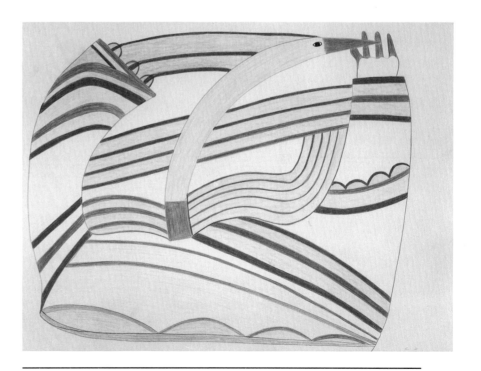

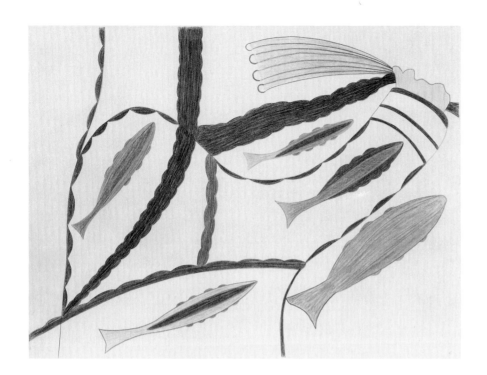

**98**

*Composition with Arm, Braids, and Fish*
1983/84
Coloured pencil on wove paper; watermark: *Arches / France*
56.7 × 76.5 cm
*Inscriptions*: signed l.r., *Pudlo* (in syllabics); Verso: l.l.,
*CD.024-3822b-83/84*
*Collection*: West Baffin Eskimo Co-operative, Cape Dorset

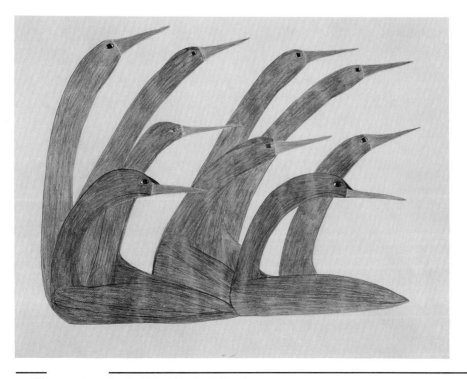

**99**

*Alerted Loons*
1985/86
Graphite, coloured pencil, and black felt pen on wove paper;
watermark: *Ragston-S-N*
50.7 × 66.4 cm
*Inscriptions*: signed l.c., *Pudlo* (in syllabics); Verso: l.l.,
*CD.024-3989-abd-85/86 (ed. P)*
*Collection*: West Baffin Eskimo Co-operative, Cape Dorset

**100**

*Shielded Caribou*

1985

Graphite and black felt pen on wove paper; watermark:
*Ragston-S-N*

51 × 66.2 cm

*Inscriptions*: signed l.l., *Pudlo* (in syllabics); Verso: l.l.,
*CD.024-3990ad-85/86(P)*

*Collection*: West Baffin Eskimo Co-operative, Cape Dorset

*Related print*: *Shielded Caribou*, Cape Dorset 1986, no. 39

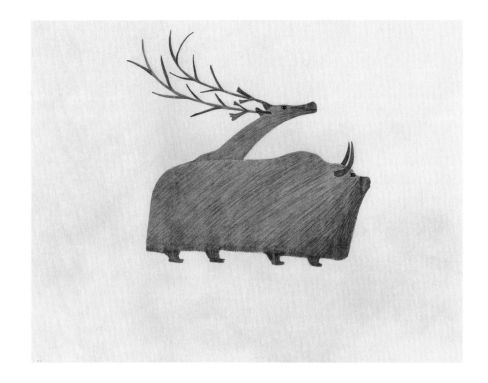

**101**

*Proud Hunter*

1986/87

Black felt pen, coloured pencil, and graphite on wove paper;
watermark: *Ragston-S-N*

50.6 × 66 cm

*Inscriptions*: signed l.r., *Pudlo* (in syllabics); Verso: l.l.,
*CD.024-4170abd-86/87(P)*

*Collection*: West Baffin Eskimo Co-operative, Cape Dorset

*Related print*: *Proud Hunter*, Cape Dorset 1987, no. 28

**102**

*Whale Hunters' Boat*
1986/87
Coloured pencil and black felt pen on wove paper;
watermark: *Ragston-S-N*
50.8 × 66.3 cm
*Inscriptions*: signed l.c., *Pudlo* (in syllabics); Verso: l.l.,
*CD.024-4175bd-86/87(P)*
*Collection*: West Baffin Eskimo Co-operative, Cape Dorset
*Related print*: *Whale Hunters' Boat*, Cape Dorset 1987,
no. 36

"Watching the plane instead of watching out for the whale's waves."

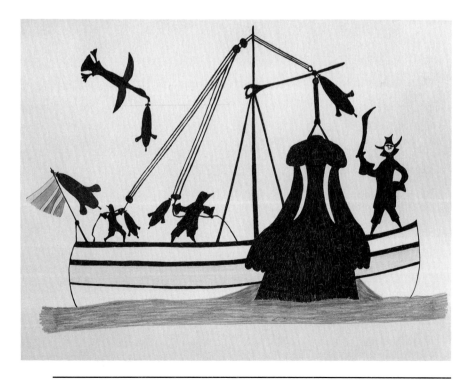

**103**

*Pulling In a Walrus*
1987/88
Coloured pencil and black felt pen on wove paper;
watermark: *Ragston-S-N*
50.8 × 66.1 cm
*Inscriptions*: signed l.c., *Pudlo* (in syllabics); Verso: l.l.,
*CD.024-4369abd 87/88*
*Collection*: West Baffin Eskimo Co-operative, Cape Dorset

**104**

*Helicopters and Woman*
1987/88
Coloured pencil, felt pen, and graphite on wove paper;
watermark: *Ragston-S-N*
50.2 × 66.2 cm
*Inscriptions*: signed l.c., *Pudlo* (in syllabics); Verso: u.r.,
*CD.024-4367 87/88*
*Collection*: West Baffin Eskimo Co-operative, Cape Dorset

"I would rather ride in an airplane. In a helicopter they
usually have a big window, and you can see everything;
it seems as if you could fall just looking out the window"
(Jackson 1979, p. 99). Perhaps that is what has happened
here to this woman who, with her decorated *amautiq*, spins
in mid-air like the helicopter's blades.

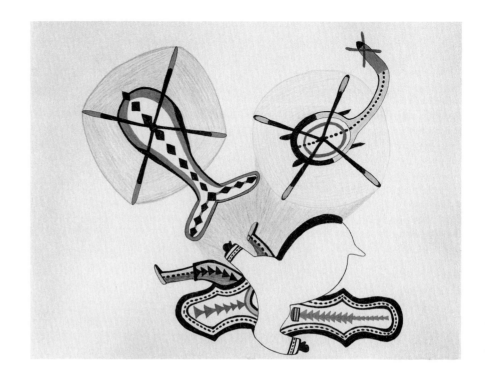

**105**

*Carried by a Kite*
1988/89
Coloured pencil and felt pen on wove paper; watermark:
*Ragston-S-N*
51.2 × 66.3 cm
*Inscriptions*: signed l.c., *Pudlo* (in syllabics); Verso: l.l.,
*CD.024-4374bd-88/89    17/31/44    50.2 × 66*
*Collection*: West Baffin Eskimo Co-operative, Cape Dorset

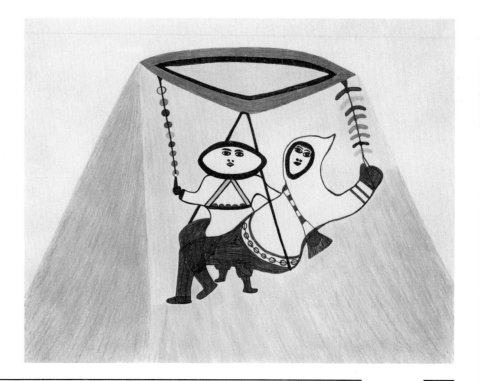

# Prints/Drawings

# Checklist

The following checklist correlates Pudlo's prints (left) with the drawings (right) on which they are based. Included in the prints are works released as part of the annual Cape Dorset graphics collections, other releases such as the so-called Dorset Series, special commissions, and two unreleased prints published in James Houston's *Eskimo Prints* (1967).

*Woman with Bird Image*
Cape Dorset 1961, no. 14
Stencil
Inscription gives sealskin stencil as medium

CD.024-56
c. 1961
Graphite on wove paper (sheet from a coil-bound sketchpad); watermark: *Howard Smith / Victory Bond / Made in Canada*
60.9 × 45.8 cm
*Inscriptions*: Verso: l.l., *CD.024-56a-59/ 65(P)*; l.r., *1-6/50/ Pudlo / CD/ F-21*
*Collection*: West Baffin Eskimo Co-operative, Cape Dorset
See cat. no. 1

*Thoughts of Walrus*
Cape Dorset 1961, no. 15
Stencil
Inscription gives sealskin stencil as medium

CD.024-10
c. 1961
Graphite on wove paper (sheet from a coil-bound sketchpad); watermark: *Howard Smith / Victory Bond / Made in Canada*
60.8 × 45.8 cm
*Inscriptions*: by Terry Ryan l.r., *Pudlo*; Verso: l.l., *CD.024-10a-59/65(P)*
*Collection*: West Baffin Eskimo Co-operative, Cape Dorset

*Man Carrying Reluctant Wife*
Cape Dorset 1961, no. 16
Stencil
Inscription gives sealskin stencil as medium
See fig. 5

CD.024-4565
July 1961
Graphite on wove paper (sheet from a coil-bound sketchpad); watermark: *Howard Smith / Victory Bond / Made in Canada*
60.8 × 46 cm
*Inscriptions*: by Terry Ryan l.r., *Pudlo / 7/61*; Verso: l.l., *CD.024-4565a-59/ 65(P)*
*Collection*: West Baffin Eskimo Co-operative, Cape Dorset

*Man Carrying Bear*
Cape Dorset 1961, no. 17
Stencil
Inscription gives sealskin stencil as medium

CD.024-2
July 1961
Graphite on wove paper (sheet from a coil-bound sketchpad); watermark: *Howard Smith / Victory Bond / Made in Canada*
60.6 cm × 45.8 cm
*Inscriptions*: by Terry Ryan l.r., *Pudlo / 7/61*; Verso: l.l., *CD.024-2a-59/65(P)*
*Collection*: West Baffin Eskimo Co-operative, Cape Dorset

*Caribou Chased by Wolf*
Cape Dorset 1961, no. 18
Stencil
Inscription gives sealskin
stencil as medium

Not located

*Man in Fish Weir*
Cape Dorset 1961, no. 19
Stonecut

CD.024-55
c. 1961
Graphite on wove paper (sheet from a
coil-bound sketchpad); watermark:
*Howard Smith / Victory Bond / Made in
Canada*
60.8 × 45.8 cm
*Inscriptions*: by Terry Ryan l.r., *Pudlo*;
Verso: l.l., *CD.024-55a-59/65(P)*; u.r.,
*CAP # / 3-305 / LR: MS / 250 / Pudlo /
F-21 / CD*
*Collection*: West Baffin Eskimo
Co-operative, Cape Dorset
See cat. no. 9

*Fish and Spear*
Cape Dorset 1961, no. 20
Stencil
Inscription gives sealskin
stencil as medium

Not located

*Sea Goddess Held by Bird*
Cape Dorset 1961, no. 21
Stencil
Inscription gives sealskin
stencil as medium

CD.024-4566
c. 1961
Graphite on wove paper (sheet from a
coil-bound sketchpad); watermark:
*Howard Smith / Victory Bond / Made in
Canada*
46 × 60.5 cm
*Inscriptions*: by James Houston (?) u.r.,
*Pudlo*; Verso: u.l., *CD.024-4566a-59/65*
*Collection*: West Baffin Eskimo
Co-operative, Cape Dorset

*Avingaluk (The Big
Lemming)*
Cape Dorset 1961,
no. 22
Stonecut

Not catalogued by the West Baffin
Eskimo Co-operative
c. 1961
Graphite on wove paper (sheet from a
coil-bound sketchpad); watermark:
*Howard Smith / Victory Bond / Made in
Canada*
60.8 × 45.7 cm
*Inscriptions*: by Terry Ryan l.l., *Pudlo*
*Collection*: Montreal Museum of Fine
Arts
See cat. no. 2

*Spirit with Symbols*
Cape Dorset 1961,
no. 49
Stonecut
See fig. 6

CD.024-11
c. 1961
Graphite on wove paper (sheet from a
coil-bound sketchpad); watermark:
*Howard Smith / Victory Bond / Made in
Canada*
60.5 × 45.8 cm
*Inscriptions*: by Terry Ryan u.r., *Pudlo*;
Verso: l.l., *CD.024-11a-59/65(P)*
*Collection*: West Baffin Eskimo
Co-operative, Cape Dorset
See cat. no. 8

*Eskimo Woman with Ulu*,
also known as *Mother
and Child with Ulu*
"Dorset Series," 1961
Stonecut

CD.024-27
c. 1961
Graphite on wove paper (sheet from a
coil-bound sketchpad); watermark:
*Howard Smith / Victory Bond / Made in
Canada*
60.8 × 45.8 cm
*Inscriptions*: by Terry Ryan l.r., *Pudlo*;
Verso: l.l., *CD.024-27a-59/65*
*Collection*: West Baffin Eskimo
Co-operative, Cape Dorset

*Man Chasing Strange
Beasts*
Cape Dorset 1963,
no. 17
Engraving
Print catalogue
incorrectly attributes to
Pitseolak Ashoona;
signed on recto, *Pudlo*
(in syllabics)
See fig. 7

Not located (drawn directly on plate, or
drawing destroyed in transfer to plate)

*Eagle Carrying Man*
Cape Dorset 1963,
no. 34
Stonecut
Title on print inscribed
in syllabics

CD.024-162
c. 1963
Graphite on wove paper; watermark:
*Bienfang / Ermine Bond*
47.8 × 60.7 cm
*Inscriptions:* Verso: l.l., *CD.024-162a-
59/65(P)*; u.r., *Pudlo*
*Collection:* West Baffin Eskimo
Co-operative, Cape Dorset

*Running Rabbit*
Cape Dorset 1963,
no. 35
Stencil
Title on print inscribed in
syllabics

Not located

*Musk Ox Trappers*
Cape Dorset 1963,
no. 36
Stonecut
Title on print inscribed in
syllabics
See fig. 21

CD.024-2815
c. 1963
Graphite on wove paper; watermark:
*Bienfang / Ermine Bond*
47.5 × 60.5 cm
*Inscriptions:* Verso: l.l., *CD.024-2815a-
60/63 / 1035*; l.r., *F-21 1-1 Pudlo CD /
SG 105*
*Collection:* Samuel and Esther Sarick,
Toronto

*Raven with Fish*
Cape Dorset 1963,
no. 37
Stonecut
Title on print inscribed in
syllabics

Not located

*Taleelayo*
Uncatalogued, 1963
Stonecut
Unreleased print,
reproduced in Houston
1967, pp. 68–69

CD.024-276
c. 1963
Graphite on wove paper
50.7 × 65.4 cm
*Inscriptions:* Verso: l.l., *CD.024-276a-
59/65*
*Collection:* West Baffin Eskimo
Co-operative, Cape Dorset

*Man with Rabbit*
"Dorset Series," 1963
Stonecut
Title on print inscribed
in syllabics

Not located

*Animal Boat*
Uncatalogued, c. 1963
Stonecut
Unreleased print,
reproduced in Houston
1967, p. 73; Terry Ryan
recalls print being
completed before his
North Baffin trip in
January 1964

CD.024-2817
c. 1963
Graphite on wove paper (sheet from a
coil-bound sketchpad); watermark:
*Howard Smith / Victory Bond / Made in
Canada*
60.1 × 45.7 cm
Inscriptions: by Terry Ryan l.r., *Pudlo*;
Verso: l.l., *1060 / CD.024-2817a-60/65*;
l.r., *6-400 / F-21 Pudlo 250 CD / SG109*
*Collection:* Samuel and Esther Sarick,
Toronto

*Spirit Watching Games*
Cape Dorset 1965,
no. 45
Stonecut
Dated 1964

Not located

*Spirits*
Cape Dorset 1966,
no. 36
Stonecut
Dated 1965

CD.024-304
c. 1965
Graphite on wove paper
50.7 × 65.5 cm
*Inscriptions:* signed l.c., *Pudlo* (in
syllabics); Verso: l.l., *CD.024-304a-59/
65(P)*
*Collection:* West Baffin Eskimo
Co-operative, Cape Dorset

*Fish Lake*
Cape Dorset 1966,
no. 37
Stonecut

Not located

*Fish Line*
Cape Dorset 1966,
no. 38
Stonecut
Dated 1965

CD.024-303
c. 1965
Graphite on wove paper (sheet from
a sketchpad)
50.8 × 65.4 cm
*Inscriptions:* signed l.c., *Pudlo* (in
syllabics); Verso: l.l., *CD.024-303a-59/
65(P)*
*Collection:* West Baffin Eskimo
Co-operative, Cape Dorset
See cat. no. 17

*The Owl*
Cape Dorset 1967,
no. 30
Stonecut
Dated 1966

CD.024-4563
1965?
Graphite and coloured pencil on wove
paper
50.5 × 65.7 cm
*Inscriptions*: signed l.c., *Pudlo* (in
syllabics); Verso: u.l., *GF* [?] / *4801*; u.c.,
*Pudloo / Yellow Eyed Bird / 1965*; l.l.,
*CD.024-4563ab-59/65(P)*
*Collection*: West Baffin Eskimo
Co-operative, Cape Dorset

*Composition*
Cape Dorset 1967,
no. 31
Stonecut

CD.024-301
1965/67?
Graphite on wove paper
50.7 × 65.4 cm
*Inscriptions*: signed l.r., *Pudlo* (in
syllabics); Verso: l.l., *CD.024-301a-59/
65(P)*
*Collection*: West Baffin Eskimo
Co-operative, Cape Dorset

*Ecclesiast*
Cape Dorset 1969,
no. 52
Stonecut
See fig. 11

Not located (described in Ottawa,
National Museum of Man 1977, no. 51,
as coloured felt-tip pen drawing, size as
print: 41 × 57.7 cm)

*Arctic Angel*
Cape Dorset 1969,
no. 53
Stonecut

CD.024-751
c. 1969
Felt pen on wove paper
61.3 × 45.8 cm
*Inscriptions*: signed l.c., *Pudlo* (in
syllabics); Verso: l.l., *CD.024-751d-66/
76(P)*
*Collection*: West Baffin Eskimo
Co-operative, Cape Dorset

*Winter Angel*
Cape Dorset 1969,
no. 54
Stonecut

CD.024-752
c. 1969
Felt pen on wove paper
45.7 × 61.2 cm
*Inscriptions*: signed l.c., *Pudlo* (in
syllabics); Verso: l.l., *CD.024-752d-66/
76(P)*
*Collection*: West Baffin Eskimo
Co-operative, Cape Dorset
See cat. no. 23

Untitled, known as
*Sea Creatures and Bird*
"Dorset Series," 1969
Stonecut

Not located

*Perils of the Hunter*
Cape Dorset 1970,
no. 38
Stonecut
Dated 1969

Not located

*Umingmuk*
Cape Dorset 1970,
no. 39
Stonecut

CD.024-1018
c. 1970
Felt pen on wove paper; watermark:
*Rives*
50.5 × 66.4 cm
*Inscriptions*: signed l.c., *Pudlo* (in
syllabics); Verso: l.l., *CD.024-1018d-66/
76(P)*
*Collection*: West Baffin Eskimo
Co-operative, Cape Dorset
See cat. no. 27

*Umayuluk*
"Dorset Series," 1970
Stonecut

CD.024-748
c. 1970
Felt pen on wove paper
45.7 × 61.2 cm
*Inscriptions*: signed l.c., *Pudlo* (in
syllabics); Verso: l.l., *CD.024-748d-66/
76*; l.l., *(P) Dorset Series*
*Collection*: West Baffin Eskimo
Co-operative, Cape Dorset
See cat. no. 25

*Fish and Bear*
"Dorset Series," 1971
Stonecut

Not located

*Goose*
Cape Dorset 1972,
no. 36
Stonecut

CD.024-1032
c. 1972
Felt pen on wove paper; watermark:
*Rives*
51 × 66.4 cm
*Inscriptions*: signed l.l., *Pudlo* (in
syllabics); Verso: l.l., *CD.024-1032d-66/
76(P)*
*Collection*: West Baffin Eskimo
Co-operative, Cape Dorset

*Fisherman*
Cape Dorset 1972,
no. 37
Stonecut

Not located

*Composition*
Cape Dorset 1972,
no. 38
Stonecut

CD.024-753
1969/72?
Felt pen on wove paper
45.6 × 61 cm
*Inscriptions*: signed l.c., *Pudlo* (in
syllabics); Verso: l.l., *CD.024-753d-66/
76(P)*
*Collection*: West Baffin Eskimo
Co-operative, Cape Dorset

*Shaman's Tent*
Cape Dorset 1973,
no. 51
Stonecut

CD.024-1065
c. 1973
Felt pen on wove paper; watermark:
*Rives*
51 × 65.6 cm
*Inscriptions*: signed l.l., *Pudlo* (in
syllabics); Verso: l.l., *CD.024-1065d-66/
76(P)*
*Collection*: West Baffin Eskimo
Co-operative, Cape Dorset
See cat. no. 41

*Family of Birds*
Cape Dorset 1973,
no. 52
Stonecut

CD.024-703
c. 1973
Felt pen on heavy wove paper
45.8 × 61.1 cm
*Inscriptions*: signed l.l., *Pudlo* (in
syllabics); Verso: l.l., *CD.024-703d-66/
76(P)*
*Collection*: West Baffin Eskimo
Co-operative, Cape Dorset

*Caribou Tent*
Cape Dorset 1973,
no. 53
Stonecut

CD.024-1064
c. 1973
Felt pen on wove paper; watermark:
*Rives*
51 × 65.5 cm
*Inscriptions*: signed l.l., *Pudlo* (in
syllabics); Verso: l.l., *CD.024-1064d-66/
76(P)*
*Collection*: West Baffin Eskimo
Co-operative, Cape Dorset

*Esigajuak*
Cape Dorset 1973,
no. 54
Stonecut

CD.024-857
c. 1973
Felt pen on wove paper; watermark:
*Rives*
65.7 × 51.1 cm
*Inscriptions*: signed l.r., *Pudlo* (in
syllabics); Verso: l.l., *CD.024-857d-66/
76(P)*
*Collection*: West Baffin Eskimo
Co-operative, Cape Dorset
See cat. no. 35

*Long Journey*
Cape Dorset 1974,
no. 36
Stonecut

CD.024-1040
c. 1974
Felt pen on wove paper; watermark:
*Rives*
50.7 × 65.5 cm
*Inscriptions*: signed l.l., *Pudlo* (in
syllabics); Verso: l.l., *CD.024-1040d-66/
76(P)*
*Collection*: West Baffin Eskimo
Co-operative, Cape Dorset
See cat. no. 47

*Winter Camp Scene*
Cape Dorset 1974,
no. 37
Stonecut

CD.024-1459
c. 1974
Felt pen on wove paper; watermark:
*Rives*
50.5 × 65.7 cm
*Inscriptions*: signed l.l., *Pudlo* (in
syllabics); Verso: l.l., *CD.024-1459d-66/
76(P)*
*Collection*: West Baffin Eskimo
Co-operative, Cape Dorset
See cat. no. 44

*Tudlik*
Cape Dorset 1974,
no. 38
Stonecut

CD.024-1267
c. 1974
Felt pen on wove paper; watermark:
*Rives*
50.6 × 65.8 cm
*Inscriptions*: signed l.l., *Pudlo* (in
syllabics); Verso: l.l., *CD.024-1267d-66/
76(P)*
*Collection*: West Baffin Eskimo
Co-operative, Cape Dorset

*Sea Dogs Chasing Fish*
Cape Dorset 1975,
no. 20
Stonecut

CD.024-1029
1974?
Felt pen on wove paper; watermark:
*Rives*
50.5 × 66.1 cm
*Inscriptions*: signed l.l., *Pudlo* (in
syllabics); Verso: l.l., *CD.024-1029d-66/
76(P)*
*Collection*: West Baffin Eskimo
Co-operative, Cape Dorset

*Fox in Camp*
Cape Dorset 1975,
no. 44
Stonecut and stencil

CD.024-1564
c. 1975
Felt pen and wax crayon on wove paper;
watermark: *BFK Rives / France*
56.1 × 76.1 cm
*Inscriptions*: signed l.l., *Pudlo* (in
syllabics); Verso: l.l., *CD.024-1564bd-66/
76(P)*
*Collection*: West Baffin Eskimo
Co-operative, Cape Dorset
See cat. no. 56

*Spring Camp at Igakjuak*
Cape Dorset 1975,
no. 27
Stonecut and stencil

CD.024-1368
1974?
Felt pen on wove paper; watermark:
*Rives*
50.8 × 65.9 cm
*Inscriptions*: signed l.l., *Pudlo* (in
syllabics); Verso: l.l., *CD.024-1368d-66/
76(P)*
*Collection*: West Baffin Eskimo
Co-operative, Cape Dorset

*Hunter's Igloo*
Cape Dorset 1975,
no. 48
Lithograph
See cat. no. 58

Drawn directly on stone

*My Home*
Cape Dorset 1975,
no. 50 (listed as *Our
Home*; image transposed
with no. 49)
Lithograph
See cat. no. 59

Drawn directly on plate

*Children on Komatik*
Cape Dorset 1975,
no. 28
Stonecut and stencil

CD.024-1350
1974?
Felt pen on wove paper; watermark:
*Rives*
51 × 65.5 cm
*Inscriptions*: signed l.l., *Pudlo* (in
syllabics); Verso: l.l., *CD.024-1350d-66/
76(P)*
*Collection*: West Baffin Eskimo
Co-operative, Cape Dorset

*The Igloo Builders*
Cape Dorset 1975,
no. 53
Lithograph

Drawn directly on stone

*Young Woman*
Cape Dorset 1975,
no. 61
Lithograph

Drawn directly on stone

*Shaman's Dwelling*
Cape Dorset 1975,
no. 32
Stonecut and stencil
See fig. 24

Not located (described in Ottawa,
National Museum of Man 1977, no. 67,
as coloured felt-tip pen drawing, size as
print: 42.5 × 58 cm)

*Thoughts of Home*
Cape Dorset 1975,
no. 62
Lithograph

Drawn directly on plate

*Spring Hunter*
Cape Dorset 1975,
no. 39
Stonecut

CD.024-1351
c. 1975
Coloured pencil and felt pen on wove
paper; watermark: *Rives*
50.8 × 65.6 cm
*Inscriptions*: signed l.l., *Pudlo* (in
syllabics); Verso: l.l., *CD.024-1351bd-66/
76(P)*
*Collection*: West Baffin Eskimo
Co-operative, Cape Dorset

*Loons and Fish*
Cape Dorset 1975,
no. 64
Lithograph
Also known as *Fish and
Loons*

CD.024-2381
c. 1975
Felt pen on wove paper; watermark:
*Rives*
50.8 × 66 cm
*Inscriptions*: signed l.l., *Pudlo* (in
syllabics); Verso: l.l., *CD.024-2381d-66/
76(P)*
*Collection*: West Baffin Eskimo
Co-operative, Cape Dorset

*The New Amautik*
Cape Dorset 1975,
no. 65
Lithograph

CD.024-2380
c. 1975
Felt pen on wove paper; watermark:
*Rives*
50.5 × 66 cm
*Inscriptions*: signed l.l., *Pudlo* (in
syllabics); Verso: l.l., *CD.024-2380d-66/
76(P)*
*Collection*: West Baffin Eskimo
Co-operative, Cape Dorset

*Two Seals*
"Dorset Series," 1975
Lithograph

Not located (appears to have been drawn
directly on stone or plate)

*Tupik*
Cape Dorset 1976,
no. L2
Lithograph
Dated 1975

Not located (appears to have been drawn
directly on stone or plate)

*Agutiit Asivaqtut*
Cape Dorset 1976,
no. L3
Lithograph

Not located (appears to have been drawn
directly on stone or plate)

*Timiat Timijut*
Cape Dorset 1976,
no. L4
Lithograph

Not located (appears to have been drawn
directly on stone or plate)

*At Tasiujajuaq*
Cape Dorset 1976,
no. L5
Lithograph

Not located (appears to have been drawn
directly on stone or plate)

*Kayak and Fish*
Cape Dorset 1976, no. 2
Stonecut

CD.024-681
1974?
Felt pen on wove paper
32.4 × 50.8 cm
*Inscriptions*: signed l.l., *Pudlo* (in
syllabics); Verso: l.l., *CD.024-681d-66/
76(P)*
*Collection*: West Baffin Eskimo
Co-operative, Cape Dorset

*Winter Games*
Cape Dorset 1976, no. 8
Stonecut and stencil

CD.024-1565
c. 1976
Felt pen on wove paper; watermark:
*BFK Rives / France*
56.2 × 76.5 cm
*Inscriptions*: signed l.l., *Pudlo* (in
syllabics); Verso: l.l., *CD.024-1565d-66/
76(P)*
*Collection*: West Baffin Eskimo
Co-operative, Cape Dorset
See cat. no. 55

*Dream of the Bear*
Cape Dorset 1976,
no. 12
Stonecut and stencil

CD.024-714
c. 1976
Coloured pencil and black felt pen on
heavy wove paper; watermark:
*Johannot*
43.5 × 56.3 cm
*Inscriptions*: Verso: l.l., *CD.024-714bd-
66/76(P)*; u.r., *Pudlo Print*
*Collection*: West Baffin Eskimo
Co-operative, Cape Dorset

*Aeroplane*
Cape Dorset 1976,
no. 13
Stonecut and stencil

CD.024-1478
c. 1976
Coloured pencil and black felt pen on
wove paper; watermark: *Arches / France*
56.8 × 76.3 cm
*Inscriptions*: signed l.r., *Pudlo* (in
syllabics); Verso: l.l., *CD.024-1478bd-66/
76(P)*
*Collection*: West Baffin Eskimo
Co-operative, Cape Dorset
See cat. no. 63

*Arctic Waterfall*
Cape Dorset 1976,
no. 15
Stonecut and stencil

CD.024-2442
May 1974
Felt pen on wove paper; watermark:
*Rives*
50.5 × 65.4 cm
*Inscriptions*: signed l.l., *Pudlo* (in
syllabics); Verso: l.l., *CD.024-2442d-66/
76(P)*; l.l., *1976 P*; l.l., *Padloo May/74*
*Collection*: West Baffin Eskimo
Co-operative, Cape Dorset
See cat. no. 48

*Spring Travellers*
Cape Dorset 1976,
no. 16
Stonecut and stencil

CD.024-1381
1974?
Felt pen on wove paper; watermark:
*Rives*
50.5 × 65.7 cm
*Inscriptions*: signed l.l., *Pudlo* (in
syllabics); Verso: l.l., *CD.024-1381d-66/
76(P)*
*Collection*: West Baffin Eskimo
Co-operative, Cape Dorset
See cat. no. 46

*Sedna*
Cape Dorset 1976,
no. 24
Stonecut and stencil

CD.024-702
1973?
Felt pen on heavy wove paper
45.8 × 61 cm
*Inscriptions*: signed l.r., *Pudlo* (in
syllabics); Verso: l.l., *CD.024-702d-66/
76(P)*
*Collection*: West Baffin Eskimo
Co-operative, Cape Dorset
See cat. no. 34

*Thoughts of My
Childhood*
Cape Dorset 1976,
no. 38
Stonecut and stencil
Dated 1975

CD.024-1541
c. 1975
Coloured pencil and black felt pen on
wove paper; watermark: *BFK Rives /
France*
56.5 × 76.2 cm
*Inscriptions*: signed l.l., *Pudlo* (in
syllabics); Verso: l.l., *CD.024-1541bd-66/
76(P)*
*Collection*: West Baffin Eskimo
Co-operative, Cape Dorset
See cat. no. 61

*Bird on the Land*
Cape Dorset 1976,
no. 40
Stonecut and stencil

CD.024-1566
c. 1976
Coloured pencil on wove paper;
watermark: *BFK Rives / France*
56 × 76.3 cm
*Inscriptions*: signed l.l., *Pudlo* (in
syllabics); Verso: l.l., *CD.024-1566d-66/
76(P)*
*Collection*: West Baffin Eskimo
Co-operative, Cape Dorset

*Winter Camp at Itileakju*
Cape Dorset 1976,
no. 41
Stonecut

CD.024-1493
c. 1976
Coloured pencil and black felt pen on
wove paper; watermark: *Rives*
42 × 53.2 cm
*Inscriptions*: Verso: l.l., *CD.024-1493bd-
66/76(P)*
*Collection*: West Baffin Eskimo
Co-operative, Cape Dorset

*Tupiit*
Cape Dorset 1976,
no. 45
Stonecut

CD.024-890
1973?
Felt pen on wove paper; watermark:
*Rives*
50.2 × 65.8 cm
*Inscriptions*: signed l.l., *Pudlo* (in
syllabics); Verso: l.l., *CD.024-890d-66/
76(P)*
*Collection*: West Baffin Eskimo
Co-operative, Cape Dorset
See cat. no. 43

*Spirits of the Sea*
Cape Dorset 1976,
no. 47
Stonecut

CD.024-701
1973?
Felt pen on heavy wove paper
45.8 × 61 cm
*Inscriptions*: l.l., *Qilakmuuttaqput
ikingmat* (in syllabics); Verso: l.l.,
*CD.024-701d-66/76(P)*
*Collection*: West Baffin Eskimo
Co-operative, Cape Dorset

*The Seasons*
Cape Dorset 1976,
no. 61
Lithograph
See cat. no. 60

Not located (appears to have been drawn
directly on stone or plate)

*Thoughts of a Child*
"Dorset Series," 1976
Lithograph

Not located (appears to have been drawn directly on stone or plate)

*Bear in Camp*
"Dorset Series," 1976
Stonecut and stencil

Not located

*Grey Bird*
Cape Dorset 1977,
no. L18
Lithograph

CD.024-1302
1976?
Coloured pencil and black felt pen on wove paper; watermark: *Arches / France*
52 × 66.4 cm
*Inscriptions*: signed l.r., *Pudlo* (in syllabics); Verso: l.l., *CD.024-1302bd-66/76(Litho)*; l.l., *0571*; l.r., *Litho 77*
*Collection*: West Baffin Eskimo Co-operative, Cape Dorset

*Women at the Fish Lakes*
Cape Dorset 1977,
no. L19
Lithograph
Dated 1976

Not located (appears to have been drawn directly on stone or plate)

*Fishing*
Cape Dorset 1977,
no. L20
Lithograph
Dated 1976

CD.024-1303
c. 1976
Coloured pencil and black felt pen on wove paper
52.1 × 65.8 cm
*Inscriptions*: signed l.r., *Pudlo* (in syllabics); Verso: l.l., *CD.024-1303bd-66/76(Litho)*; l.l., *0572*; l.r., *Litho 77*
*Collection*: West Baffin Eskimo Co-operative, Cape Dorset

*Landscape with Caribou*
Cape Dorset 1977,
no. L21
Lithograph

CD.024-1301
1976?
Coloured pencil and black felt pen on wove paper
52.2 × 65.9 cm
*Inscriptions*: signed l.r., *Pudlo* (in syllabics); Verso: l.l., *CD.024-1301bd-66/76(Litho)*; l.l., *0551*
*Collection*: West Baffin Eskimo Co-operative, Cape Dorset

*Spring Landscape*
Cape Dorset 1977,
no. 53
Stonecut and stencil

CD.024-1325
May 1974
Felt pen on wove paper; watermark: *Rives*
51.2 × 65.3 cm
*Inscriptions*: signed l.l., *Pudlo* (in syllabics); Verso: l.l., *CD.024-1325d-66/76(P)*; l.l., *Padloo May/74*
*Collection*: West Baffin Eskimo Co-operative, Cape Dorset
See cat. no. 54

*Umingmuk*
Cape Dorset 1978,
no. L21
Lithograph
Dated 1977

CD.024-1556
1977
Coloured pencil and felt pen on wove paper; watermark: *Rives*
51.2 × 66.4 cm
*Inscriptions*: signed l.l., *Pudlo* (in syllabics); Verso: l.l., *CD.024-1556bd-1977(Litho)*; l.r., *Litho 78*
*Collection*: West Baffin Eskimo Co-operative, Cape Dorset

*Yellow Boat*
Cape Dorset 1978,
no. L22
Lithograph

CD.024-1555
1976?
Coloured pencil and black felt pen on wove paper; watermark: *Rives*
51.1 × 66.3 cm
*Inscriptions*: signed l.r., *Pudlo* (in syllabics); Verso: l.l., *CD.024-1555bd-66/76(Litho)*; l.l, *2089*; l.r., *Litho 78*
*Collection*: West Baffin Eskimo Co-operative, Cape Dorset

*Naujaq Umiallu*
Cape Dorset 1978,
no. L23
Lithograph
Dated 1977

CD.024-1552
1976?
Coloured pencil and black felt pen on wove paper
38 × 47 cm
*Inscriptions*: signed l.r., *Pudlo* (in syllabics); Verso: l.l., *CD.024-1552bd-66/76(Litho) / 3040*; l.r., *Litho 78*
*Collection*: West Baffin Eskimo Co-operative, Cape Dorset

*Tulik and Sailboats*
Cape Dorset 1978,
no. L24
Lithograph
Dated 1977

CD.024-1553
1976?
Coloured pencil and black felt pen on
wove paper
38.6 × 47.2 cm
*Inscriptions*: signed l.r., *Pudlo* (in
syllabics); Verso: l.l., *CD.024-1553bd-66/
76(Litho) / 3041*; l.r., *Litho 78*
*Collection*: West Baffin Eskimo
Co-operative, Cape Dorset

*Qaqsan*
Cape Dorset 1979,
no. L25
Lithograph

CD.024-1554
1976?
Coloured pencil and black felt pen on
wove paper
38 × 47 cm
*Inscriptions*: signed l.r., *Pudlo* (in
syllabics); Verso: l.l., *CD.024-1554bd-66/
76(P)*; l.r., *Editioned*
*Collection*: West Baffin Eskimo
Co-operative, Cape Dorset

*Umingmunga*
Cape Dorset 1978,
no. 65
Stonecut and stencil

CD.024-1537
1976/78?
Coloured pencil and black felt pen on
wove paper; watermark: *BFK Rives /
France*
56.5 × 76.3 cm
*Inscriptions*: signed l.r., *Pudlo* (in
syllabics); Verso: l.l., *CD.024-1537bd-66/
76(P)*
*Collection*: West Baffin Eskimo
Co-operative, Cape Dorset

*Blue Musk Ox*
Cape Dorset 1979,
no. L26
Lithograph

CD.024-2800
1978/79
Coloured pencil and felt pen on wove
paper; watermark: *BFK Rives / France*
56.3 × 76.2 cm
*Inscriptions*: signed l.r., *Pudlo* (in
syllabics); Verso: l.l., *CD.024-2800bd-
78/79(L-79)*
*Collection*: West Baffin Eskimo
Co-operative, Cape Dorset
See cat. no. 76

*Pungnialuk*
Cape Dorset 1978,
no. 66
Stonecut

Not catalogued by the West Baffin
Eskimo Co-operative
1976/78?
Coloured pencil and black felt pen on
wove paper
56.3 × 76.3 cm
*Inscriptions*: signed l.r., *Pudlo* (in
syllabics)
*Collection*: Macdonald Stewart Art
Centre, Guelph, Ont.
See fig. 15

*Two Loons at Sea*
Cape Dorset 1979,
no. 52
Stonecut and stencil

CD.024-3554
1978
Coloured pencil and black felt pen on
wove paper; watermark: *BFK Rives /
France*
56.6 × 76.3 cm
*Inscriptions*: signed l.r., *Pudlo* (in
syllabics); Verso: l.l., *CD.024-3554bd-
78/79(P)*; l.r., *78 79 148*
*Collection*: West Baffin Eskimo
Co-operative, Cape Dorset

*Saddled Muskox*
Cape Dorset 1979,
no. L24
Lithograph
See fig. 25

CD.024-2801
1978
Coloured pencil and black felt pen on
wove paper; watermark: *BFK Rives /
France*
56.1 × 76.3 cm
*Inscriptions*: signed l.r., *Pudlo* (in
syllabics); Verso: l.l., *CD.024-2801bd-78/
79(L-79)*; l.r., *78 79 216*
*Collection*: West Baffin Eskimo
Co-operative, Cape Dorset

*Qulaguli*, also known as
*Helicopter*
Cape Dorset 1979,
no. 53
Stonecut and stencil

CD.024-1476
1976?
Coloured pencil and black felt pen on
wove paper; watermark: *Arches / France*
56.5 × 76.3 cm
*Inscriptions*: signed l.r., *Pudlo* (in
syllabics); Verso: l.l., *CD.024-1476bd-66/
76(P)*
*Collection*: West Baffin Eskimo
Co-operative, Cape Dorset
See cat. no. 64

*I Saw a Great Bird*
Cape Dorset 1979,
no. 54
Stonecut and stencil

CD.024-3555
1978
Coloured pencil and black felt pen on
wove paper; watermark: *BFK Rives /
France*
56.6 × 76.3 cm
*Inscriptions*: signed l.r., *Pudlo* (in
syllabics); Verso: l.l., *CD.024-3555bd-
78/79(P)*; l.r., *78 79 128*
*Collection*: West Baffin Eskimo
Co-operative, Cape Dorset

*Seagull and Muskox*
Cape Dorset 1980,
no. L23
Lithograph

CD.024-3562
1979/80
Coloured pencil and black felt pen on
wove paper; watermark: *BFK Rives /
France*
56.4 × 76.2 cm
*Inscriptions*: signed l.r., *Pudlo* (in
syllabics); Verso: l.l., *CD.024-3562bd-
79/80(P)*
*Collection*: West Baffin Eskimo
Co-operative, Cape Dorset

*Muskox Near Ice*
Cape Dorset 1979,
no. 55
Stonecut and stencil

CD.024-3556
1978
Coloured pencil and black felt pen on
wove paper; watermark: *BFK Rives /
France*
56.6 × 76.3 cm
*Inscriptions*: signed l.r., *Pudlo* (in
syllabics); Verso: l.l., *CD.024-3556bd-
78/79(P)*; l.r., *78 79 104*
*Collection*: West Baffin Eskimo
Co-operative, Cape Dorset

*Airplanes over Ice-Cap*
Cape Dorset 1980,
no. L24
Lithograph

CD.024-3563
1979/80
Coloured pencil and black felt pen on laid
paper; watermark: *Arches / France*
56.6 × 76.5 cm
*Inscriptions*: signed l.r., *Pudlo* (in
syllabics); Verso: l.l., *CD.024-3563bd-
79/80(P)*
*Collection*: West Baffin Eskimo
Co-operative, Cape Dorset

*Umimmak Kalunaniituk*,
also known as *Muskox in
the City*
Cape Dorset 1979,
no. 56
Stonecut and stencil

CD.024-3557
1978
Coloured pencil and black felt pen on
wove paper; watermark: *BFK Rives /
France*
56.6 × 76.1 cm
*Inscriptions*: signed l.r., *Pudlo* (in
syllabics); Verso: l.l., *CD.024-3557bd-
78/79(P)*; l.r., *78 79 188*
*Collection*: West Baffin Eskimo
Co-operative, Cape Dorset
See cat. no. 75

*A Good Catch*
Cape Dorset 1980,
no. L25
Lithograph

CD.024-3564
1979/80
Coloured pencil and black felt pen on
wove paper; watermark: *BFK Rives /
France*
56.3 × 76.2 cm
*Inscriptions*: signed l.r., *Pudlo* (in
syllabics); Verso: l.l., *CD.024-3564bd-
79/80(P)*
*Collection*: West Baffin Eskimo
Co-operative, Cape Dorset
See cat. no. 77

*Shores of the Settlement*
Cape Dorset 1979,
Commissioned Works
Lithograph
Released to the Queen
Elizabeth Hotel and the
City of Montreal

Not located (appears to have been drawn
directly on stone or plate)

*In the Lake*
Cape Dorset 1980,
no. L26
Lithograph

CD.024-3565
1979/80
Coloured pencil and black felt pen on
wove paper; watermark: *BFK Rives /
France*
56.6 × 76 cm
*Inscriptions*: signed l.r., *Pudlo* (in
syllabics); Verso: l.l., *CD.024-3565bd-
79/80(P)*
*Collection*: West Baffin Eskimo
Co-operative, Cape Dorset

*Muskox on Sea Ice*
Cape Dorset 1980,
no. 49
Stonecut and stencil

CD.024-3559
1979/80
Coloured pencil and black felt pen on
wove paper; watermark: *BFK Rives /
France*
56.8 × 76.3 cm
*Inscriptions*: signed l.r., *Pudlo* (in
syllabics); Verso: l.l., *CD.024-3559bd-
79/80(P)*
*Collection*: West Baffin Eskimo
Co-operative, Cape Dorset

*Summer Loon*
Cape Dorset 1980,
no. 50
Stonecut and stencil

CD.024-3558
1979/80
Coloured pencil and black felt pen on
wove paper; watermark: *BFK Rives /
France*
56.4 × 76.5 cm
*Inscriptions*: signed l.r., *Pudlo* (in
syllabics); Verso: l.l., *CD.024-3558bd-
79/80(P)*
*Collection*: West Baffin Eskimo
Co-operative, Cape Dorset

*Umiakjuak*
Cape Dorset 1980,
no. 51
Stonecut and stencil

CD.024-3560
1979/80
Coloured pencil and black felt pen on
wove paper; watermark: *Arches / France*
56.5 × 76.3 cm
*Inscriptions*: signed twice l.r., *Pudlo* (in
syllabics); Verso: l.l., *CD.024-3560bd-
79/80(P)*
*Collection*: West Baffin Eskimo
Co-operative, Cape Dorset
See cat. no. 78

*Two Loons at Sea*
Cape Dorset 1980,
no. 52
Stonecut and stencil

CD.024-3561
1979/80
Coloured pencil and black felt pen on
wove paper; watermark: *BFK Rives /
France*
56.5 × 76.2 cm
*Inscriptions*: signed l.r., *Pudlo* (in
syllabics); Verso: l.l., *CD.024-3561bd-79/
80(P)*
*Collection*: West Baffin Eskimo
Co-operative, Cape Dorset

*In Celebration*
Cape Dorset 1980,
Commissioned Works
Lithograph
Dated 1979; released to
the Canadian Guild of
Crafts Quebec for sale
in November 1979 to
celebrate the 30th
anniversary of the
Guild's first exhibition
of contemporary Inuit
art

CD.024-3587
1978
Coloured pencil and black felt pen on
wove paper; watermark: *BFK Rives /
France*
56.2 × 76.1 cm
*Inscriptions*: signed l.r., *Pudlo* (in
syllabics); l.r., *A*; Verso: l.l., *CD.024-
3587bd-78/79 (P-Guild Comm.)*; l.r.,
*78 79 200*
*Collection*: West Baffin Eskimo
Co-operative, Cape Dorset

*Muskox and Airplane*
Cape Dorset 1980,
Etchings Portfolio I
Etching and aquatint

Drawn directly on plate

*Muskox and Friends*
Cape Dorset 1981,
no. L26
Lithograph

CD.024-3573
1980/81
Coloured pencil and black felt pen on
wove paper; watermark: *BFK Rives /
France*
56.5 × 76 cm
*Inscriptions*: Verso: l.l., *CD.024-3573bd-
80/81(P)*
*Collection*: West Baffin Eskimo
Co-operative, Cape Dorset

*Large Loon and
Landscape*
Cape Dorset 1981,
no. L27
Lithograph

CD.024-3574
1980/81
Coloured pencil and black felt pen on
wove paper; watermark: *BFK Rives /
France*
56.5 × 76.1 cm
*Inscriptions*: Verso: l.l., *CD.024-3574bd-
80/81(P)*
*Collection*: West Baffin Eskimo
Co-operative, Cape Dorset
See cat. no. 82

*Boat and Airplane*
Cape Dorset 1981,
no. L28
Lithograph

CD.024-3853
1980/81
Coloured pencil and black felt pen on
wove paper; watermark: *BFK Rives /
France*
56.5 × 76.4 cm
*Inscriptions*: Verso: l.l., *CD.024-3853bd-
80/81 (P)*
*Collection*: West Baffin Eskimo
Co-operative, Cape Dorset

*Harpoons and Seals*
Cape Dorset 1981,
no. L29
Lithograph

CD.024-3575
1980/81
Coloured pencil and black felt pen on
wove paper; watermark: *Rives*
51.1 × 66 cm
*Inscriptions*: signed l.r., *Pudlo* (in
syllabics); Verso: l.l., *CD.024-3575bd-
80/81 (P)*
*Collection*: West Baffin Eskimo
Co-operative, Cape Dorset

*Ship of the Loon*
Cape Dorset 1981,
no. 47
Stonecut and stencil

CD.024-3567
1980/81
Coloured pencil and black felt pen on
wove paper; watermark: *BFK Rives /
France*
56.3 × 76.3 cm
*Inscriptions*: signed l.r., *Pudlo* (in
syllabics); Verso: l.l., *CD.024-3567bd-
80/81 (P)*
*Collection*: West Baffin Eskimo
Co-operative, Cape Dorset

*We Travel with the Loon*
Cape Dorset 1981,
no. 48
Stonecut and stencil

CD.024-3568
1980/81
Coloured pencil and black felt pen on
wove paper; watermark: *BFK Rives /
France*
56.6 × 76 cm
*Inscriptions*: Verso: l.l., *CD.024-3568bd-
80/81 (P)*
*Collection*: West Baffin Eskimo
Co-operative, Cape Dorset

*Loon Speaks to the
Walrus*
Cape Dorset 1981,
no. 49
Stonecut and stencil

CD.024-3569
1980/81
Coloured pencil and black felt pen on
wove paper; watermark: *BFK Rives /
France*
56.3 × 76.3 cm
*Inscriptions*: signed l.r., *Pudlo* (in
syllabics); Verso: l.l., *CD.024-3569bd-
80/81 (P)*
*Collection*: West Baffin Eskimo
Co-operative, Cape Dorset

*Ready to Fly*
Cape Dorset 1981,
no. 50
Stonecut and stencil

CD.024-3570
1980/81
Coloured pencil and black felt pen on
wove paper; watermark: *BFK Rives /
France*
56.8 × 76.3 cm
*Inscriptions*: signed l.r., *Pudlo* (in
syllabics); Verso: l.l., *CD.024-3570bd-
80/81 (P)*
*Collection*: West Baffin Eskimo
Co-operative, Cape Dorset

*The Loon and the Fish
Speak*
Cape Dorset 1981,
no. 51
Stonecut and stencil

CD.024-3571
1980/81
Coloured pencil and black felt pen on
wove paper; watermark: *BFK Rives /
France*
56.5 × 76 cm
*Inscriptions*: Verso: l.l., *CD.024-3571bd-
80/81 (P)*
*Collection*: West Baffin Eskimo
Co-operative, Cape Dorset

*Ptarmigan in the
Sunlight*
Cape Dorset 1981,
no. 52
Stonecut and stencil

CD.024-3572
1980/81
Coloured pencil and black felt pen on
wove paper; watermark: *BFK Rives /
France*
56.4 × 76 cm
*Inscriptions*: Verso: l.l., *CD.024-3572bd-
80/81 (P)*
*Collection*: West Baffin Eskimo
Co-operative, Cape Dorset

*Timiat Nunamiut*
Cape Dorset 1981,
Commissioned Works
Hand-coloured
lithograph
Dated 1976; released in
1976 to "Habitat:
The United Nations
Conference on Human
Settlements"

Not located (appears to have been drawn
directly on stone or plate)

*The Settlement from a
Distance*
Cape Dorset 1982,
no. L25
Lithograph

CD.024-3576
1981/82
Acrylic paint, coloured pencil, and black
felt pen on wove paper; watermark: *BFK
Rives / France*
56.2 × 76 cm
*Inscriptions*: signed l.r., *Pudlo* (in
syllabics); Verso: l.l., *CD.024-3576bdf-
81/82(P)*
*Collection*: West Baffin Eskimo
Co-operative, Cape Dorset

*Arrival of the Prophet*
Cape Dorset 1983,
no. L18
Lithograph

CD.024-2706
1979/80
Coloured pencil and black felt pen on
wove paper; watermark: *Arches / France*
56.5 × 76.4 cm
*Inscriptions*: signed l.r., *Pudlo* (in
syllabics); Verso: l.l., *CD.024-2706bd-
79/80(P)*
*Collection*: West Baffin Eskimo
Co-operative, Cape Dorset
See cat. no. 80

*Vision of Two Worlds*
Cape Dorset 1983,
no. L19
Hand-coloured
lithograph and stencil

CD.024-3577
1982/83
Coloured pencil and black felt pen on
wove paper; watermark: *Arches / France*
56.5 × 76.3 cm
*Inscriptions*: signed l.r., *Pudlo* (in
syllabics); Verso: l.l., *CD.024-3577bd-
82/83(P)*
*Collection*: West Baffin Eskimo
Co-operative, Cape Dorset

*A Ship Passes By*
Cape Dorset 1983,
no. L20
Lithograph

CD.024-3578
1982/83
Coloured pencil and black felt pen on
wove paper; watermark: *Arches / France*
56.5 × 76.5 cm
*Inscriptions*: signed l.r., *Pudlo* (in
syllabics); Verso: l.l., *CD.024-3578bd-
82/83(P)*
*Collection*: West Baffin Eskimo
Co-operative, Cape Dorset

*Bird of Winter Darkness*
Cape Dorset 1983,
no. L21
Lithograph

CD.024-3579
1982/83
Coloured pencil and black felt pen on
wove paper; watermark: *BFK Rives /
France*
57 × 76.8 cm
*Inscriptions*: signed l.r., *Pudlo* (in
syllabics); Verso: l.l., *CD.024-3579bd-
82/83(P)*
*Collection*: West Baffin Eskimo
Co-operative, Cape Dorset

*Landscape of Baffin*
Cape Dorset 1983,
no. L24
Lithograph

Drawn directly on stone or plate

*Ship of Loons*
Cape Dorset 1983,
no. 34
Stonecut and stencil

CD.024-3580
1982/83
Coloured pencil and black felt pen on
wove paper; watermark: *Arches / France*
56.6 × 76.6 cm
*Inscriptions*: signed l.r., *Pudlo* (in
syllabics); Verso: l.l., *CD.024-3580bd-
82/83(P)*
*Collection*: West Baffin Eskimo
Co-operative, Cape Dorset
See cat. no. 88

*The Fish Takes Flight*
Cape Dorset 1983,
no. 35
Stonecut and stencil

CD.024-3581
1982/83
Coloured pencil and black felt pen on
wove paper; watermark: *Arches / France*
56.5 × 76.5 cm
*Inscriptions*: signed l.r., *Pudlo* (in
syllabics); Verso: l.l., *CD.024-3581bd-82/
83(P)*
*Collection*: West Baffin Eskimo
Co-operative, Cape Dorset

*Journey of the Loon*
Cape Dorset 1983,
no. 36
Stonecut and stencil

CD.024-2780
1979/80
Coloured pencil on wove paper;
watermark: *BFK Rives / France*
56.3 × 76.2 cm
*Inscriptions*: signed l.r., *Pudlo* (in
syllabics); Verso: l.l., *CD.024-2780b-79/
80(P)*
*Collection*: West Baffin Eskimo
Co-operative, Cape Dorset

*Festival of the Loon*
Cape Dorset 1983,
no. 37
Stonecut and stencil

CD.024-3582
1982/83
Coloured pencil and black felt pen on
wove paper; watermark: *Arches / France*
56.5 × 76.5 cm
*Inscriptions*: signed l.r., *Pudlo* (in
syllabics); Verso: l.l., *CD.024-3582bd-
82/83(P)*
*Collection*: West Baffin Eskimo
Co-operative, Cape Dorset

*Young Girl and Muskox*
Cape Dorset 1983,
no. 38
Stonecut and stencil

CD.024-3583
1982/83
Coloured pencil and black felt pen on
wove paper; watermark: *BFK Rives /
France*
56.4 × 76.2 cm
*Inscriptions*: Verso: l.l., *CD.024-3583bd-
82/83(P)*
*Collection*: West Baffin Eskimo
Co-operative, Cape Dorset

*Metiq on Mallik*
Cape Dorset 1983,
no. 39
Stonecut

CD.024-2680
1979/80
Coloured pencil and black felt pen on
wove paper; watermark: *BFK Rives /
France*
56.1 × 76 cm
*Inscriptions*: signed l.r., *Pudlo* (in
syllabics); Verso: l.l., *CD.024-2680bd-
79/80(P)*
*Collection*: West Baffin Eskimo
Co-operative, Cape Dorset

*Journey into Fantasy*
Cape Dorset 1983,
no. 40
Stonecut and stencil

CD.024-2950
1980/81
Coloured pencil and black felt pen on
wove paper; watermark: *BFK Rives /
France*
56.2 × 76.3 cm
*Inscriptions*: signed l.r., *Pudlo* (in
syllabics); Verso: l.l., *CD.024-2950bd-
80/81(P)*
*Collection*: West Baffin Eskimo
Co-operative, Cape Dorset

*Snow Swan of Parketuk*
Cape Dorset 1983,
no. 41
Stonecut

CD.024-3584
1982/83
Coloured pencil on wove paper;
watermark: *Arches / France*
56.5 × 76.5 cm
*Inscriptions*: signed l.r., *Pudlo* (in
syllabics); Verso: l.l., *CD.024-3584b-82/
83(P)*
*Collection*: West Baffin Eskimo
Co-operative, Cape Dorset
See cat. no. 89

*Mounted Hunter*
Cape Dorset 1983,
no. 42
Stonecut and stencil

CD.024-3585
1982/83
Coloured pencil and black felt pen on
wove paper; watermark: *Arches / France*
56.5 × 76.4 cm
*Inscriptions*: signed l.r., *Pudlo* (in
syllabics); Verso: l.l., *CD.024-3585bd-
82/83(P)*
*Collection*: West Baffin Eskimo
Co-operative, Cape Dorset

*Tale of a Huge Muskox*
Cape Dorset 1983,
no. 43
Stonecut and stencil

CD.024-3586
1982/83
Coloured pencil and black felt pen on
wove paper; watermark: *Arches / France*
56.7 × 76.5 cm
*Inscriptions*: signed l.r., *Pudlo* (in
syllabics); Verso: l.l., *CD.024-3586bd-
82/83(P)*
*Collection*: West Baffin Eskimo
Co-operative, Cape Dorset
See cat. no. 85

*Fantastic Kingalaq*
Cape Dorset 1984,
no. 37
Stonecut and stencil

CD.024-3836
1983/84
Coloured pencil and black felt pen on
wove paper; watermark: *BFK Rives /
France*
56.5 × 76.2 cm
*Inscriptions*: signed l.r., *Pudlo* (in
syllabics); Verso: l.l., *CD.024-3836bd-
83/84(P)*
*Collection*: West Baffin Eskimo
Co-operative, Cape Dorset

*Gathering Moss for
the Nest*
Cape Dorset 1984,
no. 38
Stonecut and stencil

CD.024-3837
1983/84
Coloured pencil on wove paper;
watermark: *Rives*
51.5 × 66.5 cm
*Inscriptions*: Verso: l.l., *CD.024-3837b-
83/84(P)*
*Collection*: West Baffin Eskimo
Co-operative, Cape Dorset

*Hunter with Heavy Load*
Cape Dorset 1984,
no. 39
Stonecut and stencil

CD.024-3838
1983/84
Coloured pencil and black felt pen on
wove paper; watermark: *Arches / France*
56.5 × 76.5 cm
*Inscriptions*: signed l.r., *Pudlo* (in
syllabics); Verso: l.l., *CD.024-3838bd-
83/84(P)*
*Collection*: West Baffin Eskimo
Co-operative, Cape Dorset

*Loons Protecting Young*
Cape Dorset 1984,
no. 40
Stonecut and stencil

CD.024-2707
1979/80
Coloured pencil and black felt pen on
wove paper; watermark: *Arches / France*
56.5 × 76.4 cm
*Inscriptions*: signed l.r., *Pudlo* (in
syllabics); Verso: l.l., *CD.024-2707bd-
79/80(P)*
*Collection*: West Baffin Eskimo
Co-operative, Cape Dorset

*Loon in a Strong Wind*
Cape Dorset 1984,
no. 41
Lithograph

CD.024-3839
1983/84
Coloured pencil and black felt pen on
wove paper; watermark: *BFK Rives /
France*
56.5 × 76.2 cm
*Inscriptions*: signed l.r., *Pudlo* (in
syllabics); Verso: l.l., *CD.024-3839bd-
83/84(P)*
*Collection*: West Baffin Eskimo
Co-operative, Cape Dorset

*Pangniq Sniffs the Wind*
Cape Dorset 1984,
no. 42
Stonecut and stencil

CD.024-3840
1983/84
Coloured pencil and black felt pen on
wove paper; watermark: *Arches / France*
56.6 × 76.5 cm
*Inscriptions*: signed l.r., *Pudlo* (in
syllabics); Verso: l.l., *CD.024-3840bd-
83/84(P)*
*Collection*: West Baffin Eskimo
Co-operative, Cape Dorset

*Our Massive Friend*
Cape Dorset 1984,
no. 43
Stonecut

CD.024-3841
1983/84
Coloured pencil and black felt pen on
wove paper; watermark: *Arches / France*
56.6 × 76.5 cm
*Inscriptions*: signed l.r., *Pudlo* (in
syllabics); Verso: l.l., *CD.024-3841bd-83/
84(P)*
*Collection*: West Baffin Eskimo
Co-operative, Cape Dorset

*Winter Bird*
Cape Dorset 1984, Pudlo
Pudlat Folio of
Lithographs
Lithograph

CD.024-3843
1983/84
Coloured pencil and black felt pen on
wove paper; watermark: *Arches / France*
56.7 × 76.5 cm
*Inscriptions*: signed l.r., *Pudlo* (in
syllabics); Verso: l.l., *CD.024-3843bd-
83/84(P)*
*Collection*: West Baffin Eskimo
Co-operative, Cape Dorset

*Aggressive Stance*
Cape Dorset 1985,
no. 28
Stonecut and stencil
Editioned in January
1985

CD.024-3858
1984
Coloured pencil and black felt pen on
wove paper; watermark: *Ragston-S-N*
51 × 65.8 cm
*Inscriptions*: signed l.c., *Pudlo* (in
syllabics); Verso: l.l., *CD.024-3858bd-
84/85(P)*
*Collection*: West Baffin Eskimo
Co-operative, Cape Dorset

*Walrus and Young*
Cape Dorset 1984, Pudlo
Pudlat Folio of
Lithographs
Lithograph

CD.024-3844
1983/84
Coloured pencil and black felt pen on
wove paper; watermark: *Arches / France*
56.7 × 76.5 cm
*Inscriptions*: signed l.r., *Pudlo* (in
syllabics); Verso: l.l., *CD.024-3844bd-
83/84(P)*
*Collection*: West Baffin Eskimo
Co-operative, Cape Dorset
See cat. no. 93

*Bird of Autumn*
Cape Dorset 1985,
no. 29
Stonecut

CD.024-3509
1982/83
Coloured pencil and black felt pen on
wove paper; watermark: *BFK Rives /
France*
57.1 × 76.6 cm
*Inscriptions*: signed l.r., *Pudlo* (in
syllabics); Verso: l.l., *CD.024-3509bd-
82/83(P)*
*Collection*: West Baffin Eskimo
Co-operative, Cape Dorset

*Loon in Open Water*
Cape Dorset 1984,
Pudlo Pudlat Folio
of Lithographs
Lithograph

CD.024-3845
1983/84
Coloured pencil and black felt pen on
wove paper; watermark: *Arches / France*
56.6 × 76.5 cm
*Inscriptions*: signed l.r., *Pudlo* (in
syllabics); Verso: l.l., *CD.024-3845bd-
83/84(P)*
*Collection*: West Baffin Eskimo
Co-operative, Cape Dorset
See cat. no. 90

*Bird of Early Dawn*
Cape Dorset 1985,
no. 30
Lithograph

CD.024-3507
1982/83
Coloured pencil and black felt pen on
wove paper; watermark: *BFK Rives /
France*
57.2 × 76.5 cm
*Inscriptions*: signed l.r., *Pudlo* (in
syllabics); Verso: l.l., *CD.024-3507bd-
82/83(P)*
*Collection*: West Baffin Eskimo
Co-operative, Cape Dorset

*Man Among the Loons*
Cape Dorset 1984,
Pudlo Pudlat Folio
of Lithographs
Lithograph

CD.024-3846
1983/84
Coloured pencil on wove paper;
watermark: *Arches / France*
56.7 × 76.5 cm
*Inscriptions*: signed l.r., *Pudlo* (in
syllabics); Verso: l.l., *CD.024-3846b-83/
84(P)*
*Collection*: West Baffin Eskimo
Co-operative, Cape Dorset

*Confrontation*
Cape Dorset 1985,
no. 31
Stonecut

CD.024-3861
1984/85
Coloured pencil and black felt pen on
wove paper; watermark: *Ragston-S-N*
50.7 × 66.4 cm
*Inscriptions*: signed l.r., *Pudlo* (in
syllabics); Verso: l.l., *CD.024-3861bd-84/
85(P)*
*Collection*: West Baffin Eskimo
Co-operative, Cape Dorset

*Interrupted Solitude*
Cape Dorset 1985,
no. 32
Stonecut and stencil

CD.024-3498
1982/83
Coloured pencil and black felt pen on
wove paper; watermark: *Arches / France*
56.6 × 76.5 cm
*Inscriptions*: signed l.r., *Pudlo* (in
syllabics); Verso: l.l., *CD.024-3498bd-
82/83(P)*
*Collection*: West Baffin Eskimo
Co-operative, Cape Dorset

*Loons among Muskox*
Cape Dorset 1985,
no. 33
Stonecut and stencil
Editioned in 1984−85

CD.024-3855
1984
Coloured pencil and black felt pen on
wove paper; watermark: *Ragston-S-N*
51 × 66.2 cm
*Inscriptions*: signed l.r., *Pudlo* (in
syllabics); Verso: l.l., *CD.024-3855bd-
84/85(P)*
*Collection*: West Baffin Eskimo
Co-operative, Cape Dorset

*My Youthful Fantasy*
Cape Dorset 1985,
no. 34
Stonecut and stencil
Editioned in 1984−85

CD.024-3856
1984
Coloured pencil on wove paper;
watermark: *Rives*
50.6 × 66.3 cm
*Inscriptions*: signed l.r., *Pudlo* (in
syllabics); Verso: l.l., *CD.024-3856b-84/
85(P)*
*Collection*: West Baffin Eskimo
Co-operative, Cape Dorset

*The One Between*
Cape Dorset 1985,
no. 35
Stonecut and stencil
Editioned in 1984−85

CD.024-3854
1984
Coloured pencil on wove paper;
watermark: *Ragston-S-N*
50.5 × 65.9 cm
*Inscriptions*: signed l.r., *Pudlo* (in
syllabics); Verso: l.l., *CD.024-3854b-84/
85(P)*
*Collection*: West Baffin Eskimo
Co-operative, Cape Dorset

*Overshadowed by a
Great Bird*
Cape Dorset 1985,
no. 36
Lithograph

CD.024-3514
1982/83
Coloured pencil and black felt pen on
wove paper; watermark: *Arches / France*
56.6 × 76.5 cm
*Inscriptions*: signed l.r., *Pudlo* (in
syllabics); Verso: l.l., *CD.024-3514bd-82/
83(P)*
*Collection*: West Baffin Eskimo
Co-operative, Cape Dorset

*Protective Harbour*
Cape Dorset 1985,
no. 37
Lithograph

CD.024-3862
1984/85
Coloured pencil and black felt pen on
wove paper; watermark: *Rives*
51 × 66.2 cm
*Inscriptions*: Verso: l.l., *CD.024-3862bd-
84/85(P)*
*Collection*: West Baffin Eskimo
Co-operative, Cape Dorset

*Seals Surfacing*
Cape Dorset 1985,
no. 38
Stonecut and stencil

CD.024-3860
1984/85
Coloured pencil and black felt pen on
wove paper; watermark: *Ragston-S-N*
51 × 65.8 cm
*Inscriptions*: signed l.c., *Pudlo* (in
syllabics); Verso: l.l., *CD.024-3860bd-
84/85(P)*
*Collection*: West Baffin Eskimo
Co-operative, Cape Dorset

*Towering Loons*
Cape Dorset 1985,
no. 39
Stonecut

CD.024-3526
1982/83
Coloured pencil and black felt pen on
wove paper; watermark: *Arches / France*
56.5 × 76.5 cm
*Inscriptions*: signed l.c., *Pudlo* (in
syllabics); Verso: l.l., *CD.024-3526bd-
82/83(P)*
*Collection*: West Baffin Eskimo
Co-operative, Cape Dorset

*Winds of Change*
Cape Dorset 1985,
no. 40
Lithograph
Editioned in 1984

CD.024-3847
1983/84
Coloured pencil and black felt pen on
wove paper; watermark: *BFK Rives /
France*
57 × 76.5 cm
*Inscriptions*: signed l.r., *Pudlo* (in
syllabics); Verso: l.l., *CD.024-3847bd-
83/84(ed.P)*
*Collection*: West Baffin Eskimo
Co-operative, Cape Dorset
See cat. no. 95

*Aerial Portage*
Cape Dorset 1986,
no. 28
Lithograph
See fig. 18

Drawn directly on stone

*Birds Together*
Cape Dorset 1986,
no. 29
Stonecut and stencil
Editioned in 1985

CD.024-3863
1984/85
Coloured pencil and black felt pen on
wove paper; watermark: *Ragston-S-N*
49.3 × 66 cm
*Inscriptions*: signed l.c., *Pudlo* (in
syllabics); Verso: l.l., *CD.024-3863bd-
84/85(ed.P)*
*Collection*: West Baffin Eskimo
Co-operative, Cape Dorset

*Birds of the Tundra*
Cape Dorset 1986,
no. 30
Stonecut
Editioned in 1985–86

CD.024-3997
1985
Graphite, coloured pencil, and black felt
pen on wove paper; watermark:
*Ragston-S-N*
51.2 × 66 cm
*Inscriptions*: signed l.r., *Pudlo* (in
syllabics); Verso: l.l., *CD.024-3997abd-
85/86(P)*
*Collection*: West Baffin Eskimo
Co-operative, Cape Dorset

*Caribou in Winter Light*
Cape Dorset 1986,
no. 31
Stonecut
Editioned in 1985

CD.024-3988
1985
Graphite on wove paper; watermark:
*Ragston-S-N*
51 × 66.5 cm
*Inscriptions*: signed l.c., *Pudlo* (in
syllabics); Verso: l.l., *CD.024-3988a-85/
86(P)*
*Collection*: West Baffin Eskimo
Co-operative, Cape Dorset

*Imposed Migration*
Cape Dorset 1986,
no. 32
Lithograph
Editioned in 1985

CD.024-3992
1985
Coloured pencil and black felt pen on
wove paper; watermark: *Ragston-S-N*
50.7 × 66 cm
*Inscriptions*: signed l.c., *Pudlo* (in
syllabics); Verso: l.l., *CD.024-3992bd-
85/86(P)*
*Collection*: West Baffin Eskimo
Co-operative, Cape Dorset

*Loons and Seal in Ocean
Swell*
Cape Dorset 1986,
no. 33
Stonecut and stencil
Editioned in 1985–86

CD.024-3993
1985
Graphite, coloured pencil, and black felt
pen on wove paper; watermark:
*Ragston-S-N*
50.6 × 66.2 cm
*Inscriptions*: signed l.r., *Pudlo* (in
syllabics); Verso: l.l., *CD.024-3993abd-
85/86(P)*
*Collection*: West Baffin Eskimo
Co-operative, Cape Dorset

*Muskox in Flight*
Cape Dorset 1986,
no. 34
Stonecut
Editioned in 1985

CD.024-3986
1985
Coloured pencil and black felt pen on
wove paper; watermark: *Ragston-S-N*
51.6 × 66.5 cm
*Inscriptions*: signed l.c., *Pudlo* (in
syllabics); Verso: l.l., *CD.024-3986bd-
85/86(P)*
*Collection*: West Baffin Eskimo
Co-operative, Cape Dorset

*New Forms in Our Path*
Cape Dorset 1986,
no. 35
Stonecut

CD.024-3996
1985/86
Graphite, coloured pencil, and black felt pen on wove paper; watermark: *Ragston-S-N*
51 × 65.9 cm
*Inscriptions*: signed l.r., *Pudlo* (in syllabics); Verso: l.l., *CD.024-3996abd-85/86(P)*
*Collection*: West Baffin Eskimo Co-operative, Cape Dorset

*Patriarchal Protector*
Cape Dorset 1986,
no. 36
Stonecut and stencil

CD.024-3995
1985/86
Graphite, coloured pencil, and black felt pen on wove paper; watermark: *Ragston-S-N*
51 × 66 cm
*Inscriptions*: signed l.c., *Pudlo* (in syllabics); Verso: l.l., *CD.024-3995abd-85/86(P)*
*Collection*: West Baffin Eskimo Co-operative, Cape Dorset

*Protecting the Young*
Cape Dorset 1986,
no. 37
Stonecut and stencil
Editioned in 1985

CD.024-3987
1985
Coloured pencil and black felt pen on wove paper; watermark: *Ragston-S-N*
51 × 66.4 cm
*Inscriptions*: signed l.r., *Pudlo* (in syllabics); Verso: l.l., *CD.024-3987bd-85/86(P)*
*Collection*: West Baffin Eskimo Co-operative, Cape Dorset

*Proud Bearer*
Cape Dorset 1986,
no. 38
Lithograph
Editioned early 1986

CD.024-3994
1985
Coloured pencil, graphite, and felt pen on wove paper; watermark: *Ragston-S-N*
50.3 × 66 cm
*Inscriptions*: signed l.c., *Pudlo* (in syllabics); Verso: l.l., *CD.024-3994abd-85/86(P)*
*Collection*: West Baffin Eskimo Co-operative, Cape Dorset

*Shielded Caribou*
Cape Dorset 1986,
no. 39
Stonecut
Editioned in 1985

CD.024-3990
1985
Graphite and black felt pen on wove paper; watermark: *Ragston-S-N*
51 × 66.2 cm
*Inscriptions*: signed l.l., *Pudlo* (in syllabics); Verso: l.l., *CD.024-3990ad-85/86(P)*
*Collection*: West Baffin Eskimo Co-operative, Cape Dorset
See cat. no. 100

*Muskox and Loon*
Cape Dorset 1986,
Other Releases
Etching and aquatint
Editioned in 1984;
released to Norgraphics Limited, Toronto

Not located (appears to have been drawn directly on plate)

*Flight to the Sea*
Cape Dorset 1986,
Other Releases
Lithograph
Released to Marion Scott Limited, Vancouver, for sale in conjunction with Expo '86

CD.024-3991
1985/86
Coloured pencil, felt pen, and graphite on wove paper; watermark: *Ragston-S-N*
51 × 66 cm
*Inscriptions*: signed l.c., *Pudlo* (in syllabics); Verso: l.l., *CD.024-3991abd-85/86(P)*
*Collection*: West Baffin Eskimo Co-operative, Cape Dorset

*Caribou on the Horizon*
Cape Dorset 1987,
no. 26
Stonecut

CD.024-4171
1986/87
Coloured pencil and black felt pen on wove paper; watermark: *Ragston-S-N*
51.5 × 66.2 cm
*Inscriptions*: signed l.c., *Pudlo* (in syllabics); Verso: l.l., *CD.024-4171bd-86/87(P)*
*Collection*: West Baffin Eskimo Co-operative, Cape Dorset

*Caribou Spirits
Ascending*
Cape Dorset 1987,
no. 27
Stonecut

CD.024-4181
1986/87
Coloured pencil and felt pen on wove
paper; watermark: *Ragston-S-N*
50.8 × 66.2 cm
*Inscriptions*: signed l.r., *Pudlo* (in
syllabics); Verso: l.l., *CD.024-4181bd-86/
87(P)*
*Collection*: West Baffin Eskimo
Co-operative, Cape Dorset

*Proud Hunter*
Cape Dorset 1987,
no. 28
Stonecut

CD.024-4170
1986/87
Black felt pen, coloured pencil, and
graphite on wove paper; watermark:
*Ragston-S-N*
50.6 × 66 cm
*Inscriptions*: signed l.r., *Pudlo* (in
syllabics); Verso: l.l., *CD.024-4170abd-
86/87(P)*
*Collection*: West Baffin Eskimo
Co-operative, Cape Dorset
See cat. no. 101

*Startled Young Loons*
Cape Dorset 1987,
no. 29
Stonecut

CD.024-4179
1986/87
Coloured pencil and black felt pen on
wove paper; watermark: *Ragston-S-N*
51.5 × 61.2 cm
*Inscriptions*: signed l.c., *Pudlo* (in
syllabics); Verso: l.l., *CD.024-4179bd-86/
87(P)*
*Collection*: West Baffin Eskimo
Co-operative, Cape Dorset

*A Whaler's Dream*
Cape Dorset 1987,
no. 30
Stonecut and stencil

CD.024-4180
1986/87
Coloured pencil and black felt pen on
wove paper; watermark: *Ragston-S-N*
39.5 × 51 cm
*Inscriptions*: signed l.r., *Pudlo* (in
syllabics); Verso: l.l., *CD.024-4180bd-86/
87(P)*
*Collection*: West Baffin Eskimo
Co-operative, Cape Dorset

*Hunters in the Hills*
Cape Dorset 1987,
no. 31
Stonecut and stencil

CD.024-4177
1986/87
Coloured pencil and black felt pen on
wove paper; watermark: *Ragston-S-N*
50.5 × 66 cm
*Inscriptions*: signed l.c., *Pudlo* (in
syllabics); Verso: l.l., *CD.024-4177bd-
86/87(P)*
*Collection*: West Baffin Eskimo
Co-operative, Cape Dorset

*Iceberg Lookout*
Cape Dorset 1987,
no. 32
Stonecut and stencil

CD.024-4174
1986/87
Coloured pencil and black felt pen on
wove paper; watermark: *Ragston-S-N*
50.7 × 66.2 cm
*Inscriptions*: Verso: l.l., *CD.024-4174bd-
86/87(P)*
*Collection*: West Baffin Eskimo
Co-operative, Cape Dorset

*Ikkutut*, also known as
*Embarking on a Long
Journey*
Cape Dorset 1987,
no. 33
Stonecut and stencil

CD.024-4172
1986/87
Coloured pencil, black felt pen, and
graphite on wove paper; watermark:
*Ragston-S-N*
51.4 × 66.2 cm
*Inscriptions*: signed l.r., *Pudlo* (in
syllabics); Verso: l.l., *CD.024-4172abd-
86/87(P)*
*Collection*: West Baffin Eskimo
Co-operative, Cape Dorset

*New Horizons*
Cape Dorset 1987,
no. 34
Stonecut and stencil

Not located

*Aerial Migration*
Cape Dorset 1987,
no. 35
Lithograph

CD.024-4182
1986/87
Coloured pencil and black felt pen on
wove paper; watermark: *Ragston-S-N*
50.6 × 66.2 cm
*Inscriptions*: Verso: l.l., *CD.024-4182bd-
86/87(P)*
*Collection*: West Baffin Eskimo
Co-operative, Cape Dorset

*Whale Hunters' Boat*
Cape Dorset 1987,
no. 36
Lithograph

CD.024-4175
1986/87
Coloured pencil and black felt pen on wove paper; watermark: *Ragston-S-N*
50.8 × 66.3 cm
*Inscriptions*: signed l.c., *Pudlo* (in syllabics); Verso: l.l., *CD.024-4175bd-86/87(P)*
*Collection*: West Baffin Eskimo Co-operative, Cape Dorset
See cat. no. 102

*Settling for the Night*
Cape Dorset 1989,
no. 24
Stonecut and stencil

CD.024-4519
1988/89
Coloured pencil, felt pen, and graphite on wove paper; watermark: *Ragston-S-N*
51.4 × 66 cm
*Inscriptions*: signed l.c., *Pudlo* (in syllabics); Verso: l.l., *CD.024-4519-abd-88/89-01/03–51.4 × 65.8 Pr.*
*Collection*: West Baffin Eskimo Co-operative, Cape Dorset

*Muskox Migration*
Cape Dorset 1989,
no. 25
Stonecut

CD.024-4517
1988/89
Coloured pencil, black felt pen, and graphite on wove paper; watermark: *Ragston-S-N*
50.8 × 66 cm
*Inscriptions*: signed l.l., *Pudlo* (in syllabics); Verso: l.l., *CD.024-4517-abd-88/89-01–50.7 × 65.9 Pr.*
*Collection*: West Baffin Eskimo Co-operative, Cape Dorset

*Winter Dream*
Cape Dorset 1989,
no. 26
Stonecut

CD.024-4518
1988/89
Coloured pencil, black felt pen, and graphite on wove paper; watermark: *Ragston-S-N*
51.8 × 66 cm
*Inscriptions*: signed l.c., *Pudlo* (in syllabics); Verso: l.l., *CD.024-4518-abd-88/89-01/02–51.3 × 65.7 Pr.*
*Collection*: West Baffin Eskimo Co-operative, Cape Dorset

*Hunter Dreams of Fish*
Cape Dorset 1989,
no. 27
Stonecut and stencil

CD.024-4516
1988/89
Coloured pencil and felt pen on wove paper; watermark: *Ragston-S-N*
66.3 × 51.2 cm
*Inscriptions*: signed l.c., *Pudlo* (in syllabics); Verso: l.l., *CD.024-4516-abd-88/89-06/17/21–66 × 51 Pr.*
*Collection*: West Baffin Eskimo Co-operative, Cape Dorset

*Spirits in the Arctic Night*
Cape Dorset 1989,
no. 28
Stonecut and stencil

CD.024-4520
1988/89
Coloured pencil, felt pen, and graphite on wove paper; watermark: *Ragston-S-N*
66 × 50.4 cm
*Inscriptions*: signed l.r., *Pudlo* (in syllabics); Verso: l.l., *CD.024-4520-abd-88/89-03/05/121–65.7 × 50.4 Pr.*
*Collection*: West Baffin Eskimo Co-operative, Cape Dorset

*Flight North*
Cape Dorset 1989,
no. 29
Lithograph

CD.024-4560
1988/89
Coloured pencil and felt pen on wove paper; watermark: *Ragston-S-N*
51 × 66.3 cm
*Inscriptions*: signed l.c., *Pudlo* (in syllabics); Verso: l.l., *CD.024-4560-abd-88/89-21/104–50.8 × 66 Litho Print*
*Collection*: West Baffin Eskimo Co-operative, Cape Dorset

# Exhibitions

The annual releases of the Cape Dorset graphics collections are not treated here as exhibitions. They are, however, included in the Chronology, and their catalogues are given in the Bibliography.

## Group Exhibitions

### 1967

Stockholm, Konstframjandet, *Inoonot Eskimå: Grafik och Skulptur Från Cape Dorset och Povungnituk* (catalogue).

27 January–26 February, Ottawa, National Gallery of Canada / 30 June–23 July, Southampton, N.Y., Parrish Art Museum / 1–30 August, Winnipeg, School of Art, University of Manitoba / 8–29 October, Saskatoon, Sask., Mendel Art Gallery / 12 November–3 December, Moose Jaw, Sask., Moose Jaw Art Museum / 17 December 1967–14 January 1968, Saint John, N.B., New Brunswick Museum / 28 January–18 February, Montreal, Saidye Bronfman Centre / 3–24 March, London, Ont., London Public Library and Art Museum / 7–28 April, Stratford, Ont., Rothman's Art Gallery / 12 May–2 June, Sarnia, Ont., Sarnia Public Library and Art Gallery, *Cape Dorset: A Decade of Eskimo Prints and Recent Sculpture*, organized in conjunction with the Canadian Eskimo Art Committee, Ottawa (catalogue).

### 1969

25 November–15 December, Toronto, Isaacs Gallery, *Eskimo Drawings: Cape Dorset.*

### 1970

International tour, *Graphic Art by Eskimos of Canada: First Collection*, organized by the Department of External Affairs, Ottawa (catalogue).

International tour, *Graphic Art by Eskimos of Canada: Second Collection*, organized by the Department of External Affairs, Ottawa (catalogue).

### 1971

11 January–12 February, Burnaby, B.C., Simon Fraser Gallery, Simon Fraser University, *The Art of the Eskimo* (catalogue).

20 September–15 October, Toronto, Art Gallery of York University, *Eskimo Carvings and Prints from the Collection of York University* (catalogue).

9 November–9 December, Vancouver, Vancouver Art Gallery / 10 February–2 April 1972, Paris, Grand Palais / 26 April–28 May, Copenhagen, Nationalmuseet / 29 June–23 July, Leningrad, Hermitage / 5 October–10 December, London, Museum of Mankind, British Museum / 24 January–4 March 1973, Philadelphia, Philadelphia Museum of Art / 17 May–17 June, Ottawa, National Gallery of Canada on behalf of the National Museum of Man, *Sculpture/Inuit: Sculpture of the Inuit, Masterworks of the Canadian Arctic*, organized by the Canadian Eskimo Arts Council, Ottawa (catalogue).

### 1972

10–29 January, Winnipeg, Gallery 111, School of Art, University of Manitoba / 6 February–3 March, Edmonton, Alta., Student Union Art Gallery, University of Alberta / 11–28 March, Burnaby, B.C., Burnaby Art Gallery, *Eskimo Fantastic Art* (catalogue).

### 1973

International tour, *Canadian Eskimo Lithographs: Third Collection*, organized by the Department of External Affairs, Ottawa (catalogue).

6 December 1973–6 January 1974, Brussels, Studio 44, Passage 44, *Les Eskimos* (catalogue).

### 1974

30 June–17 August, Chicago, Casino Gallery, *Ulu/Inua: Form and Fantasy in Eskimo Art* (catalogue).

## 1975

September, Bonn, Rheinisches Landesmuseum / 1975–76, circulated in Italy / 15 March–1 May 1977, Ottawa, National Museum of Natural Sciences / 11 May–5 June, Saskatoon, Sask., Mendel Art Gallery / July–September, Tokyo, Wildlife Systems Corporation / 1 October–31 December, Albuquerque, N. Mex., Maxwell Museum of Anthropology / 15 January–28 February 1978, Colorado Springs, Colo., Colorado Springs Fine Arts Center, *We Lived by Animals*, organized by the Department of Indian Affairs and Northern Development and circulated in part by the Department of External Affairs, Ottawa (brochure, 2 versions).

October–November, Swift Current, Sask., National Exhibition Centre / 20 December 1975–15 February 1976, Winnipeg, Winnipeg Art Gallery, *Cape Dorset: Selected Sculpture from the Collections of the Winnipeg Art Gallery* (catalogue).

## 1976

Boston, Countway Library of Medicine, Harvard University / 24 March–23 April 1978, Timmins, Ont., Timmins Museum / 1–31 May, Minesing, Ont., Simcoe County Museum / 1–31 July, Edmonton, Alta., Strathcona Place Society / 20 September–29 October, Bridgewater, N.S., DesBrisay Museum / 17 January–7 February 1979, Waterloo, Ont., Earth Science Museum, University of Waterloo / 15 February–15 March, Hamilton, Ont., McMaster University Art Gallery / 1 April–22 July, Calgary, Alta., Glenbow Museum / 28 July–3 September, Red Deer, Alta., Red Deer and District Museum / 7 November 1979–26 January 1980, Hazelton, B.C., Northwestern National Exhibition Centre / 3–25 May, Fredericton, N.B., National Exhibition Centre, *Shamans and Spirits: Myths and Medical Symbolism in Eskimo Art*, organized by Canadian Arctic Producers, Ottawa, and the National Museum of Man, Ottawa (catalogue).

## 1977

16 July–4 September, Winnipeg, Winnipeg Art Gallery / May–June 1978, Lethbridge, Alta., Southern Alberta Art Gallery / 5 November–3 December, Sackville, N.B., Owens Art Gallery / 1 January–12 February 1979, Castlegar, B.C., National Exhibition Centre / 15 May–15 June, Calgary, Alta., University of Calgary Art Gallery / 2–30 September, Edmonton, Alta., Edmonton Art Gallery / 5 November–10 December, Summerside, P.E.I., Eptek National Exhibition Centre, *Looking South* (catalogue).

15 August–30 September, Halifax, N.S., Saint Mary's University, *Ars Sacra 77* (catalogue).

## 1978

8–29 January, Quebec City, Musée du Québec / 18 February–2 April, Toronto, Art Gallery of Ontario / 14 April–9 May, St. John's, Nfld., Memorial University Art Gallery / 1 June–31 July, Saint John, N.B., New Brunswick Museum / 20 August–8 October, Victoria, B.C., Art Gallery of Greater Victoria / 5–25 March 1979, Atlanta, Ga., Atlanta College of Art / 12 April–13 May, Syracuse, N.Y., Everson Museum of Art / 30 May–15 August, Berkeley, Calif., Lowie Museum of Anthropology / 16 September–14 October, Ann Arbor, Mich., University of Michigan Museum of Art / 21 November–31 December, Saint-Rambert, France, Musée de Saint Rambert-sur-Loire / 10 January–28 February 1980, Caen, France, Musée des Beaux-Arts / 28 March–28 April, Rotterdam, Netherlands, Museum voor Land-en-Volkenkunde / 30 June–31 July, Paris, Musée de l'Homme / 15 September–5 October, Copenhagen, National Museum of Denmark, *The Inuit Print*, organized by the National Museum of Man, Ottawa, and the Department of Indian Affairs and Northern Development (catalogue).

11 March–11 June, Winnipeg, Winnipeg Art Gallery, *The Coming and Going of the Shaman: Eskimo Shamanism and Art* (catalogue).

3–12 August, Edmonton, Alta., displayed at Eaton's during the Commonwealth Games / 4 February–4 March 1979, Kamloops, B.C., Kamloops Public Art Library / 10 June–10 August, Edmonton, Alta., Ring House Gallery, University of Alberta / 27 August–15 September, Prince George, B.C., Prince George Art Gallery / 1–21 October, Dawson Creek, B.C., South Peace Art Society / 1–21 November, Nelson, B.C., Kootenay School of Art / 4–31 December, Swift Current, Sask., Swift Current National Exhibition Centre / 15 January–17 February 1980, Charlottetown, P.E.I., Confederation Centre of the Arts / 3–22 March, Campbellton, N.B., Galerie Restigouche Gallery / 1–22 May, Thunder Bay, Ont., Thunder Bay National Exhibition Centre / 1–30 June, Fort Smith, N.W.T., Northern Life Museum / 15 July–15 August, Estevan, Sask., *Inuit Games and Contests: The Clifford E. Lee Collection of Prints*, organized by Ring House Gallery, University of Alberta, Edmonton, Alta. (catalogue).

11 August–12 November, Winnipeg, Winnipeg Art Gallery, *The Zazelenchuk Collection of Eskimo Art* (catalogue).

19 November–3 December, Jerusalem, Jerusalem Artists' House Museum, *Polar Vision: Canadian Eskimo Graphics* (catalogue).

## 1979

25 March–12 April, Birmingham, Ala., Birmingham Festival of the Arts / 21 April–27 May, Winnipeg, Winnipeg Art Gallery, *Eskimo Narrative*, organized by the Winnipeg Art Gallery (catalogue).

26 March–13 April, Bozeman, Mont., Fine Arts Gallery, Montana State University, *Canadian Eskimo Art: A Representative Exhibition from the Collection of Professor and Mrs. Philip Gray* (catalogue).

1–17 May, Saint John, N.B., Long Gallery, University of New Brunswick, *Inuit Prints in the Permanent Collection of the University of New Brunswick*.

30 May–15 August, San Francisco, Inuk 1, *21 × 12: Eskimo Drawings*.

5 June–16 September, Montreal, Montreal Museum of Fine Arts, *The Inuit Sea Goddess*.

8 July–19 August, Kingston, Ont., Agnes Etherington Art Centre / 15 September–21 October, Fredericton, N.B., Beaverbrook Art Gallery / 15 November–22 December, Calgary, Alta., Nickle Arts Museum, University of Calgary / 20 January–2 March 1980, Victoria, B.C., Art Gallery of Greater Victoria / 6 April–4 May, Windsor, Ont., Art Gallery of Windsor, *Inuit Art in the 1970s* (catalogue).

23 July–17 August, Burnaby, B.C., Simon Fraser Gallery, Simon Fraser University / 29 September–31 October 1980, Fort Smith, N.W.T., Northern Life Museum and National Exhibition Centre / 8 January–4 February 1981, Prince Albert, Sask., Grace Campbell Gallery, J.M. Cuelenaere Library / 21 March–7 April, Leaf Rapids, Man., National Exhibition Centre / 1 May–10 June, Kamloops, B.C., Kamloops Public Art Gallery / 28 August–11 October, Red Deer, Alta., Red Deer Public Library, *Images of the Inuit from the Simon Fraser Collection* (catalogue).

29 July–2 September, Surrey, B.C., Surrey Art Gallery, *Creative Flight* (catalogue).

5 October–25 November, Fort Worth, Tex., Amon Carter Museum / 3 March–May 1982, Snyder, Tex., Diamond M Foundation / 5 May–13 June, Wichita Falls, Tex., Wichita Falls Art Museum / 24 August–10 October, McAllen, Tex., McAllen International Museum, *Eskimo Prints and Sculpture*.

21 November–21 December, Montreal, Canadian Guild of Crafts Quebec, *In Celebration*.

## 1980

12 January–2 March, Winnipeg, Winnipeg Art Gallery, *Cape Dorset* (catalogue).

25 April–25 May, Guelph, Ont., University of Guelph, *The Klamer Family Collection of Inuit Art from the Art Gallery of Ontario* (brochure).

9 August–26 October, Winnipeg, Winnipeg Art Gallery, *The Inuit Amautik: I Like My Hood to Be Full* (catalogue).

5 September–5 October, Gaspé, Que., Musée régional de Gaspé / 19 December 1980–18 January 1981, Chicoutimi, Que., Musée du Saguenay-Lac-Saint-Jean / 10 April–10 May, Thetford Mines, Que., Musée minéralogique et minier de la région de l'amiante / 5–28 June, Montreal, Montreal Museum of Fine Arts / 21 August–20 September, Swift Current, Sask., Swift Current National Exhibition Centre / 31 October–29 November, Surrey, B.C., Surrey Art Gallery, *The Inuit Sea Goddess*, organized by the Montreal Museum of Fine Arts, Montreal (catalogue).

14 November 1980–16 February 1981, St. Paul, Minn., Science Museum of Minnesota / 27 February–11 April, Monterey, Calif., Monterey Peninsula Museum of Art / 30 June–23 August, Rome, Galleria Nazionale d'Arte Moderna / January–March 1984, Waterloo, Iowa, Waterloo Art Center / April–May, West Haven, Conn., National Art Museum of Sport / January–March 1985, Pensacola, Fla., Pensacola Museum of Art / January–February 1986, Muscatine, Iowa, Muscatine Art Center / April–May, Sedona, Ariz., Sedona Art Center / November 1986–January 1987, Wilmington, Del., Delaware Museum of Natural History / February–March, Brunswick, Maine, Parry-Macmillan Arctic Museum / March–May, Marshfield, Wis., New Visions Gallery / June–July, Indianapolis, Ind., Museum of Indian Heritage / September–October, New York, Staten Island Institute of Arts and Science / January–February 1988, Haverhill, Mass., North Essex Community Museum / June–July, Guelph, Ont., Macdonald Stewart Art Centre / August–September, Saint John, N.B., Aitken Bicentennial Exhibition Centre / March–April 1989, Irvine, Calif., Irvine Fine Arts Center / June–August, St. Lambert, Que., *Inuit Games: Traditional Sport and Play of the Eskimo*, organized by the Arts and Learning Services Foundation, Minneapolis, Minn. (catalogue published by the Galleria Nazionale d'Arte Moderna, Rome).

## 1981

2–16 April, Johannesburg, S. Africa, University of the Witwatersrand, Rembrandt Art Centre / 25 May–14 June, Kimberley, S. Africa, William Humphreys Art Gallery / 24 June–2 August, Cape Town, S. Africa, South African National Gallery / 19 August–4 October, Port Elizabeth, S. Africa, King George VI Art Gallery / 21 October–29 November, Durban, S. Africa, Durban Art Gallery / 14 December 1981–24 January 1982, Johannesburg, S. Africa, Johannesburg Art Gallery / 3 February–14 March 1982, Pretoria, S. Africa, Pretoria Art Museum, *Inuit Art: A Selection of Inuit Art from the Collection of the National Museum of Man and the Rothmans Permanent Collection of Inuit Sculpture, Canada*, organized by the National Museum of Man, Ottawa, and Rothmans of Pall Mall Canada Ltd., Toronto (catalogue).

5–11 June, Los Angeles, Arctic Circle, *Transformation* (catalogue).

4 September–11 October, Regina, Sask., Mackenzie Art Gallery, University of Regina, *The Jacquie and Morris Shumiatcher Collection of Inuit Art.*

3–28 October, Fredericton, N.B., Beaverbrook Art Gallery / 1–31 January 1982, St. Andrews, N.B., Sunbury Shores Arts and Nature Centre / 15 February–15 March, Edmundston, N.B., Madawaska Museum / 7 April–7 May, Charlottetown, P.E.I., Confederation Centre Art Gallery and Museum / 15 May–15 June, Moncton, N.B., Galerie d'art, Université de Moncton / 1–28 October, Halifax, N.S., Art Gallery of Nova Scotia / 15 November–15 December, Saint John, N.B., New Brunswick Museum / 10 January–10 February 1983, Sackville, N.B., Owens Art Gallery, Mount Allison University, *The Murray and Marguerite Vaughan Inuit Print Collection* (catalogue).

9 October–8 November, Cobourg, Ont., Art Gallery of Cobourg / 6–30 January 1982, St. Thomas, Ont., St. Thomas Elgin Art Gallery / 26 February–21 March, Simcoe, Ont., Lynnwood Arts Centre / 7–29 May, Woodstock, Ont., Woodstock Public Library and Art Gallery / 2–25 July, Sarnia, Ont., Sarnia Public Library and Art Gallery / 12 August–12 September, Burlington, Ont., Burlington Cultural Centre / 7–31 October, Toronto, Glendon Gallery / 7 November–2 December, Kitchener, Ont., Kitchener-Waterloo Art Gallery / 11 December 1982–9 January 1983, Oakville, Ont., Oakville Centennial Gallery, *Cape Dorset Engravings*, organized by the Department of Indian Affairs and Northern Development and circulated by the Art Gallery of Ontario, Toronto (brochure).

31 October–29 November, Surrey, B.C., Surrey Art Gallery, *The Inuit Sea Goddess* (organized to complement the Montreal Museum of Fine Arts exhibition of the same name).

7–28 November, Montreal, Canadian Guild of Crafts Quebec, *Cape Dorset: Artists of the Studio, Original Works on Paper.*

## 1982

5 June–3 October, Guelph, Ont., Macdonald Stewart Art Centre, *Inuit Art from the Art Centre Collection.*

9 December 1982–23 January 1983, Montreal, Château Dufresne, *Nöel au Château: Art inuit de la collection Macdonald Stewart Art Centre*, organized by the Macdonald Stewart Art Centre, Guelph, Ont.

## 1983

February–March, Vancouver, Inuit Gallery of Vancouver, *Return of the Birds* (catalogue).

14 May–26 June, Ottawa, National Gallery of Canada, *Animals.*

28 May–31 July, Toronto, Art Gallery of Ontario / 10 November 1983–2 January 1984, Winnipeg, Winnipeg Art Gallery / 27 February–27 May, Chicago, Field Museum of Natural History / 20 June–15 August, Calgary, Alta., Glenbow Museum / 13 September–21 October, Victoria, B.C., Art Gallery of Greater Victoria / 15 November 1984–13 January 1985, Montreal, McCord Museum / 21 February–7 April, Charlottetown, P.E.I., Confederation Centre Art Gallery and Museum, *Grasp Tight the Old Ways: Selections from the Klamer Family Collection of Inuit Art* (catalogue).

1 October–31 December, Kleinburg, Ont., McMichael Canadian Collection, *Inuit Masterworks: Selections from the Collection of Indian and Northern Affairs Canada.*

6 October–14 November, Ottawa, Rideau Hall, *The Cape Dorset Print*, organized by the National Museum of Man, Ottawa (catalogue).

1–30 November, New York, United Nations / 12 January–10 February 1984, Washington, D.C., Organization of American States / 1–24 March, Durham, N.C., Duke University / 17 April–31 May, Dallas, Tex., Dallas Historical Society / 15 June–15 September, Santa Fe, N. Mex., Institute of American Indian Arts Museum / 1 October–31 December, Los Angeles, Southwest Museum / 18 February–31 March 1985, Colorado Springs, Colo., Taylor Museum, Fine Arts Center, *Contemporary Indian and Inuit Art of Canada*, organized by the Department of Indian Affairs and Northern Development (brochure and checklist).

14 November–2 December, Paris, UNESCO, *The Arctic*, organized by the National Museum of Man, Ottawa (catalogue).

18 November 1983–20 January 1984, Ottawa, Rideau Hall, *Inuit Art at Rideau Hall*, organized by the Department of Indian Affairs and Northern Development.

## 1984

29 February–15 April, Dayton, Ohio, Dayton Museum of Natural History / 13 May–17 June, Binghamton, N.Y., Roberson Center for the Arts and Sciences / 11 July–2 September, Erie, Pa., Erie Art Museum / 23 October–29 November, New York, Bronx Museum of the Arts / 27 December 1984–24 February 1985, West Palm Beach, Fla., Science Museum / 19 March–23 April, Macon, Ga., Museum of Arts and Sciences / 19 May–23 June, Columbus, Ga., Columbus Museum of Arts and Sciences / 22 July–26 August, Columbia, S.C., Columbia Museums of Art and Science / 21 September–27 October, Nashville, Tenn., Cumberland Museum and Science Center / 1 December 1985–5 January 1986, Montclair, N.J., Montclair Art Museum / 29 January–28 February, Burlington, Vt., Robert Hull Fleming Museum, University of Vermont / 29 March–27 April, East Hampton, N.Y., Guild Hall Museum / 17 May–26 June, Annandale-

on-Hudson, N.Y., Edith C. Blum Art Institute, Bard College, *Arctic Vision: Art of the Canadian Inuit*, organized by Canadian Arctic Producers, Ottawa, with the assistance of the Department of Indian Affairs and Northern Development (catalogue).

19 May–18 August, Ottawa, National Gallery of Canada, *Cape Dorset Prints: 25 Years*.

10 November 1984–6 January 1985, Edmonton, Alta., Edmonton Art Gallery, *Stones, Bones, Cloth and Paper: Inuit Art in Edmonton Collections*.

6 December 1984–28 February 1985, Fort Worth, Tex., Fort Worth Museum of Science and History and Carlin Galleries, *The Last and First Eskimos*.

## 1985

24 March–19 May, Winnipeg, Winnipeg Art Gallery, *Uumajut: Animal Imagery in Inuit Art* (catalogue).

13 April–11 May, Montreal, Canadian Guild of Crafts Quebec, *Recent Acquisitions: The Permanent Collection of Eskimo Prints*.

13 November 1985–6 April 1986, Ottawa, National Library of Canada, *Aboriginal Rights in Canada*.

## 1986

16 January–27 April, Guelph, Ont., Macdonald Stewart Art Centre, *Inuit Art: New Loans and Acquisitions*.

1 May–8 June, Burnaby, B.C., Burnaby Art Gallery, *Northern Exposure: Inuit Images of Travel*, organized with the assistance of the Department of Indian Affairs and Northern Development and the Government of the Northwest Territories (catalogue).

6 May–6 June, Toronto, Koffler Gallery, *The Spirit of the Land* (brochure).

31 May–21 September, Calgary, Alta., Glenbow Museum, *From Drawing to Print: Perceptions and Process in Cape Dorset Art* (catalogue).

9 November 1986–3 May 1987, St. Paul, Minnesota, Minnesota Museum of Art, *The Ancestors: Links between Worlds*.

## 1987

8 February–21 June, Winnipeg, Winnipeg Art Gallery, *The Lindsay and Swartz Collections: New Acquisitions*.

21 February–28 March, Montreal, Canadian Guild of Crafts Quebec, *Permanent Collection Prints: Recent Acquisitions*.

1 March–26 July, Winnipeg, Winnipeg Art Gallery, *Winnipeg Collects: Inuit Art from Private Collections*.

8 April–1 May, Fredericton, N.B., Art Centre, University of New Brunswick, *Inuit Art in the UNB Collection*.

June, Toronto, Art Gallery of York University, *Spirit of the Land: Inuit Art from the Art Gallery of York University Collection* (brochure with checklist).

24 June–19 July, Sudbury, Ont., Laurentian University Museum and Arts Centre, *Works from the McCuaig Collection in the Laurentian University Museum and Arts Centre*.

5 December 1987–7 February 1988, Guelph, Ont., Macdonald Stewart Art Centre / 16 February–20 March, Ann Arbor, Mich., University of Michigan Museum of Art / 10 April–19 June, Winnipeg, Winnipeg Art Gallery / August–September, Yellowknife, N.W.T., Prince of Wales Northern Heritage Centre / 28 October–20 November, Halifax, N.S., Mount Saint Vincent University Art Gallery / 13 January–26 March 1989, Ottawa, National Gallery of Canada / 2 June–30 July, Tulsa, Okla., Gilcrease Museum / 26 August–29 October, Williamsburg, Va., Muscarelle Museum of Art, College of William and Mary, *Contemporary Inuit Drawings* (catalogue).

## 1988

19 January–26 February, Calgary, Alta., Petro-Canada Exhibition Gallery, *Celebration 1988* (catalogue).

10 March–17 April, Saskatoon, Sask., Mendel Art Gallery, *Inuit Carvings and Graphic Works Selected from the Williamson and Mendel Art Gallery Collections*.

17 March–23 April, Montreal, Canadian Guild of Crafts Quebec, *Works on Paper from the Permanent Collection of Inuit Art*.

21 May–5 September, Ottawa, National Gallery of Canada, *Contemporary Inuit Art*.

9 June–5 September, Lethbridge, Alta., University of Lethbridge Art Gallery / January–February 1989, High River, Alta., High River Centennial Library, *The World Around Me*.

19 June–18 September, Winnipeg, Winnipeg Art Gallery, *Building on Strengths: New Inuit Art from the Collection*.

9 December 1988–28 February 1989, Dortmund, W. Germany, Museum für Kunst und Kulturgeschichte and Museum am Ostwall / 26 June–31 December, Hull, Que., Canadian Museum of Civilization / 20 April–24 June 1990, Halifax, N.S., Art Gallery of Nova Scotia, *Im Schatten der Sonne: Zeitgenössische Kunst der Indianer und Eskimos in Kanada / In the Shadow of the Sun: Contemporary Indian and Inuit Art of Canada*, organized by the Canadian Museum of Civilization in conjunction with the University of Würzburg, Würzburg, W. Germany (catalogue, in German).

**1989**

22 January–23 April, Kleinburg, Ont., McMichael Canadian Art Collection, *Cape Dorset Printmaking 1959–1989.*

1–30 April, Kingston, Ont., Agnes Etherington Art Centre, *Collecting Inuit Art: Shifting Perceptions* (catalogue).

8 June–1 July, Toronto, Feheley Fine Arts, *Drawings of the 1960s from Cape Dorset.*

12 August–15 October, Winnipeg, Winnipeg Art Gallery, *Inuit Graphic Art from Indian and Northern Affairs Canada.*

**1990**

25 January–9 September, Hull, Que., Canadian Museum of Civilization, *Arctic Mirror: Images Created by Inuit Artists Depicting the Life and Landscape of Northern Canada.*

## Solo Exhibitions

**1976**

31 May–11 June, Surrey, B.C., Surrey Centennial Arts Centre / 2 September–3 October, Seattle, Wash., Henry Gallery, University of Washington / 10 January–28 February 1977, Scarsdale, N.Y., Greenburgh Nature Centre, an exhibition of eight 1975 prints on the theme of dwellings, organized by the Department of Indian Affairs and Northern Development and shown in Surrey in conjunction with "Habitat: The United Nations Conference on Human Settlements."

**1978**

11–25 February, Toronto, Innuit Gallery of Eskimo Art, *Acrylic Paintings on Paper by Pudlo of Cape Dorset.*

1–31 December, Montreal, Canadian Guild of Crafts Quebec, *Pudlo: Acrylic Paintings.*

**1979**

May–31 July, Winnipeg, Fleet Galleries, *Pudlo Acrylics.*

**1980**

10 May–5 June, New York, Theo Waddington Gallery, *Pudlo Pudlat: Ten Oversize Works on Paper* (brochure).

**1981**

19 April–8 May, New York, Theo Waddington Gallery, *Pudlo Pudlat: Arctic Landscapes.*

**1982**

29 January–26 February, Minneapolis, Minn., Raven Gallery, *Pudlo Pudlat: A Retrospective Show.*

26 March–26 June, Niagara Falls, N.Y., Native American Center for the Living Arts (The Turtle) / 26 July–30 August, Thunder Bay, Ont., National Exhibition Centre / 15 September–30 November, Minneapolis, Minn., Katherine Nash Gallery / 16 December 1982–23 January 1983, Halifax, N.S., Mount Saint Vincent University Art Gallery / 22 February–30 March, St. John's, Nfld., Memorial University Art Gallery / 1 September–15 October, Winnipeg, Winnipeg Art Gallery / 30 November 1983–8 January 1984, Charlottetown, P.E.I., Confederation Centre of the Arts / 15 February–29 April, Regina, Sask., Dunlop Art Gallery, *Pudlo,* organized by the Department of Indian Affairs and Northern Development (brochure).

**1984**

22 November–31 December, Montreal, Canadian Guild of Crafts Quebec, *Pudlo Pudlat Drawings: A Retrospective.*

**1987**

12 September–2 October, Toronto, Innuit Gallery of Eskimo Art, *Drawings by Pudlo of Cape Dorset.*

**1989**

29 January–4 March, Mannheim, W. Germany, Inuit Galerie, *Graphik und Zeichnung von Pudlo Pudlat.*

**1990**

23 June–4 August, Montreal, Canadian Guild of Crafts Quebec, *Pudlo Pudlat: A Retrospective.*

5 July–11 August, Ottawa, Ufundi Gallery, *Pudlo Pudlat: Drawings.*

7–28 July, Toronto, Innuit Gallery of Eskimo Art, *Pudlo Pudlat: Recent Drawings.*

# Collections

Works by Pudlo are in the following museum collections. The initials in parentheses indicate whether the collection contains Pudlo prints, drawings, or sculptures.

Agnes Etherington Art Centre, Kingston, Ont. (P)

Amon Carter Museum, Fort Worth, Tex. (P)

Art Gallery of Greater Victoria, Victoria, B.C. (P)

Art Gallery of Hamilton, Hamilton, Ont. (P)

Art Gallery of Ontario, Toronto (PDS)

Art Gallery of Windsor, Windsor, Ont. (P)

Art Gallery of York University, Toronto (P)

Beaverbrook Art Gallery, Fredericton, N.B. (P)

Canada Council Art Bank, Ottawa (PD)

Canadian Guild of Crafts Quebec, Montreal (PD)

Canadian Museum of Civilization, Hull, Que. (PDS)

Confederation Centre Art Gallery and Museum, Charlottetown, P.E.I. (PD)

Glenbow Museum, Calgary, Alta. (PS)

Laurentian University Museum and Arts Centre, Sudbury, Ont. (P)

London Regional Art Gallery, London, Ont. (P)

Macdonald Stewart Art Centre, Guelph, Ont. (PD)

Mackenzie Art Gallery, University of Regina, Regina, Sask. (P)

MacMillan Bloedel Limited, Vancouver (P)

Mark Osterlin Library, Northwestern Michigan College, Traverse City, Mich. (PS)

McMichael Canadian Collection, Kleinburg, Ont. (PD)

Mendel Art Gallery, Saskatoon, Sask. (P)

National Gallery of Canada, Ottawa (PD)

Owens Art Gallery, Mount Allison University, Sackville, N.B. (P)

Petro-Canada, Calgary, Alta. (P)

Prince of Wales Northern Heritage Centre, Yellowknife, N.W.T. (P)

Royal Ontario Museum, Toronto (P)

Simon Fraser Gallery, Simon Fraser University, Burnaby, B.C. (P)

Surrey Art Gallery, Surrey, B.C. (D)

Teleglobe Canada, Montreal (P)

Montreal Museum of Fine Arts, Montreal (PD)

Toronto Dominion Bank Collection, Toronto (P)

University of Alberta, Edmonton, Alta. (P)

University of British Columbia, Museum of Anthropology, Vancouver (P)

University of Lethbridge, Lethbridge, Alta. (PDS)

University of New Brunswick, Art Centre, Fredericton, N.B. (P)

Vancouver Art Gallery, Vancouver (S)

Winnipeg Art Gallery, Winnipeg (PD)

Xerox of Canada, Vancouver (D)

# Bibliography

Barz, Sandra, ed. *Inuit Artists Print Workbook*. New York: Arts and Culture of the North, 1981.

Bellman, David, ed. *Peter Pitseolak (1902–1973), Inuit Historian of Seekooseelak: Photographs and Drawings from Cape Dorset, Baffin Island* (exhibition catalogue, with essay by Dorothy Eber). Montreal: McCord Museum, 1980.

Blakeman, Evelyn. "Eskimo Prints Shown." *Edmonton Journal*, 31 October 1978.

Blakeman, Evelyn. "No Hunting, Just Art for Pudlo." *Edmonton Journal*, 31 October 1978.

Blodgett, Jean. *Kenojuak* (with essay by Patricia Ryan in collaboration with Kenojuak Ashevak, and notes by Terry Ryan). Toronto: Mintmark Press, 1981 (limited edition); Toronto: Firefly Books, 1985.

Blodgett, Jean. *Grasp Tight the Old Ways: Selections from the Klamer Family Collection of Inuit Art* (exhibition catalogue). Toronto: Art Gallery of Ontario, 1983.

Blodgett, Jean. "Christianity and Inuit Art." *Beaver* 315, no. 2 (Autumn 1984), pp. 16–25. (Reprinted in *Inuit Art: An Anthology*, pp. 84–93. Winnipeg: Watson and Dwyer, 1988.)

Blodgett, Jean. *Etidlooie Etidlooie* (exhibition catalogue). London, Ont.: London Regional Art Gallery, 1984.

Blodgett, Jean. *North Baffin Drawings: Collected by Terry Ryan on North Baffin Island in 1964* (exhibition catalogue, with essay by Terry Ryan). Toronto: Art Gallery of Ontario, 1986.

Bogardi, Georges. "We Are Still Alive... but Barely." *Montreal Star*, 10 January 1976, p. D-1.

Brack, D.M. *Southampton Island: Area Economic Survey, with Notes on Repulse Bay and Wager Bay*. Ottawa: Industrial Division, Department of Northern Affairs and National Resources, 1962.

Burnaby, B.C., Burnaby Art Gallery. *Northern Exposure: Inuit Images of Travel* (exhibition catalogue by Robert Lagassé). 1986.

Cape Dorset, West Baffin Eskimo Co-operative. *Eskimo Graphic Art 1960*. 1960. Reprinted by McLean Printing Services, 1971.

Cape Dorset, West Baffin Eskimo Co-operative. *Eskimo Graphic Art 1961*. 1961. Reprinted by McLean Printing Services, 1971.

Cape Dorset, West Baffin Eskimo Co-operative. *1962 Eskimo Graphic Art*. 1962.

Cape Dorset, West Baffin Eskimo Co-operative. *1963 Eskimo Graphic Art*. 1963.

Cape Dorset, West Baffin Eskimo Co-operative. *Eskimo Graphic Art 1964–65*. 1965.

Cape Dorset, West Baffin Eskimo Co-operative. *Eskimo Graphic Art 1966*. 1966.

Cape Dorset, West Baffin Eskimo Co-operative. *Eskimo Graphic Art 1967*. 1967.

Cape Dorset, West Baffin Eskimo Co-operative. *Eskimo Graphic Art 1968*. 1968.

Cape Dorset, West Baffin Eskimo Co-operative. *Eskimo Graphic Art 1969*. 1969.

Cape Dorset, West Baffin Eskimo Co-operative. *Cape Dorset Print Collection 1970*. 1970.

Cape Dorset, West Baffin Eskimo Co-operative. *Cape Dorset 1971*. 1971.

Cape Dorset, West Baffin Eskimo Co-operative. *1972 Cape Dorset Prints*. 1972.

Cape Dorset, West Baffin Eskimo Co-operative. *1973 Cape Dorset Prints*. 1973.

Cape Dorset, West Baffin Eskimo Co-operative. *Cape Dorset Prints 1974*. 1974.

Cape Dorset, West Baffin Eskimo Co-operative. *Dorset 75: Cape Dorset Annual Graphics Collection 1975*. Toronto: M.F. Feheley, 1975.

Cape Dorset, West Baffin Eskimo Co-operative. *Dorset 76: Cape Dorset Annual Graphics Collection 1976*. Toronto: M.F. Feheley, 1976.

Cape Dorset, West Baffin Eskimo Co-operative. *Dorset 77: Cape Dorset Annual Graphics Collection 1977*. Toronto: M.F. Feheley, 1977.

Cape Dorset, West Baffin Eskimo Co-operative. *Dorset 78: Cape Dorset Annual Graphics Collection 1978*. Toronto: M.F. Feheley, 1978.

Cape Dorset, West Baffin Eskimo Co-operative. *Dorset 79: The Twentieth Annual Cape Dorset Graphics Collection*. Toronto: M.F. Feheley, 1979.

Cape Dorset, West Baffin Eskimo Co-operative. *Dorset 80: Cape Dorset Graphics Annual*. Toronto: M.F. Feheley, 1980.

Cape Dorset, West Baffin Eskimo Co-operative. *Dorset 81: Cape Dorset Graphics Annual*. Toronto: M.F. Feheley, 1981.

Cape Dorset, West Baffin Eskimo Co-operative. *Dorset 82: Cape Dorset Graphics Annual*. Toronto: M.F. Feheley, 1982.

Cape Dorset, West Baffin Eskimo Co-operative. *Dorset 83: Cape Dorset Twenty-fifth Graphics Annual*. Toronto: Methuen, 1983.

Cape Dorset, West Baffin Eskimo Co-operative. *Cape Dorset Graphics 1984*. Toronto: Dorset Fine Arts, 1984.

Cape Dorset, West Baffin Eskimo Co-operative. *Cape Dorset Graphics 1985*. Toronto: Dorset Fine Arts, 1985.

Cape Dorset, West Baffin Eskimo Co-operative. *Cape Dorset Graphics 1986*. Toronto: Dorset Fine Arts, 1986.

Cape Dorset, West Baffin Eskimo Co-operative. *Cape Dorset Graphics 1987*. Toronto: Dorset Fine Arts, 1987.

Cape Dorset, West Baffin Eskimo Co-operative. *Cape Dorset Annual Graphics Collection 1988*. Toronto: Dorset Fine Arts, 1988.

Cape Dorset, West Baffin Eskimo Co-operative. *Cape Dorset Annual Graphics Collection 1989*. Toronto: Dorset Fine Arts, 1989.

Christopher, Robert. "Inuit Drawings: 'Prompted' Art-Making." *Inuit Art Quarterly* 2, no. 3 (Summer 1987), pp. 3–6.

Copland, A. Dudley. *Coplalook: Chief Trader, Hudson's Bay Company, 1923–39*. Winnipeg: Watson and Dwyer, 1985.

Crowe, Keith J. *A Cultural Geography of Northern Foxe Basin, N.W.T.* Ottawa: Northern Science Research Group, Department of Indian Affairs and Northern Development, 1969.

Dault, Gary Michael. "Inuit Painter Best with Airplanes as He Dares to Do What Others Shun." *Toronto Star*, 17 February 1978.

Driscoll, Bernadette. *Uumajut: Animal Imagery in Inuit Art* (exhibition catalogue, with essays by Robert McGhee, George Swinton, Kananginak Pootoogook, and Kiawak Ashoona). Winnipeg: Winnipeg Art Gallery, 1985.

Eber, Dorothy, ed. *Pitseolak: Pictures out of My Life*. Montreal: Design Collaborative Books in association with Oxford University Press, Toronto, 1971; Seattle: University of Washington Press, 1972.

Eber, Dorothy Harley. *When the Whalers Were Up North: Inuit Memories from the Eastern Arctic*. Kingston/Montreal: McGill-Queen's University Press, 1989.

"Eskimo Artist at Sheridan College Creates Silkscreen Banners." *Oakville Beaver*, 15 November 1978.

Field, Edward. *Eskimo Songs and Stories* (collected by Knud Rasmussen, selected and translated by Edward Field, illustrations by Kiakshuk and Pudlo). New York: Delacorte Press/Seymour Lawrence, 1973.

Freeman, Milton, R., ed. *Inuit Land Use and Occupancy Project*. 3 vols. Ottawa: Department of Indian Affairs and Northern Development, 1975–76.

Goetz, Helga. "The Role of the Department of Indian and Northern Affairs in the Development of Inuit Art" (draft manuscript, 1983–84). On file in the Documentation Centre, Inuit Art Section, Department of Indian Affairs and Northern Development, Hull, Que.

Graham, K.M. "K.M. Graham's Involvement with the Cape Dorset Art Centre 1971–1977" (prepared at the request of Wallace Brannen, 3 April 1977). On file in the Documentation Centre, Inuit Art Section, Department of Indian Affairs and Northern Development, Hull, Que.

Hale, Barry. "The Snow Prints: Inuit Visions in an Adopted Art Form." *Canadian Magazine* (*Toronto Star*), 5 June 1976, pp. 8–11.

Higgins, G.M. *The South Coast of Baffin Island: An Area Economic Survey.* Ottawa: Industrial Division, Department of Indian Affairs and Northern Development, 1968.

Hoffmann, Gerhard, ed. *Im Schatten der Sonne: Zeitgenössische Kunst der Indianer und Eskimos in Kanada* (exhibition catalogue, in German, with essays on Inuit art by Bernadette Driscoll, Dorothy Harley Eber, Helga Goetz, Ingo Hessel, Gisela Hoffmann, Odette Leroux, Maria Muehlen, Marie Routledge, and Patricia Sutherland, and entries by Angela Skinner, Dorothy Speak, and Patricia Sutherland. Stuttgart: Edition Cantz in association with the Canadian Museum of Civilization, Hull, Que., 1988.

Houston, James A. "Eskimo Graphic Art." *Canadian Art* 17, no. 1 (January 1960), pp. 8–15.

Houston, James A. "Eskimo Artists." *Geographical Magazine* (London) 34, no. 11 (March 1962), pp. 639–50.

Houston, James A. *Eskimo Prints*. Barre, Mass.: Barre, 1967; Don Mills, Ont.: Longman Canada, 1971.

Hudson, Wil. "Storm over Cape Dorset." *Montreal Star*, 6 March 1976, pp. D-1, D-6.

Jackson, Marion E. "Unedited Transcriptions of Interviews with Pudlo Pudlat, Conducted at Cape Dorset, N.W.T., May–July 1978." On file in the Documentation Centre, Inuit Art Section, Department of Indian Affairs and Northern Development, Hull, Que.

Jackson, Marion E. "Unedited Transcriptions of Interviews with Pudlo Pudlat, Conducted at Cape Dorset, N.W.T., March–June 1979." On file in the Documentation Centre, Inuit Art Section, Department of Indian Affairs and Northern Development, Hull, Que.

Jackson, Marion E. "Personal versus Cultural Expression in Inuit Prints." In *Print Voice*, edited by Walter Jule, pp. 21–25. Edmonton, Alta.: Department of Art and Design, University of Alberta, 1983.

Jackson, Marion E. *Baker Lake Inuit Drawings: A Study in the Evolution of Artistic Self-Consciousness*. Ann Arbor, Mich.: University Microfilms, 1985.

Jackson, Marion E., and Judith Nasby. *Contemporary Inuit Drawings* (exhibition catalogue). Guelph, Ont.: Macdonald Stewart Art Centre, 1987.

Kierstead, Mary D. "The Man" [profile of James Houston]. *New Yorker*, 19 August 1988, pp. 33–47.

Kingston, Ont., Agnes Etherington Art Centre. *Inuit Art in the 1970s* (exhibition catalogue by Marie Routledge). 1979.

Kritzwiser, Kay. "Everything from Mermaid Tales to 'Copters Inspires Inuit Artists." *Toronto Globe and Mail*, 9 February 1988, p. 18.

Labarge, Dorothy. *From Drawing to Print: Perception and Process in Cape Dorset Art.* Calgary, Alta.: Glenbow Museum, 1986.

Levine, Les. "We Are Still Alive." *Parachute* no. 2 (January–March 1976), pp. 23–26.

Levine, Les. "Les Levine Replies…" *Montreal Star*, 16 March 1976, p. D-6.

Lister, Beverley-Ann. "Pudlo Pudlat: Images of Change." Master's thesis, University of British Columbia, 1988.

Lyall, Ernie. *An Arctic Man: Sixty-five Years in Canada's North.* Edmonton, Alta.: Hurtig, 1979.

Martijn, Charles A. "Canadian Eskimo Carving in Historical Perspective." *Anthropos* 59 (1964), pp. 546–96.

McGhee, Robert. "The Prehistory and Prehistoric Art of the Canadian Inuit." *Beaver* 312, no. 1 (Summer 1981), pp. 23–30. (Reprinted in *Inuit Art: An Anthology*, pp. 12–20. Winnipeg: Watson and Dwyer, 1988.)

McGhee, Robert. "Prehistoric Arctic Peoples and Their Art." *American Review of Canadian Studies* 17, no. 1 (Spring 1987), pp. 5–14.

Mekler, Gilda. "Dorset Prints – Encouraging Signs of Life." *Nunatsiaq News*, 3 November 1977, p. 23.

Montreal, Canadian Guild of Crafts Quebec, *The Permanent Collection: Inuit Arts and Crafts, c. 1900–1980* (with essays by Virginia J. Watt, Helga Goetz, and Marybelle Myers). 1980.

Muehlen, Maria. "Pudlo Pudlat." In *The Canadian Encyclopedia*, 2nd ed., vol. 3, p. 1788. Edmonton, Alta.: Hurtig, 1988.

New York, Theo Waddington. *Pudlo Pudlat: Ten Oversize Works on Paper* (exhibition brochure). 1980.

Nixon, Virginia. "Eskimo Attitude: It's Either Art or Welfare." *Montreal Gazette*, 17 January 1976, p. 40.

Ottawa, Canadian Eskimo Arts Council. "Pudlo" (biographical fact sheet compiled by Ene Schoeler with information provided by Patricia Ryan). October 1971. On file in the Documentation Centre, Inuit Art Section, Department of Indian Affairs and Northern Development, Hull, Que.

Ottawa, Canadian Eskimo Arts Council. *Sculpture/Inuit: Sculpture of the Inuit, Masterworks of the Canadian Arctic* (exhibition catalogue). Toronto: University of Toronto Press, 1971.

Ottawa, Canadian Eskimo Arts Council. "Transcript of the Interview with Oshutsiak Pudlat" (interview by Sharon van Raalte, Cape Dorset, May 1985, with Maata Pudlat as interpreter). On file in the Documentation Centre, Inuit Art Section, Department of Indian Affairs and Northern Development, Hull, Que.

Ottawa, Canadian Eskimo Arts Council. "Transcript of the Interview with Pudlo Pudlat" (interview by Sharon van Raalte, Cape Dorset, May 1985, with Maata Pudlat as interpreter). On file in the Documentation Centre, Inuit Art Section, Department of Indian Affairs and Northern Development, Hull, Que.

Ottawa, Canadian Eskimo Arts Council. "Transcript of the Interview with Three Brothers: Pudlo Pudlat, Oshutsiak Pudlat, and Simeonie [Quppapik]" (interview by Sharon van Raalte, Cape Dorset, May 1985, with Maata Pudlat as interpreter). On file in the Documentation Centre, Inuit Art Section, Department of Indian Affairs and Northern Development, Hull, Que.

Ottawa, Department of Indian Affairs and Northern Development. *Cape Dorset Engravings* (exhibition brochure [by Dorothy Labarge] with text by Alex Wyse). 1978.

Ottawa, Department of Indian Affairs and Northern Development. *Pudlo* (exhibition brochure [by Maria Muehlen]). 1981.

Ottawa, Department of Northern Affairs and National Resources. *Eskimo Graphic Art.* 1959.

Ottawa, National Museum of Man. *The Inuit Print* (exhibition catalogue by Helga Goetz). 1977.

Patterson, Nancy-Lou. *Canadian Native Art: Arts and Crafts of Canadian Indians and Eskimos.* Don Mills, Ont.: Collier-Macmillan, 1973.

Patterson, Nancy-Lou, and Erla Socha, "Recent Trends in Canadian Native Printmaking," *Artmagazine* 8, no. 31/32 (March/April 1977), pp. 48–53.

Pitseolak, Peter, and Dorothy Eber. *People from Our Side.* Edmonton, Alta.: Hurtig, 1975.

"Pudlo Hangings for Indian and Northern Affairs Lobby." *About Arts and Crafts* 2, no. 3 (Winter 1978), pp. 2–3.

Raine, David F. *Pitseolak: A Canadian Tragedy.* Edmonton, Alta.: Hurtig, 1980.

[Robertson, Mary]. "Wally Brannen and Mary Robertson Discuss Pudlo's Acrylics" (transcript of an interview, c. 1977). On file in the Documentation Centre, Inuit Art Section, Department of Indian Affairs and Northern Development, Hull, Que.

Roch, Ernest, ed. *Arts of the Eskimo: Prints.* Montreal: Signum Press in association with Oxford University Press, Toronto, 1974.

Sheppard, Jenny. "Simple Lines Mask Prints' Complexity." *Hamilton Spectator*, 6 November 1976, p. 46.

Surrey, B.C., Surrey Art Gallery. *Creative Flight* (exhibition catalogue). 1979.

Swinton, George. *Sculpture of the Eskimo.* Toronto: McClelland and Stewart, 1972.

Swinton, Nelda. *The Inuit Sea Goddess* (exhibition catalogue). Montreal: Montreal Museum of Fine Arts, 1980.

Toronto, Art Gallery of Ontario. *Cape Dorset Engravings* (exhibition brochure by Karen Findlay; exhibition organized by the Department of Indian Affairs and Northern Development). 1981.

Toronto, Innuit Gallery of Eskimo Art. *Drawings by Oshoochiak Pudlat of Cape Dorset* (exhibition brochure). 1985.

Tweedsmuir, John Norman Stuart Buchan. *Hudson's Bay Trader.* London: Clarke and Cockeran / New York: W.W. Norton, 1951.

Vancouver, Vancouver Art Gallery. *Robert Flaherty, Photographer/ Filmmaker: The Inuit 1910–1922* (exhibition catalogue by Jo-Anne Birnie Danzker, with essays by Peter Pitseolak, Robert Flaherty, Jay Ruby, James M. Linton, and staff of the National Photography Collection, Public Archives of Canada). 1979.

Vastokas, Joan M. "Continuities in Eskimo Graphic Style." *Artscanada* 27, no. 6 (December 1971–January 1972), pp. 69–83.

Winnipeg, Winnipeg Art Gallery. *Cape Dorset: Selected Sculpture from the Collections of the Winnipeg Art Gallery* (exhibition catalogue by Marsha Twomey, with introduction by Terry Ryan). 1975.

Winnipeg, Winnipeg Art Gallery. *Cape Dorset* (exhibition catalogue by Jean Blodgett, with essays by James Houston, Alma Houston, Dorothy Eber, Terry Ryan, and Kananginak Pootoogook). 1979.

Winnipeg, Winnipeg Art Gallery. *Baffin Island* (exhibition catalogue by Bernadette Driscoll, with essays by Lypa Pitsiulak, Gabriel Gély, and Terry Ryan). 1983.

# Index of Titles

A page number in italics refers to the location of an illustration in the catalogue.

*Aerial Migration*   175
*Aerial Portage*   *37*, 173
*Aeroplane*   13, 31, 32, 33, 49, 78, *95*, *132*, 161
*Aggressive Stance*   171
*Agutiit Asivaqtut*   161
*Airplane*   25, *87*, *120*
*Airplane between Two Places*   32, *95*, *136*
*Airplane with Antlers*   33, *140*
*Airplanes in the Settlement*   32, *94*, *134*
*Airplanes over Ice-Cap*   165
*Alerted Loons*   *37*, *150*
*Animal Boat*   40, 157
*Arctic Angel*   158
*Arctic Waterfall*   27, *125*, 162
*Arrival of the Prophet*   141, 168
*At Tasiujajuaq*   161
*Avingaluk (The Big Lemming)*   *18*, 19, *102*, 156

*Bear in Camp*   163
*Bird and Landscape*   23, 26, *85*, *111*
*Bird and Woman*   22, *108*
*Bird Boat*   21, 40, *107*

*Bird Fantasy*   40
*Bird of Autumn*   171
*Bird of Early Dawn*   171
*Bird of Winter Darkness*   168
*Bird on the Land*   162
*Bird with Cap and Symbols*   26, *119*
*Bird with Playing-Card Designs*   23, *110*
*Birds*   19, *102*
*Birds of the Tundra*   173
*Birds Together*   173
*Blue Musk-ox*   33, *139*, 164
*Boat and Airplane*   167
*Boat at Anchor*   *132*

*Camp Scene with Igloos and Drying Racks*   27, *92*, *126*
*Caribou*   23, 34, *112*, *147*
*Caribou Chased by Wolf*   *18*, 156
*Caribou-Creature Seen from Above*   34, 36, *143*
*Caribou in Winter Light*   173
*Caribou on the Horizon*   174
*Caribou Spirits Ascending*   175
*Caribou Tent*   121, 159
*Carried by a Kite*   38, *153*
*Chased by Dogs*   19, *106*
*Children on Komatik*   160
*Composition*   158, 159
*Composition with Arm, Braids, and Fish*   36, *150*
*Composition with Arms and Bird*   36, *149*
*Composition with Caribou-Creature and Bird*   *35*, 40
*Composition with Caribou-Creature and Fish*   *35*, 40
*Composition with Caribou-Creature and Loon*   34, 40, *99*, *146*
*Composition with Komatik and Figures*   30, *129*
*Composition with Woman, Fish, and Seals*   *108*
*Confrontation*   171

*Decorated Bird*   21, *106*
*Decorated Seal*   21, *107*
*Dogs Tied to a Tree*   25, *88*, 117
*Dogs Watching a Flying Creature*   19, *103*
*Double Tent*   26, *122*
*Dream of the Bear*   161

*Eagle Carrying Man*   19, 157
*Ecclesiast*   23, *24*, 158
*Embarking on a Long Journey*   175
*Encounter with a Polar Bear*   *123*
*Esigajuak*   25, *88*, *118*, 159
*Eskimo Woman with Ulu*   156

Family of Birds   159
Fantastic Kingalaq   170
Fantasy Creature   *23, 24 113*
Festival of the Loon   169
Fish-Airplane   25, *120*
Fish and Bear   158
Fish and Loons   161
Fish and Spear   *18,* 156
Fish Composition   *23, 24*
Fish-Creatures Attack Kayak   *109*
Fish Lake   157
Fish Line   21, 40, *109,* 157
Fish Takes Flight, The   169
Fisherman   159
Fishing   163
Five Owls   40
Flight North   176
Flight to the Sea   40, 51, 174
Flying Figure   36, *148*
Fox in Camp   *90, 129,* 160

Gathering Moss for the Nest   170
Gigantic Bird on a Leash   25, *116*
Good Catch, A   33, *139,* 165
Goose   158
Grey Bird   163

Harpoons and Seals   167
He Finally Caught a Fish   22, *110*
Head of a Musk-ox   24, *115*
Helicopter   *133,* 164
Helicopters and Woman   38, *100, 153*
Hunter Dreams of Fish   176
Hunter with Heavy Load   170
Hunter's Igloo   29, *130,* 160
Hunters in the Hills   175

I Saw a Great Bird   165
Iceberg Lookout   175
Igloo Builders, The   160
Igloos in a Landscape   27, *28*
Ikkutut   175
Imposed Migration   40, 173
In Celebration   50, 166
In the Lake   165
Interrupted Solitude   172
Island Landscape   31, *133*

Jets, Boats, and Birds in Formation   32, 33, *136*
Journey into Fantasy   169
Journey of the Loon   169

Kayak and Fish   161

Landscape of Baffin   168
Landscape with Antenna   27, *126*
Landscape with Caribou   163
Landscape with Ice Floes   27, *92, 125*
Landscape with Rainbow and Sun   23, 26, *111*
Landscape with Utility Poles   27
Large Loon and Landscape   *142,* 166
Long Journey   27, *91, 124,* 159
Loon   39, *43*
Loon and Seal in Ocean Swell   173
Loon and the Fish Speak, The   167
Loon in a Strong Wind   170
Loon in Open Water   35, 36, *146,* 171
Loon Speaks to the Walrus   167
Loons among Muskox   172
Loons and Fish   161
Loons Protecting Young   170

Man Among the Loons   171
Man Carrying Bear   19, 155
Man Carrying Reluctant Wife   19, *20,* 155
Man Carrying Water   19, 20, *104*
Man Chasing Strange Beasts   *21,* 22, 156
Man in Fish Weir   *18,* 19, 23, 26, *105,* 156
Man with Rabbit   157
Men Carrying a Caribou   *103*
Metiq on Mallik   169
Modern Life and the Old Way   33, *97, 138*
Mother and Child with Ulu   156
Mounted Hunter   169
Musk-ox   *144*
Musk-ox, Frontal View   24, *86, 114*
Musk Ox Trappers   24, *45,* 157
Musk-ox with Double Horns   25, *115*
Muskox and Airplane   50, 166
Muskox and Friends   166
Muskox and Loon   51, 174
Muskox in Flight   173
Muskox in the City   *138,* 165
Muskox Migration   176
Muskox Near Ice   165
Muskox on Sea Ice   166
My Home   29, 129, *130,* 160
My Youthful Fantasy   172

Naujaq Umiallu   163
New Amautik, The   161
New Forms in Our Path   174
New Horizons   175
New Parts for an Inuk   33, *97, 142*
North and South   28, 31, 82, *93, 127*
Northern Landscape   *134*

One Between, The   172
Our Home   130, 160
Our Massive Friend   170
Overshadowed by a Great Bird   172
Owl   *17,* 39
Owl Alighting   39
Owl, The   158

Pangniq Sniffs the Wind   170
Patriarchal Protector   174
Perils of the Hunter   158
Protecting the Young   174
Protective Harbour   172
Proud Bearer   174
Proud Hunter   37, *151,* 175
Ptarmigan in the Sunlight   167
Pulling In a Walrus   37, *152*
Pungnialuk   *34,* 164

Qaqsan   164
Qulaguli   31, *133,* 164

Raven with Fish   157
Ready to Fly   167
Running Rabbit   157

Saddled Muskox   *49,* 164
Sail in the Settlement   36, *149*
Sea Creatures   32–33, *135*
Sea Creatures and Bird   158
Sea Dogs Chasing Fish   160
Sea Goddess   33, *135*
Sea Goddess Held by Bird   156
Seagull and Muskox   165
Seals Meet a Bear   25, *117*
Seals Surfacing   172
Seasons, The   30, *131,* 162
Sedna   25, *89, 118,* 162
Settlement from a Distance, The   168
Settling for the Night   176
Shaman's Dwelling   26, *48,* 160
Shaman's Tent   121, 159

Shielded Caribou   37, *151,* 174
Ship of Loons   35, *98, 145,* 168
Ship of the Loon   167
Ship Passes By, A   168
Shores of the Settlement   33, 49, 165
Skins and Blankets Hanging to Dry   33, *98, 141*
Sleeping Duck   39
Snow Swan of Parketuk   35, 36, *145,* 169
Spider   25, *116*
Spirit   *17*
Spirit Watching Games   103, 157
Spirit with Symbols   20, 105, 156
Spirits   157
Spirits in the Arctic Night   176
Spirits of the Sea   162
Spring Camp at Igakjuak   160
Spring Hunter   160
Spring Landscape   27, *128,* 163
Spring Landscape (Dirty Snow)   27, *127*
Spring Travellers   *124,* 162
Startled Young Loons   175
Summer Loon   166

Tale of a Huge Musk-ox   36, *143,* 170
Taleelayo   157
Tent and Fish   26, *121*
Tent with Caribou Head   26, *91, 121*
Thoughts of a Child   163
Thoughts of Home   160
Thoughts of My Childhood   *131,* 162
Thoughts of Walrus   155
Timiat Nunamiut   48, 168
Timiat Timijut   161
Towering Loons   172
Transported   33, *141*
Transported by a Bird   19, 20, 25, 38, *104*
Tudlik   159
Tulik and Sailboats   164
Tupiit   26, *122,* 162
Tupik   161
Two Loons at Sea   164, 166
Two Seals   161

Umayuluk   24, *113,* 158
Umiakjuak   *140,* 166
Umimmak Kalunaniituk   33, *138,* 165
Umingmuk   24, 47, 77, *86, 114,* 158, 163
Umingmunga   164

*View from the Ice*   *96*, *137*
*Vision of Two Worlds*   168

*Walrus and Young*   *147*, 171
*Walrus Close Up*   35, *144*
*Walrus on the Horizon*   35, *137*
*We Travel with the Loon*   167
*Whale Hunters' Boat*   37, *152*, 176
*Whaler's Dream, A*   175
*Winds of Change*   36, *148*, 173
*Winter Angel*   23, 24, *112*, 158
*Winter Bird*   171
*Winter Camp at Itileakju*   162
*Winter Camp Scene*   27, *123*, 159
*Winter Dream*   176
*Winter Games*   *128*, 161
*Woman Holding a Bird*   25, *119*
*Woman with Bird Image*   19, *101*, 155
*Woman with Utensils*   19, 20, *105*
*Women at the Fish Lakes*   163

*Yellow Boat*   163
*Young Girl and Muskox*   169
*Young Woman*   160

# Photograph Credits

**Catalogue and Plates**
All photography National Gallery of Canada, except cat. no. 2
Montreal Museum of Fine Arts.

**Figures**
Department of Indian Affairs and Northern Development
frontispiece (Michael Mitchell); 1, 40 (John Paskievich); back cover
(Norman Hallendy); 38 (Michel Bouchard); 3, 5, 6, 7, 11, 18, 20, 21,
24, 25
Hudson's Bay Company Archives, Provincial Archives of Manitoba,
Winnipeg    28 (J. Cantley); 31 (Ralph Parsons, HBC District Manager);
32 (James Dunlop Mackenzie); 29, 30
Marion Jackson, Ann Arbor, Michigan    39
Macdonald Stewart Art Centre, Guelph, Ontario    8, 15
Tessa Macintosh, Yellowknife, Northwest Territories    14, 22, 23, 27,
36, 37
Notman Photographic Archives, McCord Museum of Canadian
History, Montreal    34    (MP245/75[153]/Peter Pitseolak)
National Archives of Canada, Ottawa    4 (PA-145608/B. Korda); 33
(PA-175971/J.L. Robinson); 35 (PA-118724/B. Korda)
National Gallery of Canada, Ottawa    9, 10, 12, 13, 16, 17
Jerry Riley, Toronto    26
Supply and Services Canada, Photo Centre    19 (Norman Hallendy)
George Swinton, Winnipeg    2